DESIGN
PRINCIPLES
AND PROBLEMS

SECOND EDITION

PAUL ZELANSKI MARY PAT FISHER

DESIGN PRINCIPLES AND PROBLEMS

SECOND EDITION

PAUL ZELANSKI | MARY PAT FISHER

WADSWORTH
CENGAGE Learning

Australia • Brazil • Japan • Korea • Mexico • Singapore • Spain • United Kingdom • United States

WADSWORTH
CENGAGE Learning

Design Principles and Problems, 2nd Ed.
Paul Zelanski and Mary Pat Fisher

Publisher: Ted Buchholz

Editor in Chief: Christopher P. Klein

Acquisitions Editor: Barbara J. C. Rosenberg

Project Editors: Margaret Allyson, Barbara Moreland

Production Manager: Jane Tyndall Ponceti

Senor Art Director: David A. Day

Picture Editor: Carrie Ward

Photo Researcher: Elsa Peterson

For product information and technology assistance, contact us at **Cengage Learning Customer & Sales Support, 1-800-354-9706**

For permission to use material from this text or product, submit all requests online at **cengage.com/permissions**
Further permissions questions can be emailed to **permissionrequest@cengage.com**

Library of Congress Control Number: 95-60358

ISBN-13: 978-0-15-501615-6

ISBN-10: 0-15-501615-6

Wadsworth
25 Thomson Place
Boston, MA 02210
USA

Cengage Learning is a leading provider of customized learning solutions with office locations around the globe, including Singapore, the United Kingdom, Australia, Mexico, Brazil, and Japan. Locate your local office at: **international.cengage.com/region**

Cengage Learning products are represented in Canada by Nelson Education, Ltd.

For your course and learning solutions, visit **academic.cengage.com**

Purchase any of our products at your local college store or at our preferred online store **www.ichapters.com**

Printed in the United States of America
16 17 18 11 10 09

The second edition of *Design Principles and Problems* is the result of a unique collaboration between an artist who has taught basic design to a great variety of college students for more than 37 years and an experienced professional writer of college textbooks. Together we have tried to create a book that prepares a solid foundation for studying all the fine and applied arts and is at the same time readable, interesting, and clear.

The process of creating a work of art cannot be fully explained, for to a certain extent, the artist experiences the world as a young child does—directly and nonverbally. Much of what goes on during the creation of a work of art springs from the artist's intuition and imagination. What *can* be brought to conscious awareness, learned, and then used deliberately during the act of creation is a body of principles and elements of design that are common to all the visual and functional arts. Discussion of these principles and elements followed by practice in the form of studio problems is the core of this book. Intuition cannot be taught, but use of this innate faculty can be enhanced through support of an experimental attitude and through discussion of artistic behavior and artistic thinking. Throughout the text we therefore encourage students to feel more comfortable in "playing" with design, experimenting with it in seemingly childlike ways.

Good design is found in many cultures and in many forms of art. For the second edition of this book, we have broadened the visual program to encompass examples of good design from all over the world and from many media. In today's aesthetic we have rediscovered spiritual, personal, and intuitive art, and at the same time, we are embracing its antithesis: art born of high technology. The most rapidly expanding medium today is the computer. It was not created as an artist's tool, but artists are beginning to discover its tremendous potential as a distinctive medium of design. Young artists are particularly flexible in its use.

This book is structured in a way that gradually develops a practical vocabulary of design. The first chapter, "Awareness of Design," explores general considerations: the relationship of art forms to our three-dimensional world, ways in which the artist can control the viewer's response, and the combination of intellect and intuition in the creative process. The second chapter, "Unifying Principles of Design," explores the understructure of good design. It is followed by six chapters that examine the elements of design—line, shape and form, space, texture, value, and color—and the principles involved in their use. The final chapter discusses application of the principles and elements of design to three-dimensional works. In each of these latter chapters student understanding of the elements and principles of design is developed first through introductions that analyze their use in masterworks from various design disciplines. They include many twentieth-century works, for today's student will eventually stand on the shoulders of current innovators, understanding all that has gone before and researching even further into new dimensions. The understanding developed in the introduction to each chapter is then put into practice in a series of studio problems, 70 in all. These are illustrated by sample student solutions and discussed as concrete examples of the principles and elements at work.

Some of the student solutions are more successful than others, as it is instructive for students to analyze why certain designs do *not* work. The

student works were chosen to represent a range of abilities, allowing students to feel "I can do better than that!" in some cases and to feel challenged in others. The solutions also range from the very typical to the atypical—to solutions that are so unusual that some people will question whether they actually solve the problem.

The valuable critiquing process begun in the analysis of student examples in the text ideally will be greatly expanded through the instructor's critiques of the individual student's work and through the student's self-comparison with the work of other students. Those who are preparing for applied design disciplines will find it especially useful to learn how to identify and explain their reasons for employing design elements in a particular way, for someday they will have to explain and justify their intentions to clients and employers. Often this intellectual understanding of a work evolves after the piece has been more intuitively and experimentally created.

Design Principles and Problems is intended to be used flexibly. The number, sequence, and media or problems assigned can easily be adjusted to fit the length of the course, the instructor's individual style, and the students' special abilities and needs. The chapter on three-dimensional design can be omitted in courses that cover only two-dimensional design. Through such adjustments, the text can be used for one- or two-semester (quarter) courses, for art majors or nonmajors, and for students bound for either the fine arts or for applied design disciplines.

Throughout the textbook technical terms are clearly defined at the point where they are first introduced. In addition, there is a glossary of all such terms used in the text. Another special feature is an appendix that describes the materials and methods that may be used in solving the two- and three-dimensional studio problems and that offers suggestions for presentation techniques.

Acknowledgments

Throughout the development of the manuscript we were patiently and wisely guided by many teachers of design. We are very grateful for their many thoughtful suggestions, which helped us to improve the book's breadth, depth, and clarity. They include Shirley Roese Bahnsen, Mount Saint Clare College; Donald Barr, College of the Ozarks; David L. Faber, Wake Forest University; Mary Sayer Hammond, George Mason University; Leslie Kramer, Elmira College; Joseph S. Popp, College of Du Page; Lori Uffer, Brookdale Community College; Randolf A. Williams, Mahattanville College.

A number of artists have been exceptionally generous in sharing their work and ideas with us. We would particularly like to thank Jan and Peter Good for comments that will be helpful to students in understanding how the creative mind works. In addition, we appreciate the help of Steve Dolbin and his students in three-dimensional design. We would like to thank Frank Noelker for all the photographs he has taken for this new edition.

We also want to express our deep appreciation to the students who have taught us so much, particularly to those whose work is displayed in the book.

Thanks also to our professional helpers at Harcourt Brace: Barbara J. C. Rosenberg, Acquisitions Editor; Terri House, Developmental Editor; Margaret Allyson, Senior Project Editor; Barbara Moreland, Project Editor; Jane Tyndall Ponceti, Production Manager; David A. Day, Senior Art Director; Carrie Ward, Picture Editor; and Elsa Peterson, Photo Researcher.

As always, Annette Zelanski has been of great help and support, and we love her.

SHAPE
AND
FORM

SHAPE AND FORM 85

SPACE

SPACE 121

TEXTURE 149

TEXTURE

ACTUAL TEXTURE 151
SIMULATED TEXTURE 156
BUILT-UP MEDIA 158
REPETITION OF DESIGN ELEMENTS 159
TYPE AS TEXTURE 161
PRINTS OF TEXTURES 164
RUBBINGS AND TRANSFERS 166
ERASURES 168
COMPUTER TEXTURES 169

VALUE 187

VALUE

REPRESENTING VALUE GRADATIONS 189
 Graded Use of Media 189
 Optical Mixtures 190
FROM LOCAL COLORS TO LOCAL VALUES 195
FROM LOCAL VALUES TO INTERPRETIVE VALUES 196
EMPHASIS AND DESIGN INTEREST 199
SPATIAL EFFECTS 200
 Modeling of Forms 201
 Pushing Values Forward or Back 203
 Depth in Space 205

COLOR

THE THIRD DIMENSION 267

1
AWARENESS
OF
DESIGN

KEY TERMS

- abstract art
- applied arts
- color
- concept
- crafts
- design
- figure
- figure-ground relationship
- figure-ground reversal
- fine arts
- flat space
- form
- format
- ground
- line
- medium
- morphing
- nonrepresentational art
- nonobjective art
- nonfigurative art
- pictorial
- picture plane
- scanning
- shape
- space
- spontaneous interaction
- texture
- three-dimensional art
- two-dimensional art
- value
- viewing angle
- viewing distance
- visual arts

1 AWARENESS OF DESIGN

Most people already know a great deal about the art of design, but few of us recognize our own visual sophistication.

Relearning the Obvious

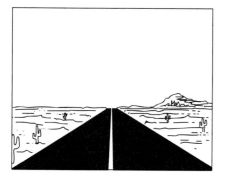

1.1 *above*
From behind the wheel of a car these simple visual sensations would be interpreted as a road stretching into the distance.

To **design** is to endow optical sensations—or *images*—with meaning. The mind does this constantly. It refuses to perceive the outside world as a chaotic jumble of meaningless sensations. Instead, it quickly registers all incoming stimuli and assigns them some orderly meaning. If you were sitting behind the wheel of a car looking through the windshield, you might receive the following set of visual sensations: straight gray line 25 feet wide, narrowing to about 2 inches. Your mind would immediately assign them the meaning: road stretching into the distance, safe to drive on for as far as you can see. [Figure 1.1]

We are perpetually bombarded with so many sensations that we cannot pay conscious attention to all of them. Instead, we learn through experiences with our environment how sensations can be interpreted and which ones can safely be ignored. For example, we often block from conscious awareness familiar sounds like the hum of the refrigerator and the tick of the clock in order to limit our attention to stimuli that interest us more. We defend ourselves from being aware of more things than we can handle at once by imposing a "defensive grid" on our perceptions. Formal education typically reinforces this process by forcing us to use our eyes solely to register information thought to have practical value.

In the world of visual stimuli, we consciously "*see*" only what we choose to focus on. The rest of our visual perceptions are consigned to a less conscious level of awareness. Even those things we focus on are run through a grid of learned meanings. For instance, we learn early in life that things appear smaller as they move farther away from us. Once we have learned this, we immediately interpret a road that diminishes from 25 feet in width to an apparent 2 inches as stretching into the distance rather than actually shrinking.

The visual vocabulary we build up over the years is full of such cues with assigned meanings and is as familiar as our verbal vocabulary. Just as we do not usually stop to think of words as we speak, we do not usually puzzle over the meaning of the things we see. To design successfully, you must create and manipulate images that communicate to the viewer the meaning or

impact you intend. To do this, you must bring back into conscious awareness responses you may now take for granted. For example, if you want people to think that a flat image you are creating has depth, you must be aware of all the visual cues you have learned to interpret automatically as depth. Awareness of these cues gives you ways of controlling others' perceptions— of making them respond to your flat image as though it had depth.

In addition to cues to meaning, other responses arise from the interaction of design elements. As you will see in Chapter 8, our perceptions of colors are affected by the colors around them. In this book, such cues and perceptual responses are expressed as principles, or basic truths, that the artist can consciously use.

Certain visual cues cannot be expressed as general principles, for not everyone has learned to assign the same meaning to them, or to respond in the same predictable way. To most people, a string of undotted lower-case *l*'s written in script looks like water. But to someone who has always lived in the desert it may be meaningless — or may look like tents. [Figure 1.2]

An artist must be sensitive to the meanings and responses viewers have built up from their experiences. It is probably safe to assume that contemporary people in industrial societies have extraordinary visual sophistication. Television has accustomed them to rapid scale changes, fade-ins, washouts, simultaneous images, and the like. TV-watching baseball fans are used to split-screen techniques and reversed angles, showing the pitcher winding up to throw, the player on first starting to steal, and the player on third starting to run for home—all at once, all in close-up, and all from different camera angles. To increase the visual excitement of scene or camera changes, television designers may use elaborate "wipes" presenting parts of a new scene as growing out of and eventually replacing the previous scene. Such visual sophistication makes it possible for contemporary viewers to accept the logic of partial figures viewed from different angles in Robert Birmelin's *The Overpass II*. [Figure 1.3]

1.2 above
Do you see waves or a line of tents?

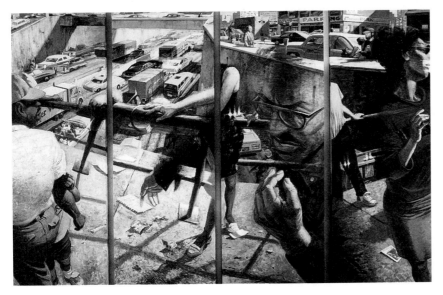

1.3 left
Robert Birmelin. *The Overpass II*. 1992-93. Acrylic on canvas, 7' 6" × 11' 4" (2.29 × 3.45 m). Contemporary Realist Gallery, San Francisco.

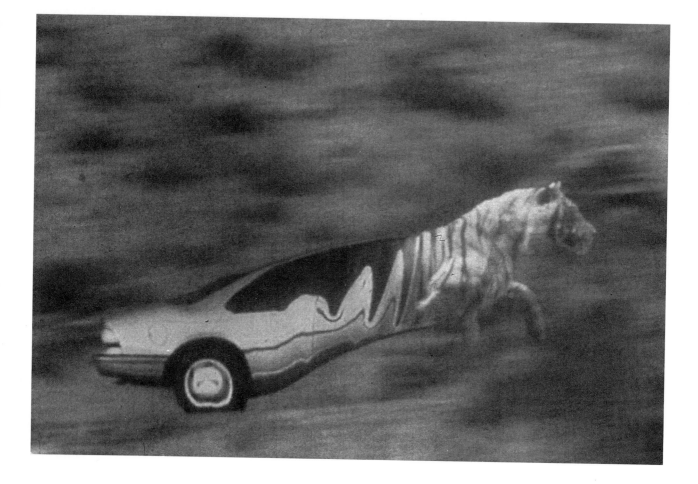

1.4 above

Two different moving objects were morphed together for the first time in the Exxon television commercial entitled "You Know," which premiered in the spring of 1991.

The use of computer graphics allows spectacular, rapidly changing, three-dimensional effects. People today are not startled by these complex visual sensations. They are familiar with them and can make sense of them. **Morphing,** a computer technology that gradually transforms one image into another, is taken for granted by today's sophisticated viewers but was stunning in its early use, such as in *Terminator 2, Judgment Day* (a hybrid of film and digital technology) and Michael Jackson's music video *Black or White.* In the Exxon television ad a car was morphed into a tiger in only a few seconds. [Figure 1.4] Such visual effects have to change rapidly, for the longer an image remains on the screen, the more likely the audience is to see through the technological tricks.

Likewise, many people are accustomed to **abstract art,** in which the artist explores general visual or spiritual qualities of an object rather than its surface appearance, or else makes no reference at all to actual objects. Sophisticated viewers will immediately try to assign object-meaning to anything remotely similar to objects from their world. It is almost impossible to look at the shapes in Figure 1.5 without assigning some meaning to them. Most people in our culture will see mounted horses, which is what the artist

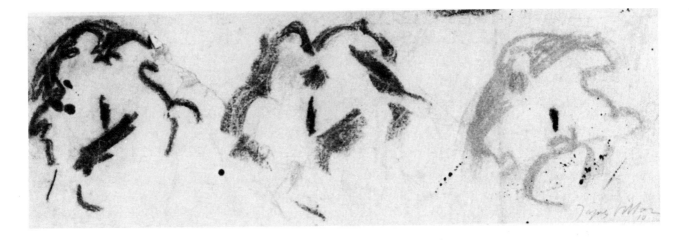

intended when he depicted only the suggestion of a rearing shape with outstretched forelegs.

When there is no reference to real objects, the work is called **nonrepresentational, nonobjective,** or **nonfigurative art.** It makes no attempt to depict anything in the world of our experiences and instead deals with the pure elements of design. Kazuya Sakai uses computer imaging to manipulate shapes, lines, and colors in ways that are unrelated to how things look and behave in the world of time and space with which we are familiar. [Figure 1.6]

Like most people in our society, you have tremendous visual sophistication. In your seeing—your ability to respond to and make sense of a variety of visual images—you are already very creative. As an artist, your task is to use consciously what you already do intuitively.

1.5 above
Jacques Villon. *Horses and Horsemen.* 1910. Crayon drawing in brown, lavender, orange, two shades of pink, with pencil, on thin tinted gray paper; 4¾ × 14⁹⁄₁₆ ″ (12 × 37 cm). Formerly offered by Lucien Goldschmidt, Inc.

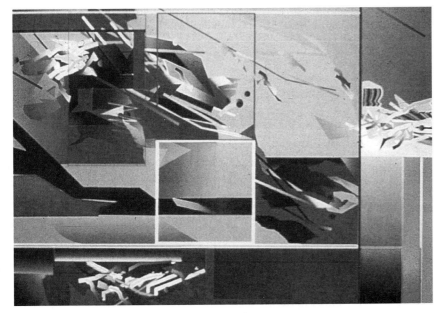

1.6 left
Kazuya Sakai. *Sky 15C.* 1989. Computer graphics print, 22 × 30″ (56 × 76 cm). Courtesy the artist.

Isolating Elements of Design

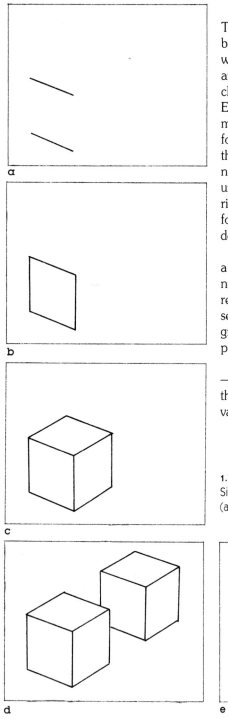

The simplest way to develop this awareness and control is to isolate some basic elements of design and try to understand them one at a time. Those we will focus on in this book are line, shape or form, space, texture, value, and color. **Line** is first, because scribbling lines is our first attempt at art as children. Laying down lines is the simplest way of developing a visual image. Elements are then added in logical order [as in Figure 1.7]: lines connected make flat **shapes;** shapes put together in space seem to suggest **form.** When forms are indicated a feeling of **space** becomes stronger. **Texture** bridges the gap from the eye to the touch. **Value**—the degree of darkness or lightness—refines responses to shape, form, space, and texture and provides the understructure for understanding color. **Color** adds a special seasoning, a richness, to our visual sensations. Finally, understandings of line, shape, form, space, texture, value, and color will be applied to three-dimensional art designed to be experienced from all sides.

It is impossible to design with only one of these elements. For example, a single line suggests to the viewer certain ideas about space. But you cannot learn everything about design at once. To take one element at a time, relearn the visual cues associated with it, experiment with their effects, and see how far they can be pushed provides a visual alphabet. With it you can gradually build up a conscious visual vocabulary for developing more complex integrations of design elements.

We typically respond to things as wholes, assigning them overall labels —road, girl, house, tree, sea—but it is possible to separate these images into the parts we are seeing. That is, we can pick out the lines, colors, textures, values, and shapes in what we see and work with them one at a time. In fact,

1.7 a-f left and below
Six of the seven elements of design:
(a) line; (b) shape; (c) form; (d) space; (e) texture; (f) value.

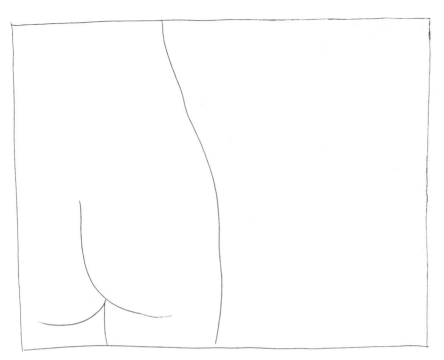

1.8 left
Pablo Picasso. *Nude* from *The Metamorphoses of Ovid.* 1931. Etching, 5¼ × 6¾" (13 × 17 cm). Spencer Collection, New York Public Library; Astor, Lenox and Tilden Foundations.

when we focus on a single part, that part can suggest the whole. In Picasso's *Nude,* drawn in 1931, a mere four lines evoke a memory of a far more complex whole. With his highly refined lines Picasso has given just enough information to make viewers "see" the shape, fullness in space, and even the texture of a woman's backside. [Figure 1.8]

Sometimes, instead of suggesting a whole object from the world of our experiences, an isolated element of design can become very exciting itself. Following the dictum "Less is more," many contemporary artists have found it possible to create an extraordinary range of responses using a single element of design. Some use nothing but pure line to provoke startling visual sensations; some focus on color combinations to make the viewer "see" things like movement, color changes, and disappearing edges.

From Life to Art

We all inhabit the same world; we are all exposed to similar visual experiences. What distinguishes artists from others who experience the same world is that artists are able to isolate from all incoming visual stimuli the basic equations that allow us to exist in and make sense of this visual world.

Some artists choose to present their observations in works that can be experienced three-dimensionally, like objects from the world of our experiences; others choose to present their observations on a flatter two-

dimensional surface with length and width but little depth. Neither way of designing is automatically closer to "real life."

Three-dimensional Art

Three-dimensional art is like the actual objects in our everyday life: They occupy space. A successful three-dimensional piece makes us want to walk around it, see it from many angles, feel its contours, perhaps hold it in our hands.

These sensations can only be suggested in a photograph, which exists on a flat plane. If we were in the same room with Adelaide Alsop Robineau's *Scarab Vase,* we would want to touch it, to follow its carved contours with our fingers, to walk around to see if something different happens on the other side. [Figure 1.9]

Moreover, to see this three-dimensional artwork as a flat photograph already reduces it to a two-dimensional experience. Although the sculpture changes continually as the viewer moves around it, in a photograph it can be seen only from one fixed angle. The picture is therefore one dimension removed from the three-dimensional world of our experiences. The sculpture does not represent real objects, and its photograph is two-dimensional, unlike our three-dimensional world.

1.9 right

Adelaide Alsop Robineau. *Scarab Vase.* 1910. Porcelain, excised and carved; height with stand and cover 16⅝" (42 cm). Everson Museum of Art, Syracuse, New York (museum purchase).

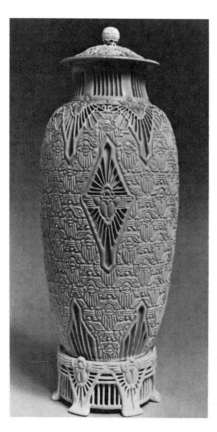

Two-dimensional Art

Some artworks presented on **two-dimensional** surfaces remind us strongly of objects from the world of our experiences. Edward Weston's photograph *Pepper #30* is such a piece. [Figure 1.10] By emphasizing the sensual forms of the peppers through careful control of values, Weston makes us almost feel their curves. Yet he has translated a three-dimensional experience into a two-dimensional study in values and forms.

In a two-dimensional work having only height and width, the surface is sometimes referred to as the **picture plane.** [Figure 1.11] Its outer dimensions, or **format,** may be of any size and shape. Rectangular formats are most familiar in Western two-dimensional art, but sometimes artists work within square, triangular, circular, or free-form formats.

Within a flat format, artists can create illusions of three-dimensionality, or deny any references to three-dimensionality, or create interactions among elements that defy comparison with anything from the world of our experiences. These three ways of working can be called pictorial compositions, flat compositions, and spontaneous interaction compositions. Some works use more than one of these possibilities. But the artist's intent tends to focus attention on a particular way of seeing and interpreting the two-dimensional picture plane.

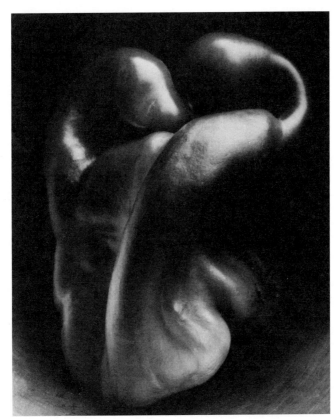

1.10 left
Edward Weston. *Pepper No. 30.* 1930. Gelatine silver print, 9⅟₁₆ × 7⅝″ (25 × 19 cm). Center for Creative Photography, University of Arizona.

1.11 above
The picture plane has only two dimensions: height and width.

Pictorial Compositions

Compositions that develop an illusion of the three-dimensional world may be called **pictorial** designs. If they are framed, the frame seems almost like a window revealing a scene that seems to have depth as well as length and width. Even though it actually exists on a flat surface, the design seems to recede into the distance or come out toward the viewer. [Figure 1.12] A. M. Cassandre's poster for deluxe touring cars develops a tremendous sense of depth in space, giving one the feeling of speeding along comfortably through rows of poplars in the French countryside. [Figure 1.13] Visual devices for creating the illusion of three-dimensionality on a flat surface—linear perspective, scale contrast, value contrast, and overlapping—will be discussed in Chapter 5, Space.

1.12 above
The pictorial illusion of three-dimensionality can be created on the flat surface of the picture plane.

1.13 right
A. M. Cassandre. *La Route Bleue* (transportation poster). c. 1929 (n.d.). Lithograph, 39⅜ × 24⅜" (100 × 62 cm). The Museum of Modern Art, New York. Gift of French National Railways.

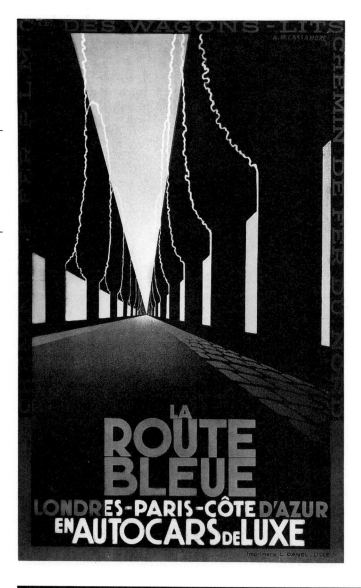

Flat Compositions

A different sense of space occurs in designs that eliminate *all* cues to depth. Instead of having the sensation of looking at a three-dimensional scene, the viewer sees only flat relationships between the **figures** and the **ground** (or surface) to which they are applied. [Figure 1.14] If there is any sense of three-dimensionality, it is that of a very shallow space. The ground may appear to lie slightly behind the figure in space, or figure and ground may be interpreted as coexisting on the same flat plane, sharing edges.

In figure-ground designs, the compositional relationship between figure and ground across the picture plane is of great importance, for the viewer's eye—if engaged—will travel across the flat surface between the edges of the figure and the edges of the ground rather than back into "space." In media that allow experimentation, or in initial sketches, the artist may shift either the figure or the edges of the ground, thus changing the **figure-ground relationship** until it is most effective. Central placement of the figure on the ground, as shown in Figure 1.14, is only one of endless possibilities. If the edges of the ground are brought in closer, or the figure so enlarged that its edges touch the edges of the ground in places, the effect will be quite different. Or imagine the opposite: a ground so enlarged or a figure so diminished in size that the figure occupies only a fraction of the surface. Would the dwarfed figure work in the center? Far to one side? Is the figure strong enough to control the reading of a much larger ground or will it work only in a confined area? If the design is framed, will the edges of the format be emphasized? How does this emphasis affect the relationship of figure to ground?

The design of a book or magazine page can be read as a figure-ground design, in which the text is perceived as a textured figure or figures on a white ground. Designers look at a page this way and thus experiment with the amount of white space to leave on each side. If there are illustrations, they also become shapes to be manipulated with relationship to the text "figure" and the ground. If you squint your eyes or let them go out of focus so that details are obscured, you can look at pages in this book as figure-ground relationships and thus make judgments about the effectiveness of their composition.

Such decisions may be made very carefully by the artist and yet be imperceptible to the average viewer, who is affected by them without being consciously aware of them. Henri Matisse (see Figures 3.20 and 4.10) composed his works through a series of small adjustments in relationships of figure to ground, figure to figure, and color to color, until the composition suited him as expressing what he wanted to convey. "What I am after, above all, is expression," he insisted. "The whole arrangement of my picture is expressive. The place occupied by figures or objects, the empty spaces around, the proportions, everything plays a part."*

When something is viewed from above, as in Piet Mondrian's interpretation of Broadway, it tends to flatten out. [Figure 1.15] Instead of seeing the scene from street level, as one with depth, Mondrian presents it from

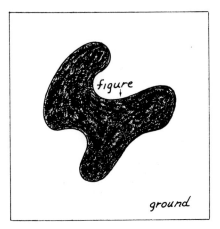

1.14 above
Figure and ground.

* Henri Matisse, *Notes of a Painter,* 1908, as quoted in Hugh Honour and John Fleming, *The Visual Arts: A History,* 2nd ed., Englewood Cliffs, New Jersey: Prentice-Hall, 1986, p. 594.

1.15 right
Piet Mondrian. *Broadway Boogie-Woogie*. 1942-1943. Oil on canvas, 4'2" × 4'2" (1.27 × 1.27 m). The Museum of Modern Art, New York (anonymous gift).

1.16 below
Winnebago moccasins. c.1920. David T. Vernon Indian Arts Museum, Grand Teton National Park, Colter Bay, Wyoming.

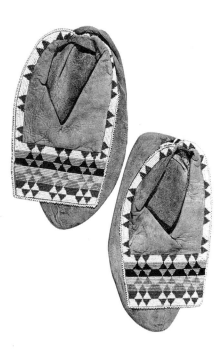

above as a grid pattern of buildings, streets, and things moving along the streets. The viewer's eye travels along the lines from shape to shape, exploring them visually, making turns across the surface of the composition but never sensing the illusion of moving back into a third dimension. Mondrian has rigorously eliminated all cues to depth, insisting that the surface of his painting be seen as a truly **flat space.** There is no overlapping, no use of perspective, no fading of colors, no clues that would be interpreted as indications of three-dimensionality. And objects toward the top of the piece are as big as—or even bigger than—objects below, making it impossible to interpret the lower part as foreground.

A slightly different kind of composition, a **figure-ground reversal,** develops when it is difficult to distinguish what is figure and what is ground.

The Winnebago moccasins shown in Figure 1.16 feature beadwork with bands of figure-ground reversals in four different color combinations. The trapezoids and triangles in one color are juxtaposed to exactly the same shapes and proportions of another color, so that one cannot say, for instance, that the dark figures on the lowest band are presented on a white ground. Visually, the reverse is equally true.

Spontaneous Interaction Compositions
A third kind of composition has been invented only recently. As in Bridget Riley's *Current*, elements of the design interact to make us perceive optically things that are not really there. [Figure 1.17]

Current has the mystery of a figure-ground reversal: We cannot be sure whether the design is black on white or white on black. But more is happening. For one thing, the painting pulls the eye in and out, developing the strong spatial sensation of several different depths in space. The curves formed by the heavier lines in the center, for instance, may seem to bulge out, while the curves between them where the lines pause and thin out may seem to recede. If you look at the painting a bit longer, you will start to "see" a tremendous amount of movement. Depending on your own mind-set, you may find this extremely exciting or so disturbing that you want to look away. But if you keep looking at it, relaxing the defensive grid that tells you nothing but white and black lines exist there, you may see the most extraordinary illusion of all: You may begin to see bands of shimmering colors along the edges of the black lines and in the white spaces between them.

All this happens in what is really only a composition of black and white lines. But Riley has skillfully handled relationships within her design to create the **spontaneous-interaction** effects. The hard edges of her lines, their precise repetition, the juxtaposition of contrasting dark and light, the size of the dark and light intervals, and the flowing movement established by the lines seem to break down our ability to see only flat black and white lines in

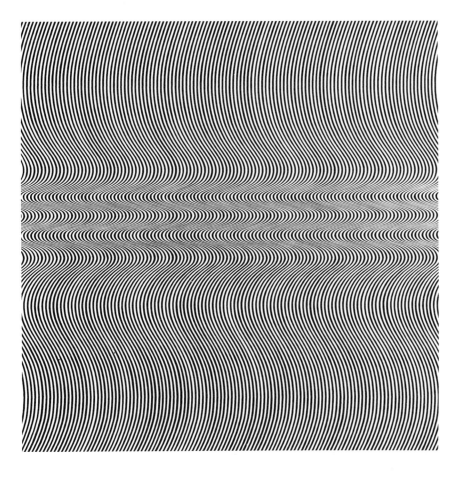

1.17 left
Bridget Riley. *Current.* 1964. Synthetic polymer paint on composition board, 4'10⅜" × 4'10⅞" (1.48 × 1.49 m). The Museum of Modern Art, New York (Philip C. Johnson Fund).

her painting. Unable to focus clearly on the lines, our eyes seem to vibrate back and forth between them, producing the strange optical sensations.

Riley has created her extraordinary effects using line alone. Other twentieth-century artists have created illusions of colors, lines, shapes, disappearing edges, or movement by using other isolated elements of design. By using certain elements of design in certain proportions interacting visually with one another, these artists have made it possible for us to see illusions *between* the lines or shapes instead of looking into the background (as in pictorial compositions) or across the surface (as in flat compositions). This evokes exciting visual sensations that go beyond anything the artists have actually placed on the two-dimensional surface.

Fine Art and the Applied Arts

1.18 below
Bruce Goff. Bavinger House, near Norman, Oklahoma. 1950. Cutaway diagram. Saucer-shaped living spaces project out from the central core.

In addition to distinctions between two- and three-dimensional works, distinctions are often drawn between the fine arts or visual arts—such as drawing, painting, printmaking, and sculpture—and the applied arts. On a superficial level, the former terms refer to works designed primarily to be looked at: "Art for art's sake." The latter term generally refers to the creation of functional objects to be used (as in interior design, landscape design, clothing design, and industrial or product design) or to commercial art, as in advertising and illustration. When functional pieces are made by hand, the disciplines involved—such as weaving and ceramics—are usually called crafts. Architecture is often considered a class by itself.

These traditional distinctions are not rigid categories, for functional pieces are often visually beautiful. All art deals with the basic elements of

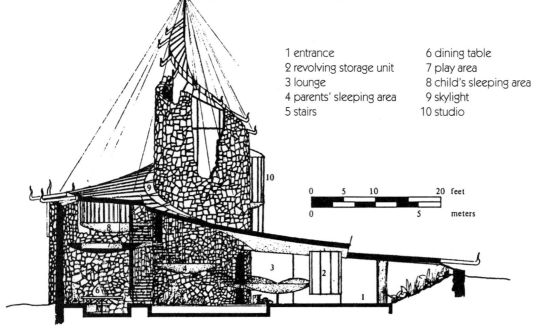

1 entrance
2 revolving storage unit
3 lounge
4 parents' sleeping area
5 stairs

6 dining table
7 play area
8 child's sleeping area
9 skylight
10 studio

0 5 10 20 feet

0 5 meters

1.19 left
Bruce Goff. Bavinger House. Interior view.
The children's play area is located over the
table and is reached by the winding
stairway.

design: line, shape, form, space, texture, value, and color. Yet the ways in which a painter and a graphic designer, for instance, use these elements may be influenced by different factors.

One variable is the audience. At one extreme, some fine artists design principally for themselves. There may be only a few people who understand and like their work and choose to buy it. Acceptance comes slowly to the innovative—Van Gogh's work was considered outrageously ugly during his lifetime. At the other extreme, those who design cars or television commercials may be instructed to appeal immediately to a large and specifically targeted audience. Factors affecting the changing tastes and habits of this audience—such as income levels, education, and areas of residence—must therefore be taken into careful consideration.

At another extreme are those who design a single work for the use of a specific client. Here both visual and functional considerations may become highly personalized. The house architect Bruce Goff designed for an Oklahoma family of four is planned specifically for their personalities and interests. In the spiral house that evolved, specialized living and playing areas project outward like saucers from a skylighted central core designed for the raising of indoor plants, a family hobby. Privacy is minimal but was less important to this family than the free-flowing spaciousness of the interior. [Figures 1.18 and 1.19]

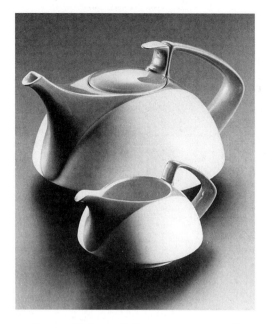

1.20 right
Walter Gropius with Louis A. McMillan and Katherine de Souza. *TAC I Teapot and Creamer (part of a tea set)*. 1968. Porcelain. Decoration "Bauhaus Hommage II" by Herbert Bayer, produced by Rosenthal Studio-linie, Selb, Germany.

In applied art or design, more mundane functional considerations must also be taken into account. Houses must be structurally sound, weather-proof, and energy efficient for the local climate. Provisions must usually be made for plumbing pipes and electrical wiring. Such considerations vary with each discipline. Practical requirements for a teapot, for example, might include good balance, heat-resistant material, a dripless spout, and a handle that can be gripped easily. To the creative designer, such practical considerations (including the issues inherent in mass production) do not render aesthetic considerations impossible. They may be seen as challenges to ingenuity rather than hindrances to art. The elegantly sculptured porcelain *TAC Teapot* shows that it is possible to create pieces that are both functional and visually exciting. [Figure 1.20] The relationship between form and function will be explored further in Chapter 9, which deals with three-dimensional design.

Controlling the Viewer's Response

When design works well, whether two- or three-dimensional, the artist typically exercises a certain control over how viewers look at and respond to the work. Possibilities considered here include controlling attention span, controlling viewing angle, controlling viewing distance, and conveying an idea.

Controlling Attention

Creators of music or literature have a long time frame in which to mold the response of their audience: the duration of a sonata, a symphony, a book. In contrast, people may respond to the visual arts very quickly and then turn away. Sometimes this may be just what the designer wants. On book covers

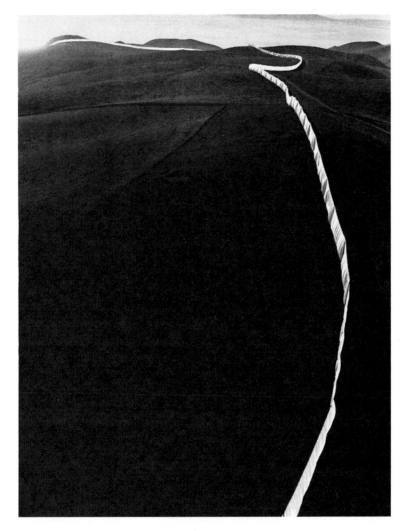

1.21 left
Christo and Jeanne-Claude. *Running Fence, Sonoma and Marin Counties, California*. 1972-1976. Nylon fabric, steel poles, cable; 18' (5.5 m) high × 24½ miles (40 km) long. Installed in Sonoma and Marin counties, California, 1976, for two weeks.

1.22 below
Peter Good. *Snowman*. United States postage stamp. 1993.

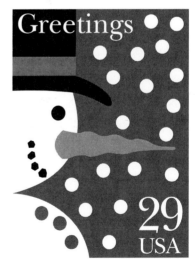

or in children's picture books, the artist may encourage people to turn the page. But in advertisements the designer must hold viewers' attention long enough for a message to register, or people will not buy the product. And in paintings that can create optical illusions, the illusion will not happen unless viewers look at the paintings for some time.

One way some artists solve the problem of holding viewers' attention is simply to make their designs huge. Anything unexpectedly large makes people pause to look because they are somewhat awed by it. It was impossible to ignore Christo's and Jeanne-Claude's 24½-mile-long curtain stretching down to the ocean in California. [Figure 1.21] On the other hand, an unusually small design can also draw attention. People are curious to see what is going on in a miniature work, so they may linger a moment to satisfy their curiosity by close examination of the design. A tiny magazine ad may thus draw attention as easily as an ad that fills the whole page. But unless a postage-stamp-sized work is clearly set off from its surroundings, viewers who have come in close to see it may be distracted by what is around it. Even when it is set off by itself on an envelope, a miniature postage stamp's design must hold its own. Peter Good's U.S. Christmas stamp is an eye-catching play of circles, dark on light and light on dark. [Figure 1.22]

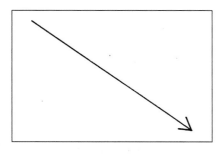

1.23 above
Scanning pattern for a rectangular format.

Understatement and overstatement work only because they are exceptions. Most visual studies are of more predictable size: a magazine page, a poster, a 16-by-20 painting to be hung on a living-room wall. In these works that do not surprise by their size, something else must hold attention. In designs that work well, this is usually an understanding and control of visual scanning tendencies.

People tend to scan a design from the top left corner to the bottom right corner. [Figure 1.23] This tendency has been found even in cultures where people are taught to read printed matter from right to left or in vertical columns from top to bottom. The importance of this principle to artists is knowing that the viewer's eye will rapidly move from upper left to lower right and then off the page unless this eye movement is slowed and directed back into the design.

One way of doing this is to present strong vertical barriers to left-right diagonal scanning. In Van Gogh's *Starry Night* the silhouette of the trees cuts across the scanning path, making the viewer look at the painting a bit longer. [Figure 1.24] Another common technique is to place in the lower right corner a barrier that prevents the eye from slipping off the page. Sometimes this visual barrier is simply the artist's signature. In Peter Good's snowman stamp, the price and country set in large type in the lower right form a visual barrier in that corner, and the snowman's projecting nose further slows diagonal scanning. [Figure 1.22]

When the function of a design is to make viewers want to turn the page over or look toward something else, however, artists steer attention away

1.24 right
Vincent van Gogh. *Starry Night*. 1889.
Oil on canvas, 29 × 36¼″ (73.7 × 87 cm).
The Museum of Modern Art, New York
(bequest of Lillie P. Bliss).

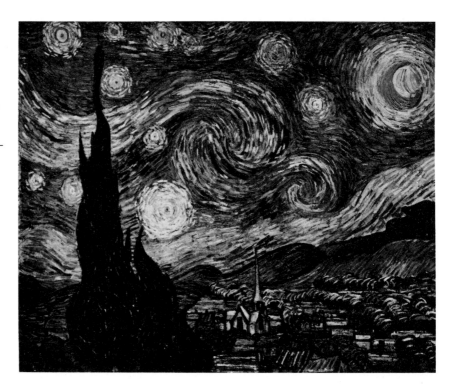

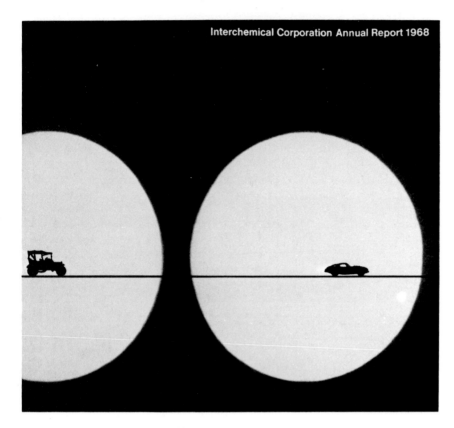

Interchemical Corporation Annual Report 1968

1.25 left
Chermayeff & Geismar Inc. Cover of
Interchemical Corporation Annual Report.
1968.

1.26 below
Lee O. Warfield and Phil Jordan
(Beveridge & Associates). Cover of
Professional Engineer magazine. April
1973.

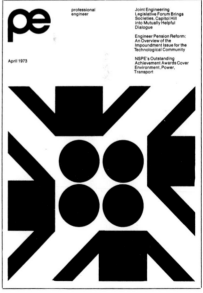

from the design itself. Lines or shapes that touch the edge of a two-dimensional work may point away from it. For example, the design in Figure 1.25 is used as the cover for an annual report. The report itself may require a lingering, detailed reading, but the cover design suggests that the viewer should look immediately inside, scanning from left to right and off the page because the cars are traveling in this direction along the strong road line that touches the edge. Following the line gives the impression that this is a progressive company on the move: from the old-fashioned Model A to a modern sports car, as if looking through binoculars at the passage of time, from an old half-circle representing a past already left behind to the full circle of the present and predictable future, and even beyond.

Whenever lines and shapes touch the edge of a design, they may function as the road line does: as pointers leading the viewer's eye away from the work. If this effect is not intended, the artist must counter by directing attention back into the work. One way is to use lines or shapes that touch the edge but do not extend very far into the center. They will tend to read as pointers from the outside in, rather than from the inside out. On the cover of *Professional Engineer,* lines touching the edges become arrows dramatically forcing the viewer's eye back into the center of the design. [Figure 1.26] Another technique is to portray actual inward movement. In *Starry Night* the sky patterns that touch the edge seem to be rolling inward rather than outward.

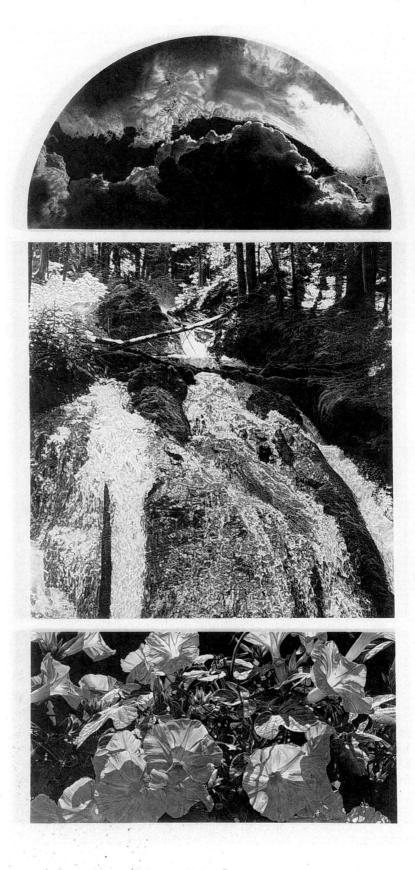

1.27 right
Don Eddy. *Imminent Desire / Distant
Longing II.* 1993. Acrylic on canvas, 6'2½"
× 3' (1.89 × .91 m). Nancy Hoffman
Gallery, New York.

Controlling Viewing Angle

Sometimes artists strongly control the viewers' sense of where they are in relationship to the work, specifying the viewpoint and angle of view. Don Eddy's *Imminent Desire/Distant Longing* takes three different **viewing angles** on a natural landscape: looking up toward the distant clouds in the sky, looking out across a waterfall from some projecting land just beyond and to the right of the major cascade, and looking at close range across a patch of morning glory flowers, perhaps from earth level. [Figure 1.27] The visual impression of these three viewing angles, each quite different, is clearly invoked even though in reality the viewer is simply looking out at a painting hung on a wall or down at a reproduction in a book.

Degas often used unusual angles to draw his viewers into the world of ballet. Instead of the standard view of the stage from the center of the theater—seen so often that people no longer find it particularly novel—Degas takes viewers into little-known positions. He shows ballet scenes from the extreme right side of the theater, the extreme left, offstage behind the flats, up through the orchestra pit, and even, in Figure 1.28, from behind a woman's fan looking down at the stage from the balcony. These novel points of view surprise the viewer into really looking and feeling personally involved, rather than just giving a routine glance to something that appears quite familiar.

The feeling of actually being part of a work of art can be exciting—as in Degas' ballet scenes—or it can be disturbing. The treatment of nudes is a

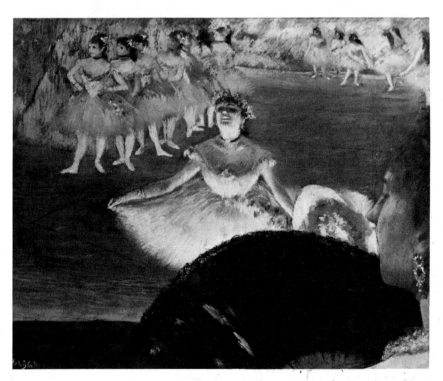

1.28 left

Edgar Degas. *Dancer with Bouquet.* c. 1878. Pastel, wash, black chalk over monotype on paper; 15⅞ × 19⅞: (40 × 51 cm). Museum of Art, Rhode Island School of Design, Providence (gift of Mrs. Murray S. Danforth).

1.29 below
Susumu Kinoshita. *Desire*. 1993. Pencil on paper, 3′3″ × 6′3″ (.99 × 1.9 m). Collector: Robert Nowinski. Keen Gallery, New York.

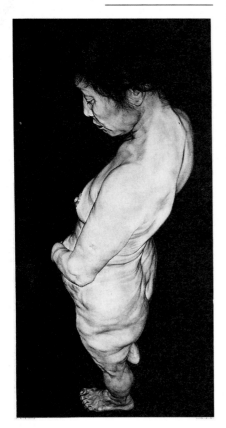

1.30 above facing page
John Fawcett. *Great Drawing* (detail). 1975. Ink. Entire work 3′6″ × 31′6″ (1.1 × 9.6 m). Collection of the artist.

1.31 below facing page
Claude Monet. *Water Lilies*. c. 1920. Oil on canvas; triptych, each section 6′6½″ × 14′ (2.0 × 4.3 m). The Museum of Modern Art, New York (Mrs. Simon Guggenheim Fund).

good example. The usual tendency in painting nudes is to give the comfortable feeling of an academic point of view. Viewers feel that they are part of an art class sketching a hired model who is posing straight in front of the group or else slightly raised on a pedestal so that everyone can see. This academic use of nude models is generally accepted in our society; it doesn't shock or offend. The viewpoint taken by Susumu Kinoshita in his pencil drawing *Desire* is totally unfamiliar. He places us above the standing model, looking down across her shoulder. [Figure 1.29] From this perspective, we can see the body in the round, with a realistic view of the effects that gravity and aging have on soft flesh.

While a strange point of view may be provocative, using too many points of view in the same design can be merely confusing, a problem that often arises in assemblages and collages. A masterful artist can piece together certain photographs taken from different angles in such a way that they make sense as in Birmelin's *Overpass II* [Figure 1.3]. But when too many points of view are given without any logic, the viewer is likely to give up and walk away.

Controlling Viewing Distance

In addition to controlling the angle from which observers seem to be viewing an image, an artist can control how close they come to see the image. This **viewing distance** affects psychological response. In general, a work that pulls people close gives them a sense of intimacy with the subject; a work that holds people away inspires a sense of awe. Often very small pictures draw viewers in to see what is going on; very large pictures normally force people to stand far away in order to make sense of the image.

This is not always the case, however. John Fawcett does autobiographical drawings with such intricate, amusing details that people inevitably stand very close in order to read as much of what is going on as they can; this happens whether the drawing is large or small. Fawcett did one drawing that was 31 feet long. [Figure 1.30] When it was hanging in the hall in our art department, students would invariably walk immediately to the left end and read their way along the entire work from left to right rather than first standing back to get the overall effect, as one usually does with a large work.

To lure people into taking the time to experience his art as he intends, Fawcett uses a number of come-ons (or come-ins, in this case). One is his use of writing. Many people are immediately curious about anything in an artwork that is written. They move in close because they want to see what it says. Another come-in is Fawcett's use of changing scale. This is difficult to handle well, but it involves the viewer in trying to make sense of the piece. A third come-in is the tiny, humorous details. People are curious, and they enjoy being entertained.

Monet has a very different way of bringing viewers in close to his painting of waterlilies. [Figure 1.31] This one is done on a huge canvas—42 feet wide. It fills an entire gallery. Yet people so often walk up to it and even touch it that a guard must be stationed nearby.

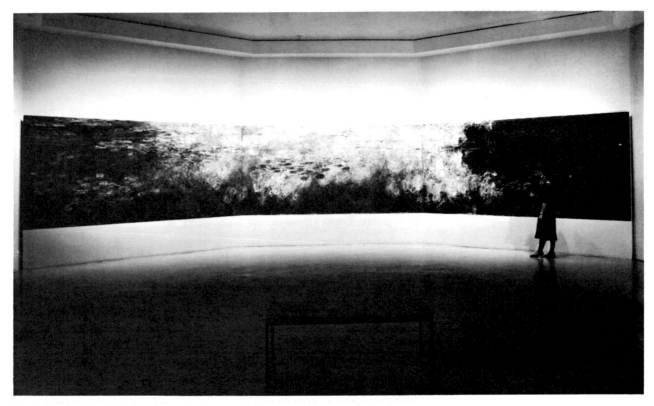

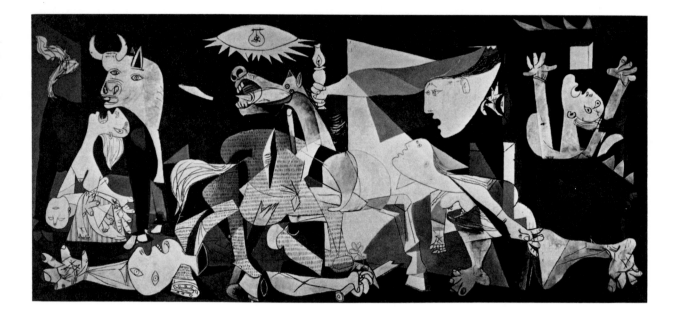

1.32 above
Pablo Picasso. *Guernica.* 1937. Oil on canvas, 11′5½″ × 25′5¾″ (3.5 × 7.8 m). Museo Nacional Centro de Arte Reina Sofia, Madrid.

What draws viewers in this case is very strange. The waterlilies painting is extremely abstract. Even at a distance it is hard to see recognizable objects in it. Monet's brush strokes and combinations of colors are deceptively free (the work is actually very carefully constructed). Yet the apparent freedom conveys a sense of immediacy, of freshness. The painting looks as if it had been completed so recently that it is still wet. The shimmering quality of Monet's water conveys visually what viewers usually experience through touch—they have the sensation that they are *seeing* what water *feels* like. Their instinctive reaction is to verify this strange sensation: They want to touch the painting to see if it really *is* wet.

Pulling viewers in is not the only way of involving them in a design. In some cases, being held away from an artwork is essential to the experience the artist wants to create. Viewing Picasso's *Guernica,* people tend to walk toward it until it fills their vision and then to stop. It will not let them come any closer, but at this point it is all-encompassing, deeply affecting viewers with a sense of horror at the inhumanity of war. [Figure 1.32]

What holds viewers away from *Guernica?* Its great size is probably one factor. People simply cannot take it all in if they stand too close. Yet size alone does not necessarily keep people away. Picasso has added other techniques, such as the use of many sharp edges. They hold people back like swordpoints—viewers sense that it would be dangerous to come in too close. The boldness of the composition and the theatrical use of contrasting values similarly halt people some distance away.

At the same time, *Guernica*'s fascinating content, its strange use of only black, gray, and white (to make tragedy universal, beyond local colors), and its careful placement of shapes and forms compel viewers to look at it. It draws us just so far, like an accident: We want to see what is going on but do not want to get any blood on ourselves. It is as though there were an invisible barrier, like the rail that separates the altar area from the congregation floor in a church. We sense that if we walked any closer we would have to participate on a very different level.

Conveying an Idea

In addition to controlling the viewer's attention, angle of view, and distance, the artist often tries to convey some idea. In a studio exercise, the content is the solving of a visual problem posed by the instructor. In commercial art, the content is dictated by the client or art director; the artist's challenge is to convey this message from another in his or her own artistic terms. In illustrations, the content visually mirrors the story line.

Viewers respond immediately to the object represented in representational art works; this seems at first to be the content of the piece. In front of Mondrian's *Tree II* you may think you know what the drawing is "about" at first glance: It is a picture of a tree. [Figure 1.33] Yet the artist may be working with more subtle content. What may have interested Mondrian here was the frenetic rhythm established by the lines of the branches and trunk. Perhaps he was looking at the tree as a study in the ways curving lines relate to each other and carve unfilled space into varying shapes. Perhaps he was experimenting with the visual flattening out of a three-dimensional object. Or perhaps he was working with all of these ideas. At any rate, the content here is far more than "tree."

By contrast, in viewing highly abstract or nonrepresentational works people tend to respond emotionally at first, expressing dislike or excitement. If they give the piece more attention, or if someone points out what the artist was trying to do, they may begin then to develop a more thoughtful view of the content. In Mondrian's abstraction *The Gray Tree* attention is drawn to the same ideas suggested in his more representational tree paintings—rhythms and relationships of lines and the spaces between them, as well as the values and textures of tree and sky—but more quickly. If viewers respond

1.33 left
Piet Mondrian. *Tree II*. 1912. Black crayon on paper, 22¼ × 33¼" (57 × 85 cm). Collection Haags Gemeentemuseum, The Hague.

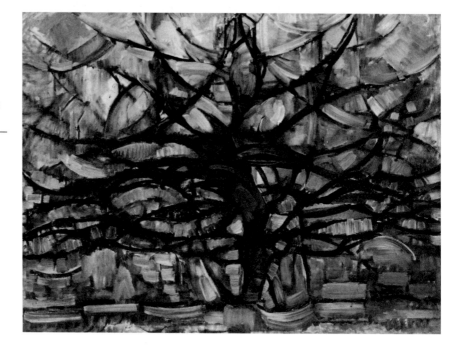

1.34 right
Piet Mondrian. *The Gray Tree.* 1912. Oil on canvas, 30⅝ × 41¹⁵⁄₁₆" (78 × 107 cm). Collection Haags Gemeentemuseum, The Hague (on loan from S. B. Slijper).

to the tree as a familiar object, they do so only after looking at the title of the painting. [Figure 1.34]

Sometimes artists completely think through the content they want to convey before they put it down; everything is planned in advance to create the desired effect. Usually, however, the evolution of a work of art is a dialogue between the artist and the work. When Peter Good was commissioned to create a new logo for the Hartford Whalers hockey team, he was given a specific message to convey. The team had been forced to play out of town when their coliseum roof collapsed; the new logo was supposed to celebrate the reunion of the Whalers with Hartford. Good's challenge was to give the H of Hartford and the W of Whalers equal billing in a design that suggests whaling and the feeling of partnership between a dynamic team and a dynamic city.

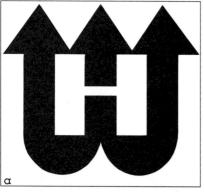

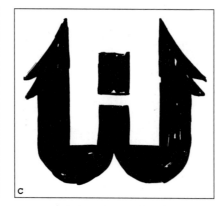

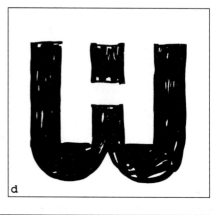

The trial sketches and the final solution, shown in Figure 1.35, reveal Good pushing this basic idea through a variety of solutions until a design evolved that well conveyed the desired message. The first solution shown (a) was accepted by the client but was unsatisfactory to Good because the H represented by the enclosed, unfilled area was stronger than the W. In the second sketch (b), Good softened the impact of the H by opening it to the surrounding space. At the same time, he made the points of the W look more like harpoons than in the first solution. In the third sketch (c) he extended the attempt to soften the H, pushing the harpoons to the side. This possibility he rejected as ugly. In the fourth sketch (d) Good tried omitting the harpoons. The result balanced the W and H but was not particularly exciting.

The fifth sketch (e) reveals the sudden inspiration of using a whale's tail. Sketch after sketch followed, with Good trying to develop a more flowing interlock between the tail and the W. When he hit on the final solution (shown as a sketch in Figure 1.35f and as the completed logo in Figure 1.35g), he wrote, "Eureka! Good 'W' and good 'H' living happily together." He describes the benefits of the final design. "(1) There is a good balance between the W and the H—some people see the W first; others see the H. (2) The tail is well integrated with the letter forms. (3) A nice flowing movement is established where the vertical strokes of the H flare. (4) The crest shape is practical for all applications." Finally, Good notes a special effect created in the "empty" H space: Light seems to flow into the H legs from the outside, becoming trapped in glimmering optical pools of brightness at their base. This heightens the contrast between the straight-based H and the curved bottom of the W, giving the design a crisp, exciting look.

Marriage of Medium and Concept

The medium chosen by the artist profoundly affects the visual statement. A small etching would have a very different impact than a large marble sculpture of the same subject matter. Sometimes artists will switch media for different effects; many artists use a single medium for everything they want to express.

1.35a-g facing page and below
Peter Good. Sketches and final design for the Hartford Whalers logo. 1979. Felt-tip markers. Final design: official logo, Hartford Whalers Hockey Club. Collection of the artist.

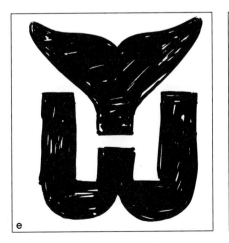

e

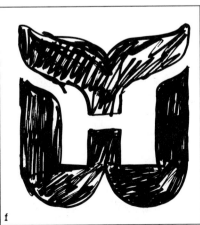

f

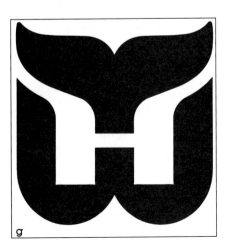

g

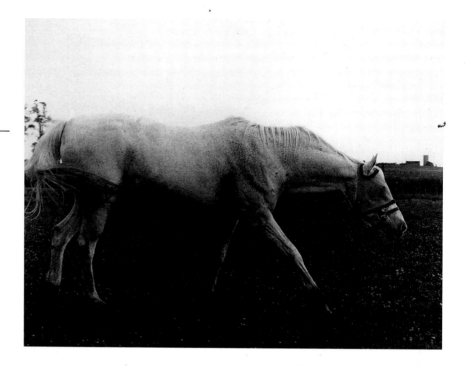

1.36 right
Frank Noelker. *Untitled.* 1993. Toned waxed gelatine silver print, 3'5" × 4'2" (1.04 × 1.27 m). Courtesy the artist.

The artist's reasons for using a certain medium are often a mixture of practical and conceptual considerations. Listen to Frank Noelker, who treated his horse image shown in Figure 1.36 as a 4-foot-long waxed photograph:

> I choose photography over other media more because of its speed than its "truthful" relationship to the empirical world. I can get my feelings on paper more quickly by use of this optical/chemical process than through other art processes, such as drawing and painting.
>
> I print my photographs large to make them more confrontational than traditional sized pictures. While my imagery itself is not confrontational, I do want it to dominate a particular physical space.
>
> I tone my pictures with blue toner to offset the warm tone of the mural paper that I use. Another reason I use the blue toner is because I can't control it completely. This lack of control is key to my art making process. The toner builds up randomly, referencing the randomness of nature, which contrasts with the other "scientific" aspects of the photo process.
>
> Another important aspect of my work is the fact that I wax the surface of my prints. This process, also difficult to control, gives the prints a sensual wetness from some viewing angles and a wax patina from others. The angle where you see the wax patina reinforces the fact that you are looking at a photograph of an animal (an interpretation, the sum of many choices), not an animal itself.

I consider the frame to be an integral part of my presentation. . . . I work the wood to an elegant finish to avoid any rustic interpretations of my work.*

The sensuous way that oil paint moves when it is applied to a surface, the resistance of wood as the printmaker cuts into the block, the endless and rapid changes possible in computer graphics, the recycling of found and used materials in a collage—each medium makes its own underlying statement about the nature of things.

The Creative Process

As Good's experimentations illustrate, art is not just the mechanical manipulation of materials and design principles; it is a creative process. Beyond a certain point, a masterpiece simply defies analysis, for its whole is much more than the sum of its parts. This effect is sometimes called *synergy*— two or more elements interact to create effects of which they are individually incapable. The whole therefore cannot be fully understood by analyzing its parts. Yet it is possible to recognize aspects of the creative *process* that make this synergy possible.

One facet of creativity is understanding and valuing what others have created. In this book and in classroom situations, you will continually be asked to respond to and appreciate what other students and professional artists have already done. But do not let the past limit you. You can learn what other artists have done and then stand on their shoulders, using their discoveries as a basis for exploring further.

Creativity also requires some intellectual work. To relate past experiences to the solving of a present visual problem and even to develop new problems to be solved takes real concentration and logical thought.

Designing is not simply an intellectual exercise, though. Good design springs from a marriage of intellect and intuition. To a certain extent, things you learn intellectually may eventually become so much a part of you that you use them without thinking, but working intuitively also means exploring beyond what you know. Discoveries of new possibilities in materials often spring from intuitive thinking. You are working intuitively when you feel a sense of immediacy and oneness of purpose with the media and when you seize and build on chance discoveries from random manipulations of design elements. You may be feeling your way intuitively when you push and pull the seeds of ideas through varied possibilities, when you experiment with solutions to see how far you can stretch them before they stop working. This childlike playfulness—an attitude of wonder, of discovery, of poking things to see what they will do—is very much part of the exciting solutions that sometimes evolve.

One of Janet Good's paintings is shown in Figure 1.37. She describes the intuitive process by which her works evolve:

* Frank Noelker, personal communication.

1.37 right
Janet Cummings Good. *January 1994.*
1994. Oil and graphite on linen, 4′ × 4′
(1.22 × 1.22 m). Collection of Arthur
Pincus, courtesy the artist.

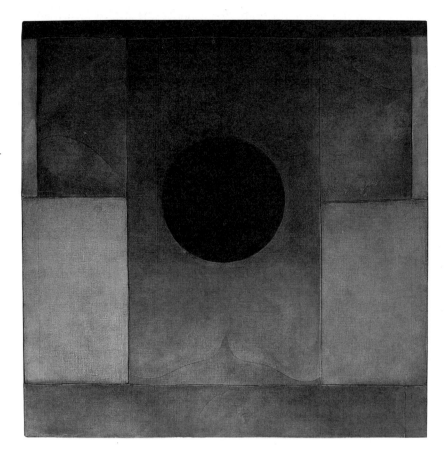

I never do preliminary sketches and I rarely have a conscious plan for the form or color of a finished painting. Any given painting goes through countless transformations as I play with the tension between the form and composition. My decisions are intuitive and unconscious. Often I'll grab a tube of paint and wonder why it's in my hands. It's only after the fact that I can see a rationale and pattern to what I have been doing.

Even "bad" choices are helpful, as they force me to actions that I would not otherwise have made. Painting for me is like being asked to play a game, without being told the rules, only knowing that the game is being played well when it feels right.[*]

Art often emerges from the unexplored territory of the mind, which recognizes the visible world as an illusion amidst the truth of matter, of the cosmos. Modern physics, as well as spiritual sages, confirm that what we perceive as separate, solid, permanent objects is actually an ocean of perpetual change, electrons hurtling through empty space, within a vast time frame that dwarfs the lifespan of a human being and totally changes its

[*] Janet Good, personal communication.

meaning. If art is a search for truth, then what seems illogical to the limitations of the "rational" mind may actually be a fruitful direction for discovery.

Open-mindedness, a willingness to experiment and make mistakes, is important to creativity. Rather than regarding the principles and visual cues used in design as absolute rules, use them as you will. Experiment with them, learn how they work by actually using them in designs, but do not be completely bound by them. Some of the most exciting designs violate all the old rules for what a work of art is supposed to be like. Only through experimenting with known ideas about design can you gradually discover for yourself what is worth knowing and what can be discarded.

2

UNIFYING PRINCIPLES OF DESIGN

KEY TERMS

- abstract
- asymmetrical balance
- cropping
- economy
- emphasis
- focal point
- gestalt
- harmony
- horizontal balance
- pattern
- repetition
- rhythm
- scale
- semi-abstract
- symmetrical balance
- unity
- variety
- vertical balance

2
UNIFYING
PRINCIPLES
OF
DESIGN

Whether "fine" or "functional," in art the parts traditionally have been expected to fit together to make a coherent whole. This **unity** may not be visibly apparent in the world around us. The artist selects, isolates, and manipulates elements at will so that they have a certain visual coherence.

If all the parts are working together well, the whole will seem to be more than the sum of its parts. To isolate the parts and study them individually is therefore very difficult and inadequate in explaining the fullness of a piece's impact. This characteristic of successful art is called the **gestalt** of a work—a configuration so unified that its properties cannot be determined by analyzing the parts in isolation.

Many attempts have been made to define the principles by which artists create this dynamic unity within their works. The list of strategies used to create a sense of **harmony**—of orderly, pleasing relationships between parts of the whole—commonly includes repetition of similar elements, variety, rhythm, balance, emphasis, and economy. We will explore these principles in the following sections, with an important reminder: They are valuable as guides but not as absolute rules that must all be followed in every work of art.

Some artists find they can convey their intent without using all the traditional principles of design. And some intentionally violate the principles of harmony to create a sense of *discord* in order to make some statement about the lack of harmony in the world. There is a great difference between an unskilled composition without unity and Alfonso Ossorio's *Feast and Famine,* in which starkly different elements are juxtaposed to create an impression of fragmentation and conflict. [Figure 2.1] They are somewhat unified by being collected within one format, but even then there are parts bursting beyond the edges. Such works point out the social tensions in the dark underbelly of society, the random chaos and conflicts within the untamed mind. In the noisy, urbanized, industrialized world, this cacophony has become so familiar that people are now more likely to accept it in a work of art. Free-form jazz music that was once rejected as strangely jarring now seems quite normal; Stravinsky's *Rite of Spring* caused a small riot when it was first performed in 1913, but now its atonalities are so thoroughly accepted that it is played as background music in films.

Ultimately, it is the viewer who unifies a work of art by perceiving the relationships suggested by the artist. Today's viewers are perhaps more willing to unify a design than ever before, for they have been heavily exposed

2.1 above
Alfonso Ossorio. *Feast and Famine*. 1966.
Plastic and mixed mediums on wood,
4'8" (1.42 m) diameter. Los Angeles
County Museum of Art.

to the rapid visual changes used in modern television editing; they can hold together a series of different images of varying size as a unified visual experience. The traditional principles for unifying designs are nevertheless still useful concepts to consider.

Repetition

2.2 above
Mughal Huqqa vase. First half of 18th century. Green glass with gilt floral decoration; height 7½″ (18.9 cm), diameter 7″ (17.8 cm). Victoria and Albert Museum.

One of the simplest relationships for a viewer to grasp in a design is the **repetition** of similar elements. Repetition of identical or similar lines, shapes, forms, textures, values, or colors creates a predictable **pattern:** a coherent visual structure. We respond easily to designs that mirror the repetitive growth patterns of nature. A flower is a series of similar petals; a sliced onion is a series of rings.

The exquisite Mughal Huqqa vase shown in Figure 2.2 features repetition of three leaf shapes, with those in the bulbous central band diminishing in size as the vessel curves inward, accentuating its pleasing roundness.

In Frans Hals's painting of five women, the repetition is more subtle. [Figure 2.3] Yet the similarity in value, shape, and placement of the heads, bibs, and hands against the dark dress of the period gives the viewer a way to interpret this picture as a unified whole. When we see similar design elements, our eyes tend to follow a path from one to the next, linking them visually. Many viewers would look at this composition from head to head, then from hand to hand, as shown in the diagram of the painting in Figure 2.4.

Sometimes the understructure of a work of art is planned to repeat a certain shape subtly. Many artists do this subconsciously or intuitively, but to those interested in analyzing a work of art, these devices become quite evident. Perugino's crucifix triptych seems carefully composed of a series of triangles. [Figure 2.5] As indicated by the dashed lines in Figure 2.6, Jesus's gaze falls on his mother, whose downcast eyes strike the base of the cross. The stakes at the base redirect the viewer's gaze up to the face of the devotee to the right of the cross and thence, following her eyeline, back up to Jesus. These implicit lines form two triangles divided by the vertical of the cross and the precise horizontal relationship between the two women's heads.

2.3 right
Frans Hals. *The Women Regents of the Old Men's Home at Haarlem.* 1664. Oil on canvas, 5′7″ × 8′2″ (1.7 × 2.5 m). Frans Hals Museum, Haarlem.

2.4 above
Analysis of the visual path through *The Women Regents of the Old Men's Home at Haarlem.*

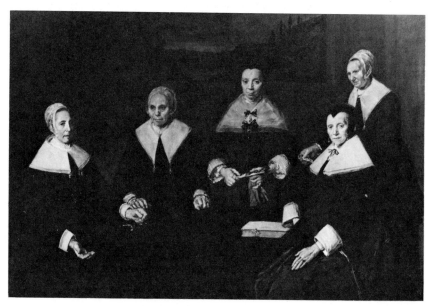

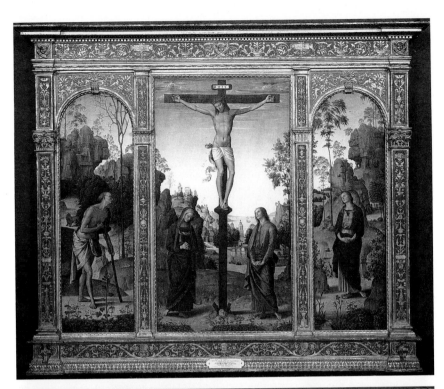

2.5 above left
Perugino. *The Crucifixion with the Virgin, Saint John, Saint Jerome, and Saint Mary Magdalene.* c. 1485. Oil on panel transferred to canvas; left panel 37½ × 12" (95.2 × 30.5 cm), framed 4'4¹¹⁄₁₆" × 5'5⅛" (1.338 × 1.654 m); middle panel 39⅞ × 22¼" (1.013 × .565 m), framed 52¹¹⁄₁₆ × 65⅛" (1.338 × 1.654 m); right panel 37½ × 12" (95.2 × 30.5 cm), framed 52¹¹⁄₁₆ × 65⅛" (1.321 × 1.654 m). Andrew W. Mellon Collection, National Gallery of Art, Washington, DC.

2.6 below left
Lines showing visual perspective.

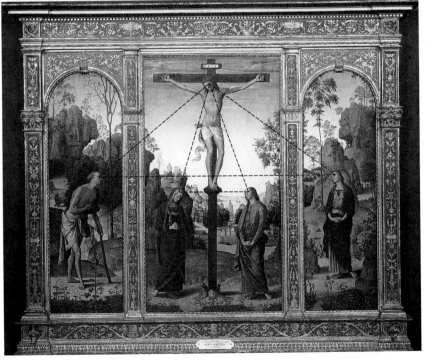

Another triangle can be imagined in the visual relationship between the woman to the far right, the disciple at far left toward whom she is looking, and Jesus, toward whom the disciple is gazing. As we follow these eyelines, we "see" a series of triangles that provide a subconscious, invisible structure unifying the painting.

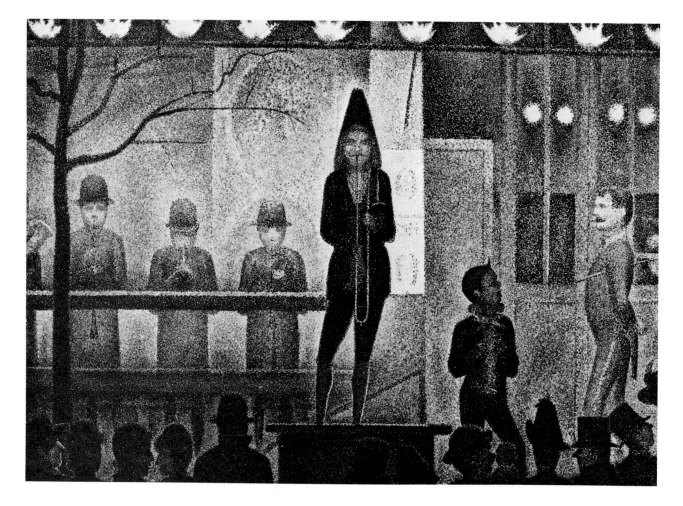

2.7 *above*
Georges Seurat. *Circus Sideshow ("La Parade")*. 1887-1888. Oil on canvas, 3′3¼″ × 4′11″ (1.0 × 1.5 m). Metropolitan Museum of Art, New York (bequest of Stephen C. Clark, 1960).

Artists have also used repetition of similar strokes, textures, or colors to help viewers pull a design together. In Seurat's *Side Show*, the repetition of small dots throughout the painting and of similarly shaped gaslights above and heads of the onlookers below helps the viewer unify figures doing a variety of things. [Figure 2.7] Even though the dots vary considerably in value and color, their similarity in shape helps us see the composition as a whole made of pulsations of darker and lighter dots. The gaslights and onlookers are not identical either, but they are similar enough to build a sense of repeating and therefore logically related elements.

Variety

Paradoxically, a second way of suggesting unity within a design is to *vary* its elements, either as slight variations repeating a central theme or as strong contrasts. Precise repetition runs the risk of boring the viewer. Although

humans find considerable satisfaction in the repetition of familiar things, we also like the spice of **variety.** And even in variety we can discover relationships.

Ryuichi Yamashiro's poster for a forest conservation movement uses two groups of Japanese characters meaning "Tree," "Grow," and "Forest." [Figure 2.8] With these symbols, Yamashiro simply varies the size of the characters to build a visual pattern of what appear to be small and large trees in a forest. We are placed above it, looking downward, as a parent would look down with care upon a child.

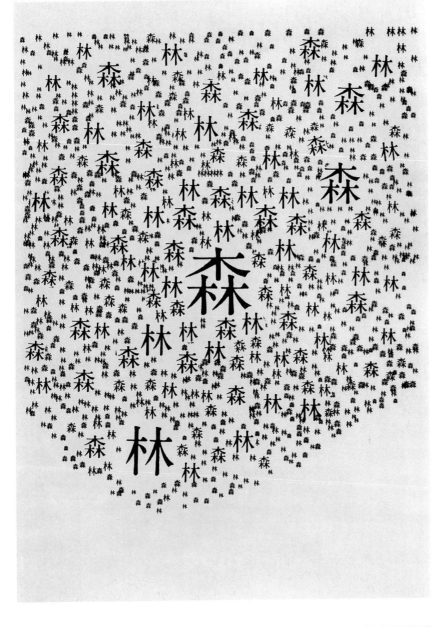

2.8 left
Ryuichi Yamashiro. *Forest.* Poster for a forest conservation movement. 1962. Silkscreen, 41 × 29½" (104 × 75 cm). The Museum of Modern Art, New York (gift of the artist).

2.9 right
Sandra Farrell and Richard Farrell. Porcelain place setting. 1980. Dinner plate 11" (28 cm) square, salad/dessert plate 7" (18 cm) square, shallow serving bowl 11" (28 cm) square, mug 3½" (9 cm) high × 3" (8 cm) diameter. The "cloud" goblet: hand-blown glass by Josh Simpson. Courtesy the artists.

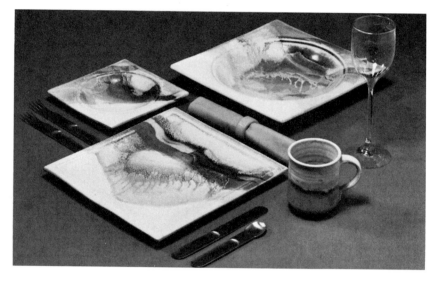

In Sandra and Richard Farrell's porcelain place setting, the dinner plate, salad or dessert plate, and shallow serving bowl all carry out the theme of a square format glazed with landscapelike designs in the same pastel colors, yet no two designs are alike. [Figure 2.9] These variations on the theme invite people to compare the designs within a single place setting and then walk around the table to see the other settings.

2.10 above
Yin and yang, symbol of the unity of opposites.

2.11 right
Chambered nautilus. Radiograph. Eastman Kodak Company, Rochester, New York.

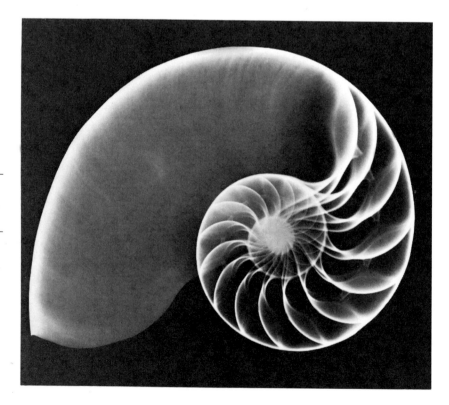

Instead of using slight variations on a unifying theme, artists sometimes present polar opposites—a very rough-textured area contrasted with a very smooth-textured area, a very dark area contrasted with a very light area, a convex shape fitted into a concave shape. Such contrasts challenge the viewer to compare the elements and actively synthesize the contrasting parts by recognizing the relationship between them: They are opposites that seem to complete each other, like the unity of *yin* and *yang* in Chinese philosophy. [Figure 2.10] In the chambered nautilus, the busy whorled pattern of growing chambers to the right contrasts dramatically with the quiet unornamented simplicity of the outer shell, but they coexist as the active and passive elements of a single whole. [Figure 2.11]

Seen another way, strongly contrasting elements are opposite poles on the same continuum. Dark and light are extremes of value; rough and smooth are extremes of texture. A work that contrasts darks and lights may be unified by its persistent references to value; a work that contrasts rough and smooth areas may be unified by its persistent references to texture.

Rhythm

Repetition of similar or varying elements in a design tends to set up a visual **rhythm,** a particular beat marking the movement of the viewer's eye through the work. Figures tend to be picked up as pulsations, intervals between them as pauses. When the beat is one viewers can sense, it too helps them experience a design as an organized, unified whole.

Visually, a picket fence has the same kind of staccato rhythm as a piece of music in which all notes are of the same duration, equally spaced and equally accented. [Figure 2.12] A work in which lines are more continuous and curving suggests a more flowing rhythm, with gradual crescendos and decrescendos, as in Margaret Bourke-White's photograph of contour plowing. [Figure 2.13]

Although a plowed field and a picket fence have regular intervals between similar figures, many designs have a more syncopated rhythm built on

2.12 left
The equal spacing between its parts sets up the staccato rhythm of a picket fence.

2.13 above
Margaret Bourke-White. *Contour Plowing.*
1954. Photograph.

variations in the repeated figures and in the intervals between them. In *Six Persimmons*, the third persimmon from the left presents an off-beat counterpoint to the steadier but slightly varying rhythm of the lined-up fruits. [Figure 2.14] The large stepping stones in the Japanese garden shown in Figure 2.15 are designed to conduct people through the sensual experiences of the garden at an informal, erratic rhythm. Normal walking cadence is deliberately interrupted to suggest pauses for contemplation of the surroundings. Some designs have complex jazzlike rhythms, with many different beats being played against each other at the same time. In Al Held's *Northwest*, progressions of rectangular, tubular, and triangular forms are all being played at once. [Figure 2.16]

2.14 above
Mu-Ch'i. *Six Persimmons*. c. 1270. Sumie on Chinese paper, 14½ × 11¼″ (37 × 29 cm). Daitokuji Temple, Kyoto, Japan.

2.15 right
Garden of the Katsura Palace, near Kyoto, Japan. Early 17th century.

2.16 right

Al Held. *Northwest.* 1972. Acrylic on canvas, 9½ × 14′ (2.9 × 4.3 m). Andre Emmerich Gallery, New York.

Balance

Another basic way in which artists may help viewers see a design as a unified whole is to balance it visually. They distribute the apparent weight of the elements so that the work does not appear about to topple from being heavier on one side than the other.

The easiest way to create a sense of balance is to make both sides of a design mirror images or almost mirror images of each other, as in Ludwig Hohlwein's advertisement *Deutsches Theater*. [Figure 2.17] This kind of balance, known as **symmetrical balance,** is very familiar to us. The left side of a chair looks like the right side; the left side of a face looks very much like the right side of the same face. Expressed as a seesaw, symmetrical balance occurs when figures that are exactly alike in *visual weight* (or apparent heaviness) are placed on either side of a central fulcrum, or balancing point. [Figure 2.18]

In **asymmetrical balance,** figures that differ in visual weight are carefully juggled to create the appearance of balance. This can be done in many different ways. In Van Eyck's painting the large central madonna-and-child mass and the symmetry of the architecture help to stabilize the differing weights of the other three figures. [Figure 2.19] In addition, the sizes and positions of the figures to either side of the madonna counterbalance each other, as in the diagram of asymmetrical balance in Figure 2.20. The clerical figure to the left is so tall and so far from the center that he offsets the weight of the two somewhat smaller, somewhat closer-to-the-center figures on the right. In general, the farther a figure is from the center, the more visual weight it will suggest.

In addition to position and size, visual weight is affected by other factors such as color, value, and degree of detail. In general, areas that are light in value, brightly colored, or highly detailed draw the viewer's attention more than areas that are dark, dull, or less complex; they therefore carry more

2.18 *above*
Symmetrical balance expressed as the distribution of visual weights on a seesaw.

2.17 *above*
Ludwig Hohlwein. *Deutsches Theater.* Advertisement for a restaurant. 1907. Lithograph, 4′1³⁄₁₆″ × 3′ (1.25 × .91 m). The Museum of Modern Art, New York (gift of the Lauder Foundation).

2.19 *above*
Jan van Eyck. *The Virgin with the Canon van der Paele.* 1436. Oil on panel, approximately 4′ × 5′2″ (1.2 × 1.6 m). Musees Communaux, Bruges, Belgium.

2.20 *above*
Asymmetrical balance expressed as the distribution of visual weights on a seesaw.

2.21 right
Sanchez Cotan. *Still Life.* c. 1602-1605. 25 × 33⅛″ (64 × 85 cm). Museo de Bellas Artes, Granada, Spain.

a

b

2.22 above
Vertical balance: (a) true center, (b) optical/emotional center.

visual intensity for their size. In Sanchez Cotan's *Still Life* the highly detailed, light-colored vegetable on the right counterbalances the far larger dark shadow on the left. [Figure 2.21] In fact, the strange crescent-shaped vegetable on the right seems so heavy that it would threaten to tip the composition in its direction without the anchoring stability of the window frame and the counterbalancing vegetables left of center.

In addition to **horizontal balancing** of the right and left sides of a design, a sense of **vertical balance** between the upper and lower areas may be important, too. Here absolute symmetry may feel wrong to viewers. If a figure is placed precisely in the middle of a two-dimensional surface, as in Figure 2.22a, it may seem too low. Often viewers prefer to see beneath a figure a slightly larger area than above it, giving the impression that it is being adequately supported, as in Figure 2.22b.

To get a sense of vertical balance, look at Ellsworth Kelly's *Apples.* [Figure 2.23] They are placed so high that the space beneath seems almost like a table supporting them. To experiment with their vertical placement, try cutting two large black L's out of construction paper and using them to reframe the design. If you frame the picture in such a way that the apples are even higher than in the original, it may not make any sense. They are too high above your line of vision to be on a table, and they appear to be floating—an illogically imbalanced impression. Now try framing the apples so they appear to be exactly in the center of the frame. How do you feel about this placement? Do you find Kelly's original solution more satisfying or exciting? Do you think he improved the piece by pushing the apples as high as he could on the page without making them seem to float?

In Sesshu's *Landscape* the landscape image is placed entirely below the center of the scroll, with a small unfigured area left at the bottom as foreground. [Figure 2.24] The intent seems to be to represent the world we know as an insignificant gesture within the universe. Do you think this unusual placement works? Does the sky seem too heavy to occupy so much area? Are the inked areas below strong enough to bear the sky's weight? What would happen if the dark area at the top were eliminated? If the hazy

tallest mountain were eliminated? Can this almost unnoticeable shape be seen as a device allowing even greater height in the sky area?

There are no absolute answers to these questions. Sometimes artists intentionally unbalance a design to create a particular effect. Preferences for symmetry or asymmetry in art change with the times. Also, much artistic balancing is done intuitively rather than intellectually. It is nevertheless important to recognize that people do respond to visual weighting in a design, for this is another principle you can use to organize the whole in any way you intend.

2.23 above
Ellsworth Kelly. *Apples*. 1949. Pencil, 17 × 22⅛" (43.4 × 56.4 cm). The Museum of Modern Art, New York (gift of John S. Newberry).

2.24 right
Sesshu. *Haboku Landscape*. 1420-1506. Hanging scroll; ink on paper, 28⁵⁄₁₆ × 10½" (72 × 27 cm), painting only. Cleveland Museum of Art (gift of the Norweb Foundation).

Emphasis

In addition to repetition, variety, rhythm, and balance, artists commonly unify their designs by creating a single **focal point:** the area toward which the viewer's eye is most compellingly drawn. If a design has no focal point drawing attention inward, it may seem to fall apart, making it difficult for the viewer to organize what is going on.

There are many techniques for drawing attention to a portion of a design. Four of these are shown in Figure 2.25. Placing a figure near the center of a two-dimensional work or slightly above center often helps draw attention to it (a). Any kind of contrast creates emphasis. In a field of straight lines, a circle will draw attention to itself (b). In a design that consists largely of dark areas, a light area will stand out; in a group of light-colored areas, a dark figure will be emphasized (c). A large figure may draw more attention than smaller figures (d).

2.25a-d right
Emphasis achieved by: (a) central placement, (b) contrast of shape against lines, (c) contrast in values, (d) contrast in size.

Another technique is to group peripheral elements about the intended focal point. In Rembrandt's *Christ Healing the Sick*, gathering the figures around Christ helps to make him the center of interest. [Figure 2.26] Even more striking is the use of light: He seems to be the source of the light illuminating the figures nearby. The isolation of his standing, lighted figure against the dark background further draws attention to him as the center of interest, despite his asymmetrical, off-center placement.

Scale—the relationship between the size of an image and the size of its surroundings—is another form of contrast used to create emphasis. [Figure 2.25] In Giotto's *Madonna Enthroned*, the madonna and child are emphasized by their large size relative to that of the other human figures. [Figure 2.27] Note, too, that all the other figures are looking at them, helping draw our attention to this center of interest. In other works, peripheral figures emphasize a certain area by pointing toward it, leading the viewer's eye toward this focal point.

2.26 above
Rembrandt van Rijn. *Christ with the Sick Around Him, Receiving Little Children ("The Hundred Guilder Print")*. c. 1649. Etching, second state; 10⅞ × 15½" (28 × 39 cm). Metropolitan Museum of Art, New York (bequest of Mrs. H. O. Havemeyer, 1929, H. O. Havemeyer Collection).

2.27 right

Giotto. *Madonna Enthroned.* c. 1310. Tempera on wood, 10'8" × 6'8" (3.3 × 2.0 m). Galleria degli Uffizi, Florence.

Economy

A final principle to consider in organizing a design is **economy**—using only what is needed to create the intended effect, eliminating any elements that might distract attention from the essence of an idea.

Artists working from nature often look amid the busy details for the few elements that will convey the idea of the whole thing. The result may not match our visual impressions of the object, but the reference to its essence is recognizable. Picasso did a series of lithographs that reveal his attempts to capture the nature of a bull. [Figure 2.28] His concept evolved from attempts to emphasize the bull's shaggy bulk, to depictions of the bull's structure as a series of flat surfaces, to an extremely economical statement that draws our attention to the bull's massive humped shoulders and body form. The bull is presented as a beast of great masculine mass that is emphasized by contrast with the extremely delicate line used.

This process of elimination, of isolating the essential formal properties of a physical object, is one form of **abstract** art. This is work in which the attempt to depict objects realistically has been pushed to the background or abandoned altogether, with attention instead placed on patterns of line, shape, value, or color. When there is some reference to real objects from the natural world, but depicted with economy of means and more attention to underlying design, as in Picasso's bull, it may be called **semi-abstract** art. Picasso has used a series of ways of presenting a bull in visual shorthand. Abstraction is apparent even in Neolithic cave paintings, but in Western art it appeared as a specific aesthetic approach early in the twentieth century.

Another way in which artists sometimes apply the principle of economy is to show only part of an image, giving enough information for viewers to complete it mentally. This technique—similar to **cropping** in photography—draws the viewer into creating the visual experience and may help focus attention on a particular area. The Volkswagen ad uses only the top outline of the "Beetle," yet this leaves enough information for the public to "see" clearly the familiar car. [Figure 2.29] It was easy to identify this shape because it was such an accessible part of the 1960s visual vocabulary. The viewer was then drawn into answering the question proposed in the ad's headline.

This cropping technique is often used in advertising to keep the viewer from being diverted by nonessential details. In ads for women's jewelry, the top of the model's head is usually cut off to make us look at the necklace and earrings rather than her hairdo. In ads for men's suits, the models' feet are often left off to keep us from focusing on the shoes.

There is a limit to how much can be cut off. If a figure is cropped at the knees or right through the eyes, viewers may be so disturbed that they focus on the cropped area rather than on what was supposed to be the center of interest. Slight changes in the degree of economy used may make a crucial difference in the viewer's ability to respond to a visual study as a logical whole.

45 **I. December 5, 1945**

46 **III. December 18, 1945**

47 **V. December 24, 1945**

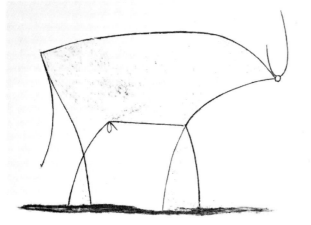

48 **VII. December 28, 1945**

49 **XI. January 17, 1946**

2.28
Pablo Picasso. *The Bull (Le taureau).*
December 5, 1945-January 17, 1946. Five
of eleven progressive states of the same
lithograph on Arches paper, each 12⅝ ×
17½" (32.1 × 44.5 cm). National Gallery of
Art, Washington, D.C. (Ailsa Mellon Bruce
Fund).

The excitement of using a minimum of visual cues to provoke a complex response is that it involves viewers in the creative experience. The less an artist shows us, the more of ourselves we have to bring to a design to give it meaning.

2.29 left
DDB Needham Worldwide for Volkswagen United States Inc. *How Much Longer Can We Hand You This Line?* (advertisement). 1969.

3
LINE

KEY TERMS

- calligraphy
- crosshatching
- edges
- expressive line
- gesture

- hatching
- negative area
- positive area
- stippling
- value contrast

3
LINE

The difficulty about working with line is in knowing what it is, how far it can be pushed, and when it stops being line and becomes something else. Dictionaries and art books offer lengthy explanations of line. A paraphrase of Paul Klee's definition is, "A line is a dot out for a walk." In general, a line is a mark whose length is considerably greater than its width.

The distinction between lines and shapes is a subtle one that sometimes depends on *scale*—the relationship between the size of an image and the size of its surroundings. As illustrated in Figure 3.1, large surroundings can dwarf a shape and turn it into a line (a); small surroundings can make a line appear to expand into a shape (b). A letter of the alphabet blown up far larger than its usual scale may stop being linear and instead become a shape (c). Herbert Sahliger's ad for Greenpeace, an international environmental protection organization, uses a line that could almost be read as a shape, so large is it in relationship to the ground on which it is drawn. [Figure 3.2] But it has such a commanding gestural quality—as if the hand of the Creator were drawing matter into existence over the face of the primeval waters—that we respond to it as a powerful line.

a

b

c

3.1 a-c left
Scale can: (a) turn a shape into a line, (b) turn a line into a shape, (c) turn a letter into a shape.

3.2 right
Herbert Sahliger. *For the Sake of Creation*. Poster for Greenpeace.

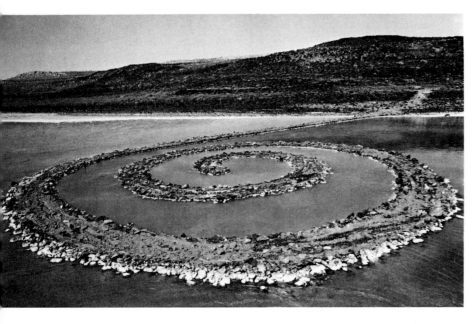

3.3 left
Robert Smithson. *Spiral Jetty.* 1970. Black
rock, salt crystals, earth, red water (algae);
coil 1500' (457 m) long, 15' (4.6 m) wide.
Great Salt Lake, Utah.

In Robert Smithson's earthwork *Spiral Jetty* a point of rocks 15 feet
wide seems to be a curling line when seen from a distance, for it is sur-
rounded by an even greater expanse of water. [Figure 3.3] But if you take
four pieces of paper and gradually cover up more and more of the sur-
roundings of the spiral, at some point you may see it, too, as a shape.

Lines may also lose their individual linear identity when used *en masse.*
A multitude of lines drawn close together can create an illusion of texture
(see Eudice Feder's *Swarm,* Figure 3.4), as discussed in Chapter 6. It can
also produce gray values, as discussed in Chapter 7.

3.4 left
Eudice Feder. *Swarm.* 1988. Plotter
drawing, ball point, felt tip, ink; 30 × 25"
(76 × 63.5 cm). Courtesy the artist.

Creating Lines

a

b

c

3.5 a-c above
A line is formed along an edge where: (a) two values meet, (b) two surfaces meet, (c) two surfaces intersect.

3.6 right
Kaethe Kollwitz. *Self-Portrait in Profile.* 1919. Lithograph, 13¼ × 11¼" (34 × 29 cm). William Benton Museum of Art, University of Connecticut, Storrs (Landauer Collection of Kaethe Kollwitz).

The most familiar lines are those laid down with a pen or a pencil or a brush. Computer drawing programs can now simulate the same effects. In many of the studio problems in this chapter, lines are also made with strips of paper so they can be pushed around and experimented with. Nor do the possibilities end here.

Fibers sometimes have strong line elements. So do works using type or writing. Some sculptures read as linear patterns in space. In two-dimensional work, strong lines may be formed along the **edges** where two different value areas or surfaces meet or intersect. [Figure 3.5] By heightening the **value contrast** (the degree of difference between light and dark areas) along the hairline and features of her self-portrait, Kaethe Kollwitz has created lines without actually drawing them. [Figure 3.6]

Potters develop lines with glazes, sculptors with contours and edges. Lines can be projected into space with neon lights. In earthworks, enormous lines are made on the earth's surface with trenches or rocks or fabrics, or even in the sky with balloons or kites. [Figure 3.7] Architecture too may use striking lines. The line of water placed by Louis Kahn in the center of the Salk Institute court is totally nonfunctional, but it is an exciting focal point in this architectural environment. [Figure 3.8]

Lines usually reflect the implement that made them. In Reuben Nakian's *Rock Drawing* a sharp-edged tool has apparently been used to draw scarlike lines into the terra cotta. [Figure 3.9] The clay's bulky, abstract, seemingly random structure heightens the sharp, thin, straight quality of the lines by contrast.

Jacqueline Monnier. *Skyworks*. 1976.
Paper collage and acrylic; 11 kite tails,
various widths, 26¼ to 52½' (8 - 16 m)
long. Courtesy the artist.

3.8 above
Louis Kahn. Central court, Salk Institute of Biological Studies, La Jolla,
California. 1967. Concrete, teak wood, marble.

3.9 right
Reuben Nakian. *Rock Drawing*. 1957. Terra cotta, 10 × 14¼ × 6" (25 ×
36 × 15 cm). The Museum of Modern Art, New York (fund given in
memory of Philip L. Goodwin).

3.10 right
David Howells. *Alphabet* of freely written flourished capitals, lower-case and numerals, in black and green on gray paper. 23 × 18½″ (58.4 × 47 cm). Courtesy of David Howells, Shoreham-by-Sea, U.K.

3.11 below
Jan Groth. *Sign 1967.* 1967. Black and white wool, woven; 4′7″ × 16′5″ (1.4 × 5.0 m). The Carnegie Museum of Art, Pittsburgh (museum purchase, Patrons' Art Fund, 1972).

Artists sometimes make a point of exaggerating the characteristics of the line-making tool they are using. David Howells works with a calligraphy pen to produce bold lines whose width can be varied by changing the pressure. Howells bears down hard on the strokes that help us recognize the letters in Figure 3.10 and uses a very light touch to add the remaining lines and to embellish them with flourishes.

Occasionally artists go to great lengths to disguise the tools used to create line. In Jan Groth's tapestry *Sign,* a whimsical line that appears as free and unselfconscious as a child's movements is actually the result of extremely intellectual, highly skilled craftsmanship. [Figure 3.11] In weaving the easiest lines to make are straight lines that follow the horizontal and vertical threads of the fabric being created. To create in tapestry a free-flowing line against the background takes tremendous discipline. People who know from experience how difficult this is will probably be delighted with Groth's result.

In addition to disguising his tool, Groth has also disguised the motion used to make his line. In some designs, however, the **gesture** used to create line is visibly recorded. In Japanese **calligraphy** (the art of fine handwriting) the first lessons are given as large arm movements in the air. The lines that form words therefore exist not only in calligraphers' minds but also in their bodies, like ballet movements. The written word exists as a stroke that perhaps goes up and is then pulled down very hard to widen the brush mark. This act—the line's moving—is as important as the final product. The calligraphic tradition of line as arm movement has strongly influenced many Western artists. The result of these fast brush strokes, as we see in the book cover designed by Antoni Tàpies, is a spontaneous and free-flowing line. [Figure 3.12]

3.12 left
Antoni Tàpies. Cover for *Cinc Poemes* (in Catalan) by Joan Brossa. 1973. 7½ × 8″ (19 × 20 cm). Fundacio Antoni Tapies, Barcelona.

3.13 right
Jackson Pollock at work in his studio, East Hampton, New York. 1951.

A flowing, gestural quality in line does not indicate that the motion used to make it was totally spontaneous. There is a certain element of chance in such works, indeed, but Japanese calligraphers train for years before they can "spontaneously" produce beautiful lines. When Jackson Pollock flung paint from a brush onto huge canvases, he did not do so randomly. He worked with this technique for so long that he developed tremendous control of his arm movements, making possible carefully calculated effects such as exciting color juxtapositions. [Figure 3.13] To control lines without actually touching them is very difficult. If you have ever blown through a straw to move ink around on a page, you know how hard it is to guide a line when the action used to make it is some distance away.

Expressive Qualities of Lines

The way a line is drawn out from a point gives it a certain character, a unique **expressive** quality. Look at the lines illustrated in Figure 3.14. If you fill a Japanese or watercolor brush with ink or paint, you can study the way line changes in character. Start a line just using the tip. Slowly increase the pressure as you drag the brush so that the line flares out. Continue to draw until the brush is dry (a). How would you describe the different line qualities thus created?

Line directs the viewer's eye. If a line has a smooth surface, the eye travels along it easily; if rough or broken, it slows the eye. Lines may be tightly controlled with small hand movements (b) or freely gestured through space (c). Such characteristics tend to evoke emotional responses in the viewer. Line that rises and falls into sharp points may suggest anger, hostility,

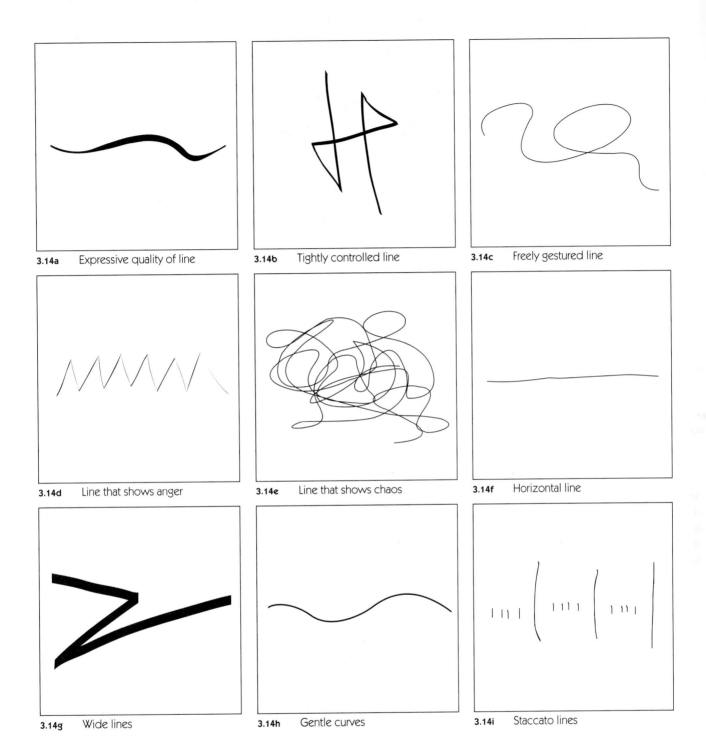

3.14a Expressive quality of line

3.14b Tightly controlled line

3.14c Freely gestured line

3.14d Line that shows anger

3.14e Line that shows chaos

3.14f Horizontal line

3.14g Wide lines

3.14h Gentle curves

3.14i Staccato lines

danger (d). Line that continually veers one way and then another with no resolution may evoke a sense of chaos (e). Horizontal line may be read as calmness or emotional flatness (f). Wide lines may convey a bold feeling (g). Gentle curves may provide a pleasant, restful sensation (h). One can almost "hear" the different sounds implied by lines, be they staccato (i) or lyrically flowing. There is nothing absolute about these relationships between line and feeling, but the visible character of line always holds the potential for evoking emotional responses.

3.15 right
Michael Mazur. *Her Place (2)*. Study for
Closed Ward Numbers 8 and 12. 1962.
Brush, pen, and brown ink; 16¾ × 13⅛"
(43 × 33 cm). The Museum of Modern
Art, New York (gift of Mrs. Bertram Smith).

Michael Mazur has used jerky inked lines that vary erratically from thick to thin to help suggest the fragmented personality of a mental patient. [Figure 3.15] The feeling he evokes in the viewer is one of horror; this is not a pleasant sight. By contrast, the flowing dry-brush line George Sklar has used to define his raccoon evokes warm feelings toward this creature by suggesting the softness of its fur. [Figure 3.16] A bold, flat line challenges the viewer to respond immediately to its directness. Fernand Léger's solid, rigid,

3.16 right
George Sklar. *Raccoon.* 1947. Wash
drawing, 10¾ × 9½" (27 × 24 cm).
Philadelphia Museum of Art (given by Miss
Edith B. Thompson).

flat brush line provokes a direct perception of the image as "woman, hands before face." The line's lack of subtlety flattens the emotional response, as though she were a robotlike machine in a mechanical age. [Figure 3.17]

In certain eras and cultures, writing has been elaborated out of love for the sheer beauty of the mark. Spencerian script could hardly be read but it had amazing life. It expanded, contracted, caressed the viewer's eye. People responded to its delicacy. The art of beautiful writing has been highly developed in Islam, springing from great devotion and reverence for the word of Allah, as revealed in the Holy Koran. [Figure 3.18]

3.17 above
Fernand Léger. *Face and Hands*. 1952. Brush and ink, 26 × 19¾" (66 × 50.1 cm). The Museum of Modern Art, New York (Mrs. Wendell T. Bush Fund).

3.18 left
Page from a Koran with Kufic letters. 12th century. Location unknown.

Line Drawings

3.19 above
Noemi Zelanski drawing

When line is used to depict forms that can be linked to the objective world, artists must be keenly aware of the cultural experiences that shape viewers' responses. To people in our culture, the child's drawing shown in Figure 3.19 is obviously a human body. Even though it does not really look much like one, it approximates the conventional model for figures that children in this culture learn to use at an early age (with the addition of a feature of which this child was particularly aware: her nursing mother's breasts). To people from another culture, this sight might not suggest a human figure at all, since their shorthand for a figure might be entirely different. To someone from a society that practices body tattooing, a drawing of a tattoo alone might be interpreted as a person. It might even be seen as a distinct individual.

Since the mind refuses to accept chaos, it will try to fit lines it perceives into some category it has built up from previous experiences. For example, scribbled spirals may be interpreted as seashells. In some ways, this tendency restricts artists' freedom to make viewers see what they intend, but it also opens up new possibilities. Skillful designers play with the tendency to see familiar forms in everything by using only a minimum of visual clues to evoke a far more elaborate response. The forms outlined in Ellsworth Kelly's *Apples* (Figure 2.23) could be anything more or less spherical—rocks, oranges, beanbags. But the addition of a tiny clue—a stemlike mark sticking out of the tops of some of these shapes—allows viewers to recognize them immediately as apples. Seen by themselves, the marks would not really look like stems. In juxtaposition to the apple shapes, however, they allow viewers to interpret the drawing as Kelly intended.

A Matisse head assumes the same kind of visual sophistication on the part of the viewer. [Figure 3.20] It actually consists of only a series of

3.20 right
Henri Matisse. *Maria Lani.* Drawing.

disconnected lines. People are so accustomed to looking at faces that they immediately see these lines as a whole face, interpreting one line as an eyebrow, another as a mouth, another as a chin, and so on. The line that suggests an ear is merely a half-circle, but viewers easily associate it with the far more complex shape of the human ear. If these lines were separated, they could be rearranged to form a totally nonobjective unit, as in Figure 3.21. Here the lines have lost all identity other than their own. But the way Matisse put them together gives viewers no choice but to interpret them as a face.

Lines are commonly used to describe the contours and distinguishing features of objects. But they may also be used to build up textures and *tones,* areas of different values. In printmaking, the techniques of **hatching** and **crosshatching** with repeated and superimposed lines or **stippling** with dots are often used for these purposes. [Figure 3.22] Parmigianino's etching of *The Annunciation* uses close, heavy lines for darker tones and thinner, softer, more widely spaced lines for lighter tones, leaving the white of the paper unmarked for the lightest of values. [Figure 3.23]

3.21 above
Nonobjective rearrangement of the lines in *Maria Lani.*

3.22: below
Hatching, crosshatching, and stippling.

Hatching

Crosshatching

Stippling

3.23 below
Parmigianino. *The Annunciation.* c. 1527-30. Etching. British Museum.

Positive and Negative Areas

Use of line also involves issues of what are sometimes called positive and negative areas in a work of art. A **positive area** appears to be occupied or filled, in contrast to a **negative area,** which appears empty or unoccupied. The positive area of a design, however, is not always the area worked with a medium. Viewers will not automatically respond to lines laid down as positive figures seen against the negative background of an unworked surface. Rather than drawing the viewer's attention to themselves, lines may draw attention to shapes they define in unworked areas. Look at the use of line in Figure 3.24. Many people see two close-set lines as defining a shape on a background (a). Two diagonal lines might define three triangular shapes (b). Two crossed lines may be seen as the edges of four positive shapes (c). Lines

3.24a
Two lines that may be seen as a shape.

3.24b
Two lines that create three shapes.

3.24c
Two crossed lines may be seen as edges of four positive shapes.

3.24d
Two lines that create one shape.

3.24e
Two lines that create two or more shapes.

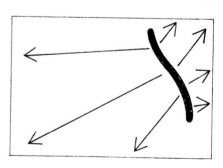

3.24f
Relationship of a line to the edge of a design.

close to the *edge* of a design may totally lose their identity as lines and refer instead only to shapes (d). Where lines cross, they may create a point of tension, as if between opposing shapes (e). Even when a line clearly exists as a linear figure against a background it is seen not in isolation but in relationship to the edges of the paper (f).

Line's potential for controlling viewers' responses to unfilled areas should not be overlooked—and can, in fact, be used skillfully to advantage. In Picasso's *Nude* (Figure 1.8) very little area is actually covered by line, but the unfilled areas are working as hard as the drawn-in lines. In Picasso's drawing the deceptively simple lines tell viewers to construct in their imaginations a woman's body on the left side of the design. The left side is no more filled in than the right side, yet viewers obligingly *see* a form rounded outward on the left and receding space on the right. If you crop off some of the empty space on the right, you will find that the figure tends to flatten out. The unworked area is actively helping to create the desired three-dimensional illusion.

It is inaccurate, then, to view unworked space as the passive part of a design and worked areas as active. The principle involved is more dynamic: In an effective design, unworked areas are as active as anything else; they just happen to be made of the surface with which the designer started. Unworked areas can advance, recede, or enhance illusions, and the same is true of worked areas.

Implied Lines

Sometimes we see lines that do not exist. These are *implied lines.* If someone draws an hourglass shape in the air with both hands, you "see" the curves of a female body. If you stare at Figure 3.25, you may see the implied lines of a square in the center of the design. If the four real lines are pulled apart and thinned out, you may see a circle between them. [Figure 3.26] In

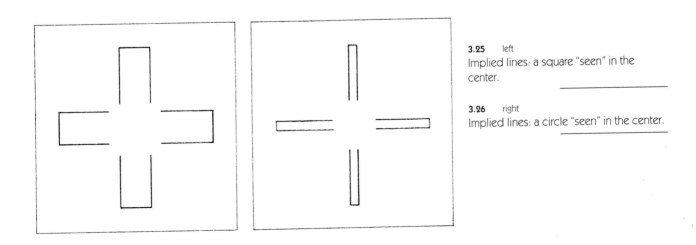

3.25 left
Implied lines: a square "seen" in the center.

3.26 right
Implied lines: a circle "seen" in the center.

3.27 right
Josef Albers. *Sanctuary*. 1942. Lithograph, 19 × 23¾" (48.2 × 60.2 cm). Collection of the Josef and Anni Albers Foundation.

Josef Albers's *Sanctuary* very strong implied lines can be seen along the diagonals, where the true lines of the composition change direction. [Figure 3.27]

It becomes obvious that we must abandon the idea that the only lines we can see are those the artist has laid down. When you allow yourself to experience and be aware of whatever responses an artwork provokes, you may begin to see even more surprising optical effects. In *Sanctuary* the horizontals and verticals may start to shift in and out, creating strange spatial ambiguities. The lines may also start to move. As they do you may begin to see colors along their edges and intersections. By using sharply contrasting lines in precise relationships to one another, Albers has created the potential for a spontaneous interaction. This will not occur unless you open your mind to unusual visual sensations. We may overlook far more than we observe in our daily lives because we often look, but seldom do we see.

STUDIO PROBLEMS

The best way to learn what line can do is to experiment with it. You must take a line and move it around on a page, discovering for yourself what happens as its position changes. You must experience for yourself the magic of a line existing in space, of a line growing to the point that it becomes a shape, of lines relating to one another to suggest objects from the world of our experiences.

The studio problems that follow will help you begin to explore the possibilities and characteristics of line. Although there are many media and methods to create lines, master use of the simplest materials and methods before exploring further. Many of the exercises call for lines cut out of sheets of construction paper and glued with rubber cement onto a construction-paper groundsheet. This method allows experimentation; it avoids the conceit of holding on to something already created. It also avoids handicapping those who do not draw well. Other problems can be done with pencil or pen. If you have access to computer graphics, you could solve them on computer. You may want to repeat some of the problems using different media. For detailed information on the use of various media, see the Appendix.

The solutions shown should not be regarded as models, but rather as single examples taken from the infinite range of possibilities. If you approach the stated problems creatively, your solutions may be quite different from the examples.

3·1
SUBDIVISION OF A GROUNDSHEET

Cut pieces of black construction paper and glue them onto four white 8-by-10-inch groundsheets or draw lines on a computer to solve the following problems.

A. Using only straight horizontal and vertical lines, divide the page into a design that emphasizes line but develops interest in how the space is subdivided.

B. Do the same thing using only diagonal lines.

C. Do the same thing using only curved lines.

D. Do the same thing using at least one horizontal or vertical, one diagonal, and one curved line.

Whenever you lay down lines on a surface you carve this ground into areas or perhaps into distinct shapes. Even when you manage to hold viewers' focus on your lines—to get them to respond first to the lines they see—their response will also be affected by how these lines *control* or organize the unfilled area around them. If the unworked areas lack unity, your designs may seem disorganized, adrift in space. For an effective, unified design you have to make unfilled areas work as hard as filled ones. Note that different kinds of lines carve unworked areas into different kinds of shapes.

Horizontal and vertical lines

When only horizontals and verticals are used, almost any design is likely to be interpreted architecturally. Because our culture's architecture is based largely on right-angle joints of straight horizontal and vertical elements, the lines will carve the space into areas that suggest pieces of buildings or architectural plans viewed from above.

Architectural suggestions are especially strong if many lines touch the edge of the groundsheet, as in Figure 3.28, which could be associated with a floor plan or the understructure of a building. The widest lines of the framework unify the design by carving unfilled areas into a series of rectangles. No two are the same size, but the repetition of this general shape helps hold the design together. Within this logical framework, the variation in the width of lines and the discovery that some of them end in space add interest and humor to the design. The lower two vertical unattached lines help control the large unfilled area on the lower right, directing the viewer's eye back into the design rather than letting it slide off the page.

Diagonal lines

Diagonals often carve unfilled areas into shapes that seem to thrust vigorously outward from each angular corner. At the same time, the unfilled corners may take on the appearance of lines. In Figure 3.29, where black lines seem to radiate from a source at either side, the white triangles they frame are drawn in to such a fine point that they appear almost to be pointing lines. Tension is created in these areas as the eye shifts back and forth between the black lines and the sharply pointed ends of the triangles. As it does so, a spontaneous interaction may develop—a play of grays along the edges and perhaps little black triangles darting out from the intersections.

In addition to turning unfilled areas into near-lines with exciting optical effects, this student is also working with an interplay of almost-similar shapes. The shapes above and below the central line that runs from one intersection to the other are enough like each other to invite comparison but different enough to make this comparison interesting. Part of the excitement of this design is the discovery that what begins in the center as a near-mirror image evolves into shapes that are less and less alike. Near the corners, no two are at all similar.

Curved lines

Curving lines often give unfilled (as well as filled) areas a flowing, rhythmic quality. In Figure 3.30 a gentle rocking movement is suggested. Curving lines also tend to enclose the space within them. Here the viewer automatically completes the oval shape suggested by lines that curve toward each other. The tendency is to see this design not as random lines floating in space but as a unit: perhaps a transparent seedpod with curled embryo inside ready to burst forth. Even if not associated with a natural object, the design is still likely to be seen as a single form.

This design controls a tremendous amount of unfilled space by its own position alone. The typical way

3.28 above
Subdivision of a groundsheet by horizontal and vertical lines. Student work.

3.29 above
Subdivision of a groundsheet by diagonal lines. Student work.

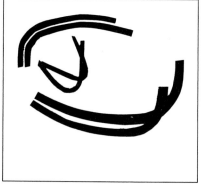

3.30 above
Subdivision of a groundsheet by curved lines. Student work.

of controlling unfilled areas is to use lines that corral shapes, surrounding or backing them into corners, as in Figure 3.29. It is much more difficult to control unfilled areas when nothing touches the edge of the page. In the "seedpod" design, empty areas are given an important function by the positioning of the image: They are used to suspend it in space. The large white void on the bottom keeps it from dropping off the page; the equal areas to either side keep it from sliding off one side or the other; and the small white area at the top keeps it from crowding into the frame.

All four kinds of line When horizontals, verticals, diagonals, and curved lines are used together, the result usually suggests a picture from the world of our experience. Figure 3.30 is nonobjective, yet it is vaguely reminiscent of something—a sunset? a boat deck? No matter what kind of sense a viewer makes of this design, there is a strong impression that the lines and unfilled areas do not stop at the edge of the page. Enough information is given for them to be followed to some logical conclusion. The arc on the left is probably completed symmetrically. This student has thus controlled the

unfilled areas on the page, those extending *off* the page, and—by making them fill in these areas in their imagination—the viewers' response.

In using four different kinds of lines together, you may encounter difficulty unifying your design. In Figure 3.31, the groundsheet is subdivided into a series of three-line units. They are held together as variations on a theme and as units sharing a common focal point. All straight lines point toward the lower left corner. As in the other parts of this problem, unfilled areas must also work well. The unfilled areas carved out on either side of the diagonal are reversals of each other, the space in the lower left corner is corraled by the arcs, and the large unfilled area at the upper right provides a serene counterpoint to the more filled areas, yet it is balanced by the more active parts of the design.

The student did not achieve this blend of filled and unfilled areas on the first try. Like many of the other student and masterworks shown in this book, this design is the final result of a long trial-and-error process. The student kept pushing lines around and changing them until everything seemed to work well together.

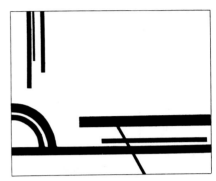

3.31 *above*
Subdivision of a groundsheet by horizontal, vertical, diagonal, and curved lines. Student work.

3•2
EBB AND FLOW OF BLACK AND WHITE

A. Cut black paper strips of various widths and place them as parallel lines on a white 8-by-10-inch groundsheet in such a way that the white lines they create alternate in predominance with the black lines. The emphasis should ebb and flow from one to the other.

B. Do the same thing using pencil, pen, or computer for the black lines.

The preceding problem concentrated on controlling unfilled areas in designs. This problem requires using unworked areas as both figure and ground. As you experiment with varying the width of the black lines to emphasize or play down the white of the groundsheet, you will also be creating

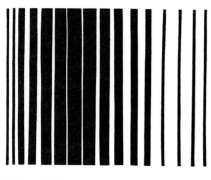

3.32 above
Ebb and flow from black to white cut lines. Student work.

spatial illusions. The rhythmic shift from black to white may begin to suggest a pattern undulating in and out in space. Both black lines and white spaces can either advance or recede, depending on the visual clues with which you surround them. The treatment of the border will influence whether the white is most readily seen as ground or figure.

Cut strips In Figure 3.32, gradual changes in the size of lines and the spaces between them create a sense of logical rhythmic variation. Since about equal amounts of both colors are used, it is not immediately clear whether white has been applied to black or vice versa. The dark area on the left could be seen as receding, with the white area to the right bulging forward like a fluted column. But be-

cause the border has been left white, viewers could interpret the white in the design as background, bringing the black part bulging forward. This ambiguity adds to the intrigue of the gradual shift from black to white.

Drawn lines Since computer printers, pens, and pencils can make much finer lines than paper strips, it is possible to put on many more of them, creating numerous repetitions of the ebb and flow of dark and light areas. This makes it easier to create a pattern that seems to undulate in and out, if this is your intent. However, if you use a single pen or pencil, it is more difficult to vary the width of the black lines than working with cut papers.

In Figure 3.33, rendered on computer, all the black lines are exactly the

3.33 right
Ebb and flow from black to white drawn lines. Student work on computer.

same thickness. Yet the changing width of the white intervals between them does create dark and light areas, as required by the problem. The use of a black border separates the white areas from the groundsheet, decreasing the chances that the predominance of white will cause these white areas to be seen automatically as background. As for the blacks, in some areas the black lines are so close to one another that they can hardly be seen separately from the white lines. Here an optical mixture of black and white occurs, making the viewer see gray mid-tones. These gray areas suggest the shadows developed on three-dimensional objects as they curve away from a light source, a subject explored further in the next chapter. Another clue to three-dimensionality is the diminishing of the white spaces in width as they approach the "shaded" areas. This suggests movement into the distance,

for things appear visually smaller as they move away from us.

The shading and size change create a rippling curtainlike illusion of convex and concave curves. However, it is not clear which of the light sections are going in and which are coming out, an ambiguity that compels us to look at the design longer. If you give it some time and are receptive to anything that happens, you may start to "see" some spontaneous interaction effects. In the areas where the black lines are so close that it is hard to read them individually, the dark masses may waver. You may also see colors, perhaps yellows flashing horizontally across the design. In juxtaposing many black and white lines as called for in this problem, you have the opportunity to increase the excitement of your solution by creating spontaneous interactions—either by accident or by conscious planning—as in Bridget Riley's *Current* (Figure 1.17).

3·3 FOUR UNIFIED AS ONE

Subdivide an 8-inch square into four 4-inch squares, each of which contains a design made individually of parallel drawn straight lines.

This problem gives you an opportunity to experiment with variety. Because of the way the problem is set up, almost any solution will work as a unit. The repetition of the small squares and similar lines gives a logical structure to the whole that holds it together no matter what is going on in the individual squares. Out of an instinctive desire

for order, viewers will discover certain rhythms and patterns among the four squares. You are therefore free to design each square separately rather than worrying about how the pieces will fit together.

If you regard each small square as a separate unit, you can create a solution with more variety than if you concentrate on the links between units. You could use this problem to experiment with variations on a theme. On one square you could have many lines close together, on a second a few lines farther apart. A third square could have a hard line alternating with a soft line; a fourth could have more soft lines and fewer hard ones. When you put all four together, the result is the visual equivalent of four-part harmony in music. Separate parts of the design can work together to create a whole that is

3.34 above
Four squares unified as one. Student work on computer.

more exciting than any of the parts in isolation.

In Figure 3.34, solved on computer and printed on a 600 DPI laser printer, the lines within the squares do not meet, but they work well together because they are all variations on the same theme. In this case, it is the ebb and flow of black and white lines, an idea carried over from the previous problem. Each square uses a different kind of shift, producing a different spatial sensation. To have a design breaking itself up spatially along both horizontal and vertical axes at the same time is very strange, but it works because our need for order is satisfied by the logic of repeated squares and similar lines.

3·4
HARMONIOUS LINES

Cover a white groundsheet with similar nonparallel lines. The lines can be drawn, made from cut black papers, or created on a computer.

Rather than catering to the frequent tendency among design students to isolate an image, this problem requires you to work the whole page —to explore what happens if you touch the edges all around and perhaps experiment further with ideas picked up in previous problems. You will also find that in using many similar, nonparallel lines you will build up a sense of harmony—of different voices blended together—in the lines themselves or in the spaces between them.

In the solution shown as Figure 3.35, the student used similar curved lines drawn on a computer. After working out the basic design, the student made it smaller and repeated it to create an allover pattern based on the juxtaposition of like lines and like shapes. The computer allows an

3.35 a & b right
Harmonious lines. Student work on computer.

a b

image, once made, to be manipulated in many ways.

A solution done with straight lines would create a very different effect, but so long as the lines repeat a similar theme, the orchestration of the parts will hold together as a harmonious pattern.

3.5

BENDING STRAIGHT LINES

A. Using two nonparallel lines subdivided equally, connect the opposite points with straight lines.

B. Do the same thing starting with more than two lines, connecting each to the nearest line.

In this complex problem, a precise intellectual approach can produce delightful curved arcs in the unfilled areas, using nothing but straight lines. The original nonparallel lines can be penciled in and erased afterward or left as part of the design. Either way, the original lines must be subdivided into equal numbers of points. If you start with lines of unequal length, the point-to-point spacing along each line will be different. As a simple example, if you used a 4-inch line and an 8-inch line for the first part of the problem, the 4-inch line could be marked at 1/4-inch intervals, while the 8-inch line would be divided into 1/2-inch intervals in order to use the same number of dots. In the first problem, you would then connect the first dot on one line with the *last* dot on the other, then the second dot with the second-last dot, and so on. In the second part of the problem, you again break the lines into equal numbers of points and then connect points with those on the nearest line.

Once you understand the mechanics of this problem, you may want to repeat it to see what happens when you vary the original lines. If you start with parallel lines, no arcs will appear. It helps to experiment with thumbnail sketches first. If you then do your finished designs on very large sheets of paper, you can crop them afterward to a size that works well, paying attention to unfilled as well as filled areas.

Working with two lines Even a simple solution to this problem can be beautiful. Figure 3.36 shows the connection of two lines of equal length (made with a pencil and then

3.36 left
Arc originating from two lines. Student work.

3.37 right
Arc originating from four lines. Student work on computer.

erased), both divided into 25 dots. The lines drawn from these dots produce an airy structure twisting in space to frame a lovely arc on the right. Although the beauty of the curve draws most attention, other unfilled areas are also well controlled as a series of triangular spaces.

Working with more than two lines Viewers tend to interpret the curves, diminishing scale, and shadow effects created by converging lines as indications of the rounding of forms in space. This tendency adds an interesting ambiguity to solutions done with more than two lines, for they appear to be twisting in several directions at once. For instance, it is difficult to make spatial sense of Figure 3.37 because each corner seems both to overlap and to be overlapped by the corner beyond it. In addition to the interest of its spatial illogic, the design is a series of beautiful unfilled and partially filled arcs. The student designer programmed it on a computer for a precise symmetry that rarely appears in human drawings. The computer's drawing needle also created an interesting textural effect with its wavering lines. Although the design is built from the two sets of right angles that form a rectangle, each line is connected to a line it does not parallel, so this solution does fall within the specifications.

3·6 AN EXERCISE IN CALLIGRAPHY

Using a wide brush and black ink of acrylic paint, write your name. Do not be concerned with whether it can be read. Focus instead on using your whole arm to create an expressive line—one that conveys an emotional attitude.

Most of the previous problems called for tight hand and finger movements to cut paper and draw lines. This problem is a chance to experiment with sweeping whole-arm movements. It also draws a temporary shift from the intellectual approach to a

more spontaneous and free way of creating lines. The name is of little importance; it is used only as a vehicle for freeing line, since you are already accustomed to scrawling your signature in a hurry.

Any kind of ink, paint, or brush will do. You can use India ink, blue-black pen ink, black acrylic paint thinned as much as you like, or anything else that will allow you to create a fluid line. If you can afford a Japanese calligraphy brush, experiment with its effects. You could buy a good water-color brush, for it will be needed for later problems. If you have trouble loosening up, use a wide, cheap brush —even a 2-inch paintbrush from a hardware store. Since lines usually reflect the tool that made them, a rough tool will produce a rough line that you cannot rigidly control.

The free action used to make letter forms is more important in this problem than whether they are recognizable letters. Expressive lines that cannot even be read can be beautiful in themselves and in the unfilled areas they define. In Figure 3.38 the artist's name is Andrea Schwartz, but whether her design says Andrea or Schwartz is a mystery. She used sweeping arm movements directing a large and rather unwieldy brush. Although the line seems bold and quick, it is very formally controlled. It is placed on a precise horizontal just above the center of the page. The cropping on the right side gives a feeling of continuing circular movement, punctuated and enlivened by an occasional vertical stroke.

To create an expressive (or emotional) line you must be as uninhibited in your arm movements as dramatic actors are with their voices. An expressive line may BOOM OUT TO FILL THE ROOM (or become very soft to pull you in). If you held your breath in the past few problems as you concentrated on controlling lines, here you can (and should) breathe freely as you work. Let line flow with your breathing, bounded only by the limits of what the brush can do.

Since this problem can be done quickly, you can express your name calligraphically again and again. As

3.38 left
Calligraphy with a large brush. Student work.

3.39 right
Calligraphic statement controlling a huge
groundsheet. Student work.

you repeat the problem, you may find
yourself loosening up more but at the
same time learning to exercise in-
creasing control over your quick,
"spontaneous" arm movements. Pay
attention also to how your design fits
on the page; experiment with place-
ment and with making your name or
the groundsheet larger or smaller to
see what works best.

Figure 3.39 is exciting because so
small a worked area controls such a
huge sheet of paper by its directness
and simplicity. The name Liz is used al-
most like an artist's signature—a visual
period to keep the eye from dropping
off the page. After making the original
line on a small piece of paper, the stu-
dent felt that it would work better with
a tremendous amount of white around
it, so she glued it onto a much bigger
sheet. The fluid statement is so strong
that the groundsheet could almost be
doubled in size again without over-
whelming it.

3•7
BLIND CONTOURS

Do a pen, pencil, or computer
drawing of an inorganic object and
then one of an organic object with-
out looking at the groundsheet.
Look at the object. If necessary,
hold a sheet of cardboard above
the groundsheet so that you cannot
see your drawing. Try drawing each
object several times, then choose
the best one in each category.

Your first response to this problem
may be "I can't do it. How can I draw if
I can't see what I'm doing?" You may
be surprised to find that you can com-
municate with your hand better than
you expect. After all, you can hold
your fingers 2 inches apart or curve

them into a C without looking at them. If you concentrate on the proportions and characteristics of the object you see, you will eventually be able to draw it without looking at what you are doing. Placement on the page deserves thought, too, for this has a dramatic impact on how well a design works. Drawings can be done on large sheets of paper and then cropped afterward to a size and placement that work well.

The first few attempts to draw a blind contour are usually terrible, but trying is fun. When you finally discover that you can think in terms of proportions—and that it is not a good idea to pick up your hand—your solutions will improve. The line may become extremely expressive because you are really trying to get through to your fingers what you see.

Figure 3.40 gives a strong feeling of the sink. The drawing is also very three-dimensional. These things happened because the student was thinking of the object and really trying to convey its essential roundness or its sharpness without being overly intellectual.

Blind drawings of organic objects often work surprisingly well, too. The tomatoes in Figure 3.41 have a strong feeling of roundness and fullness and truly sit inside their plastic container. Even the lines used to get to the next spot are agreeable, for they convey a lively feeling of something close to growth.

The spontaneous quality of the lines in these solutions was created intuitively rather than intellectually. Most of the other problems in this book require more intellectual responses. Doing blind contours should encourage you to work more intuitively. The ultimate goal in art is a merger of intuition and intellect.

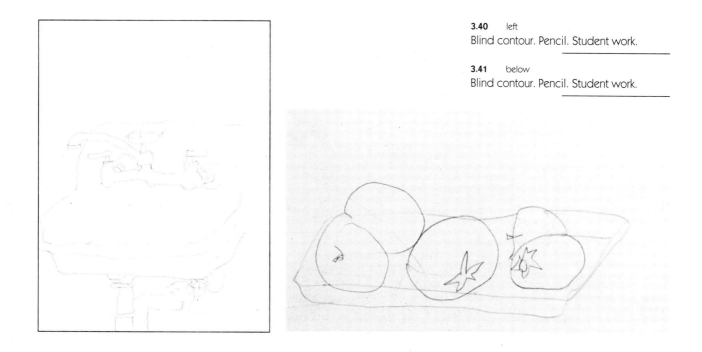

3.40 left
Blind contour. Pencil. Student work.

3.41 below
Blind contour. Pencil. Student work.

DESCRIPTIVE LINE

A. Choose any subject and draw it with a single continuous line that never crosses itself.

B. Draw the same subject using only parallel vertical lines.

In the blind contours problem you learned to express the essence of an object with an intuitive line. Here you are asked to capture the essence of a subject in more controlled circumstances: to combine the freedom of the recent problems with the intellectual approach of the earlier problems. You could draw anything from a simple still life to a complex landscape or cityscape.

Although your linear description of the subject may be partially intuitive, to use a single line that may repeatedly double back but never cross itself requires continual decision making: How can I get there from here? You may have to think through the entire composition before you start. The second part of the problem gives a chance to experiment with some things you have learned about using line, but in a more representational drawing than those called for earlier.

Line can do anything you want it to. Intent is an intangible element of art, but sometimes the sheer desire to make something come out a certain way will help you create a solution that works.

Figure 3.42 demonstrates well-controlled use of descriptive line. To place one object in front of another yet develop them both with the same continuing line is extremely difficult. The student had to keep thinking ahead in order to get the line to fill in all the details desired—shading and bark on the tree, overlapping of the tree by the bench and grass, and indications of the thickness of the wooden pieces of the bench. The fact that they

3.42 right
A single descriptive line. Student work.

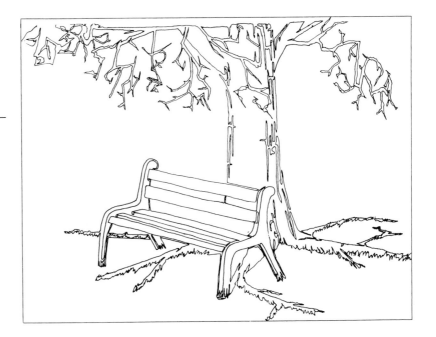

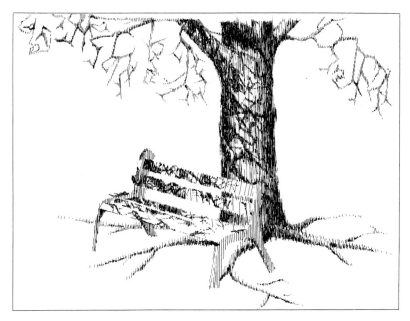

3.43 left
Vertical lines used descriptively. Student work.

all grow from the same line unifies them as an intriguing organic whole.

In the second part of the problem, shown in Figure 3.43, the student chose to emphasize the shadows created by the branches. Despite the strange patterns thus created and the lack of any outlines, lines used to suggest the objects easily can be distinguished from lines used to indicate shadows on them. The student made this distinction possible by varying the kinds of lines used: long, thin lines to describe the texture of the objects and shorter, thicker lines for the shadows.

Even while juggling these two kinds of line, the student also found it possible to vary the distance between lines used for the tree in order to give an illusion of shading on an object that seems fully founded in space. This is scarcely possible in the first part of the problem. As a result, the first tree looks much flatter. You may see other kinds of comparisons in your two drawings, differences that result from two very different ways of using line.

4

SHAPE AND
FORM

KEY TERMS

- abutting shapes
- biomorphic
- form
- hard edge
- interlocking shapes
- leading edge
- mass
- optical figure-ground reversal
- overlapping shapes
- physical figure-ground reversal
- plane
- plane structure
- shading
- shape
- soft edge
- tension
- volume

4 SHAPE AND FORM

The words **shape** and **form** are commonly used interchangeably. Here we will use them to mean two rather different things: a shape is a figure that appears to be flat, whereas a form is a figure that appears to be three-dimensional. Other terms commonly used for form are **mass** and **volume,** and the word *form* sometimes refers to the overall organization of a work. This chapter examines a number of aspects of working with shape and then looks at some ways of giving flat images the illusion of three-dimensionality. This discussion will continue in Chapter 5, for designs that develop illusions of forms also work with illusions of space.

Designs that Emphasize Shape

Designs emphasizing line were experimented with in Chapter 3. In this chapter, focus will be shifted to designs that draw attention to shapes and forms they contain. In Mark Wilson's computer plotted drawing *CTM E20*, the lines are likely to be interpreted as the outlines of shapes rather than as autonomous lines. [Figure 4.1] The focus is on the shapes and the relationships among them. The artist was investigating the visual effects of mathematical progression. The result at first emphasizes a sequence of shapes, but as the shapes become smaller and more numerous on the left and right sides of the composition, a different play becomes evident between the

4.1 right
Mark Wilson. *CTM E20*. 1986. Acrylic on linen, executed by Alphamerics plotter and IBM PC. Courtesy the artist.

4.2 left
Georgia O'Keeffe. *White Barn No. III.*
1932. Oil on canvas, 16 × 30" (41 × 76
cm). Collection Mr. and Mrs. Paul Mellon,
Upperville, Virginia.

texture and a more form-oriented concern in the bottom right section of the composition.

Even more representational designs may emphasize shapes. Georgia O'Keeffe's *White Barn* may be seen at first not as a barn but as a rather wavy-edged trapezoid supported by two smaller black rectangles that divide the lower white area into three white rectangles. [Figure 4.2] Even the sky becomes a large shape fitting against the shape that constitutes the roof. The not-quite-logical nature of the painting, with its nonmatching horizon lines on either side of the barn and pools of light coming *out of* rather than flowing *into* the barn doors, increases the possibility that viewers will respond to it as an abstract assemblage of shapes.

Sources of Shapes

Designers have vast resources as they seek inspiration for intriguing shapes. These include geometric shapes, invented shapes, letters, numbers, and familiar objects.

Geometric Shapes

The most familiar shapes are geometric—circles, squares, rectangles, triangles, and so on. People respond to these shapes readily, and artists can take advantage of this familiarity. Rectangles are so quickly seen as abstractions that O'Keeffe can make viewers see abstract rectangles instead of barn doors.

With only three lines of different weights, Piet Mondrian carves the square turned as a diamond into five geometric shapes. [Figure 4.3] Some are asymmetrical, suggesting larger shapes completed beyond the picture

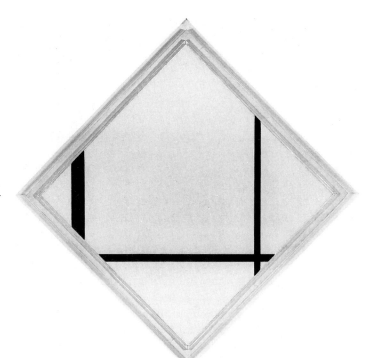

4.3 right
Piet Mondrian. *Fox Trot A.* 1930. Canvas, diagonal 3'7¾" (1.09 cm). Yale University Art Gallery, New Haven, CT (gift of the artist for the Collection Societe Anonyme).

4.4 above
A triangle whose base is not parallel to the bottom of the picture plane may seem to be tipping.

plane. Do you see the largest shape as an asymmetrical five-sided shape or a section of a larger rectangular shape? Is the frame a window onto a part of a repeating grid pattern rather than the outer limits of the design? With seemingly simple means, Mondrian has capitalized on our familiarity with geometric shapes to suggest a variety of complex visual interpretations.

Because geometric shapes are so familiar, artists must assume that viewers have preconceived notions about what these shapes will do. Circles may threaten to roll away unless held in place by something. If the base of a triangle is parallel to the bottom of the picture plane, it appears reassuringly solid. However, if it is anything but parallel to the bottom of the design, the triangle may be interpreted as tipping unless it is somehow held in visual balance. [Figure 4.4]

Invented Shapes

Invented shapes can be used more freely than geometric shapes, since no one knows from experience how they might behave. In Gorky's painting *Composition,* there are hints of a triangle here, a circle there. [Figure 4.5] For the most part, these are a series of unrecognizable shapes—the result of a playful, almost childlike squeezing and bending of matter to produce unfamiliar shapes that fit together in intriguing ways. Nothing seems to be logically supported by anything else, but this is of no consequence because these shapes do not remind us of the world on which our notions of order are based. Instead, they come from a fantasy world of the artist's invention in which anything seems possible.

4.5 left
Arshile Gorky. *Composition.* c. 1938-1940.
Oil on canvas, 2'10" × 4'8⅛" (.85 ×
1.4 m). Hirshhorn Museum and Sculpture
Garden, Smithsonian Institution (gift of
Joseph H. Hirshhorn, 1966).

Enlarged Lines, Letters, and Numbers

In Robert Motherwell's paintings (such as Figure 4.6, commissioned for the new wing of the National Gallery of Art), shapes are based on tremendously overgrown lines. They appear to be the calligraphic art of a giant working with a massive brush. Being an average-size human, Motherwell actually used brushes that were much smaller than the line shapes he made. Rather than applying them with single rapid strokes, he filled in the shapes, even adding what appear to be drops of paint from an enormous brush.

A similar source of shapes is letters and numbers blown out of their normal scale or cropped almost beyond recognition. Figure 4.7, the cover of a review of typography as "graphic language," features type as shape by taking a 3, blowing it up so that it is larger than the page, and then cropping it

4.6 left
Robert Motherwell. *Reconciliation Elegy.*
1978. Acrylic on canvas, 10' × 30'4"
(3 × 9.2 m). National Gallery of Art,
Washington, DC (gift of the Collectors
Committee).

so that it becomes a play of dark positive shapes and negative unfilled shapes carved out of the background. Just enough information is left for us to connect the positive shapes mentally as a single 3 shape.

Familiar Objects

A final source of shapes lies in the flattening out of three-dimensional objects from the world of our experiences.

While a letter or number printed on a flat ground is truly flat, an apple is not. But Takashi Kono's poster for a tea ceremony publication interprets a three-dimensional apple as a seemingly simple geometric circle shape and leaf shape. [Figure 4.8] They are put together to make an elegant whole that is much more complex than it first appears. Nothing is actually geometric. The section of branch shown is not symmetrical; it tilts and changes width from left to right. Even the leaf is asymmetric. The edges of the apple "circle" are not uniformly smooth. Nevertheless, the apparent austerity of the shapes set against an expansive black ground reflects the stark simplicity

4.7 above
Giancarlo Iliprandi. Cover of a review of typography on "graphic language." 1971. 12½ × 6½" (33 × 17 cm). Zeta's Pubblicazioni Tecniche, Milan.

4.8 right
Takashi Kono. *Ideal Relationship* (poster for tea ceremony publication). 1955. Silkscreen, 28⅝ × 10¼" (73 × 51 cm). Museum of Modern Art, New York (gift of the artist).

4.9 left
Paul Klee. *Dying Plants (Sterbende Pflanzen).* 1922. Watercolor, pencil, pen and ink on paper, mounted on cardboard; 19⅛ × 12⅝" (49 × 32 cm). The Museum of Modern Art, New York (The Philip L. Goodwin Collection).

of the tea ceremony, while the subtle nuances suggest the tea ceremony's exquisite attention to the smallest details. In this quietly powerful statement, even the broadened calligraphic letters below begin to read as a series of flat shapes. The near-geometry of the flat shapes has an immediate appeal that works well in commanding attention to the graphic design, but one is also rewarded by examining it at greater length.

Shapes that remind us of structures from the natural world may be called **biomorphic** shapes. In the hands and teaching of Paul Klee, shapes of relatively simple natural forms, such as leaves and snails, are deeply explored for secrets to their underlying essence, and thence to their Creator. [Figure 4.9] "For the artist," Klee asserted, "dialogue with nature remains a *conditio sine qua non.*" The artist probes nature by "visible penetration," in

which "the object grows beyond its appearance through our knowledge of its inner being, through the knowledge that the thing is more than its outward aspect suggests." Thus the artist develops "a synthesis of outward sight and inward vision," and:

> It is here that constructions are formed which, although deviating totally from the optical image of an object yet, from an overall point of view, do not contradict it. Through the experience that he has gained in the different ways and translated into work, the student demonstrates the progress of his dialogue with the natural object. His growth in the vision and contemplation of nature enables him to rise towards a metaphysical view of the world and to form free abstract structures which surpass schematic intention and achieve a new naturalness, the naturalness of the work. Then he creates a work, or participates in the creation of works, that are the image of God's work.*

Unfilled Areas as Shapes

In a work that emphasizes shapes, unfilled areas may be seen as positive shapes. Giancarlo Iliprandi's cropped "3" divides the unfilled ground into three positive shapes, one of which looks like a mouse's ears. In the tea ceremony poster, the major shape—the apple—is an unfilled area defined by the filled area that surrounds it. In Henri Matisse's *Venus* an unworked area is the main figure in the design. [Figure 4.10] Matisse reveals that he has applied dark shapes to a light groundsheet; the groundsheet can be seen on either side. What viewers usually respond to first, however, is the unworked area representing an armless female torso. The title of the piece and the exaggeration of the breasts and hips to the exclusion of arms are clues that add to an intellectual appreciation of the design, for they may remind viewers of Venus figurines and sculptures created as long ago as the Paleolithic Age. Even though the female shape is an unworked area of the composition, Matisse has steered viewers toward seeing it as the figure and the dark shapes as background and toward responding to the unworked area on a very sophisticated level.

When the true background of a design—the ground to which the artist has applied a figure or shape—can itself be seen as a positive shape, a *figure-ground reversal* may develop. Viewers may not be sure which is actually the ground and which the applied figure. In M. C. Escher's *Symmetry Drawing E96*, you may see white birds flying to the right or black birds flying to the left. [Figure 4.11] It is nearly impossible to see both readings at the same time. Your mind will want to interpret the edges between black and white as

* Paul Klee, "Ways of Studying Nature," Lecture at the Bauhaus, 1923, as quoted in Richard Verdi, *Klee and Nature,* New York: Rizzoli, 1984, pp. 17-18.

4.10 left
Henri Matisse. *Venus.* 1952. Paper collage
on canvas, 39⅞ × 30⅛" (100 × 76 cm).
National Gallery of Art, Washington, DC
(Ailsa Mellon Bruce Fund).

4.11 above
M. C. Escher. *Symmetry Drawing E 96.*
1955. India ink and watercolor in gray
brown, 11⅞ × 8⅞" (30.3 × 22.5 cm).

4.12 below
Physical figure-ground reversal: positive
and negative areas are equal.

belonging either to the white birds or black, but not both simultaneously. As you keep looking at the design, therefore, your interpretation of what is figure and what is ground will keep reversing.

The simplest way to understand figure-ground reversal is to look at checkerboard patterns of black and white squares. In a checkerboard segment of only four squares, two will be black and two will be white. [Figure 4.12] Since there are exactly equal amounts of black and white, it is impossible to tell which is the background and which is the figure. You can perceive black squares against a white background or white squares diagonally against a black background. This is called a **physical figure-ground reversal.** The yin and yang symbol shown in Figure 2.10 is another example.

4.13 right
Optical figure-ground reversal: positive and negative areas are unequal, but it is still possible to perceive either as figure or ground.

In a checkerboard segment of nine squares, five squares may be black and four white (or the reverse). [Figure 4.13] Even though the number of black and white squares is no longer exactly equal, it is still impossible to tell what is figure and what is ground; the design can still be seen as black on white or white on black. This is called an **optical figure-ground reversal** because the viewer still can perceive both repeating patterns of diagonally linked shapes. Optical figure-ground reversals tend to occur when there is less white area than black, because white often seems to expand, whereas black tends to contract.

Implied Shapes

In addition to making viewers see shapes in unworked areas of a design or suggesting ambiguities about what is figure and what is ground, some designers create illusions of shapes that are not there at all. With a bare minimum of lines, Jerzy Trelinski evokes the impression that the lines are the edges of implied geometric shapes—rectangles and circles. [Figure 4.14] The one seemingly insignificant line down the left side of the upper-most implied rectangle begins to finish the outlines of that shape, provoking us to read also the other barely delineated areas as shapes. If you cover that faint line in the upper rectangle, you may notice that your perception of the rest of the design shifts from implied shapes to a series of lines.

Arthur Hoener's color action drawing *Overlapping Three* uses only white circles with black dots of varying size to create the illusion of three overlapping diamonds. [Figure 4.15] These implied shapes seem to jut out along the **leading edge** (the one that appears closest to the viewer) formed by each diagonal row of circles containing the smallest black dots. From that point they seem to fade slowly into the background, as though these were flat shapes turned slightly away from a light source so that their far edges are in shadow. Yet there are no edges, no diamonds, no shadows, only circles with dots in them. Viewers who look long enough at this drawing may see

4.14 left
Jerzy Trelinski. Cover for *Interfashion Lodz
'87*. From *12th International Poster
Biennale Warsaw 1988*, organized by
Ministry of Culture and Arts, Central Office
for Art Exhibitions Union of Polish Graphic
Designers. Courtesy the artist.

spontaneous interaction effects: The diamonds may shift, multiply, and even
develop colors and jagged horizontal waves of white. To create these in-
triguing illusions, Hoener used so many little circles that it is impossible to
focus on any one of them—instead viewers are forced to "unfocus" and
to perceive larger shapes and spatial effects in the drawing.

4.15 left
Arthur Hoener. *Overlapping Three*. 1979.
India ink, 30 × 40" (76 × 102 cm).
DeCordova Museum and Sculpture Park,
Lincoln, Massachusetts.

Holding Shapes Together

If a number of shapes are scattered through a work with no apparent relationship to one another, they may appear to be adrift in space. Even repetitions of similar shapes, as in Figure 4.16, may be insufficient to unify a design. Devices to avoid this "scattershot effect" by making shapes appear to fit together include overlapping, abutting, interlocking, mutual tension, and suggestions of a continuous whole.

Overlapping

In Hoener's drawing the diamond shapes seem to be nestled one behind the other in space, for parts of the "farther" ones are obscured by the "closer" ones. In Bronzino's *Portrait of a Young Man,* many areas are painted in such uniform colors that you can study the painting as a play of shapes, one atop the other or set at angles to each other. [Figure 4.17] **Overlapping** is part of the "glue" that holds the shapes together.

4.17 right
Bronzino. *Portrait of a Young Man, possibly Guidobaldo II, Duke of Urbino.* c. 1550. Oil on wood panel, 37⅝ × 29½" (96 × 48 cm). Metropolitan Museum of Art, New York (bequest of Mrs. H. O. Havemeyer, 1929. H.O. Havemeyer Collection).

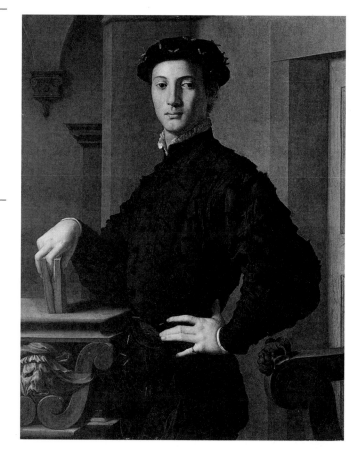

Abutting

A second way shapes can relate to one another is simply to be next to—
abutting—one another. In Figure 4.18, each shape touches other shapes.
Where they meet, they share an edge. That is, the line along which they
meet seems to belong not to one or the other but to both. The shared edge
creates the illusion that the shapes are adhering to one another. In the poster
for the Bauhaus, a major international design center in early twentieth-
century Germany, edges are shared even between type and shapes, with
abutting so strongly cohesive that it seems impossible to pull the thing apart.
[Figure 4.19]

Interlocking

A third way of holding shapes together is **interlocking** them like the pieces
of a jigsaw puzzle. Often this is done by matching one curve to another—
convex to concave, as in Figure 4.20. If there is unworked ground between
them, it may also become highly active, as an intermediary implied shape

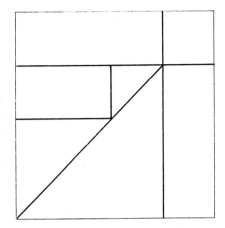

4.18 above
Abutting shapes share edges.

4.19 left
Joost Schmidt. Poster for Staatliches
Bauhaus Ausstellung (National Bauhaus
Exhibition). 1923. Lithograph, 26¼ × 18⅝″
(67 × 47 cm). The Museum of Modern
Art, New York (gift of Walter Gropius).

4.20 below
Two shapes that fit together, concave to
convex, with implied shape between
locking them together.

4.21 right
Katherine Krizek (KatherineKrizekDesign, Verona, Italy). *Shaker Screen* space dividers for Cappellini Spa, Orosio, Italy. Bent plywood with natural, hazelnut, and smoke finishes; panels 6′ × 3′8⅞″ (1.83 × 1.14 m) and 5′3″ × 2′11½″ (1.6 × .9 m). Courtesy the designer.

that further locks the pieces together as a unified whole. Katherine Krizek interlocks concave and convex shapes three-dimensionally in her plywood space dividers for a spa. [Figure 4.21]

Although the most familiar puzzles are those made with jigsaws, which can cut curved lines, some designers fit straight-sided "puzzle pieces" together. The shapes in Charles Sheeler's *Barn Abstraction* fit together like a puzzle made with a saw that can make only straight cuts. [Figure 4.22] Sheeler has turned a set of farm buildings into a series of flat, overlapping shapes with few diagonal edges that could be interpreted as perspective lines. Instead of existing one behind the other, as do farm buildings in the world of our experiences, the resulting shapes seem to abut each other almost on a single **plane,** or two-dimensional surface. Abutting alone might hold the shapes together, but Sheeler has added an extra device: the shaded "puzzle" piece in the center. Its identity as part of a building is unclear, but it seems to act as an angle iron forcing the rest of the shapes to stay together. It works so well that Sheeler was able to omit lines defining the edges of some of the shapes. Along the bottom and the upper right side they seem to merge with the ground and the sky. Even so, the design does not appear to be falling apart, for the shapes are firmly clamped together by the "angle-iron" piece.

Mutual Tension

In some works, shapes are held together by mutual **tension** rather than by
any overt overlapping or interlocking. In Figure 4.23, the cover design for
an annual report, the body of the *i* and the cropped dot do not touch at all;
they even curve away from each other. Yet enough information is given for
us to see the two together as a stylized lower-case *i* (which, as we know from
our experience with letters, has a dot above). And the two pieces are placed
close enough for a sort of gravitational pull to exist between them, giving the
area of attraction/separation an exciting feeling of tension.

Suggestions of Continuity

Shapes may also be held together by suggestions that they form a continu-
ous whole. Figure 4.7 could be perceived as a series of dissociated shapes.
But a single visual clue—a hint in the upper right corner that the dark fig-
ures are connected in an area farther to the right that has been cropped off
—allows viewers to connect the three dark pieces to "see" a 3. Even though
the middle and lower segments do not touch, they are held together by au-
tomatic association with what is seen above. The 3 is interpreted as a shape
that is interrupted but nonetheless continuous.

 If you now look back at Arshile Gorky's *Composition* (Figure 4.5), you
can see that the artist has used many of these techniques to hold his invented
shapes together. In some areas they abut, sharing edges; in others they in-
terlock. Here and there they seem almost to interlock; trying to see whether

4.24 right
Ellsworth Kelly. *White—Dark Blue.* 1962.
Oil on canvas, 4'10¼" × 2'9" (1.5 × .8 m).
Collection of the late E. J. Power, England.

they would fit together becomes part of the fun of exploring this piece. In addition, the circles in the center and the ovals toward the bottom right seem to be laid one on top of the other. The dark shape on the far right and the "cap" above it seem to be held together by mutual attraction and by faint lines suggesting that they were once parts of a continuous whole. Finally, Gorky ties shapes together by crowding them so that they appear to be competing for the same space. Instead of being adrift on a background these nameless shapes are squeezing toward each other, fitting together in an intriguing variety of ways.

Edges

Looking at a design that emphasizes shapes, viewers typically scan from one shape to the next, comparing them, looking at how they fit together, and taking note of any unusual things that are happening. In addition, they may look at each shape, following its *edges* or boundaries. These edges may affect the speed with which the work is viewed, the direction in which the viewer looks, and the unity of the composition. Sometimes edges can also be seen as lines.

Visual tracing of the outline of a shape may be fast or slow, depending on the character of the edge. Visual scanning of shapes with complicated edges is slower than scanning of those with straight edges. Compare the Motherwell piece (Figure 4.6) with Ellsworth Kelly's *White—Dark Blue.* [Figure 4.24] To scan the Motherwell shapes, the eye must travel over a long and circuitous visual path. The straight sides of the Kelly shapes scan far more rapidly. This information can help artists control the amount of time viewers will spend looking at a work.

Kelly's painting also demonstrates another principle involving edges: If they are somewhat pointed, they direct the viewer's eye in a particular direction, like an arrow or a pointing finger. In this case, the sharply pointed dark triangular shapes point to the center, keeping the powerful thrust of the white E shape from carrying the eye off the page.

A distinction can be made between hard and soft edges. In a **hard-edged** work, such as Kelly's, precise boundaries and perhaps strong value contrasts render shapes clearly distinct from their surroundings. By contrast, in a **soft-edged** work the boundaries between shapes and surrounding areas are blurred, and their values and colors may be similar. This soft blending makes it more difficult to distinguish shapes than in a hard-edged composition, in which the shapes used are immediately apparent to the observer. In Turner's *Snow Storm: Steam-Boat off a Harbour's Mouth*, the shape of the boat is very hard to find because its outlines are blurred by the atmosphere of swirling snow and water. [Figure 4.25] The mast is one of the few clues that a boat shape does exist in this soft-edged painting.

Hard edges of different value—either lighter or darker—than the shapes to which they belong may be seen alternately as shared edges or as lines. When one views Noguchi's sculpture court for the Beinecke Rare Book and

4.25 *above*
Joseph Mallord William Turner. *Snow Storm: Steam-Boat off a Harbour's Mouth.* Exh. 1842. Oil on canvas, 3 × 4' (.9 × 1.2 m). Tate Gallery, London (Clore Collection).

Manuscript Library at Yale from above, lines are everywhere—crossing each other at precise right angles on the mezzanine, circling around each other and even climbing up the sides of pyramids in the marble sculpture court below. [Figure 4.26] This is nevertheless an architectural environment created of precision-cut shapes; the lines seen are actually their shared edges. The possibility of perceiving the dark areas as either lines or the edges of shapes adds an intriguing dimension to appreciation of this extraordinary work.

From Shape to Form

In two-dimensional art, a shape given the illusion of three-dimensional volume or mass can be called a *form*. When artists want to give shapes depicted on a flat surface the illusion of three-dimensional form, they can choose from

4.26 left
Isamu Noguchi. Model of sculpture court for the Beinecke Rare Book and Manuscript Library, Yale University. 1960.

a number of visual clues that people tend to interpret as form. These visual clues include plane structure, overlapping, and shading.

Plane Structure

To represent straight-sided figures as having three dimensions, one commonly used device is the depiction of several sides or *planes* of the figure at once, rather than only its flat face.

We are familiar only with the two-dimensional front of a keyhole, but in the early 1970s, painter Miriam Schapiro had computer programs developed that allowed her to visualize what flat letters, numbers, and shapes would look like as three-dimensional forms. She had them "viewed" from an angle that revealed their **plane structure.** After she selected the variations she most liked, she enlarged them, projected them onto canvas, and painted them as monumental forms. [Figure 4.27]

Some artists have dealt with the underlying plane structure of figures that in real life have rounded contours. Jacques Villon's athlete seems to have muscles of steel because the curves of his body are broken down into many flat planes, giving him the visual weight and volume of a man-made

4.27 right
Miriam Schapiro. *Keyhole.* 1971. Acrylic on canvas 6′ × 8′11″ (1.83 × 2.72 m). Hardware: Hewlett-Packard 2116B computer, Hanston Omnigraphic incremental point plotter. Software by David Nalibof. Courtesy the artist.

4.28 right
Jacques Villon. *L'Athlete de Duchamp.* 1921. Black lead pencil touched with blue and red pencil on thin white paper, 10⅜ × 8⅛″ (26 × 20 cm). Museum of Fine Arts, Boston (George P. Gardner Fund).

structure. [Figure 4.28] The planes are not a precise representation of his muscle structure. Observers nevertheless tend to respond immediately to this image as a three-dimensional human form infused with great strength.

Overlapping

When one surface of a figure is overlapped and therefore partially obscured by another, viewers interpret them as being lined up in space with some degree of depth. In Figure 4.29, the overlapping in the feet and in the closed left hand of the figure on the right in this Egyptian wall painting is a slight

4.29 left
Wall painting, tomb of Queen Nefertari at
Thebes. XIX Dynasty (c. 1342-1200 B.C.).
Goddess Isis accompanying the queen
into the next world.

reference to three-dimensional form, even though the artistic conventions of the day tended to avoid other clues to three-dimensionality.

Shading

Form is also indicated by **shading.** Areas curving or facing away from a light source appear darker than areas facing the light source. Shading—the depiction of relative darkness in areas where light has been partially blocked—can suggest the rounding of a form in space. [Figure 4.30] In Rembrandt's self-portrait the dark area on the right side of the nose contrasts dramatically with the very light area on the left side. [Figure 4.31] This contrast in values gives the nose the appearance of projecting far outward from the face, since it seems to block most of the light coming from the window. The changes in contrast elsewhere on the face are more gradual, so viewers interpret these contours as more gently rounded than the nose. When used to bring out the three-dimensionality in a form, shading is somewhat like the modeling of a sculpture; this technique is therefore sometimes called *modeling.*

4.30 above
Representation of form by shadowed areas that curve away from a single light source.

4.31 right
Rembrandt van Rijn. *Rembrandt Drawing at a Window* (the smaller plate). State IV. 1648. Etching, 6¼ × 5³⁄₃₂″ (16 × 13 cm). Metropolitan Museum of Art, New York (gift of George Coe Graves).

Illogical Uses of Form

Plane structure, overlapping, and shading can be used to create representational illusions of forms from the three-dimensional world. However, since these artistic conventions are taken from familiar ways of perceiving, they can also be used to create illogical illusions that nonetheless have an air of familiarity. Four examples follow.

Stanislaw Wieczorek turns the plane structure of a V in a spatially impossible direction. [Figure 4.32] Its geometrically precise sides suggest a logical form. But when we see a flat face with sides that veer off in two different directions, the mind is boggled (and therefore its attention engaged) by trying to make sense of what it perceives.

Richard Lytle adds shading to what would otherwise be seen as a series of flat ovals. [Figure 4.33] This forces the viewer to perceive them as some kind of rounded forms, for they appear to be curving away from a light source, leaving more distant areas of their surfaces in shadow. However, these strange "seed pods" are not all shaded on the same side, as they would be if there were a single light source. The two complete forms lowest on the page are actually shaded on opposite sides, a logical impossibility. Instead of

4.32 below left
Stanislaw Wieczorek. Poster for Salon Zimowy Rzezby. 1988. From *12th International Poster Biennale Warsaw 1988*, organized by Ministry of Culture and Arts, Central Office for Art Exhibitions, Union of Polish Graphic Designers.

4.33 below right
Richard Lytle. *Pod Series No. 15*. 1973. Charcoal on paper, 30 × 22″ (76 × 56 cm). Collection of the artist.

4.34 *above*

James Rosenquist. *The Light That Won't Fail.* 1961. Oil on canvas, 5'11¾" × 8'¼" (1.8 × 2.4 m). Hirshhorn Museum and Sculpture Garden, Smithsonian Institution (gift of Joseph H. Hirshhorn, 1966).

presenting a predictable arrangement of plant forms on a sunny window ledge, Lytle has created a puzzling composition of undefinable forms with a mysterious light source that changes constantly, casting varying shadows on objects.

Lytle's and Wieczorek's works use surreal, illogical shading and plane structure in their suggestions of form. Other artists have played with the illusion of form by using two-dimensional shapes and three-dimensional forms in the same work. James Rosenquist presents shapes and forms simultaneously and further confuses things by varying the scale of the objects represented. In *The Light That Won't Fail,* he puts together a woman's head with a suggestion of form in its shading, stockinged feet with shading and shadow suggesting form, the utterly flat shadow of a woman's hand with a cigarette, a hazy flat sun or moon, and a comb that appears slightly rounded in space. [Figure 4.34] All are presented against flat rectilinear background shapes. Add to this strange combination of shapes and forms the fact that no two objects are in the same scale. The hand is far too large to belong to

a woman the same size as the face shown, the feet are far too small, and the comb is absurdly large. The effect is that of a series of 1940s billboards peeling off to show a segment of each layer. What holds it all together is the huge comb across the top, for its repeating teeth spread across all the segments lock these pieces together and satisfy the mind's search for order.

The viewer's sense of logic is challenged in a different way by Georgia O'Keeffe's *Goat's Horn with Red*, which at first glance appears to be the skull of a curly-horned animal. [Figure 4.35] After you look at it awhile, the assumption that you are seeing a realistic representation falls apart. The shading, which should make the eye socket recede as though it were a concave form, is so dark and uniform that the socket instead becomes a shape popping forward. The white section of the curved horn should be a shaded area because it is on the underside. But, instead of being darker than the rest of the horn, it is far lighter and so uniform that it too becomes a shape popping forward. Even more illogical is the treatment of the rest of the circular area inside the horn. Rather than appearing as a hole revealing the background, it is shaded to look like a rounded ball protruding outward. Logically, it should be a flat area; instead, it appears to have greater volume than anything else in the picture.

4.35 left
Georgia O'Keeffe. *Goat's Horn with Red.* 1945. Pastel on paperboard, mounted on paperboard; 31¹¹⁄₁₆ × 27⅞″ (80 × 71 cm). Hirshhorn Museum and Sculpture Garden, Smithsonian Institution (gift of Joseph H. Hirshhorn, 1966).

STUDIO PROBLEMS

In this chapter, we have seen sophisticated examples of the fascination you can evoke with shapes and forms. To build toward this artistic maturity, you must start with very simple exercises to see what shapes and forms can do. The results probably will not look like finished works of art, since you will be isolating only one element of design. In a finished work of art, artists usually manipulate more than one element. For instance, the impact of O'Keeffe's skull depends not only on what she does with shapes and forms but also on her use of value and color. Nevertheless, these exercises will help you to increase your visual vocabulary and will provide opportunities to experiment with the principles and illusionary devices presented thus far. Most suggest use of black and white construction paper; the drawing problems can be done with any media described in the Appendix, including computer. The cut-paper exercises will be hard-edged, offering opportunities for dramatic results but requiring careful control to hold the designs together.

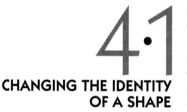

CHANGING THE IDENTITY OF A SHAPE

A. Cut a 3- or 4-inch square of black construction paper. Then cut it up and use the pieces to make a design on a white 8-by-10-inch groundsheet in which observers will not recognize the original square.

B. Cut out another 3- or 4-inch square of black construction paper. Cut it into pieces also, but arrange them on an 8-by-10-inch white groundsheet in such a way that the design still looks like a square or looks as if it could easily return to a square.

Although this problem sounds rather restrictive, it actually gives you a chance to experiment with any of the properties of shapes discussed in the introduction to this chapter. You can work with invented shapes, implied shapes, negative shapes, different ways of holding shapes together, various kinds of edges, and even turning shapes into forms. See how thoroughly you can destroy the identity of the square—and then how you can build the viewer's interest in reassembling a square in the second design. If you enjoy this problem, viewers of your designs probably will, too.

Destroying a square A square can be cut into curvilinear shapes, triangles, invented shapes, lines—none of which will resemble the original square. Even if some 90-degree corners are left intact, as in Figure 4.36, it may be impossible to see the shapes as parts of a square. Instead, they are reassembled here to look like a humorous machine chugging its way off the page.

Pay attention to placement, control of unworked areas, and ways of holding shapes together, for much of your design may consist of unworked white ground. In Figure 4.36 the "machine" is pressed low on the page so that it seems to have considerable weight, and its placement to the right of center adds to the illusion that it is moving to the right. The near-

4.36 below
Destroying a square. Black construction paper. Student work.

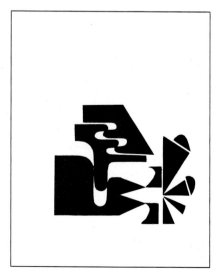

interlocking of the central pieces adds two more dimensions to the illusion of movement: The upper segment seems to be moving up and down in the slot, while the uppermost piece moves right and left to mesh with it. These counter-movements seem to slow the forward progress of the lopsided, propeller-driven machine, enhancing its humorous illogic.

The activity of this design is increased by all the nearly touching edges; the tension that seems to hold them together also sets up a spontaneous interaction effect. If you stare at the white areas where two black shapes almost meet, the edges may begin to overlap and change colors.

Reassembling a square Solutions to the second part of the problem should somehow recreate a square or suggest that one can be made from the pieces shown. Figure 4.37 uses the latter approach, for the viewer can readily push the clipped-out pieces back together mentally to form a square. But there is an intriguing paradox here. The student has created from the straight-edged pieces of a geometric shape—the square—the illusion of an organic shape that may be growing rather than collapsing back into a square. Instead of focusing on putting the black square together again, attention may be drawn to the unworked white shape delineated by the black pieces. Like a budding weed or a stalk of wheat, it looks as though it could continue growing until the entire area is filled with the image. How well do you think the placement of the figure works?

4.37 *above*
Reassembling a square. Black construction paper. Student work.

4.38 *above*
Dividing a groundsheet into shapes: a typical solution. Black construction paper. Student work.

4.39 *left*
Dividing a groundsheet into shapes: an atypical solution. Black construction paper. Student work.

4·2
DIVIDING A GROUNDSHEET INTO SHAPES

Divide an 8-by-10-inch groundsheet into five or six shapes, using black and white construction paper or computer.

It would be easy to *place* shapes on a groundsheet, but this is not what the problem requires. The entire design must appear as shapes, *including* what can be seen of the groundsheet. This means that views of the groundsheet—whether black or white—must be perceived not as background but as shapes that are as positive as those that have been added. The shapes can relate to each other in any way—overlapping, abutting, interlocking—but they all must be seen as shapes. Beyond satisfying the requirements of the problem, the solution should call attention to itself as an interesting design. Compare Figures 4.38 and 4.39. Figure 4.38 solves the problem well. The white shapes left uncovered are as positive as the black shapes applied. They will therefore be perceived as five shapes abutting on the same plane —or as figure and ground continually reversing, for it is not clear whether white has been applied to black or vice versa. When we scan this design,

however, what we find is not unusually interesting.

By contrast, the second solution shown (Figure 4.39) is exciting—but it may not solve the problem. Many people perceive it as three white shapes against a black background. If this were the only interpretation possible, the design would not solve the problem. If you look at it for a while, however, you may begin to see that this design could be interpreted in a number of other ways. For instance, the design could be seen as five or six shapes competing for control of an area to the right of center. Rather than radiating outward, they seem to be squeezing inward, especially the triangular shapes. This creates an area of extreme tension where they are crowding in, an effect that gives the design considerable excitement. Other ways of looking at this solution produce strange spatial effects.

These varying interpretations may do a good job of holding our attention, although it could still be argued that the design does not quite solve the problem. In so complex and creative a design, this becomes a matter of individual judgment.

In both the more exciting and the less exciting solutions, the students used hard-edged geometric shapes, perhaps because geometric shapes are most familiar. You might want to experiment instead with invented shapes having irregular edges, such as the shape of a sweater thrown on a floor, or with torn rather than cut pieces of paper.

Nothing in the problem says that the shapes applied to the groundsheet have to abut one another. All that is required is that the entire design be turned into, made up of, five or six shapes.

4·3
FIGURE-GROUND REVERSALS

A. Using black and white shapes, create a figure-ground reversal.

B. Create a figure-ground reversal using black, white, and gray shapes. The viewer should not be able to distinguish which color you used as ground and which colors you added.

In solving Problem 3.2 you may have created a figure-ground reversal intentionally or accidentally. In a figure-ground reversal it is hard to tell whether black figures have been applied to a white background or white to black; the design can be perceived either way. This exercise gives you a chance to experiment with what it takes to create this effect—and then to extend it to three colors. Solutions can be done with cut papers or any drawing or painting tools. Note the effect of mat color, if you use a mat. Using the information given earlier in this chapter, try to create at least one physical figure-ground reversal and one optical figure-ground reversal.

Black and white reversal If you find it difficult to create a figure-ground reversal, cut a piece of paper half the size of your groundsheet into shapes and then apply the shapes to the groundsheet. This will create a physical figure-ground reversal that should work optically but may not, depending on factors such as mat choice.

Figure 4.40 is a physical reversal of equal amounts of black and white. Here the student has increased the chances that the viewers will be able to see either black or white on top by using an almost symmetric, repeating

4.40 below
Black and white figure-ground reversal. Student work on computer.

4.41 left
Black, white, and gray figure-ground
reversal. Student work on computer.

design. The rhythm of white, black, white, black, white around the sides and the repetition of similar shapes in each corner help to make the viewer flip-flop in reading which is on top. How would use of a black mat affect perception of this solution? A white mat? A gray mat?

Black, white, and gray reversal The solution shown to the second part of the problem uses a computer drawing to develop an illusion of three colors reversing. [Figure 4.41] It is hard to tell which of the three colors was originally background and which were added to produce the images. Although there appears to be slightly more white than gray or black, and a white area surrounds the design, the design works as an optical figure-ground reversal because the three colors are juxtaposed in so many ways that none can clearly be seen as the background for the whole design. The black rule helps to isolate it from the white of the groundsheet.

4•4
BLACK ON WHITE, WHITE ON BLACK

A. Cut five black shapes and arrange them on a white 8-by-10-inch groundsheet.

B. Cut five white shapes and arrange them on a black 8-by-10-inch groundsheet.

This problem gives you a chance to explore the visual differences in working with black on white and white on black. What you learn can be applied to dark and light areas in general. The differences will be especially easy to see if you use exactly the same shapes in each part of the problem, but they may be apparent even if you use different shapes. Since this problem is not rigidly defined, it also gives you a chance to experiment with various properties of shapes.

Black on white When black is applied to a white ground, shapes

4.42 above left
Black on white. Student work.

4.43 above right
White on black. Student work.

tend to be seen together as a unit if they are touching or nearly touching. The shapes used in Figure 4.42 may be perceived as some kind of flying object or creature rather than as five separate shapes. This student used negative as well as positive shapes to good advantage, for the viewer has the choice of seeing the two white half-circles within the image as interesting parts of the figure itself rather than as holes revealing the background.

White on black When white shapes are placed on black, they often create a paradoxical effect: We still tend to interpret these designs as black images on a white background. In Figure 4.43 the image appears to be a large black 4-like shape against a white background rather than a white circle, triangle, rectangle, square, and paral-lelogram against a black background. Perhaps this is partly because the white areas do not explicitly touch each other, forming a coherent figure, in contrast to the large uninterrupted black shape; perhaps it is also because we are so accustomed to working with dark colors on light groundsheets (in

writing as well as artwork) that it is very difficult to shift gears and interpret dark colors as the background and light colors as the figure applied to them.

In general, since we are accustomed to applying rather small amounts of one color to a background (rather than almost covering the background with the applied color, which seems inefficient), we tend to interpret as figure the color that covers the least area. However, white seems to expand visually, whereas black shapes of the same size appear smaller. Even though a large amount of black is left uncovered by the white shapes in Figure 4.43, the white shapes seem to expand, helping to relegate themselves to background status. If you choose to present a large light area as a figure against a dark ground, you must be aware of viewers' tendencies to see such designs the other way around.

4·5
GROWING SQUARES

A. Cut five 1-inch squares out of black construction paper. Arrange them in a design that works well on a white 8-by-10-inch groundsheet.

B. Do the same thing using five 2-inch squares.

C. Do the same thing using five 4-inch squares, trimming off pieces that overlap the edges of the groundsheet.

This problem involves experimenting with what happens as you change the scale of a figure relative to the groundsheet. The process is carried so far that by the third part of the problem the figures cover an area far greater than the groundsheet itself. Even if you crop them where they spill over the edge, the large black squares may overwhelm the white of the groundsheet, often drawing attention to the shapes formed in the small unfilled areas. Understanding how emphasis changes as scale does has many applications, including the placing of type on paper.

1-inch squares The problem here is to keep the small black squares from being overwhelmed by the relative immensity of the groundsheet. Scattering them about randomly does not usually work very well, for viewers will be unable to find any relationship between the shapes. If instead you group the squares to form a single figure, it may then seem too small in relationship to the groundsheet. The student who designed Figure 4.44 arrived at an interesting solution to this

problem: Create an incomplete figure, pulling one piece far out to help control the rest of the groundsheet. In this case, the wayward black square appears to be the missing edges of an unfilled star shape defined by the edges of the other black squares. The star is slightly skewed, so the stray piece would not quite complete it, but the illusion works. In fact, the lack of symmetry in the lower figure and the turning away of the upper piece from the precise position necessary for it to drop directly down and complete the "star" give the design a fanciful, slightly chaotic appearance. Viewers cannot determine whether the pieces are just beginning to coalesce or just starting to burst apart. Movement between the lower figure and the upper square is strongly suggested, tying the two together logically by mutual tension.

2-inch squares This part of the problem is easier, for the proportion of figures to groundsheet automatically works better. This being the case, you will not have to work so hard to control the groundsheet and can instead experiment with the shapes' relationships to one another. If you overlap them, you may suggest illusions of three-dimensional space. In Figure 4.45 relationships between shapes are used to evoke a feeling of uneasiness, of instability. The student has piled up the squares in such a way that they seem just about to topple over. The white slits left where the squares join become highly active with flickering black points at the intersections, increasing the sense that something is happening there. By placing the stack slightly to the left of center, the student added to the off-balance sensation and gave the stack room to fall.

4-inch squares When the squares have the potential to cover more area than the groundsheet, they

4.44 *above*
Design with five 1-inch squares. Student work.

4.45 *below*
Design with five 2-inch squares. Student work.

4.46 above
Design with five 4-inch squares. Student work.

will tend to overwhelm it. This tendency may be used to create drama or to shift emphasis to what is left of the groundsheet.

In the solution shown in Figure 4.46, the student chose to dramatize the relationships of the black squares to one another. The central square is a strong focal point, not only because of its position but also because everything else is marginally attached to it. There is a compelling sense of motion: The central square seems to be spinning around, with its hinged ap-

pendages flapping awkwardly. The tension points built up in the sharp white angles where the hinged square "arms" barely join the central square add to this curious illusion of activity. Although the total figure suggested is symmetrical, what is shown is an interesting asymmetrical close-up, forcing the viewer actively to fill in the missing edges. Since squares and groundsheet are initially the same size—80 square inches—you will have to crop the edges of your squares if any of the ground is to show through.

IMPLIED SHAPE AND FORM

A. Using any materials you like, make a design in which there is an implied shape.

B. To create the illusion of implied forms, draw only the negative, unfilled areas between a group of forms. This could be stones in a stone wall, leaves on a plant, objects in a still life, pillows on top of one another, a pile of boxes, shoes thrown together, or almost any group of objects with three-dimensional volume.

Both parts of this problem ask you to control interpretation of an area without actually putting anything in it. In a sense you may have done this already. In some of the earlier problems, you may have made viewers "see" foreground and background in large unfilled areas; without giving any direct clues, you may have suggested this in-

terpretation by your placement of a figure. Here you focus specifically on making viewers see something that really is not there by inference from what is given.

Implied shape In Figure 4.47, solved on computer, the illusion of circles is so strong that viewers can "see" their edges. The implied circles stand out as though they were flat disks placed on top of the black lines, which seem to continue and to be connected unseen behind the disk. The illusion works so well that the "circles" seem to be a different white than the white of the background. In solving this problem, it is easiest to make viewers "see" a geometric shape that is highly familiar.

Implied form As the first exercise in form, you are to imply the volume that distinguishes shape from form. This can be done by shading, overlapping, or showing more than one side. Here you can experiment with yet another way of suggesting volume: indicating only the unfilled intervals or shadows between voluminous forms.

Solutions to this problem often work surprisingly well. If you are familiar with stone walls, you may "see" in Figure 4.48 large stones bulging out

and receding into cool shadows. Rather than perceiving only the flat outlines of stone shapes, you can feel the weight, the mass of the stone forms. By working only the negative spaces, you can make viewers respond to the implied positive forms that lie between them.

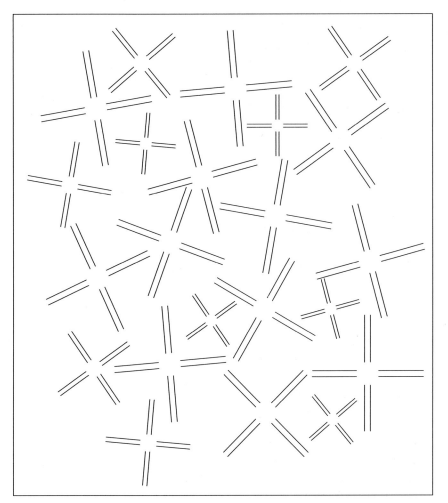

4.47 left
Implied shape. Student work on computer.

4.48 below
Implied form. Student work on computer.

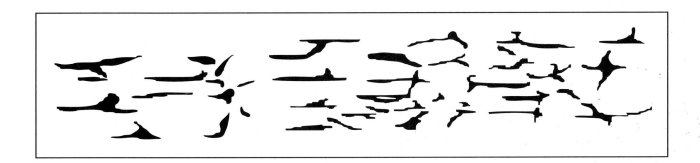

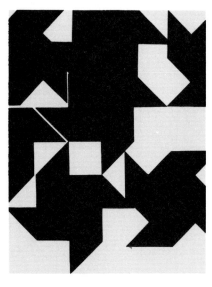

4.49 above
Design featuring a shape. Student work.

FROM SHAPE TO FORM

A. Using an 8-by-10-inch format and any materials you choose, create a design featuring a flat shape or a series of shapes.

B. In a second 8-by-10-inch design, turn the same shape (or shapes) into a three-dimensional form (or forms) of the same size.

To solve this problem, think back to what you have already learned from the earlier problems—ways of creating excitement in a design using flat shapes and—from the introduction and the last problem—ways of turning shape into form. In the examples shown, the student has chosen a pinwheel as the basis for her designs. In the first part of the problem, illustrated as Figure 4.49, the shape is repeated, varied, cropped, and overlapped through the design with a full, recognizable pinwheel isolated only once:

4.50 right
Turning a shape into a form. Student work.

in the lower left corner. The abutting and overlapping pinwheel segments also carve out a series of interesting white shapes in the unfilled areas. The design does a good job of holding the viewer's attention because it is intriguing to wander visually through the design, comparing the many different pieces of pinwheels with the whole one, exploring the constantly varying white shapes around them, and finally rediscovering and focusing on the single pinwheel shape in a highly unusual place for a focal point: the lower left corner.

The second part of this solution is as stark and apparently simple as the first is complex. Here in Figure 4.50, the black background has the same function as the complex repetitions of the first design: turning the viewer toward the only piece of the design that seems to make sense. Though executed with a minimum of parts, this lower left corner is ingeniously worked out. A single piece of light gray has been added to suggest a shaded plane of a pinwheel structure that now seems to have great volume. This prompts observers to "see" three other sides of the pinwheel form in what is really only unworked white space. Imaginative viewers may also perceive two implied lines defining these planes in the white area on the top of the pinwheel. The illusion created is that of standing on an extension of the foreground suggested by the white area at the bottom of the design and looking across a stark, still, unfamiliar, but extremely solid multisided form.

A far easier way to solve this problem would be to take a simple shape such as a circle, place it so that it looks right on the page, and then give it an illusion of form by drawing in some shading. By now, though, you should have a large repertoire of ideas to draw on for ways of handling shapes. In a

class situation, there should be great variety in the solutions created, with at least a few people willing to try something as difficult and complex as the examples shown. This willingness to stretch your imagination—to push an idea as far as it will go—is called for again in the next problem.

4.8 METAMORPHOSIS

A. In a series of steps, change one shape into another, using any materials you choose.

B. In a second series, change one form into another.

This problem draws your attention to specific characteristics of various shapes and forms. It also provides another opportunity to experiment with ways of suggesting three-dimensional form on a two-dimensional surface. You may work with geometric shapes or the flattened outlines of objects with animate forms or inanimate forms, or both. There are no limitations on how you present your steps or how many steps you use. These decisions are part of the problem.

Shape to shape　　One way to begin is with a familiar geometric shape, turning it into another familiar geometric shape in a series of five or six steps. Figure 4.51 shows an ingeniously worked-out metamorphosis from the flattened shape of a jet plane to the flattened shape of a boat. The transformation is extremely rapid because the steps are not divided into individual frames and because the objects themselves suggest forward movement. Surprisingly enough, the movement decelerates as it progresses across the page—from the rapid thrust of the jet to the leisurely pace of the sailboat. This should not make any sense, but it does because the transitional steps are so logical. They all appear to be forward-moving vehicles that would really fly, float, or (in the case of the two central figures) move amphibiously through both water and air.

The basis for the metamorphosis is established in the first figure and then gradually realized. The tail and far wing will become sails, the body and closer wing will become the hull, and the un-worked black areas between will be used both as active mast and as a glimpse beneath the sails of the background. The horizontal black line helps unify the steps since it appears in each step and emphasizes the horizontal left-to-right movement. Can this line, especially in the two images on the left end, suggest overlapping of the far wing by the plane's body, indicating a degree of three-dimensionality? It is very difficult to fully flatten a three-dimensional object into a shape.

4.51　below
Metamorphosis from shape to shape.
Student work.

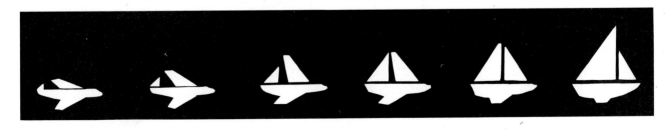

4.52 *above*
Metamorphosis from form to form.
Student work.

Form to form To indicate form, you can use plane structure, overlapping, shading, or depiction of the spaces and shadows between forms. In the solution shown as Figure 4.52, the student used shading to help create the illusion that an apple and a clock are similar forms. Without the intermediate steps, the viewer would see no similarity between the two. But the introduction and then enlarging of a circular highlight on the front of the apple makes the metamorphosis possible. The difference between the second and third frames may be somewhat too great to work well, however. Do you think an extra step is needed here? What about the treatment of the apple stem? Do you find its transition to a clock-top in the last frame too sudden? How could this evolution have been begun earlier?

There are no limits to what you can do with this problem. One student turned a droopy plant into a fan; another turned a pumpkin into a piece of pumpkin pie. You could animate the sequence, using a flip book or movie film to show many minute changes in a long series of steps. Using only a few steps requires you to think ahead: to prepare the basis for the final result in the very early frames. If your results are well-articulated or humorous, so much the better. But the main focus in this problem is *thought*—carefully calculating how to get from here to there.

5
SPACE

KEY TERMS

- atmospheric perspective
- background
- compositional position
- eye-level line
- flat space
- foreground
- horizon line
- illusionary space
- linear perspective
- middle ground
- multiple-point perspective
- one-point perspective
- overlapping
- point of view
- reverse atmospheric perspective
- scale
- two-point perspective
- vanishing point

5
SPACE

Unlike line, shape or form, texture, and color, space is not an element actually laid down in a design. However, in two-dimensional works that convey an illusion of three-dimensionality, the spatial depth viewers are led to associate with the images may be as important as the images themselves. We therefore devote most of this chapter to the effects that can be created through devices viewers automatically interpret as three-dimensionality.

Over the centuries, artists have discovered a number of visual cues that viewers will interpret as depth. Some of these cues are illustrated in Figure 5.1. In Western culture, if parallel lines seem to converge at a distant vanishing point (an illusion called **linear perspective**), most viewers will interpret what they see as a composition with great depth (a). Large foreground images contrasted with smaller background images increase this sensation,

5.1 a-d right
Devices suggesting depth in space.

for things seen at a distance appear smaller (b). Likewise, because of atmospheric haze in long-distance views, edges and color contrasts are seen more clearly in close areas than in distant areas. Sensations of value differences are stronger in nearby objects than in those far away, so high-contrast, hard-edged foreground images fading to low-contrast, soft-edged background images tend to be seen as depth (c). Finally, when objects seem to overlap one another—the ones in front obscuring parts of those in back—viewers tend to see them as lined up in three-dimensional space (d).

In the pages that follow, we will examine use of these devices for creating illusions of three-dimensionality on a two-dimensional surface. We will also look at how some artists have used the picture plane as a truly **flat space.** Actual three-dimensional artwork will be explored in Chapter 9.

Linear Perspective

In representational art, one of the most common indications of spatial depth is the convergence of parallel lines toward a **vanishing point.** This is the point at which, if extended far enough, they would seem to join and then vanish from the viewer's sight. For instance, if you can see for miles along a straight road, the sides that are in reality parallel appear to draw closer and closer to each other and finally disappear at the vanishing point, as indicated in Figure 5.2.

When receding lines are horizontal (parallel to the earth) they seem to vanish at the **horizon line.** In an ideal situation—totally flat terrain—the horizon line is the point at which you see the ground and the sky meet, since the earth curves away from your view. When there are mountains, trees, or buildings in the way, the horizon line is the point where sky and ground would seem to meet if the landscape were flat and featureless.

If an object seems to be receding into the distance in a direction perpendicular or diagonal to the earth's surface, its parallel lines will converge, but not on the horizon. If you are looking up at a church steeple, its vertical lines, if extended, will seem to meet somewhere in the sky above.

The angle at which parallel lines seem to recede toward a vanishing point depends on the observer's **point of view.** Shapes in your visual path will appear quite different when you are lying on your stomach and when you are standing on a ladder, different when you are looking up or down and when you are looking straight ahead.

These visual phenomena—known as *linear* (or vanishing-point) *perspective*—apply to any object in the visual path but are most easily seen in straight-sided figures. Their artistic representation is so complex that extensive books have been written on the intricacies of the subject. In a basic design course, however, all you really need to know is the rudimentary principles of one- and two-point perspective. These are briefly explained here, followed by an exploration of artists' varying uses of linear perspective.

5.2 below
In linear perspective, extended parallel lines converge toward a vanishing point on the horizon line.

The Mechanics of Linear Perspective

In drawing from nature, the ideal horizon line is frequently difficult to pin-point in an obstructed landscape. Artists often find it easier to work from their **eye-level line,** the imaginary line they "see" if they look straight ahead and from left to right. On the drawing sheet, the eye-level line is always parallel to the bottom of the page, running horizontally from the left side to the right side.

Depending on the form of objects and the observer's point of view, the objects' outlines may recede toward one, two, three, or more vanishing points. In **one-point perspective,** the sides of all figures recede toward a single vanishing point on the eye-level line. Lines that begin above the eye-level line will drop diagonally down toward it; lines that begin below the eye-level line will rise diagonally toward it, as shown in Figure 5.3. Vertical lines indicating height and horizontal lines indicating width remain parallel.

In simple **two-point perspective,** the viewer is typically looking at a form from a viewpoint that reveals a corner. The two visible sides (and perhaps the top of the form, if the viewer is looking down on it, or the bottom if looking up) stretch away toward two vanishing points on the *eye-level* line. Now only the vertical lines remain parallel. Other lines that are in reality parallel seem to diminish diagonally toward one of the two vanishing points to either side. This visual law applies not only to the outer edges of the form but also to parallel lines within it, such as window frames, as indicated in Figure 5.4.

When there are more than two sets of parallel lines, objects may be seen in **multiple-point perspective.** [Figure 5.5] For instance, if cubes were

5.3 right

In one-point perspective, one surface of all objects is parallel to the picture plane and all extended parallel lines converge toward a single vanishing point at the eye level of the viewer.

5.4 left above
In two-point perspective, no surfaces are parallel to the picture plane and all extended parallel lines converge toward either of two different, widely separated vanishing points at the eye level of the viewer.

5.5 left below
In multiple-point perspective, extended parallel lines converge toward three or more vanishing points at the eye level of the viewer.

arranged randomly on a tabletop, the table's sides and the cubes' sides might conceivably recede toward many different vanishing points. If no two cubes were lined up quite the same way, each one might have its own set of vanishing points if seen in two-point perspective. All these vanishing points would nevertheless be on the same eye-level line.

Uses of Linear Perspective

Linear perspective may be used to create a striking illusion of depth on a two-dimensional surface. It was first developed and used by Renaissance painters, as some of them delighted in plotting linear perspective lines and using them to create realistic illusions of depth in renderings of architectural scenes. The floor tiles, table edges, window frames, arches, and ceiling beams of Dirk Bouts's *Last Supper* altarpiece are all precisely drawn to a converging point above the head of Jesus, thus emphasizing him as well as creating an impression of three-dimensional interior space. A detail of this painting is shown twice in Figure 5.6, once with these linear perspective lines superimposed.

Even in nonarchitectural scenes, converging parallel lines immediately suggest depth. In Figure 5.7, Peter Bresnen's parking lot mural humorously sweeps the viewer from the shallow space of car parking lines into the deep space of a view along the Nova Scotia coastline as the sides of the road converge to a distant point. If the road is deleted, the space appears much shallower.

In computer graphics, linear perspective is used to heighten the entertainment value of games and films by creating on a two-dimensional screen the illusion that viewers are actually moving through a deep three-dimensional space or that the space is advancing or receding around them at great speed. To create the special visual effects for the movie *Tron*, computers were programmed to analyze the three-dimensional measurements of everything in a scene (in Figure 5.8 this includes the light cycles, the walls of light, graphics

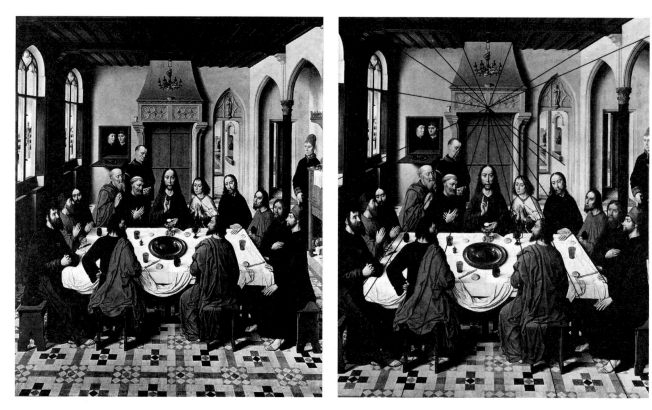

5.6a & b *above*
(a) Dirk Bouts. Polyptich of the Last Supper. Central panel: The Last Supper. 1464-1468. Panel 6' × 5'⅛" (1.83 × 1.53 m). Church of St. Pierre, Louvain, Belgium. (b) Lines showing linear perspective.

on the far wall, and the grid pattern on the floor) and render them in precise linear perspective as the light cycles moved and "camera angles" changed. In Berenice Abbot's photograph of Wall Street, the downward convergence of the parallel lines shows us that we are high above and slightly to the right of Wall Street in New York City. [Figure 5.9] The photograph has been taken from the dizzying perspective of the roof of a tall building, a point so

5.7 *right*
Peter Bresnen. Parking lot mural. 1985. Dartmouth, Nova Scotia.

5.8 left
Frame from a computer-generated video game segment in Steven Lisberger's film *Tron*. 1982.

5.9 below left
Berenice Abbot. *Wall Street, Showing East River, from Roof of Irving Trust & Co. Building*. May 4, 1938. Photograph, from Federal Arts Project "Changing New York." Museum of the City of New York.

5.10 below right
Robert Weine, director. *The Cabinet of Dr. Caligari*. 1920. Producer: Decla-Bioscop (Erich Pommer). Designers: Hermann Warm, Walter Reimann, Walter Rohrig. Film Stills Archive, The Museum of Modern Art, New York.

high that the busy activities at street level seem far distant, dwarfed by the buildings themselves.

In three-dimensional design, linear perspective is often used in exaggerated fashion by set designers to force the reading of a relatively shallow space as a much deeper space. In the classic film *The Cabinet of Doctor Caligari*, the bridge over which the actors are advancing at the top of the set has to be of a certain width simply to allow them to pass through it. [Figure 5.10] Otherwise, the set designer might narrow its sides as it recedes from

the front of the set to make it appear to recede farther into space. The alternative chosen here was to paint dark shadows on the ramp, bringing those shadows quickly toward a vanishing point for an exaggerated impression of depth.

Intentional Misuse of Linear Perspective

Design excitement can also be increased by intentional misuse of linear perspective. In traditional linear perspective there may be many vanishing points but only one point of view, for the observer cannot logically be in more than one place at once. However, intentional use of several different points of view may entice viewers into examining a work for some time to try to determine its visual logic.

In Jack Beal's *Still Life with Self-Portrait,* the parts of the picture make sense in isolation but not together, for information is given from two very different points of view. [Figure 5.11] In the lower part of the canvas we seem to be looking down on a quilt-covered tabletop with a number of objects on it. In the upper part we seem to be looking up at the same tabletop from below, seeing more of the same objects from a different point of view and

5.11 right
Jack Beal. *Still Life with Self-Portrait.* 1974.
Oil on canvas, 29 × 28″ (74 × 71 cm).
Valparaiso University Art Collections
(Sloan Fund Purchase).

5.12 left
Bernard Chaet. *July 10:30.* 1971. Oil on canvas, 4'4" × 3'6" (1.3 × 1.1 m). Alpha Gallery, Boston.

catching a glimpse of the artist himself glaring down at us. This perspective turns the "tabletop" in the lower part of the painting into an almost vertical plane falling away from the top. Instead of resting calmly on this surface, the objects therefore must be clinging to it, for they would otherwise be falling off. Combining the two points of view is illogical—and therefore intriguing, for it takes us into a fantasy world where nothing can be interpreted according to our usual expectations.

Bernard Chaet's *July 10:30* plays with different points of view in a less obvious way. [Figure 5.12] We seem to be standing on the turn in the stairway and looking in several directions at once—a physical impossibility. We can see the upper floor where the hallway reaches a dead-end corner. We can also visually explore the foyer downstairs. Chaet has even lowered the handrail on the lower stairs to allow us to see into the room under the mezzanine. In order to see as much of it as we do, we would probably have to

5.13 right
Georgia O'Keeffe. *A Street in New York.*
1926. Oil on canvas, 4′ × 2′6″ (1.2 ×
.8 m) Collection of Steve Martin. Gagosian
Gallery, New York.

5.14 below
Depth in space suggested by scale.
Varying the size of the same shape makes
the smallest appear to be farthest away.

be farther down the stairs and to the left. To see the front door as being so wide as it is shown, we would have to be standing even farther to the left, beyond the wall. None of the perspectives is quite right—the walls are not even parallel, and we seem to be looking from several different points of view at once. This intentional misuse of linear perspective gives Chaet's painting a dreamlike quality. Although the objects in it seem solid enough when examined one at a time, the ways they relate to one another are like a remembered view from a staircase. They encourage us to take nostalgic pleasure in walking through this odd house.

Intentional use of unusual or illogical perspectives can provide a great range of emotions in the observer. The Chaet work evokes a desire to linger, to enjoy, and to explore, as well as a sense of comfortable familiarity. By contrast, Georgia O'Keeffe's skewing of linear perspective in *A Street in New York* can evoke a nightmarish sense of fear. [Figure 5.13] Instead of receding as we look up at them, her buildings get *larger* as they loom above us, reducing *us* in size. At the same time, the view down the street

diminishes so rapidly toward a vanishing point below the bottom of the picture that what we can see of the sky is like a blade thrusting its way into the city. The dismal street lamp at its base sheds no light. The overall effect is one of coldness, of loneliness, of an environment in which buildings matter more than people. Chaet invites us to wander through his house; O'Keeffe warns us to stand back. This is not a street on which we want to walk.

Scale

A second device that helps viewers "*see*" spatial illusions in design is **scale** of objects represented, that is, their relative visual size. In the world of our experiences we have learned that objects close to us will appear larger than objects of the same actual size that are far away. [Figure 5.14] Artists often use this principle to give the impression that some images are farther away than others. In Pieter Brueghel's *Hunters in the Snow,* the hunters and even their dogs are larger than people around the fire. [Figure 5.15] These figures, in turn, are far larger than the skaters on the frozen

5.15 below
Pieter Brueghel the Elder. *Hunters in the Snow.* 1565. Oil on panel, 3'10" × 5'4" (1.2 × 1.6 m). Kunsthistorisches Museum, Vienna.

ponds below. The trees and buildings show the same gradual scaling-down. Rather than interpreting the image as a depiction of giant and dwarfed forms, viewers automatically perceive the largest ones as closest and smaller ones as farther away. Learned expectations that objects will shrink visually as they become more distant prejudice observers toward interpreting differences in scale as indications of relative distance rather than relative size.

The tennis ball in A. M. Cassandre's poster is so much larger than the player on the other side of the net that it zooms off the page, almost as if it were coming directly at us. We would not see such an exaggerated difference in scale unless the ball were right before our eyes. [Figure 5.16]

People will apply the same expectations to even less representational art. In Figure 5.17 it is not at all clear what the artist is depicting. But wherever the circles become smaller, we tend to interpret them as being farther away from us. The result is an image that undulates in space, plunging very deep near the center, bulging out very close to us on either side, constantly rolling in and out.

Normally we interpret scale distortions as events taking place beyond our own frame of reference. On encountering Catherine Henry's 2 1/2-foot-wide lips, the sophisticated viewer automatically assumes that this close-up view has been greatly enlarged, not that this is the mouth of a giant

5.16 above
A. M. Cassandre. *Lawn Tennis*. 1932. Lithograph, 5'1¾" × 3'10½" (1.57 × 1.18 m). The Museum of Modern Art, New York (given anonymously).

5.17 right
Angela Delaura. *Vortex*. 1973. Ink and acrylic on Belgian linen, 32 × 32" (81 × 81 cm). Collection of the artist.

woman. [Figure 5.18] The enlargement is like that of a photograph, for even in such a shallow space, Henry uses photorealistic perspective, focusing most sharply on the creases in the food-stained, lipstick-smeared lips, and slightly blurring details that are ever so slightly further away, such as the wrinkle lines alongside the nose.

By contrast, Joseph Raffael's 5 1/2-foot-long painting will look like only a blown-up photograph of fish if it is viewed from a considerable distance or reproduced in much smaller scale. [Figure 5.19] As we move in closer—a gallery experience that you can simulate by examining the detail shown in Figure 5.20—something happens to our sense of scale. We begin to be drawn into the world of the painting on a microscopic level. The strokes are laid down in such a way that they no longer resemble three-dimensional fish as we are accustomed to seeing them. Instead, the painting becomes a maze of flat shapes of many colors. It is almost as though we are seeing the workings of each tiny cell, the dynamic interplay of energy and matter. In order to see the painting this way, *we* seem to have changed in scale. We become tiny adventurers ourselves, wandering through this marvelous world of details we are normally too large to see and appreciate.

5.18 above
Catherine Murphy. *Persimmon*. 1991. Oil on canvas, 25¾ × 29″ (65 × 74 cm). Private collection.

5.19 left
Joseph Raffael. *Before Solstice*. Water color on panel, 26 × 44½″ (66 × 113 cm). Nancy Hoffman Gallery, New York.

5.20 above
Detail of 5.19

Overlapping and Position

Another familiar device viewers automatically interpret as an indication of depth—and which can therefore be used to evoke either realistic or strange spatial effects—is **overlapping.** An object partially hidden by another seems to exist behind it in space. In Ansel Adams's *Yosemite Valley from Inspiration Point* viewers will automatically interpret the mountainous forms as existing one behind the other in space. [Figure 5.21] The fact that each form obscures part of another helps observers to make spatial sense of the composition. Even the clouds are pushed back in space by the form looming in front of them.

In addition to overlapping, the **compositional position** of forms relative to the picture plane helps viewers to organize them in space. The area at the bottom of the picture plane is often seen as **foreground**—the portion of an image that is closest to the viewer. The central portion of the picture plane

5.21 below
Ansel Adams. *Yosemite Valley from Inspiration Point, Yosemite Valley, California.* c. 1940. Photograph.

5.22 left
William Bailey. *Eggs.* 1967. Oil on canvas,
29 × 36″ (74 × 91 cm). William Benton
Museum of Art, University of Connecticut,
Storrs (gift of Jeffrey Kossak).

is often interpreted as **middle ground**—an area of varying depth in the middle distance. The upper part of a work will often be seen as **background** (with the exception of landscapes in which the sky seems to project forward from the background over the head of the viewer). In Western culture, people tend to interpret the lower part of a composition as closer than the upper part because representational paintings in our artistic traditions have usually been composed this way.

These learned associations and artistic conventions are so strong that their spatial effects can be evoked with a minimum of clues. Most people automatically perceive a three-dimensional illusion of eggs scattered one behind the other on a table in William Bailey's *Eggs.* [Figure 5.22] The simple dark band at the bottom is seen as foreground, the egg-laden band as middle ground of varying depth, and the dark band at the top as background. Only two visual clues to such an interpretation are given. For one thing, the slight shadows beneath the eggs themselves give them an appearance of three-dimensional volume, so observers can assume that the "tabletop" on which they seem to rest must have some degree of depth. Second, a very subtle indication of overlapping of one egg by another in the center confirms that these eggs are sitting at varying distances from the viewer rather than rising above each other on the flat picture plane. If you cover the "overlapped" egg with your finger, the image you perceive may start to flatten out. The eggs may seem to float up and down in a single vertical plane, like the bouncing balls once used to help movie audiences follow the words of songs.

Atmospheric Perspective

5.23 above
The illusion of spatial depth created by the devices of atmospheric perspective: softer edges, less value contrast, and less detail in the areas intended to appear farther away.

In addition to linear perspective, scale, overlapping, and position on the picture plane, artists can use a group of techniques known collectively as **atmospheric perspective** to indicate spatial depth. When they want certain areas of a two-dimensional work to appear more distant than the others, they may use softer edges, less value contrast, and less detail in these areas in order to push them back in space. In Figure 5.23 these devices make the hills seem much farther from the observer than the foreground plane. The devices are based on the principle that things seen at a distance are less distinct than things seen up close. The farther away something is from us, the more atmospheric haze may obscure our view of it, as in the very hazy mountains of China in the magazine layout shown as Figure 5.24. As a result, more distant objects do not appear to have the fine details, strong value contrasts, and sharp edges of closer objects.

Artists often use this familiar phenomenon to suggest three-dimensional depth, even in nonobjective works or in much shallower representational space, like room interiors or Catherine Henry's *Persimmon* (Figure 5.18), an extreme case. When images are extremely close to the observer, they may be seen in **reverse atmospheric perspective:** The closest areas are blurred out of focus, with the sharpest edges and strongest value contrasts in areas that are slightly farther away.

5.24 right
Magazine layout. Client: Royal Viking Lines. Pentagram Design, San Francisco.

Illusionary Space

The devices we've discussed so far work by reminding viewers of familiar visual clues to spatial interpretation, but some artists create illusions of space that defy normal expectations of spatial logic. They create spatial sensations that simply cannot be—according to what we know of space—yet they are still perceived spatially. In M. C. Escher's *Relativity,* areas of human activity make spatial sense in isolation but not necessarily in relationship to one another. [Figure 5.25] Yet areas drawn with different floor lines are linked by dual-purpose architectural features: floors that become walls, stairways in which treads and risers are interchangeable, and stairways in which figures are seen walking on both the upper and lower sides of steps. This spatial jumble is given a sense of solidity by the use of the base of the picture plane as the floor line for the largest and closest climbing figure. Furthermore, the design is unified by consistent use of linear perspective, with parallel lines receding toward a single vanishing point somewhere beyond the top of the picture plane. Nevertheless, the design seems to exist in some other dimension where space is not organized quite as we know it.

5.25 left

M. C. Escher. *Relativity.* 1953. Lithograph, 10¾ × 11½″ (27 × 29 cm). M. C. Escher Foundation, Haags Gemeentemuseum, The Hague.

5.26 right
Rene Magritte. *Personal Values.* 1952. Oil on canvas, 31⅝ × 39½" (80 × 100 cm). Collection Harry Torczyner, New York.

Effective individually, the spatial devices we've discussed are powerful in combination. They can give the sense of actual space to very strange images. Rene Magritte's *Personal Values* uses linear perspective in the lines of the ceiling, floor, and bed to create the immediate illusion of a three-dimensional room. [Figure 5.26] The room is mirrored at a slight angle on the armoire, skewing the perspective lines toward a different vanishing point. Objects overlap one another, telling us where they stand in spatial relationship. But the scale within this precise framework is utterly surreal, with shaving brush, soap, goblet, and comb monstrously enlarged. The comb is so large in proportion to the bed that we read it as taller than a human being. These grossly enlarged private objects are presented, strangely, in proper proportion to each other, giving the dreamlike painting a second level of spatial logic. It is as though two different worlds occupied the same space, existing simultaneously where even walls become transparent as glass into endless space.

Shallow Space

Impressions of three-dimensionality on a two-dimensional surface are inevitably illusionary, even when they seem logical. Some artists prefer to treat the picture plane as the flat surface that it *is*, refusing to develop three-dimensional illusions thereon. Piet Mondrian's *Composition with Red,*

Yellow and Blue holds our attention at the level of the canvas itself, reading relationships of flat lines, flat shapes, edges of figures and ground across the picture plane. [Figure 5.27] Mondrian called his approach "Neo-Plasticism" and asserted that in viewing its ascetic purity, its balances of opposing elements, not only individuals but also society could resolve their inner tensions and reach harmonious balance. He set up very clear rules for this "art of pure relations." Among them were these:

1. The plastic medium should be the flat plane or the rectangular prism in primary colors (red, blue, and yellow) and in non-color (white, black, and gray). In architecture, empty space counts as non-color. The material can count as color.

2. There must be an equivalence of plastic means. Different in size and color, they should nevertheless have equal value. In general, equilibrium involves a large uncolored surface or an empty space, and a rather small colored surface or space filled with matter.

3. The duality of opposing elements in the plastic medium is also required in the composition.

4. Abiding equilibrium is achieved through opposition and is expressed by the straight line (limit of the plastic means) in its principal opposition, i.e., the right angle.

5. The equilibrium that neutralizes and annihilates the plastic means is achieved through the proportions within which the plastic means are placed, and which create the living rhythm.

6. All symmetry shall be excluded.

Neo-Plasticism's means of expression is pure and definite color, in planes which remain equivalent to the surface of the picture; in other words, color remains flat on a flat surface. It is not weakened by having to follow the modulations of the form. . . .

To be concerned exclusively with relations, while creating them and seeking their equilibrium in art and in life, that is the good work of today, that is to prepare the future.*

To Mondrian, the flat surface is not emotionally flat. In the master's hands, it becomes a dynamic microcosm of life.

5.27 *above*
Piet Mondrian. *Composition Red, Yellow, and Blue.* 1921. Haags Gemeentemuseum, The Hague.

* Piet Mondrian, "General Principles of Neo-Plasticism," as quoted in Michel Seuphor, *Piet Mondrian, Life and Work,* New York: Abrams, pp. 166, 168.

STUDIO PROBLEMS

In the space problems that follow you can explore ways of representing space as we know it—and experiment with illusions of space as we do not. Before you begin the more difficult problems in linear perspective, you might try two quick free problems. The emphasis in the first two problems is not on perfection of drawing but on beginning to see objects in space and to represent spatial interrelationships and spatial relationships between them and the viewer. Most of the problems here are set up as drawing problems, but problem 5.7 could be done with any two-dimensional technique described in the appendix. Linear perspective problems require a ruler.

5.28 below
Changing scale. Student work.

5·1
CHANGING SCALE

Draw a 1-by-2-inch rectangle. Then, by changing the scale of details in and around it, create five designs in which it seems to be at five different distances.

One way to control the apparent distance of an object in space is to change its scale relative to other objects depicted. This problem requires the reverse: Control the apparent distance of an area by changing the scale of its surroundings. Unlike the other problems posed thus far, this is a free problem. If regular problems are steps

toward building a visual vocabulary, free problems are your first attempts at poetry. They should be works of art. Although they should be built on what you have already learned, they should be very personal.

The student who drew the scale changes shown in Figure 5.28 chose to use representational images exclusively and to have them all relate to familiar human activities to ensure that viewers would respond instantly to the dramatic changes in scale. Each scene controls the observer's point of view: suspended high in the air looking down on the rectangular top of a large truck, gazing horizontally across a movie audience or into a doorway, staring at an eraser held very close. Although the actual size of the rectangle remains unchanged, changing its surroundings can make it look as large as a movie screen or as small as a perforation in a computer card. Since the card

is blown up larger than life-size, it reduces the *viewer* in scale. In the computer and doorway frames, the rectangle becomes a negative space —a hole revealing the background; in the movie scene, a three-dimensional illusion seems to jut forward from its surface. This problem allows experimentation with a great variety of spatial effects.

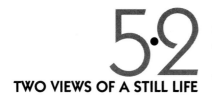

5·2

TWO VIEWS OF A STILL LIFE

A. Arrange a simple still life on a board using actual objects. Place it on the floor. Look straight down on it from above and draw the shapes you see.

B. Raise the board onto a table, look at the objects from a standing or sitting point of view, and draw what you see.

The first part of this problem is not an exercise in design—it simply establishes spatial relationships between objects from a perspective that turns them into flat shapes. A tissue box, a cracker can, and a can of cleanser become a simple grouping of flat geometric shapes when viewed from above to determine how they are actually lined up in a space across the plane of the board on which they are resting. [Figure 5.29]

The second part of the problem is the main focus here: The challenge is to represent clearly the spatial relationships among the forms you have arranged as seen from the side. In Figure 5.30, viewers can easily tell that the cleanser can is in front of the tissue box because it overlaps it. The tissue box seems to be receding in space because it is drawn in a linear perspective; the right end is drawn larger than the left end, so the right end will be perceived as closer to the observer. The spatial relationship between the tissues and the cracker can is a bit ambiguous, however. From the information given, their far corners appear to be almost touching. But according to the bird's-eye view done earlier, there should be more space between the crackers and the tissues than between the tissues and the cleanser. How could this relationship have been

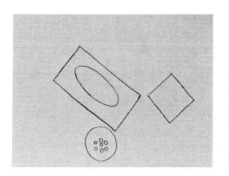

5.29 below left
Still life from above. Student work.
————

5.30 below right
Still life from the side. Student work.
————

5.31 above
One-point perspective. Student work on computer.

5.32 below
Two-point perspective. Student work on computer.

represented visually? One possibility would be to have made the edge of the cracker tin more distinct than the edge of the tissues, bringing the former forward through association with atmospheric perspective. You may need to use a number of spatial devices to make viewers perceive on a two-dimensional surface the spatial relationships you see in three dimensions.

5·3

ONE- AND TWO-POINT PERSPECTIVE

A. Choose a point of view inside a building from which its parallel lines seem to be converging toward a single vanishing point. Draw what you see in one-point perspective.

B. Choose a point of view outside a building from which its parallel lines seem to be converging toward two vanishing points. Draw what you see in two-point perspective.

To do this simple perspective problem, use the information on the mechanics of linear perspective given in this chapter. To avoid confusion, choose simple subjects for this two-part problem. Hallways are usually good examples of one-point perspective; buildings viewed from one corner are usually good examples of two-point perspective. A ruler will be useful for drawing straight lines and for extending those that are converging parallels toward an implied vanishing point on an implied eye-level line.

One-point perspective Viewers are accustomed to interpreting converging diagonals as depth. This familiarity makes the illusion of linear perspective work. In Figure 5.31 the student created a simple one-point perspective drawing using the computer with a simple drawing program,

rather than one with a built-in perspective command. The student used the knowledge required to do this type of drawing, based on looking down the hall in a building on our campus. Does it really work? You be the judge. Check it to see if there are any mistakes. If you want to create an intellectually correct spatial illusion of one-point perspective, you must be sure that all parallel lines would meet at a single vanishing point if extended.

Two-point perspective In the example shown in Figure 5.32, the student has used the computer and a simple computer drawing program to do an example of two-point perspective. The software program did not have a built-in perspective command. The student made the drawing based on the rules of two-point perspective. Flaps were added to a simple box, thus complicating the solution. Are the flaps scaled in logical proportion to each other, given their varying distances from the viewer?

In these simple perspective drawings, *all parallels should vanish at the same point, and all vanishing points should be on the same eye-level line.*

In these space problems you will be dealing with drawings that can easily be related to objects in our three-dimensional world. If you make a mistake, viewers will immediately sense that something is not quite right. Sometimes you can turn this response to your advantage, and later problems will give you a chance to do so. But if you intend to present an accurate linear perspective drawing, you must keep in mind the few rules given in this chapter.

5·4
ABOVE AND BELOW EYE LEVEL

Draw three objects above eye-level line and three objects below it in a two-point perspective.

Although your eye-level line stays constant in a linear-perspective drawing, you can see objects above and below in relationship to it. If an object is entirely above your eye-level line, you can see part of its bottom when you look up. If an object is entirely below your eye-level line, you can see part of its top by looking slightly down. All parallel lines will still meet in vanishing points somewhere on the single eye-level line. In other words, the height of your eyes relative to the ground will not change, but you may look up or down to examine your surroundings.

Whether or not to erase the eye-level line is your choice, but the objects you choose should have some straight edges in order to use linear perspective in an obvious way. In the example shown in Figure 5.33, the student chose to erase the eye-level line, giving objects above the eye level a strange floating quality. The solution is not done in perfect linear perspective. Extensions of the lines receding to the left in the lower objects meet at a point slightly farther to the left on the eye-level line than do those originating in the upper objects. Yet the design is reasonably accurate, and the student added a tremendous amount of visual excitement to what could otherwise be a visually boring exercise by using voluminous letter forms for two of his objects. The visual pun E–Z (whether intentional or not) adds to the charm. The student also chose an interesting asymmetry: He placed the vanishing points at different distances from the center. The right vanishing point is much closer to the center than the left one.

We do indeed perceive this composition as three-dimensional objects in space, but since they are somewhat unfamiliar and placed in strange relationships to each other, to the foreground, to our eye level, and to vanishing points in the distance, it takes a while to determine where we are

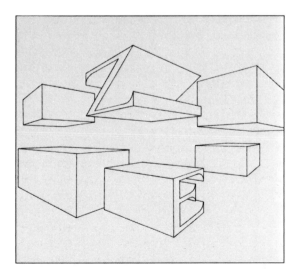

5.33
Images viewed above and below eye level. Student work.

standing and what we are seeing. This design therefore holds our attention well. Would you give it a higher or lower grade than a more technically accurate but boring solution? There is no right answer to this question; classes and professors and those who pay for artwork differ in their opinions.

SHIFTING PERSPECTIVE

Draw three objects in linear perspective using differing vanishing points on eye-level lines for each one.

Although it is important to learn the mechanical skills of simple one- and two-point perspective, it is also acceptable to misuse them after you master them. You can do anything you like with the elements of design so long as you are consistent and know what you are doing. The object is to make a design work well. This does not necessarily mean sticking to the rules—but if you transcend them, you should do so purposefully and knowingly.

In earlier space problems, if you unknowingly made mistakes in linear perspective the mistakes could have detracted from your designs. This problem gives you a chance to see what unusual effects you can create by intentionally going beyond the rules. In this case, you will be drawing each object correctly in itself but not in its usual relationship to the other objects.

Some artists feel that this is a way of realistically representing what they see. Linear perspective is an artifice to the extent that it shows a scene too large to be seen all at once without moving our eyes. Cézanne, for one, rejected this device and drew each seen portion of a landscape or still life individually rather than relating them to one another through consistent use of linear perspective. The choice is yours. Yet before rejecting or purposely skewing linear perspective you should become familiar with its traditional use, as a device to which viewers respond strongly as an indication of spatial depth.

In the solution shown in Figure 5.34, the student created an inexplicable sense of uneasiness by shifting the vanishing points. All objects seem at first to vanish to a single point, but as we look longer we realize that they do not—each has its own vanishing point. Yet all five seem to be sharing the same space at the same time.

The uneasy response to being not quite sure what is going on could conceivably be put to good use in certain kinds of design. Here, though, you are asked only to create an unusual effect rather than to make some conscious use of it in a true work of art. In this series of problems, the focus is more on mastering and understanding perspective illusions than on creating designs that really work well.

5.34 right
Shifting perspective. Student work on computer.

5·6

UNFAMILIAR POINT OF VIEW

Draw something in accurate one- or two-point perspective but choose a point of view that makes the perspective lines seem unfamiliar.

In most representational drawings the eye-level line is parallel to the horizon, as if the artist were standing or sitting and looking straight out. We are so familiar with this point of view that any other seems strange—even hard to interpret. For this exercise you need only look at something from a nonhorizontal point of view—such as lying in a doorway looking up along one side or on top of a building looking down—to create a drawing that will not seem right to viewers, even though it is. In the preceding exercise you purposely shifted perspective to create a drawing that looks wrong. Here you are asked to find a point of view from which accurately drawn perspective lines will seem unfamiliar because they do not fit into our accustomed horizontal frame of reference.

In the solution shown in Figure 5.35, the student placed himself sideways to some structures in or between buildings and looked up. The result is totally unrecognizable; it may make us feel uneasy because we cannot make any sense of what is shown. Although objects seem to overlap each other and diminish toward an eye-level line slightly below the center of the page, these clues are meaningless when taken out of our usual horizontal frame of reference. The resulting confusion tends to turn the drawing into a flat abstraction of lines and shapes that about each other rather than forms existing on different planes in space. This student's refusal to vary the width of his lines or to indicate shading on any of the objects heightens the flatness and unfamiliarity of his design.

Although linear perspective is one of the strongest devices for creating an illusion of three-dimensional space, you need only make a slight shift in the way you use it (in this case, turning your eye-level line away from the usual horizontal point of view) to create studies that puzzle and intrigue viewers. Rather than looking at such a composition, thinking "Oh, of course—it's a _____" and then looking away, viewers might spend a long time trying to figure out what they are seeing. As emphasized in Chapter 1, holding viewers' attention is often a major part of what you are trying to do in controlling design.

5.35
An unfamiliar point of view. Student work.

5·7

SPATIAL ILLUSION

Create a simple spatial illusion, making viewers puzzle over spatial relationships that do not seem possible in the world of their experience.

If your intention is to hold viewers' attention, a spatial illusion will give them plenty to play with visually. One of the most famous spatial illusions is a tuning fork in which the same edges seem to form two lines at one end and three at another. To create this illusion, the artist twisted the same line into appearing to be an inside edge on one end and an outside edge on the other. In developing spatial illusions you can use the various spatial devices

5.36 above
Spatial illusion. Student work.

explored in this chapter to trick viewers into seeing something that defies their notions of spatial logic.

The solution shown in Figure 5.36 uses both atmospheric perspective and linear perspective to confuse its spatial interpretation. The design seems to be based on pyramids, which we know to be four-sided. Impossibly, three of those four sides seem to be shown at once. Further, they are twisted in space by unlikely shifts from sharp contrast to muted contrast. According to our expectations of atmospheric perspective, the high-contrast areas should be closer than the areas where the lines do not stand out so sharply from the background. This would mean that the figure is bulging forward in the center, receding on the diagonal faces to

either side, but at the same time coming forward along both the long diagonal edges. These border both areas that seem to recede and those that seem to come forward—a logical impossibility.

Despite this paradox, the design has a certain solidity and authority, as though it would work if only the observer could grasp the key to its interpretation. Instead of losing interest or turning away uneasily, viewers may therefore keep wondering and exploring, searching for some way to interpret what is shown. Not even the fact that the figure is perched precariously on one edge is overly disturbing, for the two diagonals in the interior of the figure seem to hold it in bold dynamic balance.

5·8
CLOSER AND FARTHER

Do one or two charcoal drawings of two similar objects. Either draw one from a close point of view and the other from a more distant point of view or make a single drawing showing one near and one far.

This problem is a stepping stone toward the chapters on texture and value that follow. At the same time, it will give you a sense of the differences encountered when you look at an object from some distance and when you look at an object closer than you normally would. This is the reason for using two objects: to get you to *look* at them differently. (If you use the same object, you might simply repeat the drawing on a different scale.)

For experimenting with texture and value in this problem, use sheets

of inexpensive charcoal paper. Their coarse texture will be picked up by the charcoal, adding a new dimension to your drawings. For value, start by rubbing the entire sheet lightly with a piece of soft charcoal to produce a middle tone, a medium gray. Then add more charcoal in areas you want to represent as darker; use a charcoal eraser on areas you would like to represent as lighter than the middle tone.

A "far" view In figure 5.37 the student chose to draw a plant, looking at it from a slight distance with an eye-level line about midway on the plant and on the page. Above this line, parts of the bottoms of leaves are revealed; below it the tops and furled edge of leaves can be seen. Overlapping, atmospheric perspective, and scale are the clearest clues to how the leaves of this plant are organized in space. The spatial position of the small stalk that rises from a point just right of center is somewhat ambiguous, however. Its base is overlapped by another stem, pushing it back. Yet the strange shapes

5.37 below
A "far" view. Student work.

in its top are drawn with some of the strongest contrasts between lights and darks in the whole drawing. Does it perhaps jut forward where these strong contrasts appear? Spatial ambiguities like this may be intentional; they give the drawing an intriguing, mysterious in-and-out flow in space reminiscent of Richard Lytle's seedpod drawing (Figure 4.33).

A "near" view For a close-up drawing, the student who drew Figure 5.38 chose to look so closely at a rubber plant that its leaves disappear off the page. In fact, so close-up a view of this plant is given that atmospheric perspective is reversed: The leaves are so close that they are out of focus, while the stem beyond is shown in high-contrast, highly articulated detail. The original drawing is much larger than life, reducing the *viewer* to a much smaller scale.

From this miniaturized perspective, the joints where leaves branch off from the stem become fascinatingly intricate. Their rhythmic yet varied repe-

5.38 left
A "near" view. Student work.

tition is an aspect of plant structure that is usually not noticed from a more normal viewing distance. Shading and value contrast between edges are handled so well that the viewer has a strong sensation of being surrounded in space by extremely voluminous forms. From the bug's-eye view offered, this is indeed an intriguing and unfamiliar space to explore.

6

TEXTURE

6
TEXTURE

In everyday speech, **texture** means sensations we get by touch. If we run a hand over an object, its surface can feel hairy, slick, rough, sandy, bumpy, or coarse-woven. In art, this definition of texture is often broadened to include **visual texture**—sensations taken in visually but interpreted tactilely.

Visual impressions of what something would feel like if touched may or may not correspond to its actual surface texture. The vegetable okra looks hairy, but boiled or stewed, it slips smoothly down the throat when swallowed. A snake looks slimy but its skin is actually dry to the touch. The Old Masters developed to a high art the skill of painting areas to look like the "feel" of materials such as the satin, lace, and brocade in John Singleton

6.1 right
John Singleton Copley. *Portrait of Mrs. Thomas Boylston.* 1766. Oil on canvas, 4'1" × 3'2" (1.3 × 1.0 m). Harvard University Portrait Collection, Harvard University Art Museums (bequest of Ward Nicholas Boylston, 1828).

6.2 left
Norma Minkowitz. Jacket, back view.
1979. Mohair, boucle, velour, knitted and
crocheted; 23 × 18″ (58 × 46 cm).
Collection of Christine Carter Lynch.

Copley's portrait of Mrs. Thomas Boylston. [Figure 6.1] If touched, of course, their canvases feel like flat, slightly rough, painted surfaces. We might interpret a skillful pencil drawing of bark as rough texture, even though we know we would feel only the smoothness of the paper and the shallow indentations of the pencil marks if we ran a hand over the drawing.

All works of art have an actual textural effect that can be felt and a (perhaps different) textural effect that is interpreted visually. Since every work of art has a surface of some sort, texture is an element in every design. In some works, the textural treatment of the surface is the element we notice first because it draws our attention more strongly than do the lines, shapes, forms, values, or colors used. Norma Minkowitz's jacket may impress observers first as an exuberant proliferation of knitted and crocheted textures. [Figure 6.2] In this chapter we will focus on such works, examining some of the ways artists have made us respond to textural sensations.

Actual Texture

One of the most obvious ways to evoke a response to texture is the use of **actual textures**—materials that already have noticeable textures. Sometimes this is done in the form of a **collage,** a composition in which various found materials and/or objects are glued onto a stiff backing. In Anne Ryan's *Collage No. 538,* scraps of cloth with varying textures are used as an abstract combination of flat shapes. [Figure 6.3] Yet the main interest of the work is not the shapes themselves but their surface texture. Many viewers are

tempted to run a hand over this piece, feeling the differences in texture from one scrap of cloth to the next. Failing this, they like to "feel" each piece visually and develop a mental image of how it would feel to the touch.

Something rather different is going on in Miriam Schapiro's *Window on Montana*. [Figure 6.4] The scraps of chintzlike cloth and paper used in this collage have patterns on them—flowers, birds, horses, geometric designs—rather than distinctive surface textures. Yet each pattern creates a textural impression of sorts. The patterns themselves are so unimportant that Schapiro placed some of them upside down and sideways. Instead of perceiving a line of birds left of center, we may see a vertical line of coarse, open-textured material. In general, there is a feeling of spaces between living things in the center and of close-textured, almost smotheringly busy

6.3 right
Anne Ryan. *Collage No. 538.* 1953. Paper, sand, fabric on paperboard; 12½ × 9¹³⁄₁₆″ (32 × 25 cm). Hirshhorn Museum and Sculpture Garden, Smithsonian Institution (gift of Joseph H. Hirshhorn, 1966).

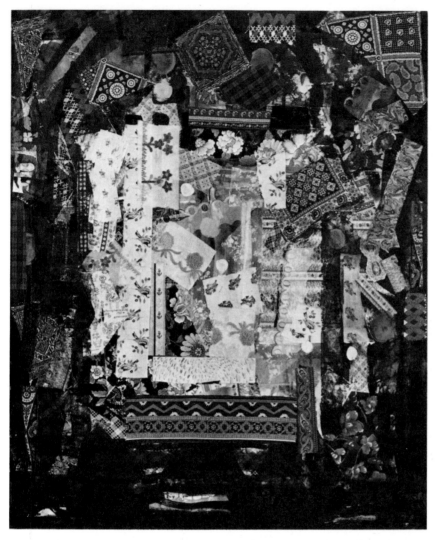

6.4 left
Miriam Schapiro. *Window on Montana.*
1972. Acrylic and fabric, 5′ × 4′2″ (1.5 ×
1.3 m). Courtesy the artist.

accumulations around the edges. As observers, we may feel as though we are standing in a darkened room cluttered with antiques and looking through a window to a more spacious natural world outside.

In collages, found materials are often presented out of context so that viewers will be aware of their particular beauty. This experience is particularly valuable in our throwaway society in which few people take the time to savor experiences of the senses. Kurt Schwitters's collage *Elikan* invites a response to the subtle texture differences in the scraps of paper as they playfully interact with the texture of the printed word. [Figure 6.5]

Actual textures are sometimes used to add a humorous touch to two-dimensional works. In Peter Good's appliquéd fabric collage, actual fabrics have been carefully selected for their resemblance to a car's grille, wrapping paper, road surface, and even puffs of exhaust smoke. [Figure 6.6] The "frame" itself provides extra textural sensations. Repetition of circles and

6.5 right

Kurt Schwitters. *(Elikan)*. c. 1925. Collage of cut-and-pasted paper, candy wrappers, advertisement. 17⅛ × 14¼″ (43.5 × 36.2 cm). The Museum of Modern Art, New York. Katherine S. Dreier Bequest. Photograph © 1995 The Museum of Modern Art, New York.

uniform top-stitching hold these varying textures together. Against this plausible, unified backdrop, the use of designer labels as road signs is delightfully humorous—a visual pun in which status symbols used in unfamiliarly large scale actually become direction markers to states of mind in fashion.

In addition to relatively flat collages, textures are often an important feature in **assemblages**—works assembled from three-dimensional objects originally created for other purposes. Varujan Boghosian's *Feeder* combines found objects with contrasting textures. [Figure 6.7] Observers are invited to explore them visually, lingering over the smoothness of the antique bisque doll head and the roughness of the weathered wood behind. Despite their contrasting surface textures, they are tied together by the patina of age, a subtle textural effect also found in other objects in the assemblage.

Fully three-dimensional works are often created to draw attention to surface texture as well as to form. Ursula von Rydingsvard's *For Paul* is simultaneously a massive boulderlike form and a study in the coarse, organic, craggy textures of the deeply worked cedar blocks of which it is constructed. [Figure 6.8]

6.6 left
Peter Good. *December*. 1982. Mixed media; fabric applique and watercolor; 14 × 16″ (36 × 41 cm). Private collection.

6.7 above
Varujan Boghosian. *The Feeder*. 1971. Construction, 5′ × 2′4″ (1.5 × .7 m). Courtesy the artist.

6.8 left
Ursula von Rydingsvard. *For Paul*. 1990-92. Cedar and graphite, 13′ × 10′6″ × 12′6″ (3.96 × 3.2 × 3.81 m). Storm King Art Center, Mountainville, New York (gift of Sherry and Joel Mallin, the Horace W. Goldsmith Foundation, the Ralph E. Ogden Foundation, Vea G. List, Anne M. Hatch, and Steven and Nancy Oliver).

Simulated Texture

In addition to working with actually textured materials, artists have many ways of applying paint, ink, or pencil to **simulate texture.** The most familiar method is use of darks and lights to suggest textural effects, as in the ridges and furrows in bark or the threads and spaces between them in cloth. In Figure 6.9, Andrew Wyeth applies this technique to the figure of an old woman. On the arm closest to us, painstaking use of dark and light details makes us "see" wrinkles in her skin, the larger ridges of her blood vessels, and the folds of skin on her knuckles and at the base of her fingers. The mottled background patterns and crumpled wrinkles of her undergarment makes it appear more coarse-woven than her polka-dotted bed jacket, which falls in softer folds and seems to have the smoothness of cloth woven with several hundred threads per square inch. The texture of her face seems more weatherbeaten than wrinkled with age, as though she has spent a great deal of time outdoors. Her hair is drawn in such a way that it creates the illusion of yet another texture: fuzziness. Note that areas Wyeth did not want viewers to focus on, such as the bedsheet, are not drawn in simulated texture at all. Their lack of texture heightens by contrast the great attention given to textures of the woman's clothes and body.

In Ralph Goings's painting of an Airstream trailer, the illusion of a satin-smooth surface seems almost more "real" than any actual trailer would be.

6.9 right
Andrew Wyeth. *Beckie King.* January 17, 1946. Pencil on paper, 30 × 36" (72 × 86 cm). Dallas Museum of Art (gift of Everett L. DeGolyer).

[Figure 6.10] Goings created this textural effect by using an **airbrush,** a tool that atomizes paint. Had he brushed it on by hand, the paint strokes would probably have shown, marring the illusion of a slick surface.

Goings's painting is an attempt to depict **local texture**—the actual surface texture of an object from the world of our experience. Artists may choose instead to use **interpretive texture** to depict the essence of something rather than only its superficial appearance. For instance, an artist working with local texture would represent a bird as a creature covered with feathers. But in *Bird in Space,* Constantin Brancusi used highly polished bronze, perhaps to capture the essence of a bird in flight: a fleeting shimmer of light reflected off an extremely graceful and quick being. [Figure 6.11]

6.10 above
Ralph Goings. *Airstream Trailer.* 1970. Airbrush, 7 × 9½″ (18 × 24 cm). Museum moderner Kunst Stiftung Ludwig, Vienna, on loan to Sammlung Ludwig, Aachen.

6.11 right
Constantin Brancusi. *Bird in Space.* 1928. Bronze, 54 × 8½ × 6½″ (137 × 22 × 17 cm). The Museum of Modern Art, New York (given anonymously).

Built-Up Media

In contrast to airbrushing, which eliminates brush marks by spreading paint thinly and evenly, many artists physically build up paint or other somewhat liquid media to produce rough textures. Oils or acrylics can be applied unthinned so that strokes of the brush or palette knife leave a textured impression. Van Gogh brushed paint on so thickly that his brush strokes became integral parts of his finished works. This effect, called **impasto,** can be seen

6.12 right
Lee Krasner. *Night Light (Little Image).* 1949. Oil on linen, 40¼ × 27" (102 × 69 cm). Robert Miller Gallery, New York.

in *Starry Night* (Figure 1.23). Other artists have used modeling paste, car putty, or sand to thicken paint; then they treat it texturally.

Lee Krasner uses oil paints to build up a thick crust on her canvas. Rather than appearing heavy because of the paint's thickness, however, the textural illusion in *Night Light* is a mysteriously airy mesh of many fine lines. [Figure 6.12] Attention is drawn to the light spaces receding beneath the built-up lines, as if they represented constant surging movement by countless unknown things in the sky, a universe whose intricacies are still beyond our understanding.

Repetition of Design Elements

Artists may create a subtle sense of visual texture that is neither three-dimensional nor precisely representational. Similar lines or shapes used repeatedly in a design often create a visual illusion of texture. Our ability to perceive shapes individually breaks down when those shapes are presented repeatedly, especially if they are small.

The black-on-white images in the foreground of the Auschwitz poster read as grave crosses marking the anonymous dead. [Figure 6.13] But, as the crosses seem to become smaller and more numerous, as if filling the land into the distance, one ceases to see them as crosses and instead reads them as abstract texture.

Andrea Wisnewski's cut-paper design, in the tradition of Eastern European folk art, repeats white lines on a black ground as well as black lines on

6.13 left
Meinhard Barmich. *Auschwitz. 12th International Poster Biennale, Warsaw 1988.* Courtesy the artist.

6.14 right
Andrea Wisnewski. *Faith*. 1993. Cut paper,
7½ × 11¼″ (19 × 29 cm). Courtesy the
artist.

a white ground, giving a stylized impression of the texture of leaves, wool, and pebbled ground. [Figure 6.14]

Andy Goldsworthy's photograph *Thin edged stones laid around a hollow* turns a three-dimensional group of rocks into a two-dimensional visual texture through the repetition of light triangular forms around a dark oval shape. This makes a strange and strong visual texture of contrasting rough and smooth surfaces, with an unusual dimensional feel or "look." [Figure 6.15]

Three-dimensional works in which a design element is repeatedly used may likewise transcend the surface textures to create a different visual texture. The dress of the magical figure shown in Figure 6.16 creates an impression not so much of cord as of the hairiness of some unknown creature. This weirdly hairy visual texture is heightened by contrast with the smoothness of the metal rings around the neck.

6.15 right
Andy Goldsworthy. Thin edged stones
laid around a hollow. Clapham Scar,
Yorkshire, January 1980. Courtesy the artist.

6.16 left
Ancestor cult figure, Gabon, Masango people. Mid-19th century. Musee de l'Homme, Paris (given by Charles Roche).

Type as Texture

Type may be used to create a visual texture more important in a design than the legibility of the letters or numbers used. In traditional printing with metal type, each letter or number to be printed consists of a raised image—an actual texture—on a flat background. [Figure 6.17] Inked and printed, it may reproduce a visual textural effect, especially when combined with other printed letters. In Brenda Miller's *Diagonal Alphabets (26) Interior West,*

rubber type for each letter of the alphabet has been stamped directly on the wall, one on top of another. [Figure 6.18] In the darkest areas, all twenty-six letters have been stamped in the same location, creating a dark, heavily textured visual effect. In other areas only a few letters have been over-stamped, creating a lighter, more delicate effect. The nearly white lines where only one letter was stamped are the only places where the letters actually can be read. Seen from a distance (as in Figure 6.19), these drawings are not perceived as letters at all but as strangely textured geometric forms whose surfaces catch the light in varying ways.

In the head of Picasso, used as a promotion poster for The Word/Form Corporation, the letters printed make sense in themselves as the words from an essay on Picasso. [Figure 6.20] Yet reading this essay is secondary to the textural effect created by varying the size of the typeface. The largest of the white letters stand out sharply against the black background as prominent facial features, whereas the smaller typefaces seem to recede as shadowed areas.

A textural effect results from the repetition of letters even when all are printed the same size, in the same value. Any printed page has a certain visual texture. Robert Witz has pushed this effect even further in his word drawing *The Work Ethic*. [Figure 6.21] To convey at the same time a

6.17 *above*
Example of raised type.

6.18 *right*
Brenda Miller. *Diagonal Alphabets (26)*. 1975. Rubber stamps with ink and pencil on wall; one of 8 panels, each 4'4" × 4'4" (1.3 × 1.3 m). Courtesy the artist.

visual texture and a sense of the unrelenting pressure of the work ethic, he has jammed together a succession of "works" interlaced with clichéd admonitions about work. Follow any line and you will eventually uncover statements that are depressingly or comically familiar.

6.19 above
Installation view of *Diagonal Alphabets (26)* at the Whitney Museum of American Art, New York, 1976.

6.20 left
Paul Siemsen. *Picasso* poster for promoting a studio-printer. 1978. Four size/weight combinations of type, 26 × 33" (66 × 58 cm).

6.21 above

Robert Witz. *The Work Ethic*, detail. 1973. India ink and paper, entire work 8¼ × 11" (21 × 28 cm). Collection of the artist.

Prints of Textures

6.22 below

Michael Trevitich. Cover of part 57 of *Book of Life*, encyclopedia issued in magazine form. 1970. Marshall Cavendish, Ltd.

Another way of creating textural illusions is to ink a textured surface and press it onto paper. This process transfers to the paper the visual contrast between the raised surfaces and the sunken areas. If anything, such visual contrast is heightened by making the print, even though the print itself is flat to the touch.

For example, if you look at your fingertips you can just barely make out finely whorled ridges and grooves on the skin surface, but if you press your finger onto a pad of ink and then onto a piece of paper, your fingerprint will show these lines in sharp contrast. The same thing has been done in Figure 6.22. The face of the man on this encyclopedia cover features eyes made of greatly enlarged fingerprints and a mouth made of a lip-print. Within this highly stylized representation of a man, the magnified texture of these skin surfaces is a surprising reminder of our organic selves.

A **woodcut** may be handled in such a way that the grain of the wood is printed as a textural element in the design. Gus Mazzoca's *Self Portrait* also creates a shaggy texture across the skin and a wildly bristled texture in the beard by the strong contrast between black raised and white cut-away areas. [Figure 6.23] In the Mazzoca woodcut we respond not only to the rough texture of each individual fingerprint but also to the overall texture created by their repetition. The same is true in John Fawcett's rubber-stamp drawing, but here it is carried a step further. [Figure 6.24] Most of the figures are prints made by rubber stamps, but many different rubber stamps are used. Part of the satisfaction of viewing this drawing is isolating a single object and then seeing it used over and over again. If you abandon the search for individual objects and look at the drawing as a whole from some distance, the overall effect is one of horizontal bands of different textures.

6.23 left
Gus Mazzoca. *Self Portrait.*
1993. Woodcut, 16½ × 10"
(42 × 25 cm). Courtesy the
artist.

6.24 below
John Fawcett. *Rubber Stamp
Drawing #4.* 1980. Ink, 22 ×
36" (56 × 91 cm). Collection
of the artist.

Rubbings and Transfers

Another technique used to create unique textural effects is **rubbing**—placing a sheet of paper over a textured object and rubbing the surface of the paper with a pencil, crayon, or similar medium. This process transfers the texture to the top of the sheet both as contrasting values (the raised areas picking up more of the lead or crayon) and also as a slight raised effect on the surface of the paper. There will also be a third source of texture: the similar lines laid down in making the rubbing. If rough-textured paper is used, its texture will also be picked up and emphasized by the rubbing.

A slightly different technique, **transfer,** creates a textural impression on the *back* of the sheet. In this case, a sheet of paper is laid face-down on a flat-surface design and the back of the sheet is rubbed firmly with a blunt object. This process forces some of the surplus ink off the original and onto the

6.25 right
Mary Frank. *Amaryllis.* 1976. Monotype on two sheets, each 22¼ × 30″ (56 × 76 cm). Metropolitan Museum of Art, New York (on loan from Midtown Payson Galleries, New York).

6.26 left
Max Ernst. *Blue and Rose Doves.* 1926.
Oil on canvas, 31⅞ × 39⅜" (81 × 100 cm).
Kunstmuseum, Dusseldorf (im Ehrenhof).

other side of the page. A **monotype** may be created in this way. In Mary Frank's *Amaryllis,* a flat surface has been painted with ink, which is then transferred to the paper laid on top of it. The result shows the grainy textural qualities of that surface, plus textural inconsistencies in the amount of ink picked up. [Figure 6.25]

The textural and conceptual potential of rubbings is suggested by the early twentieth-century work of Max Ernst. He became obsessed with the textural patterns he discovered in an old wooden floor that had been walked on and scrubbed for so long that its grain was prominently exposed. By a technique he called **frottage,** he took rubbed impressions of the grain and then in these rubbings discovered and elaborated images that he considered hidden visions. Excitedly, he took the impressions of leaves, rough fibers, palette-knife markings on canvases to see what images were hidden in them. Then he began scraping the paint off prepared canvases as they lay against mesh or caning or coiled twine. In Ernst's *Blue and Rose Doves,* the weave of the canvas is clearly revealed, as are the textural effects of his scrapings. [Figure 6.26]

Robert Rauschenberg invites us to respond to a great variety of visual textures in his *Small Rebus.* [Figure 6.27] These include transfers, rubbings, silkscreens, actual stamps, magazine pictures, photographs, a map, a child's drawing, and bits of material, all presented together like remnants of earlier lives being exposed, as wallpaper peels away in an old house. In our throwaway society, even once-cherished photographs may eventually be discarded; we have so many photographs, so many possessions, that each loses

6.27 *above*
Robert Rauschenberg. *Small Rebus.* 1956. Combine painting, 2'11" × 3'10" (.8 × 1.2 m). Museum of Contemporary Art, Los Angeles (The Panza Collection).

its significance. Rauschenberg has reclaimed some of these things considered no longer useful and has called attention to them by presenting them out of context, in juxtaposition to other unrelated discards. The effect seems artless, yet it is carefully planned to coax us to linger over and savor the visual sensations offered. In other works Rauschenberg has invited viewers to spend some time experiencing a tire track, a quilt, street signs, machine parts—familiar objects whose very familiarity deadens our appreciation of their visual and tactile richness.

Erasures

Visual texture also may develop when the artist takes away from what has been laid down. Ways of removing and changing marks are important "tools" for the artist, but they are not often so regarded. In the creative

6.28 left
Rick Bartow. *The Reluctant One.* 1993.
Pastel and graphite on paper, 26¼ × 40"
(67 × 102 cm). Jamison Thomas Gallery,
Portland, OR.

process, the subtraction of "mistakes" often leads to exciting new means of expression. **Erasure** may be an intentional approach to composition in itself. As creator, the artist can play the role of destroyer also, as Rick Bartow does in his *The Reluctant One.* [Figure 6.28] He has pushed the fresh workability of chalk to an extreme, overlaying colors, smearing them to blend shapes and hues, and erasing some areas to create an ever-changing interplay of soft masses and shaggy, broken surfaces. The result is at once spontaneous and intricately worked out, with textural ambiguities adding to the psychological and mystical subtleties of this part-animal, part-human imagery.

Computer Textures

The excitement of texture has taken hold also in the world of computer graphics. Once used for areas of flat color, computer graphics systems now often include special software for creating an unlimited range of textural effects. In addition to textures built up in drawing programs, textures can be manipulated with imported images as a starting point. An example is shown in Figure 6.29. Using Photoshop's Gallery Effects Sprayed Strokes filter, a biomorphic design taken off a CD-ROM photo disc can be radically transformed in ways such as turning the information into diagonal strokes of any specified width and length (Figure 6.30). Using other filters, an image could be given the texture of carved marble or the appearance of a pastel or graphite pencil drawing. Or a "tile" could be excerpted from an image (Figure 6.31), manipulated in a great variety of ways, and then repeated as a textural pattern (Figure 6.32) that could be used behind another image.

6.29 right
A low resolution version of a Photo Disc CD-ROM image. _____

6.30 above
A new texture is formed after blurring and embossing. _____

6.31 right
This is the original area selected from the CD image. _____

The possibilities are so numerous that the computer artist can now create textures no one has ever conceived before, because no one has ever seen them. In the past, we could refer to the textural illusion of fabric, of sand, of bark, of wood. But to what can we compare the visual texture shown in Figure 6.30? With the multitude of possibilities for manipulation, it takes great discipline to limit one's choices. In computer graphics, it is now easy to do many things, but aesthetics requires selectivity.

6.32 left
The size of tiled images is unlimited.

STUDIO PROBLEMS

In the problems that follow you will be asked to draw attention to interesting textures. Remember that most finished works of art involve many of the elements you are isolating in this course. In finished works you have the option of using textures to enrich the visual experience without asking the viewer to focus on textural sensations alone.

For exercises involving printing of textures, water-soluble inks can be painted directly onto textured surfaces with a brush or rolled on with a hand-inking roller—a *brayer*. If the objects used are small, the simplest way to ink them is simply to press them against an inked stamp pad. For rubbings, a light to medium-weight paper and a soft pencil work well. In collage problems, rubber cement makes a good glue and the back of a drawing pad a suitably heavy cardboard backing, though any relatively heavy paper can be used. For problems using letters, tools can range from drawing media to typewriters and press-on type (pregummed letters and numbers of varying sizes and styles). Press-on type is sold in sheets at art supply stores. If you place a sheet of press-on type face down on a piece of paper and rub the back of the sheet with a pencil, the letters are transferred to the paper below.

6·1 TEXTURE DISCOVERIES

Search for interesting textures. Experiment with three ways of reproducing them: Do a series of prints of actual textures, a series of rubbings of actual textures, and a series of drawn textures.

This is largely a discovery problem. It is less important in this problem to create a good design than to explore your environment for textures that interest you and figure out ways to reproduce them. Do as many as you can.

Printing In the printing sample shown, the student rolled ink onto a number of surfaces and pressed them onto paper as prints. [Figure 6.33] The ball of twine in the lower right probably was rolled slightly to get its print since a ball has no flat surface. The result gives a lot of information about the object used to make the print, as do some of the other prints. The tightly coiled spring, the gear, the

6.33 below
Printed textures. Student work.

highly patterned heel of a shoe, and the instep of a Chinese-made shoe complete with characters are recognizable and yet intriguing. What the other objects are is not immediately apparent, but the patterns made by inking and printing them are interesting textures.

Rubbing Rubbing textures creates a somewhat different effect than printing them. Rubbings show not only the high points in a textured material but also a suggestion of shading between them. Whereas prints have only two tones—figure and background— rubbings usually result in a greater variety of values. These can be manipulated at will to some extent by varying the pressure of the pencil used. A soft pencil will allow a greater range in values than a hard one and will pick up the surface features of a texture more quickly.

Drawn textures The first two parts of this problem are fairly easy; al-

most anything will make a print or a rubbing. You may enjoy finding and reproducing textured materials. Drawn textures are harder. In the example shown in Figure 6.34, some of the drawings work better than others as textures. The drawing in the lower right corner gives the strong impression that you would feel rootlike ridges if you ran your hand over it—even though you have no idea what it is. The strands of twine above it also work well as visual textures, not so much because of the thread lines on the twine as because of the overall effect of lights and darks alternating. As suggested elsewhere, in this grouping of ten drawn textures, dots or lines placed close together make a visual texture; even scribbling produces a visual texture. But not all drawing has a distinctly textural effect. Which of these drawings fails to suggest texture, in your opinion?

6.34 above
Drawn textures. Student work.

DESIGNING WITH A SINGLE TEXTURE

A. Find a single textured surface and create a design using it as a print.

B. Create a design using a single texture as a rubbing.

C. Create a drawn design focusing on the texture of a single object.

For this problem you can find a single elegant texture and try reproducing it in each of the three ways given, or you can choose three different objects. You can use the object once or many times in the same design. The point here is to go beyond

the discovery process begun in the first problem by looking more carefully at a single object and exploring ways to use its texture within a good design. Now many things you have learned before can be brought into play, such as placement of an image on a groundsheet, illusions of space, relationship of shape to shape, and so on.

Print You could choose to create a design using a single object inked and stamped again and again. In the example shown in Figure 6.35, the student has managed to make a single print of a highly unlikely object: a banana.

The mere improbability of a banana-print is amusing. Even in a flat black-and-white design, the print creates the illusion of a very ripe banana. The dark areas that have picked up and transferred the ink suggest brown ripening spots; their soft edges give the impression of squishiness. The

white areas that did not pick up any ink allow the "yellow" of the banana to be imagined. Even the banana's three-dimensionality comes through, for the lengthwise lines indicating the planes of the surface have been printed with the "closest" central planes wider than the "farther" planes receding above and below.

In addition to its banananess, the print is well designed. Its placement slightly off-center and off-balance produces a whimsical effect, like a teeter-totter or a crooked grin. The banana's length is exaggerated by the strong horizontal format of the print. To heighten the impact of this unusual format, the student isolated it above center on a large black mat that is nearly square.

Rubbing In areas with old cemeteries, you might choose interesting gravestones for rubbings. How well they will work will depend partly on how much of the stone is chosen, how carefully it is rubbed, and how the print is matted.

Shown as Figure 6.36 is a less obvious solution. This student has discovered a lovely, seemingly organic texture in the bottom of a plastic basket. Her print has the nearly symmetrical rhythm of a many-petaled flower, but rather than pointing off the page, the "petals" seem to point toward a more sharply defined area in the center. The repetition of so many similar shapes creates an effect of pulsation in the central areas of sharpest contrast. The pulsation heightens the sensation that the image is vibrantly alive.

6.35 above
A single printed texture. Student work.

6.36 below
A single rubbed texture. Student work.

6.37 left
A single drawn texture. Student work.

It is difficult to control the outer edges of a rubbing. You can rub a larger area than you need and then crop the paper to get a piece with clean edges. Instead, this student planned ahead exactly how much of the pattern she wanted and stopped precisely at the edges of this area. This left an unworked white border that sets the rubbing off against the black mat.

Drawn texture In well-done prints and rubbings the illusion of texture is so strong that viewers may want to reach out to feel them. To evoke this response in a drawn texture is much more difficult. In the solution shown in Figure 6.37, the student has done an excellent job of capturing the texture of an old sneaker.

In drawn textures it is not essential to reproduce every thread or lump. The decision lies in choosing just enough of the texture to waken associations in the viewer's mind. Here the student has shown a minimum of the canvas body and framed edges of the sneaker to make us "see" the entire battered shoe. On the lace, we are invited to focus on the tiny threads starting to escape as the result of wear and age.

You may find it difficult to apply to drawings the things you learned earlier with cut-paper lines and shapes. To develop a good relationship between figure and ground seems harder in a

drawing, yet the principles are the same. In the sneaker drawing, the student handled this well, controlling a large area of unworked space with a relatively small image. What can be seen of the shoe-top, eyelets, and lace suggests a much larger three-dimensional whole that fills the page and even extends beyond it. The frayed lace is treated as a line that twists and turns in space. Its ragged edges slow scanning of the study, prolonging the time viewers will spend exploring the design. This visual slowing also adds to the aged quality of the image, for we tend to associate age with slowing down.

6·3

MIXING TEXTURAL TECHNIQUES

Create a design using two or three of the textural techniques you have experimented with so far: rubbings, prints, and drawings.

Like the preceding problem, this one is so unstructured that it is almost a free problem: a chance to use what you have learned in creating a highly personal work of art. In a classroom situation, responses should be extremely varied. Nevertheless, the general task each person faces is the same: to use different textural techniques together in a design that works well.

The first solution shown is an elegant combination of prints and drawing. [Figure 6.38] The printed areas below are quite different from the drawn areas above, yet they are held together by gradual scale changes and similarity of shapes. With this logic as an anchor the student has presented a curious combination of spatial effects. Something awesomely large—perhaps a giant tree or a mesa—seems to

6.38 right
Mixed textural techniques. Student work.

6.39 left
Mixed textural techniques: an atypical solution. Student work.

be growing up out of the ground filled with vaguely familiar lumpy forms—faces? stones? bulbous potatolike roots? To heighten the sense of upward growth, the student left contrasting arcs of unworked white to either side. She also chose to place the design below the center of the black mat, a placement that gives the illusion of great space to expand upward into. If you cover some of the top of the mat, the growing "trunk" may begin to look somewhat squashed.

The student who created the second solution, shown in Figure 6.39, responded to childhood associations with rubbings by dropping all inhibitions about what a problem solution should look like. The result can be seen as spontaneous, charming, and witty. It does work as a design; it holds to-

gether and it keeps the viewer's attention. And in a sense, it does solve the problem. The student has drawn fake writing as one textural technique. The writing works as texture and also pulls us in to read what is written. What we find is wordlike chunks of script and sometimes real words, so we may keep trying to decipher the "sentences" even though they ultimately make no sense. This scribbly script also serves to tie together what is underneath: a series of "rubbings" whose texture is not in what was being rubbed but in the freely stroked crayon rubbing lines themselves.

This solution differs considerably from almost all the student work shown so far. In the others, it is very clear that the students have been asked to do a particular thing and that

this is the requirement with which they are working. By contrast, what is important in this solution is what the student did with the requirement given. Rather than being limited by the specifications, he used them to create a whimsical work of art in which the solution to the problem is secondary, barely recognizable. Neither the problem-solving nor the problem-transcending approach is necessarily better than the other—but it is important to recognize that both are possible. The eccentric who expands everyone else's awareness by pushing the limits is invaluable.

6·4
PAPER BAG DRAWING

Crumple a paper bag. Draw it, paying attention both to its texture and to how it works on the page as a design.

This is basically a drawing problem, but a good drawing should be composed as carefully as any other design. It also gives you a chance to experiment with representing hard and soft edges and subtle visual variations in an object whose underlying texture is everywhere the same. You will not need to give very many visual clues to get viewers to respond to overall texture. Once you give an indication of a texture, it is very easy for observers to see it everywhere.

There is no one way to represent the texture of a crumpled bag. In the first solution, shown in Figure 6.40, the student has drawn shading lines following the direction of each facet of the bag. This is logical, for on close examination the paper used to make grocery bags does have a noticeable vertical grain. When crumpled, the grain slants away from the vertical in many different directions, as in this drawing. The soft pencil shading also picks up the grain of the groundsheet, an effect that readily translates into the texture of the paper bag.

6.40 left
Paper bag drawing. Student work.

6.41 right
Paper bag drawing. Student work.

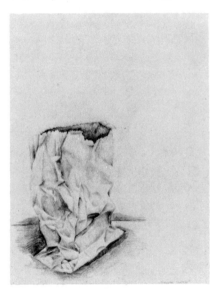

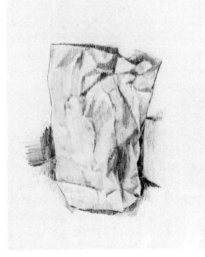

The second solution uses only vertical lines drawn close together to suggest the texture of the bag. [Figure 6.41] Although this is no longer a true representation of the actual direction of the grain, it works. The impression given is of a rather stiff object made from a coarse wood. Although the edges along which the bag was crumpled were also composed of a succession of vertical lines, the slightly rounded edges and shaded areas suc-cessfully illustrate the beginnings of a breakdown in the bag's crispness.

How well do you think values are used to illustrate three-dimensionality and spatial relationships in these two studies? How well do you think the placement of these bags works in relation to the groundsheet? Could you use fewer clues—a visual shorthand—and still coax viewers to interpret your drawing as a crumpled bag of a certain texture?

6.42 above
Letters as texture. Student work on computer.

6.43 below
Letters as texture. Student work.

6•5
LETTERS AS TEXTURE

Use letters of the alphabet—in the form of press-on type, type cut from magazine ads, or handwriting—in such a way that they lose their identity as letters and present, instead, a textural sensation.

Letters are lines. Enlarged, they may become shapes. As illustrated in this chapter, many artists have also used letters to create textural effects. This problem gives you a chance to experiment along the same lines—to discover for yourself that letter forms can seem to rise off the page, creating visually the illusion of ridges you could feel with your hand.

The letters could lose their identity by becoming part of something else, by being greatly enlarged (as shown in Figure 6.42), or greatly reduced, by being cut into unrecognizable bits (as in Figure 6.43), by being written illegibly, or by being repeated so many times that the viewer's first impression is one of texture. The examples shown here were done in black and white, with the high contrast between the two values helping to separate them spatially, as though the black lines were raised higher than the white background. This effect also works by association, because we are accustomed to seeing type as high areas that take ink and low areas that do not. Even in compositions with less

value contrast—such as black letters against a brown groundsheet—letters can still be used texturally. Their interest for the viewer lies partly in the illusion of a texture that could be felt and partly in the seeming possibility that they might be recognized or read if studied long enough.

6•6

PRINTED MATTER AS SHAPES

Select swatches of printed matter from magazines or newspapers. Create a nonrepresentational design using cutout pieces of this printed matter as shapes rather than as words to be read.

This problem may not seem to have much to do with texture, but it will help you break away from looking at printed matter only as something to be read, expanding your awareness of

its textural qualities. It also forces you to deal with the *visual weight* of various typefaces.

People typically perceive dark areas as being somehow heavier than lighter areas. In the solution shown in Figure 6.44, the heaviest shapes are not the largest ones but those with the greatest dark area. The small piece on the lower right—thin white type on a black background—seems almost to be made of cast iron. Also very heavy in visual interpretation is the block of type on the left. Even though it is actually black on white, there is so much black and so little white that it appears very dark and therefore very heavy. If these two dark blocks were placed on the top with the lighter blocks beneath, the design would seem implausible because observers would feel

6.44 right
Printed matter as shapes. Student work.

that the light areas could not hold up the "heavier" dark ones. Imbalance can be used intentionally to create tension, but if created by mistake imbalanced weighting can prevent a composition from working well.

In solving this problem you must also be sure that if observers read the words in the printed matter, they do so secondarily, responding first to the visual texture created. In Figure 6.45 we do not respond initially to the printed matter as such, for none of the pieces is shown right-side-up. The large letters are cropped in such a way that they cannot be read even if the page is turned. Contrast between different sizes and kinds of type and between the differing colors used for print and background makes each piece stand out as a separate shape. Yet the pieces abut and interlock to form a whole that seems satisfyingly well-balanced in terms of visual weight.

LETTER FORMS IN A REPRESENTATIONAL DESIGN

Use letters in any form—type, printed matter, writing, computer print, or whatever—to create a representational picture of a still life, a landscape, or a person.

Much of our mental world depends on association with the world of our outer experience. Many people find it easier to create designs that can readily be related to this world than to create abstractions of shapes, which cannot. Nevertheless, this problem can be extremely challenging, depending on the task you set for yourself. A landscape made from cutouts of printed matter is a fairly easy solution, though you must be sure that the types used represent the intended textures well. Figure 6.45 is a somewhat more imaginative solution: Two apples are made of the written words *apple* and *stem*. By changing the size, spacing, and value of the letters, this student not only created the shapes of the apples but also gave them the illusion of volume. The apple to the left, though smaller, clearly sits in front of the one to the right because the left apple is done in sharper contrast and because it overlaps the apple on the right in one spot. The symmetry of the apples' placement is relieved by the differences in their forms. How do you respond to the textural effect? Does this wiry writing remind you of an apple's crispness? Or does it look too much like steel wool to work as apple? The problem said nothing about using the local texture—the real texture of the actual object. How far we can

6.45 below
Letter forms in a representational design. Computer print, student work.

6.46 right
Letter forms in a representational design. Student work.

deviate from local texture and still produce a design that works is a matter of individual opinion.

The second solution reflects an even more challenging technique: creating both texture and voluminous shading with a manual typewriter. [Figure 6.46] Computers can now be programmed to "draw" everything from Snoopy to Mona Lisa with type, but to do this so accurately without a computer is quite difficult.

The student placed the lines of letters spelling out his subject's name so close together that they will be perceived not as words but as a slightly fuzzy overall texture. That this texture would extend uniformly from the hair to the shirt seems logical. But notice that the student managed to make a value change partway down so that the hair will be perceived as darker than the shirt. To indicate value differences on the face, he struck the keys more softly for lighter areas and even partially erased some letters to get a greater range of value contrasts.

This is the last of the regular problems dealing with letters as texture. They are designed to counteract the learned habit of seeing type only as a vehicle for the written word. If you are interested in going into advertising, these problems may help familiarize you with many different ways of representing letters, for in advertising you will have to work with typography and letter forms constantly.

6·8
PHOTOGRAPH SHIFT

Choose an interesting black-and-white photograph—either an original or one from a magazine. Cut it into strips and glue them down in such a way that the edges are no longer continuous. The overall effect should now be a nonobjective design of varying textures.

Like other problems in this chapter, this is partially a discovery problem. It begins with a search for interesting materials. To see possibilities for a good design in a photograph or a block of printed matter takes an expanded awareness. This sensitivity to the possibilities of using found materials in a different way is valuable, for even in advertisements artists often start with things that are not their own creations.

The student who created the solution shown in Figure 6.47 found a photograph that worked very well for this problem: an extremely high-contrast picture of a flower. Even the original was almost an abstraction of lines, shapes, and textures. Cut into irregular strips that are shifted up and down, the picture almost totally loses its identity as a flower. Instead of being parts of recognizable petals, the veined

6.47 left
Nonobjective design from a cut photograph. Student work.

sections become shapes with intriguing surface textures because of the repetition of lines. These textures are emphasized by contrast with the slick all-black and all-white shapes that result from staggering of shaded areas and background.

In solving this problem, you must use the entire picture you choose. You can cut the strips in any direction, size, or shape, so long as the shapes are relatively consistent. If you wish, you may trim the edges afterward to restore a rectangular format and further camouflage the original picture. The student whose work is shown here chose instead to leave the irregular cut edges jutting into the black mat. This decision pulled the mat itself in as an exciting part of the composition.

6·9
REAL TEXTURES

Create a design using materials with actual textures. The viewer should want to touch it.

This problem takes you into a new area—searching for found materials that evoke interesting tactile sensations. There are certain objects in our environment that we automatically want to reach out and feel. We like to explore with our fingers the cool smoothness of satin, the soft short nap of suede, the denseness of fur, the graininess of sandpaper, the coarseness of burlap, the moist fleshlike texture of newly peeled green wood.

Only some of these intriguing textures can be worked into a two-dimensional design. The difficulty of this problem lies in presenting tactile materials so that they form a good

6.48 right
Real textures. Student work.

design that will hold together. Many solutions to this problem almost immediately fall apart. For instance, if you try to work with pasta, it will be very difficult to keep the material from cracking or coming unglued. Your solution should make viewers want to touch, and it should be sturdy enough to withstand years of touching.

Whether the solution shown in Figure 6.48 meets both these requirements is an open question. The student arranged feathers on a light box and took a *photogram* of them. This process is different from photography in that a light source is used to record images directly on a special paper without a camera. It produces some beautiful transparencies and lighting effects that would not happen in a conventional photograph or a design in which feathers were simply glued onto a backing. And the resulting picture captures textures ranging from the stiffness of the quill feathers to the lighter-than-air delicacies of the wispy down.

It has been argued that this work does not solve the problem because if observers ran their hands over it, all they would feel would be the consistent texture of the paper. The student who created it, however, has argued that he used actual textures originally and that only the final presentation departs from the expected. It does invite touching and visual lingering, it stands up well over time, and it captures the textures of feathers in exciting and beautiful detail.

6·10
DRAWN-TEXTURE ENCORE

Do another design using drawn texture. It should evoke a strong tactile sensation, but the emphasis should now be on the design as a whole, not just on the texture.

This problem echoes earlier problems with drawn textures, but now you have more experience with texture to draw on, more discoveries behind you. With this expanded awareness of textures, can you now use them confidently in creating a work of art? Use of texture—even drawn textures—can work extremely well without being strictly representational. Your own sensitivity and design sense can lead you beyond inch-by-inch copying to capture the essence of a textural experience.

In the first solution, shown in Figure 6.49, the student presents an unusual highly designed shape overlaid with the texture of bark. This segment of a tree would never be seen in nature. But it seems somewhat familiar, for the rounding of the top and bottom and the shift toward darker values on the left automatically remind us of the three-dimensional rounding of a tree trunk. Within this strange—but logical—framework, the texture of the bark is beautifully drawn. We strongly sense that we would feel deep fissures and surface variations if we touched it.

The second solution shown was done on computer. [Figure 6.50] Here there is no carefully drawn bark, but yet it has a surface texture similar to the rugged, rough visual appearance of thick bark. This solution shows what can be done with a computer, and with a little more work it would be impossible to distinguish the drawing from the surface of a real tree. What characteristics might be changed to make it more realistic?

6.49 left
Drawn texture as art. Student work.

6.50 above
Drawn texture as art. Student work on computer.

Perhaps you can find nontactile "textures" in the world of your experiences. There is a texture to music, yet you cannot feel it with your fingers. We talk about the texture of a person's voice—smooth, rough, silky—yet we cannot touch it. We think of food as having texture, but we usually feel it with our lips, tongue, eyes, and teeth rather than our hands. And, as emphasized in this chapter, we may perceive tactile sensations in visual textures, yet if we ran our hand over them we would feel only the smoothness of the paper. Sensitivity to the richness of these "textural" sensations—as well as more obvious uses of texture—can add an exciting dimension to the art of design.

7
VALUE

KEY TERMS

- chiaroscuro
- continuous tone
- digitize
- gradation
- gray scale
- local value
- mid-tone
- modeling
- optical mixture
- pixel
- toning
- value
- Weber-Fechner Theory

7
VALUE

"I have always loved light. . . . Its manifestations serve as symbols of the greatest secrets of the unknown." These are the words of Wynn Bullock, whose photograph *The Window* is a continual play of light against darker tones and blacks.* [Figure 7.1]

7.1 right
Wynn Bullock. *The Window*. 1957,
Photograph. Courtesy of the Wynn and
Edna Bullock Trust.

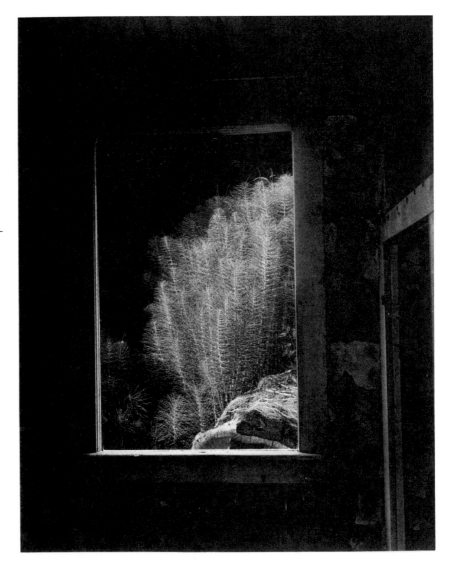

* Wynn Bullock, quoted in David Fuess's introduction to *Wynn Bullock,* Mullerton, NY: Aperture, 1976.

In design, **value** means the degree of lightness or darkness reflected from a surface. Since we see our world in colors, it is initially difficult to extract this quality from all the other qualities of color. But value is of such compositional and conceptual importance that the artist learns to look at things as does a photographer who works in black and white, manipulating areas of darks, lights, and midtones. Much work is also executed in black, white, and gray tones—for they can be quite powerful in themselves without the addition of chromatic hues.

Theoretically, there could be an almost infinite number of value gradations between true black and true white. The gray scale in Figure 7.2 ranges from black to white in ten equal steps, but many more intermediate stages could be added between the ones shown. If you examine Wynn Bullock's photograph closely, you may distinguish a variety of values. He has manipulated values to show us a full tonal range, from the true black of the areas in deepest shadow to true white where the sunlight strikes most directly. The extreme contrast between these two is mitigated by **mid-tones,** from the palest to the darkest of grays. Study the natural scene framed by the window and the dimly seen interior: How many different grays have nature and the photographer's skill interwoven here?

These slight gradations from darker to lighter grays can be compared to volume in music—loudness and softness. By this analogy, lines and shapes are the notes and chords played, and color becomes the timbre of the instruments. Value is thus a critical element in a fully orchestrated design. A symphony in which all notes were played at the same volume would soon lose the audience's interest.

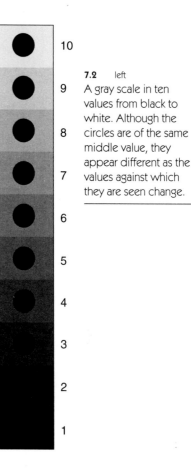

7.2 left

A gray scale in ten values from black to white. Although the circles are of the same middle value, they appear different as the values against which they are seen change.

Representing Value Gradations

Artists have devised many ways of showing a range of values in a single design. These include both physical use of various media and optical mixtures relying on interaction of design elements.

Graded Use of Media

In pencil drawings, a softer pencil can produce a darker value; pressing down harder makes darker areas than using the pencil lightly. In paintings, white and black paint can be mixed in varying amounts to get different values of gray. The mixing of a **gray scale** can be done by eye or by scientific rules. According to the **Weber-Fechner Theory** to get equal arithmetic steps (1, 2, 3, 4, 5 . . .) paints must be mixed geometrically (that is, to a certain amount of black one unit of white should be added for the second step, two units of white for the third step, four units of white for the next step, eight for the next, and so on). Paints or inks can also be thinned to create lighter and lighter values as well as an increasingly transparent effect. In photography, lens opening, shutter speed, time of day, lighting, and type of film can be chosen to increase or soften value contrasts.

Artists sometimes choose to work on a surface that has been given an all over mid-value rather than to face the stark whiteness of a prepared canvas or piece of paper. This is called **toning,** for the words *tone* and *value* are often used synonymously. For a charcoal drawing, the paper can be toned by rubbing the whole sheet with soft charcoal and then with a soft rag. This removes excess chalk and lightens the value. The drawing can then be created by working both up and down from this mid-tone: erasing areas for lighter values and adding more charcoal for darker values. For oil paintings, canvases are sometimes given an all over tone with earth colors. Areas can then be wiped away with turpentine or painted with light pigments to give light values and worked with darker pigments for darker values.

Optical Mixtures

In addition to these techniques for physically lightening or darkening areas of a design, there are ways of creating values through **optical mixtures.** That is, varying amounts of whites and blacks can be juxtaposed to create the illusion of shades of gray. In Georges Seurat's *Sleeping Man,* the apparent value changes running diagonally through the drawing are largely visual mixtures of black and white. [Figure 7.3] The whole sheet has been rubbed to a very light tone, but the somewhat darker areas over the man's shoulders have not been rubbed. Instead, the black chalk has been used in such a way as to be deposited in smaller and smaller amounts. The grainy surface of the paper has picked it up as dots. Although what we are actually seeing is black dots against near-white, we tend to mix the two visually to see a range of grays.

7.3 right
Georges Seurat. *Sleeping Man.* Black chalk, 9 × 12″ (24 × 31 cm). Louvre, Paris.

7.4 left

Albrecht Dürer. *Self-Portrait at Age Twenty Two.* 1493. Pen and ink on paper, 11 × 8″ (28 × 20 cm). Metropolitan Museum of Art, New York (Robert Lehman Collection, 1975).

The tendency of the eye to read mixtures of dark and light marks as mid-values has long been noticed and used by artists to transcend the value limitation of working in black and white. We tend to see gray tones when looking at many small dots of varying size (stippling) or closely placed parallel lines (hatching) or crossing parallel lines (crosshatching), so these devices are often used in drawings and printmaking. A self-portrait and sketch of a crumpled pillow by the German artist Albrecht Dürer reveals these techniques clearly, showing how he used hatching and crosshatching to build up a great range of tones and thus depict the modeling of forms in space as they curve toward and away from a light source. [Figure 7.4] His mastery of such techniques was so skillful that in his engraving of *St. Eustace,* we do not see the lines and dots he has used to create tones; instead we see such delicate

7.5 left
Albrecht Durer. *St. Eustace.* 1501.
Engraving, 14 × 10″ (35.5 × 25.9 cm).
British Museum, London.

7.6 above
Detail of 7.5.

blends of black and white that the engraving gives the impression of a **continuous tone** photograph. [Figure 7.5]

Optical mixing of dark and light marks is in fact used in transferring continuous tone photographs to a form that can be printed by a printing press using a single ink color, such as black ink printed on white paper. The photographs are scanned for value and then transformed into screen patterns of tiny dots that the eye will mix as a range of values. The dots may be somewhat apparent in low-quality newspaper printing, but in high-resolution printing with very fine screen patterns, they become almost invisible. Figure 7.6 magnifies the screen pattern used to print Wynn Bullock's photograph (Figure 7.1) in this book.

The use of dots to create values is given exaggerated visibility in Thomas Porett's computer print. [Figure 7.7] Using his own software and an early Apple computer, the artist accentuated the computer's low resolution. The computer monitor is divided into a certain number of **pixels** (short for picture elements), the mosaic-like blocks whose position is numerically specified

by the computer programmer. The more pixels on the monitor, the higher the resolution of the image. Each pixel can be given different information regarding its color. In a one-bit (binary digit) coloring system, the computer can turn only one switch on or off for each pixel. If the switch is off, the pixel is black, unlit. If it is on, the pixel is illuminated, white. In an eight-bit color system, there are 256 possible values from black to white.

Using an electronic scanner, the artist can read the values of each area of an existing image, then direct the computer to convert them into pixels of corresponding value. Once they are thus **digitized,** these can be manipulated electronically. In the image shown, Porett accentuated the dark and light areas selectively using a "paint" system of computer graphics. He then laid several versions of the image on top of one another, but slightly offset, so that the pixels become horizontally elongated. The ink-jet print shown

7.7 below
Thomas Porett. *Ikons: An Interactive Image Journey.* 1983. Ink-jet print on paper, 12½ × 12½" (32 × 32 cm). Hardware: Apple 2+ computer. Software by the artist. Courtesy of the artist.

7.8 right
Vincent van Gogh. *Cypresses.* 1889.
Pencil, quill, and reed pen, brown ink on
woven paper, 24⅛ x 18⁹⁄₁₆" (62.2 x 47.1
cm). The Brooklyn Museum. Frank L.
Babbott and Augustus Healy Funds.

represents only one of a tremendous variety of choices the viewer could make in altering the image. The project was designed as an interactive experience in which the viewer alters the instructions to the computer to see what happens. In this version, turning the page sideways and holding it at a distance to allow some optical mixing of the distinct pixels allows you to see the representational image that has been almost totally camouflaged by cropping and selective use of values.

The amount of light and dark in an optical mixture may be controlled by the thickness of the marks, how close they are placed, or both, as in Van Gogh's ink drawing *Cypresses 1889.* [Figure 7.8] This drawing is done with a reed pen and ink on paper, with only an area of the sky and grass

near the bottom right corner not covered with marks. Nevertheless, when compared with each other, some dark areas seem darker than others. The darkest area is in the center, where the black lines are laid down very close to each other. The lightest areas are those where the lines are laid down sparsely against the white background.

This same principle applies to value in printed matter. Type is usually printed in black and white. The thickness of letters and the closeness of their spacing give some lines of type a darker value than others. If you examine any advertisement in which several different sizes of type are used, you will probably find value differences. The greater the amount of white in an area, the lighter it will appear.

A final optical illusion used to change values is juxtaposition of light and dark areas. Our eyes deceive us. If a mid-tone gray is placed over a black and a white, as in steps 1 and 10 of Figure 7.2, the gray will appear very light next to the black but very dark next to the white. Artists often take advantage of this optical illusion to raise or lower values. Andrew Wyeth's drawing of Beckie King (Figure 6.9) exaggerated the age- and sun-darkened effect of the old woman's arms by placing them against a white sheet. If Wyeth had instead drawn her with her arms folded against her bed jacket, they would not have looked so dark. Wyeth has already drawn Beckie's arms darker than her face, illustrating in truly different values our tendency to perceive areas differently depending on their surroundings.

From Local Colors to Local Values

It is one thing to know how to represent values graphically and quite another to interpret the world of our experience in terms of value. We perceive our world in colors. We see grass as green rather than as mid-tone. To see an object in terms of values requires translating local colors into **local values.** We see a lemon as yellow, with light yellow highlights where the light strikes it and nearly brown shading where less light reaches it. To draw it in pencil, however, we have to interpret the lemon's colors as gradations of light and dark. These effects of light and shadow in art are sometimes called **chiaroscuro,** an Italian term meaning "light and dark."

A black-and-white photograph translates colors into values automatically. David Kelly's photograph takes plantings that would in real life be seen as mostly green and interprets them as a series of textured shapes and lines of different values. [Figure 7.9] The darkest areas are the four-sided figures on each side, the grass at the bottom is a mid-tone, the triangle coming down from the top is a few steps lighter, and the plants that form a horizontal line near the bottom are the lightest. Within each plant group there is also a range of values, from black shadows to nearly white highlights. These variations would not be nearly so apparent—or so exciting—in a color photograph.

7.9 right
David C. Kelly. *Untitled*. 1979. Black-and-white photograph, 5¾ × 7" (15 × 18 cm). Courtesy of the photographer.

From Local Values to Interpretive Values

To see local values in a colored scene, artists may look for the darkest and lightest areas. These extremes then provide a frame of reference for interpreting other areas as values. But values seen need not be reproduced precisely. Artists often choose to interpret values somewhat differently than a photograph would. Whereas trees are normally perceived as dark, Louis Eilshemius chose to use a near-white as the dominant background value for his pencil drawing of an old sawmill clearing being overgrown by vegetation. [Figure 7.10] Although he has used values ranging from this near-white to black, he has used the darkest values in small amounts to soften their contrast with the surrounding whites. This sparing use of darks makes the drawing more exciting by forcing viewers to fill in the details with imagination. From the minimal clues given, a sun-washed clearing, the crumbling timbers of an abandoned structure, and the darkness of the woods beyond can be imagined.

Another way of using values selectively is to draw different areas in different value ranges. Michael Mazur has done this in his *View into Broadway*. [Figure 7.11] His unusual linear perspective is made even more dreamlike by his choice of values. To the right, darks are almost totally washed out in some areas by what seems a flood of sunlight from the upper right. But areas on the other side of this building are partially sun-struck, too,

7.10 left
Louis M. Eilshemius. *Old Saw Mill.* Pencil on white paper, 4½ × 6¾" (12 × 17 cm). Mead Art Museum, Amherst College (gift of Roy R. Neuberger).

7.11 left
Michael Mazur. *View onto Broadway.* 1971. Pencil on paper, 40½ × 26½" (103 × 67 cm). Private collection.

and some areas on the right are heavily shadowed. If any one segment is isolated, the value range within it seems to make sense.

It is in relationship to one another that the values seem beyond the range of familiar experience. Nevertheless, if you were to look through a multipane window and draw what you saw in each pane separately without referring to the other pane-views, the result might be something like this. In one isolated frame you might use values ranging from 1 to 5 on a 10-step scale; in another, you might use steps 6 to 10. Instead of looking at overall comparisons —"This is the lightest area in this whole scene;" "This is the darkest"—you would be making these comparisons only within the limited area on which you were working. The result would have an intriguing fragmented logic, like the treatment of values on Mazur's Broadway corner.

Artists have various reasons for using interpretive rather than local values. Perhaps the most common of these are to emphasize certain areas, heighten design interest, create certain spatial illusions, and influence the viewer's emotional reaction to a work.

7.12 right
George de la Tour. *Joseph the Carpenter.* c. 1645. Oil on canvas, 4′5⅞″ × 3′4⅛″ (1.4 × 1.0 m). Louvre, Paris.

Emphasis and Design Interest

Light and dark areas may be used to steer the viewer's eye toward a focal point. In Georges de la Tour's *Joseph the Carpenter,* the light from the candle floods the child's face and forehead and Joseph's arms, drawing immediate attention to these areas and relegating the rest of the canvas to relative obscurity. [Figure 7.12]

Neither dark nor light automatically draws the viewer's attention. Whereas De la Tour used a light area as a focal point, Charles Sheeler used a dark focal point—the stove. [Figure 7.13] The large area washed out to

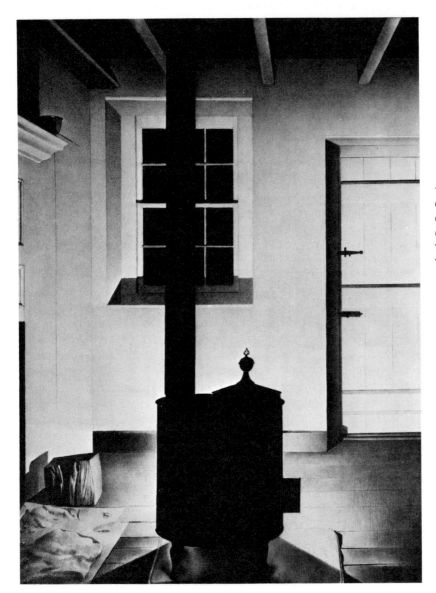

7.13 left
Charles Sheeler. *Interior with Stove.* 1932. Conte crayon, 28⅝ × 20¾" (73 × 52 cm). Collection of Joanna T. Steichen, New York. The Museum of Modern Art, New York.

7.14 right
Imogen Cunningham. *Black and White Callas, 1920s.* Vintage silver gelatin print. Galerie zur Stockeregg, Zurich.

near-whiteness—ostensibly by the fire's light—heightens the blackness of the stove itself. Its central position and stark blackness pull attention toward the stove as the focal point of the drawing.

Conversion of the value gradations of the three-dimensional world into extreme black-and-white contrast is often used to decrease viewers' associations with objects and instead to draw attention to their abstracted shapes or patterns. Imogen Cunningham has so increased the value contrast in her closeup photograph of a calla lily that the image no longer makes visual sense as a flower. [Figure 7.14] Rather, one is struck by the thrusting of the stamen, like a shiny iron rod, into the darkness of the enfolding petals.

Spatial Effects

Values are used in certain ways to indicate **modeling** of figures. They may be used in rather different ways to persuade viewers to perceive areas of landscapes as near or far or to perceive a certain amount of depth in a picture.

Modeling of Forms

A gradual change in values usually indicates gradual rounding toward or away from the viewer or a light source. In the Northern Sung period painting shown in Figure 7.15, a gradual shift in values across every rocky prominence helps us to perceive them as having a strangely soft roundness despite their craggy outlines.

7.15 left
Attributed to Li Cheng. *A Solitary Temple amid Clearing Peaks.* Northern Sung dynasty (A.D. 960-1127). Hanging scroll, ink and slight color on silk; 44 × 22″ (112 × 56 cm). The Nelson-Atkins Museum of Art, Kansas City, Missouri (purchase: Nelson Trust).

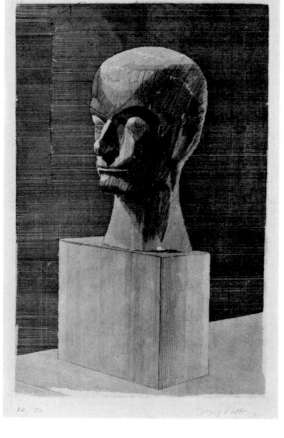

When transitions are more abrupt, the contours of a form appear more angular. In Villon's portrait of Baudelaire straight edges with strong value contrasts have been used on the nose and cheek to create the illusion of planes angling off so sharply in space that one catches the light whereas another right next to it is totally in shadow. [Figure 7.16] Note that the cube below the bust is not treated the same way. If it were, the facet on the right end would be darkly shadowed. Instead, Villon has selectively used angular shadows only on the head to increase its boldly chiseled effect.

We respond so readily to gradations in value as spatial shading that artists can use the barest suggestion of value changes to evoke an extremely complex spatial sensation. Rico LeBrun used the merest shorthand for value changes on the legs of his *Reclining Figure*. [Figure 7.17] Though very little is actually given, we immediately fill in the missing details and "see" plumply spreading fat-dimpled legs.

In some near-abstractions of figures, value clues are given in great detail to help viewers make spatial sense of an object they cannot quite identify. Charles Sheeler uses carefully worked-out value details in his *Nude*. [Figure 7.18] The top of the leg on the right is slightly lighter than the leg underneath to help distinguish the two. The most detailed area (the large stomach folds) is given great depth by the extreme range of values used. Note that the skin in front of each fold is lightened considerably, a commonly used technique that helps observers perceive one edge as being in front of another instead of abutting.

Pushing Values Forward or Back

Although white comes forward in Sheeler's stomach folds, both white and black can be pushed forward or back in space, depending on other spatial clues given. In the Girl Scout logo shown in Figure 7.19, black shapes are used at three different distances from the viewer, and one white face shape appears closer than the other. This illusion that both black and white areas exist at different distances from the viewer is created by the simple device of overlapping.

In atmospheric perspective, things to be seen as closer are shown in sharper detail and value contrast than things far away. This often means that both darks and lights can be seen in the near distance but only mid-values in the far distance. This information is usually used in depicting landscapes with great depth and therefore considerable atmospheric interference with vision. Georges Seurat uses this effect to create a sense of three-dimensional space on the flat picture plane in *Bathers, Asnières*. [Figure 7.20] The strong contrasts between dark and light areas in the immediate foreground quickly shift to softer and softer value contrasts as the scene recedes from the viewer,

7.19 above
Logotype of Girl Scouts of the U.S.A., 1978. Art director: Saul Bass. Designers: Art Goodman and Vahe Fattal.

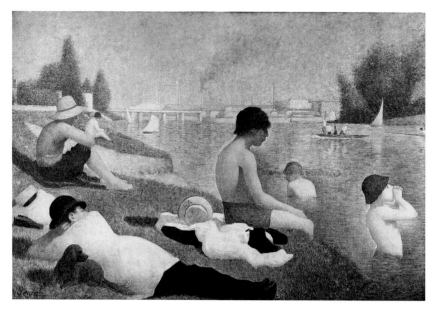

7.20 left
Georges Seurat. *Bathers, Asnières*. 1883-84. Canvas, 6'7⅛" × 9'10⅛" (2.1 × 3 m). National Gallery, London.

7.21 right
Gerard Doudera. *Gray Water with
Shadow*. 1976. Oil on canvas, 4'2" × 3'8"
(1.3 × 1.1 m). Collection of the artist.

until one can barely make out the details of bridge, boat, and buildings in the
almost uniformly light tones of the distance.

The same principle of atmospheric perspective applies to things seen
under water. Even when water is very clear it quickly obscures our ability to
see value contrasts.

In Gerard Doudera's *Gray Water with Shadow,* the lower part of the
painting is done in atmospheric perspective. [Figure 7.21] Stones in the
nearby foreground, though abstract, are painted in a great range of values.
These rapidly fade out into the limited value range in the center of the paint-
ing. Values, however, get darker again in some of the upper areas.

It would be hard to make sense of a value transition like this in a picture
of mountain ridges lined up one behind the other. But anyone who has ever
seen a body of clear water can interpret what is happening here: Water ap-
pears darker as it gets deeper. This painting therefore indicates spatial
changes in two directions—horizontal distance from the viewer and vertical
distance from the water's surface toward the bottom. In addition to associa-
tion with water's effects on value, Doudera uses changes in scale and posi-
tion on the page to help viewers interpret where the dark areas exist in

space. Dark stone shapes that are largest and lowest on the page are nearby, apparently under shallow water. Those that are higher on the page and smaller are to be interpreted as farther away, in deeper water.

Depth in Space

When areas of a work are treated in the same value range, they tend to flatten out. The Indian gouache painting shown in Figure 7.22 depicts the Nawab, his elephant, and his attendants as what seem to be thin, flat, cut-out shapes placed one in front of another. Historically, gouache is typically handled as a uniform color, with no shading, thus producing this spatially flat effect.

In certain contexts, scattering values about, as if randomly, may make representational spatial sense. Vija Celmins's *Galaxy* captures the sense of infinite depth in space by juxtaposing star shapes of many sizes and gray

7.22 below
Deccan. *Nawab I'tisam al-Mulk on an Elephant.* Hyderabad, c. 1795. Gouache and gold on paper, 12 × 16″ (30.7 × 40.5 cm). Victoria and Albert Museum (bequeathed by Sir Robert Nathan).

7.23 right
Vija Celmins. *Galaxy No. 5.* 1974.
Graphite on acrylic ground, 10 × 13"
(25 × 33 cm). McKee Gallery, New York.

values. [Figure 7.23] If they were all represented in the same gray against a black background, viewers would tend to perceive them equally far away. So many variations are given here, however, that no two appear to be at the same distance. We seem to be looking through a telescope and seeing countless stars, in countless different locations in space. The blurred gray edges that prevent clear focusing even on the largest, brightest stars help push the whole image back even farther.

In some works values ebb and flow from one value extreme to another throughout, but they do so gradually. This too makes spatial sense, as an undulation up and down, in and out. In Richard Ziemann's *Forest Floor,* except where light-toned leaves seem to have fallen from unseen trees above, transitions between lighter and darker values in the vegetation are rarely abrupt. [Figure 7.24] They change by close steps in the value scale. This gradual transition produces a softly rolling effect. Some clumps seem to be slightly taller (and therefore closer to the observer) than others, but there are no dramatic contrasts in height. The gentle in-and-out rhythm may be as calming to the viewer as a lullaby.

Emotional Effects

Values are often used to evoke a certain emotional response to a work. There are no absolute rules for how values will affect viewers, but this complex subject is worth discussion.

7.24 left
Richard Claude Ziemann. *Forest Floor*.
1967. Etching, 9⅞ × 7¹⁵⁄₁₆″ (25 × 20 cm).
William Benton Museum of Art, University
of Connecticut, Storrs (gift of Alumni
Annual Giving Program).

7.25 below
Robert Wiene, director. *The Cabinet of
Dr. Caligari*. 1920. Designers: Hermann
Warm, Walter Reimann, and Walter Rohrig.
Producer: Erich Pommer, Decla-Bioscop.
The Museum of Modern Art, New York /
Film Stills Archive.

Strong value contrasts tend to provoke immediate emotional response. In the 1920 German movie *The Cabinet of Dr. Caligari* (a still from which is shown in Figure 7.25), stark contrasts of light and shadow were actually painted on the floor and the faces of main characters to heighten the sensation of horror.

A dark background with light images can evoke a sense of fear, like dreadful dreams in darkness. Hyman Bloom used this value combination in his *Fish Skeletons* to exaggerate the grotesque quality of his images. [Figure 7.26]

In John Gregoropoulos's *Autobiography*, dark values fill a large part of the canvas, with light values used only as accents. [Figure 7.27] However, the psychological mood it creates is not strongly negative. It seems rather to be the haziness of an image from a dimly remembered past. The shadows

7.26 above right
Hyman Bloom. *Fish Skeletons*. 1956. White ink on maroon paper, 17 × 23" (43 × 58 cm). Collection of Mrs. Ralph Werman.

7.27 below right
John Gregoropoulos. *Autobiography*. 1975. Oil on canvas, 7¾ × 12⅜" (20 × 32 cm). Collection of Annette Zelanski.

and highlights, the horizon on one side but not the other, make sense only within the context of a memory in which accuracy of detail has been lost. The true blacks on the sides have been added to help us recognize the muted nature of the values in the rest of the painting. Like a music teacher hitting a note on a pitchpipe to let singers hear how far off-key they are, these black-blacks help us to see that even what seemed black in the painting really was not. They announce, *"This* is black."

True blacks and true whites do not appear very often in artworks. The photograph of pilgrims watching the sun rise from Mt. Fuji makes full use of

7.28 left
Herbert Ponting. *Pilgrims on Mount Fuji.*
Photograph.

the unusual lighting conditions to evoke a feeling of humility and awe before the splendor of the heavens. [Figure 7.28] The pilgrims become mere silhouettes, their black shapes contrasting with the purely white clouds beyond. The spiritual focus of the photograph, however, is neither black nor white but light gray where the sun is just breaking through.

Predominantly light values often evoke a light emotional response, a feeling of happiness. Surely this is the case in the gouache painting of Indian women celebrating Holi. [Figure 7.29] In this riotous festival celebrating the end of winter, people gaily take to the streets to throw powdered paint

7.29 left
Punjab. *Ladies Celebrating Holi.* Kangra, dated 1788. Gouache on paper, 6 × 10⅛" (15.5 × 25.8 cm). Victoria and Albert Museum (bequeathed by P. C. Manuk and Miss G. M. Coles).

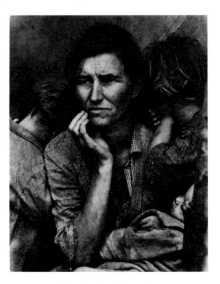

7.30 above
Dorothea Lange. *Migrant Mother, Nipomo, California.* 1936. Black and white photograph. The Oakland Museum, Oakland, California (gift of Paul S. Taylor).

7.31 right
Mark Rothko. Untitled (black and gray). 1970. Acrylic on canvas, 5'8" × 5' (1.7 × 1.5 m). Museum of Contemporary Art, Los Angeles (gift of the Mark Rothko Foundation, Inc.)

on one another. The lightness of the mood is matched here by the light values, accented only by the bits of black representing the women's hair.

A range of mid-values that cannot be mistaken for blacks or whites can convey a sense of hopelessness or depression. In Dorothea Lange's photograph grays predominate. [Figure 7.30] The children's heads are turned away, hiding the light tones of their faces. Even the relative lightness of the baby is half-hidden. This "gray" feeling emphasizes the desolate look in the mother's face, evoking compassion from those who view the photograph.

Even in abstractions in which there is no recognizable image to influence our emotional response, values can affect us strongly. Observers of Mark Rothko's black and gray painting may be touched by a sense of despair. [Figure 7.31] The black is so much more intense than the gray that it seems, slowly, to be crushing it. If we identify with the passive gray area, we too may feel oppressed.

When black and white are juxtaposed, a powerful contrast can be felt, but neither overwhelms the other. A true white is just as strong as a black. In Robert Motherwell's *Black and White Plus Passion,* even the small area of

white seems capable of holding off an enormous black area, of passionately and perhaps even playfully fighting back. [Figure 7.32] It even seems to be growing, making inroads into the territory held by the black. This is not to imply that black will always be read as emotionally negative and white as emotionally positive. Black is associated with death in some parts of the world, but other peoples mourn a death by dressing in white. The skillful artist controls both darkness and light and can make them say whatever he or she intends.

7.32 above
Robert Motherwell. *Black and White Plus Passion*. 1958. Oil on canvas, 4′2″ × 6′8″ (1.3 × 2.0 m). Private Collection.

From Values, Color

One more dramatic illusion can be created using only the value scale. If sharply contrasting blacks and whites are juxtaposed as repeated lines or shapes, they may create mysterious color sensations. For instance, if you stare fixedly at the striped figure and the vertically striped background in J. Seeley's photolithograph in Figure 7.33, you may begin to see colors flashing among the stripes—perhaps red, brownish yellow, green, blue, or

purple, depending on the type of lighting where you are. This is a spontaneous interaction, a device discussed in Chapter 1. Why it works is not clear, but it involves what happens when our visual-perception mechanisms are presented with the two extremes of the value scale at the same time.

Arthur Hoener carried this even further. His *Color Action Drawing—Internal Echo* is composed of thousands of small black-edged circles whose outer dimensions are always the same. [Figure 7.34] In the center, the thickness of the black edges changes ever so gradually, creating the extraordinary illusion of a full value scale. Even more surprising is the discovery that the drawing as a whole has a reddish cast, even though no red pigments have been used. This is a subtle reaction that some people may not have. Hoener felt that, using only blacks and whites in certain proportions, artists can make observers "see"—or at least feel—specific colors other than black and white.

Since we each bring to a work of art our own perceptions and prejudices, it is unlikely that mixing colors from blacks and whites will become an exact science. But the mere possibility that colors can be seen in black and white works is an exciting example of the powerful effects that can be created through thoughtful use of values.

STUDIO PROBLEMS

Value graduations can be created with an assortment of pencils, black and white acrylic paints, black water-soluble ink thinned with water, black-and-white magazine pictures, a package of gray silk-screened papers, or computer. Each can be used to create a range of gray values, from black to white, but each will give a somewhat different value scale. Factors to consider in purchasing and using these materials are explored in the Appendix. Those most appropriate for each problem are specified in the problems. Charcoal is not recommended for any of the exercises, for it is difficult to use in creating precise value graduations.

7·1
GRAY SCALE

Make two ten-step gray scales. Use pencil to make the first scale; mix black and white acrylic paints for the second.

This is a problem in seeing. There are many grays between black and white. It is not easy to see—and then reproduce—them as logical steps that vary only slightly from the one before. One way to deal with this difficulty is to do a great many different samples and then pick out those that seem to be equal steps away from each other. It is easiest to draw or paint larger areas than you need and then cut each one you use down to size and glue it onto a rather stiff groundsheet. Trying to work on tiny precut scraps of paper or directly on the groundsheet is very difficult.

The student who constructed the pencil scale shown in Figure 7.35 managed to get a good black and to lighten it in a reasonable progression

toward the white by allowing more and more of the white paper to show. Pencils were changed to lighten the graphite laid down. You may want to try using a 2B for the darkest end, an HB for the middle grays, and a 2H for the lighter values. Use of only one pencil, also legitimate, will give a different value range.

In addition to discriminating steps that vary equally rather than jumping too far or resembling each other too closely, you should also pay attention to working the surface evenly. Instead of a textured effect in which pencil strokes or lighter and darker areas can be seen on the same chip, try to get an even, flat overall effect.

In solving the painted gray scale problem, you could conceivably use the Weber-Fechner Theory that geometrically differing ratios of black and white can be mixed to produce arithmetically different values of gray. [Figure 7.36] However, rather than measuring out minute amounts of black and white, you will get more practice in seeing value gradations if you mix them by eye. As in the scale done in pencil, try to apply the paint evenly for a flat, no-strokes-showing effect. Sometimes a textured appearance is desirable in a design, but you should also know how to hide your tracks.

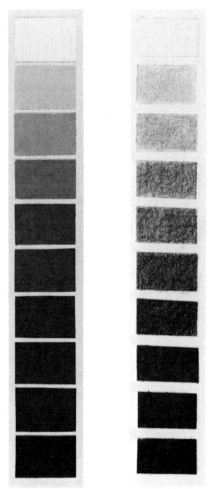

7.35 above left
Gray scale. Pencil. Student work.

7.36 above right
Gray scale. Acrylic paint. Student work.

NAME IN GRAYS

Present your name on a 5-inch-square sheet of paper, using a series of gray values.

In Chapter 1 you wrote your name as a design in order to combine freedom and control in the use of line. Here, writing your name becomes a vehicle for experimenting with the gradations of the gray scale that you learned to make and differentiate in the last problem. The values could change by logical steps.

Figure 7.37 uses this technique with the computer, which has a gray scale printed as percentage screens. The name reads very high off the picture plane. The name can be read easily in black, but as we go back through lighter values, it becomes more abstract. Since this progress is a spatially logical one from dark to light values, the entire design is perceived as a three-dimensional form in motion.

If there is no logic to the sequence of grays used, either arithmetically or visually, the apparent spatial distances between lines will change abruptly and unpredictably. Faced with this spatial illogic, viewers may give up and interpret the whole design as relatively flat. This is neither good nor bad in itself, but it is an effect of which you should be aware, for you may want to use it in some cases and avoid it in some others.

7.37 right
Name painted in grays. Student work on computer.

7·3
A PAINTING IN GRAYS

On a 5-by-7-inch sheet of paper, do a painting in gray values. Cover the whole sheet.

The only restrictions on this problem are those indicated above. You can do anything you want on your small piece of paper as long as you do it in painted grays. With this freedom,

you should be able to combine ideas picked up earlier in the course with your personal likes and dislikes to produce something approaching a finished work of art.

In the solution shown, the gradations of gray have a mysterious beauty that draws viewers into looking at the painting for a long time, trying to interpret what is shown. [Figure 7.38] Is it tree rings? Geodes? Are they flat or do they curve in and out? How do they relate to each other in space? As well as being hauntingly enigmatic, the subtle gradations in values are lovely. This is a composition that pleases the eye while teasing the brain.

7.38 above
Painting in grays. Student work.

7·4
A PENCIL DRAWING IN GRAYS

Do a 5-by-7-inch design in gray values using pencil.

It is very difficult to cover a large area with a continuous tone in pencil. To do so, you must simply be very careful. Whether you use the end or the side of the pencil, you must always *draw* with it rather than smear it back and forth. Draw from edge to edge, line to line, always using the same pressure. Only then will your solution to this problem look like a work of art.

In the first solution, an interesting idea has been marred by technical imperfection. [Figure 7.39] The student obviously put a great amount of time into solving this problem. To measure and then fill in all those shapes was time-consuming. Their varying scale and use of transparencies—areas changing in value as a tinted but trans-

parent band passes over them—give this design a lot of potential. The mysterious lack of logic in the transparencies is interesting: None of the transparent swaths seems to change the values "beneath" it in the same ways in all places. Some areas become lighter: Others under the same band become darker where it passes over.

7.39 below
Pencil drawing in grays. Student work.

7.40 right
Pencil drawing in grays. Student work.

Despite these potentially interesting effects, the design would be stronger were the edges crisp and had the pencil been applied more consistently. Edges blur and run together rather than maintaining the distinct values that were intended. Perhaps recognizing that the design threatened to fall apart, the student added a black line within the white border. But this is not enough to hold the vague areas together.

The second solution shown is very successful, largely because of the force of excellent pencil work. [Figure 7.40] The dark foreground area is put down very nicely, edges of the shapes on it are crisply drawn, and values of the shapes in the "sky" are suitably flat. Like the first one, this student had an interesting idea for a design; the difference lies in the execution.

The idea here is the peculiar spatial illusion. The large shapes and strong value contrasts at the bottom of the page help viewers perceive it as foreground. Beyond, the ovals diminish to a tiny overall pattern that can be interpreted as being very far away. Even though blacks and whites appear together here, this area seems neither black nor white but something in between—a gray value made by juxtaposition of small, broken amounts of black and white. Above, the background imperceptibly changes to white, and the shapes begin to grow again until those at the top are as large as those at the bottom of the page. This creates the impression that these

shapes are either coming out at us from the distant area in the center or being sucked into it. We are pulled into the design, too, for these odd objects seem to be passing both over our heads and under our feet and continu-ing on beyond us. The drawing is so well done that the mechanics do not call attention to themselves, freeing us to lose ourselves in the unfamiliar spatial sensations the design evokes.

7.5

A DESIGN IN GRAY PAPERS

Do a design in gray values using papers from a silk-screened gray pack or found papers from magazines, cut and glued to a backing.

For this problem you may want to buy a package of silk-screened papers that reproduce a gray scale in ten or more values. Color-Aid makes a gray pack like this. Or you might prefer to look for large flat areas of gray values in magazine pictures. The Color-Aid papers are beautifully printed, but it is interesting to search for "found" gray papers.

In the solution shown in Figure 7.41, found gray papers are used to create a seemingly childlike image. Perhaps it was the nature of the assignment (rummage through magazines and cut and paste) that liberated this student from preconceived notions about what a design should look like. Enough information is given for viewers to perceive a house or barn with a garagelike annex and sky beyond with a balloon floating by. The vertical gray shape in front of the "garage" is puzzling—is it actually some object in front, or is it a driveway entering the garage? If so, it is done as we "know" driveways look rather than as our artistic traditions of linear perspective would dictate.

The humor and spontaneity of this piece is unexpected. Whether as viewers we enjoy these qualities or dismiss the design as a simplistic and quick solution depends on how open we are to expanding our definitions of art.

7.41 above
Design in gray papers. Student work.

7.6

LETTERS IN VALUES

Create a design using whole letters of any size—press-on type, cutouts from magazines, drawn letters, or computer type. Use a range of gray values in the letters and/or the spaces between them.

If you are planning to go into graphics, you will find it helpful to keep experimenting with different ways of presenting printed messages. The solution shown in Figure 7.42 demonstrates that type can be used to create interesting designs. All the areas are tightly controlled. The black shapes are strong, solid points that the other shapes work against. The negative shapes become as important as the letters themselves. Most particularly, the negative shape under the M and over the E seems almost to make a new letter, half covered by a transparency effect that works because of the logical

7.42 below
Letters in values. Student work on computer.

value change. The value changes add interest to the design, for the areas are not trite repetitions of letter shapes nor do they have the tendency of block letters to flow together into a single shape. The borders hold all the shapes together.

GRID IN GRAYS

Create a grid pattern that changes size along one or two axes. Fill in the blocks with a range of grays, using paints, ink, or pencil, or weave the grid from varying gray papers.

To solve this problem you can use graph paper already marked in a grid pattern, increasing or diminishing the number of squares used as the basis for each row, or you can mark less uniform variations in size on a blank groundsheet or solve the problem on a computer grid. The rows within the "checkerboard" can be curving, rather than straight. The size of the blocks should change along either the horizontal or vertical axis, or both, as in the example shown in Figure 7.43.

Technically, this is one of the most difficult problems in the book. If it is not done with precision, any sloppiness in edges or lack of flat consistency in filling the blocks will be apparent immediately. This kind of work is tedious, but the discipline is essential in creating finished works of art.

In addition to training in discipline, this problem gives you a chance to experiment with spatial effects by using changes in both scale and value. If you choose, you may be able to transcend the flatness viewers expect in a black-and-white checkerboard pattern. Figure 7.43 does not create an illusion of three-dimensionality. Both

7.43 right
Grid in grays. Student work.

values and the sizes of shapes change along two axes. The shapes grow and shrink so rapidly, however, that the design appears very flat despite the more gradual and consistent shift in values.

In solving this problem, you are not restricted to a single set of value shifts, or to using the darkest values in the largest blocks, or to creating an illusion of three-dimensionality. A number of shifts in both size and value could be used, in either gradual or random sequence. Despite the rigid skill and pattern requirements imposed by this problem, solutions can still vary considerably.

7.8

TRANSFORMING LOCAL COLOR TO LOCAL VALUE

Working from a copy of a famous painting, convert it to values of gray. Either look carefully and paint the values you see on a separate sheet or divide the painting into a grid of squares, reproducing on a separate sheet the predominant value in each square.

Previous exercises in this chapter will have helped train your eye to see value changes and your hand to create them. This problem and the next should help you train your eye to see values in the colored world of your experience, to interpret areas as a range of darks and lights rather than as an assortment of color hues.

Two methods are suggested. The first is the most obvious: Look at a painting, distinguish the values in its colors, and then do the painting as a study in grays. For instance, although a brown and a green differ in hue, you might determine that they are the same value and thus represent them by the same gray tone. Compare areas to determine relatively lighter and darker values that can be shown as steps in the gray scale.

Using the first method, one student interpreted Salvador Dali's *Crucifixion* in flat areas of gray. [Figures 7.44 and 7.45] The cross was seen as a form done in ten values. In this interpretation values range from black to a light gray. The student saw the woman's face as the lightest part of the painting, so it was painted a near-white that contrasts sharply with the black of the sky. The object of this problem is to represent the values of the original as accurately as possible. This student chose to work only with the major areas in the original, leaving out more subtle shifts in shading and detail. Within that framework, the interpretation is reasonably accurate in most areas. You might prefer to follow the original of your painting in greater detail, though this takes more time and discrimination.

For the second method, obtain a cheap reproduction of a master work. Use a ruler to draw a grid of same-size squares directly on the surface of the reproduction. Number the horizontal and vertical axes along the margins for reference. Prepare your own paper in the same way, using very light pencil for the grid lines—again numbering the outer rows of squares in the margins. Then draw or paint each square in the dominant value you see in its corresponding square in the reproduction.

Squares should be no larger than 3/8 inch. This size produces an abstraction of the painting that allows you to see its underlying value structure. The smaller the squares relative to the

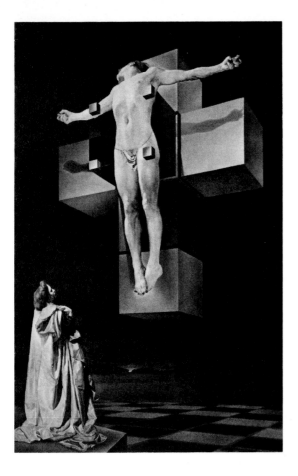

7.44 above left
Salvador Dali. *Crucifixion.* 1954. Oil on canvas, 6'4½" × 4'3¾" (2.0 × 1.2 m). Metropolitan Museum of Art, New York (gift of the Chester Dale Collection, 1955).

7.45 above right
Local color to local value. Student work.

7.46 near right
Local color to local value. Student work.

7.47 far right
Eugene Delacroix. *Greece Expiring on the Ruins of Missolonghi.* 1826. Oil on canvas, 6'10" × 4'7" (2.1 × 1.4 m). Musee des Beaux Arts, Bordeaux.

whole, the more representational the solution will be and the more complicated the analysis of how the values relate to each other.

Figure 7.46 is an interpretation of the predominant value shifts in Eugene Delacroix's *Greece Expiring on the Ruins of Missolonghi,* based on a grid

of 3/8-inch squares. [Figure 7.47] Both the 9 3/4-by-6 1/2-inch reproduction and the solution were divided into 17 squares horizontally and 26 vertically. Numbers 1 through 17 were used for reference along the top, 1 through 26 along the sides. Values were then transferred one square at a time. The square in the lower right corner was black in the original, so this student penciled in a black square. The near-white of the skin and gown of the woman representing Greece are the lightest areas of the picture. They are shown as pale grays through the center of the grid representation. The highlighted blue velvet of her arm to the left in the original becomes a range of mid-tone grays; the shadowed blue of her other arm is shown as darker grays. The resulting abstraction of values reveals that Delacroix has used a pleasing blend of gradual value shifts and more sudden contrasts in working out the value structure of his painting.

7·9
PAINT A PHOTOGRAPH IN GRAYS

Choose a color photograph from a magazine. Repaint 20 to 25 percent of it in grays, following the original values so closely that the area you have painted fits logically with the unpainted, colored area.

To work well, this problem requires an even more accurate translation of local color into local value than the last one. But it is pleasant to paint over someone else's work, following lines and shapes that are already given and seeing how closely you can match the values. This problem is like a "paint-by-number" toy with black as 1 and white as 10—but you have to figure out what the numbers are.

If a well-done solution is photographed in black-and-white, it should be very hard to distinguish the area painted in grays from the original. By this test, the two solutions shown here differ somewhat in quality.

In the first solution, shown in Figure 7.48, the student has painted in grays a rectangle from the top of the child's cheeks to the woman's knuckles. Where values of the original and the one painted portion do not match, the straight edges of this rectangle can be seen. Most of the mistakes made err in being too dark, as if a slightly darkened plastic film had been laid over this section of the picture. The range of values in the insert is fairly logical in itself, but not in relation to the original.

7.48 left
Painted photograph in grays. Student work.

7.49 right
Painted photograph in grays. Student work.

It is difficult to distinguish the area in grays in the second solution, however. In Figure 7.49, the values of the helmet, arm, and football jerseys are reproduced so accurately that the gray-painted area (the lower left quadrant) flows logically into the rest of the picture. This student has actually cut away the lower fourth and painted it freehand, which is an option. In this black-and-white reproduction, the only clue to the changes is the shadow made by the cut edge of the photograph.

7·10
SPINNING PATTERN WHEEL

Cut an 8-, 10-, or 12-inch disk out of stiff white paper such as mat board. Using only black ink or paint and the white of the board, create a design on it. After it dries, insert a thumbtack from the back to the front. Use either a tack with a high rounded head or sandwich a piece of kneaded eraser between it and the disk to hold it up higher. Spin the disk on a flat surface to see what develops.

Solutions to this problem should be interesting as black-and-white designs. If the right proportions are used, a design might develop color from spontaneous interactions. When spun, it should seem even more exciting.

As indicated in this chapter, different values can be produced not only by paint mixing but also by optical mixing of small quantities of black and white close to each other. We might therefore expect that spinning a circular black-and-white design would force viewers to mix them optically. Dark grays should appear in areas with much black and lighter grays in areas with more white.

This happens to a certain extent in some designs. More often, what can

be seen in these spinning wheels of black and white is not a series of grays. What appears is colors that flash and change as the spinning slows. Using only black and white, in certain combinations, at certain speeds, you can develop wave frequencies that happen to correspond to the frequencies of certain colors. They form a fascinating moving pattern that will not at all resemble the design's appearance when still. Designs that radiate from the center and use at least as much white as black seem to work best. Fluorescent lighting adds to the color sensation because of the pulsating effect of the gas.

When spun, the disk shown in Figure 7.50 creates six beautiful concentric circles of varying values and hues.

In certain lights some of them seem to flash golds and blues. Some people also see purples, reds, and greens in this wheel. These are inexact labels for the hues created, for they glow more like lights than like flat painted areas. Some people see colors in these wheels more easily than others do.

In addition to the color sensations, when spun, this wheel also creates spatial illusions that transcend the flatness of the design at rest. As this large, elegant wheel turns more and more slowly, both color and spatial illusions continue almost until it stops. At the point that they finally fade, the contrast between the extraordinary effects in space and color and the black-and-white figure-ground reversal of the original design is truly startling.

7.50 *above*
Spinning pattern wheel. Student work.

8

COLOR

KEY TERMS

- analogous hues
- "color picker"
- color scheme
- color solid
- color wheel
- complementary hues
- double complementary schemes
- hue
- light mixtures
- local color
- middle mixture
- negative afterimage
- optical mixture
- palette
- pigment
- pointillist
- primary color
- reflected color
- refracted light
- saturation
- secondary color
- simultaneous contrast
- split complementary schemes
- subjective color
- tertiary color
- value
- visible spectrum
- wavelength

8
COLOR

When artists are limited to black and white, using a range of grays permits a great variety of effects. When there are opportunities to work with color, a whole new world of visual sensations opens up. The sudden appearance of colors in this chapter should be a breathtaking change from the black-and-white reproductions used earlier.

Even with an extremely limited **palette** (the range of colors actually used in a work), as in Franz Kline's *De Medici,* the addition of color dramatically changes the character of the work of art. [Figure 8.1] Kline has used colors as a great chef would use herbs—just a slash of green and a touch of yellow. Used even this minimally, they add a sensuous richness to the painting that also transforms the black and white used. The knowing touches of green and yellow set up new relationships in the painting so that the black and white can be seen as colors, too. The black becomes more lyrical than just black. The yellow seems almost lighter than the white.

Color is an extraordinarily rich tool for artists. It is also extremely complex. Unlike learning the skillful use of the elements of design explored earlier, just beginning to appreciate what color can do requires comprehensive study. Even so, we will provide a simplified explanation of the properties of color, examine several theories of color mixing, and introduce some ways in which open-minded artists have transcended the old "rules" to produce startling effects with color.

8.1 right
Franz Kline. *De Medici.* 1956. Oil on canvas, 6'9½" × 9'6" (2.1 × 2.9 m). Collection of Mr. and Mrs. David Pincus.

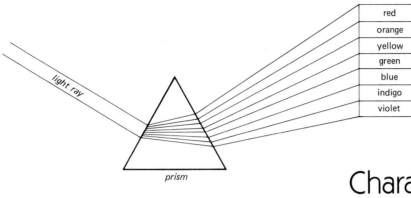

8.2 left
The visible spectrum produced when a ray of light passes through a prism.

red
orange
yellow
green
blue
indigo
violet

light ray

prism

Characteristics of Color

We tend to think of **local color** as a characteristic of objects—a lemon "is" yellow, grass "is" green. However, what we interpret as color is not a property of objects themselves. It is a function of the light reflected from them.

When a ray of white light from the sun passes through a glass prism or a spray of water its energy is broken or **refracted** into the rainbow spectrum of colors that humans can see. This **visible spectrum** of light refracted through a prism ranges from red to violet, as shown in Figure 8.2. The colors which we can distinguish correspond to different **wavelengths,** or frequencies, of electromagnetic radiation. There are many other wavelengths that we cannot see at all; infrared, ultraviolet, x-rays, and radio waves are invisible to us.

Artists usually reproduce the colors of the visible spectrum using **pigments,** substances that reflect approximately the same color as is seen in the band of the same name in a spectrum of refracted light. For instance, yellow pigment absorbs all colors except yellow, reflecting yellow back to the observer. No color actually exists until this reflected wavelength of light is received by the eye and interpreted by the brain.

In **reflected colors** there are many variations on the pure colors of the refracted light spectrum. Over the years, theorists have devised many different ways of squeezing these variations into a single theory of the relationships among the colors that we see. In the seventeenth century, Isaac Newton noticed that the red-purple at one end of the visible spectrum looked very similar to the purple at the other end. He therefore drew the two ends of the spectrum together, producing the first **color wheel.** [Figure 8.3] More recently, some theorists have proposed using triangles or intersecting triangles to express color relationships, but color wheels are still widely used.

8.3 right
Newton's color wheel, from *Optice* by Sir Isaac Newton. 1706. The names of the colors are in Latin. Rare Book and Manuscript Library, Columbia University, New York.

Hue

Color wheels are two-dimensional models of color relationships that deal only with **hues**—the names of colors (red, blue, blue-green, and so on). Hues opposite each other on a color wheel are said to be **complementary;** hues next to each other are called **analogous.** If complementary hues are juxtaposed, each appears brighter; if closely analogous hues are juxtaposed, they tend to blend visually, and it may be difficult to see the edge that separates them.

Even in simple color-wheel models, controversies have arisen over which few hues are the basic ones from which all other hues can be mixed. There are at least five different possibilities that seem to be true, depending on the situation. In **light mixtures,** as in film, photography, computer graphics, and TV, where refracted light operates, all hues can be obtained from combinations of the rays that produce red, green, and blue-violet. [Figure 8.4] They are called **primaries** and are represented in Figure 8.4 by larger circles than the **secondaries,** which are colors produced by mixing two primaries. If you look at a color-television picture with a magnifying glass, you will discover that all the colors are actually combinations of tiny red, green, and blue-violet dots. Watch for a picture with a lot of yellow; if you examine it closely, you will find that it actually consists of red and green dots. There is no yellow as such in color-TV transmission. If all the refracted colors of light are recombined, the result is clear white light.

In mixing pigments, where reflected rather than refracted light operates, the primaries are traditionally considered to be red (magenta), yellow, and blue (turquoise). [Figure 8.5] Surprisingly enough, these are the exact hues obtained as secondaries in light mixtures. But if two pigment primaries are mixed, they form a rather different set of hues than those found on the light-mixture color wheel. The secondaries in pigment mixtures are orange, green, and purple (or violet). If secondaries and primaries are mixed, a third set of hues is created: **tertiaries.** In pigment mixtures, these can be called orange-yellow (the hue obtained by combining orange and yellow), red-orange, red-purple, purple-blue, blue-green, and yellow-green. [Figure 8.6]

8.4 near right
In refracted light the primary colors are red, green, and blue-violet; the secondaries are magenta, yellow, and turquoise.

8.5 far right
In pigments the primary colors are traditionally thought to be red (magenta), yellow, and blue (turquoise); the secondaries are orange, green, and purple (violet).

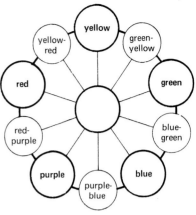

8.7 above

In Munsell's color wheel the five principal colors are red, yellow, green, blue, and purple; hues that can be mixed from adjoining principal colors are named for both.

8.6 above

The traditional wheel of pigment mixtures, showing (1) primary colors, (2) secondary colors, (3) tertiary colors. The gray circle in the center represents the neutral gray created when complementary colors (those lying opposite each other on the color wheel) are mixed.

If reflected colors that lie opposite each other are mixed, they produce a neutral gray.

Finding that actual pigment mixing based on this traditional pigment wheel did not necessarily produce colors that varied from each other in equal steps, Albert Munsell worked out a third color circle with five "principal" colors that relate to each other and to intermediary mixed colors on a more precise numerical basis. Munsell's principal colors were red, yellow, green, blue, and purple. [Figure 8.7]

Wilhelm Ostwald worked out still another color circle that was based chiefly on how colors are presumably perceived by the eyes and brain rather than on the light or pigment mixtures in the world that we experience. In Ostwald's color theory, the primary colors are red, yellow, sea green, and blue—four in all. [Figure 8.8]

Yet another system was devised by Arthur Hoener. Illustrated in Figure 8.9, it deals with the relationships between certain colors and the background against which they are presented. In this system orange, green, and violet can be used as primaries to produce yellow (orange plus green), blue (green plus violet), and red (violet plus orange). If, for instance, you stare at

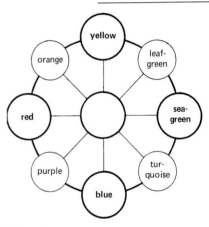

8.8 above

In Ostwald's color wheel the primary colors are red, yellow, sea-green, and blue. The secondaries are orange, purple, turquoise, and leaf-green.

8.9 below

In Hoener's color wheel the primary colors (orange, green, and violet) can be juxtaposed to create the secondaries (yellow, blue, and red).

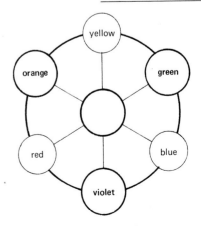

8.10 right
Arthur Hoener. *Penuous.* 1974. Acrylic on masonite, 23½ × 23½″ (60 × 60 cm). Collection of Mr. and Mrs. Walter Tower, West Newton, Massachusetts.

a medium green circle for a time and then glance immediately at a white area, you will "see" its complement red emerging from the white. A lighter green circle will make the background appear greenish; a dark-green circle will make the background appear whiter, and the green will look almost black. If two colors are presented in the right amounts against a light-colored background, their effects will mingle, producing an overall illusion of a single color that is different from either. Whereas the classic theory of pigment mixtures defined yellow and red as primaries, claiming that they cannot be mixed by combining any other two colors, Hoener demonstrated that yellow and red can be mixed visually using pigments. If you look closely at the "yellow" shape coming down from the upper right of Hoener's *Penuous,* you will discover that it actually consists of green and orange circles on a light background. [Figure 8.10] And the "red" shape coming up from the bottom is actually violet and orange circles on a light background.

Hoener referred to this optical mingling of color energies as synergistic color mixing. By transcending the dogmatic "rules" of color mixing, he greatly expanded our knowledge of how colors work together.

Value

Hues are not the only variations we see in colors. Another variation is **value** —their degree of lightness or darkness. To see what great difference a value change can make, arrange colored papers in a line or a wheel with primaries

graduating into secondaries and secondaries into tertiaries. Hold a white sheet between the colored sheets and position a light source so that a shadow falls partially on them. Comparison of the lighted portion of each hue with its shadowed portion will demonstrate that the amount of light reflected strongly affects how colors are seen. If a sheet of cardboard is held just above the colors, obscuring even more light, a very dark value will be created.

Georgia O'Keeffe used an extremely limited hue palette in her 1977 painting *From a Day with Juan, II.* [Figure 8.11] The only hues used are blue and gray. Yet by gradually varying their value from very light at the bottom to very dark at the top, O'Keeffe provided a great range of color sensations. If you cover the middle of the painting you will see how different the

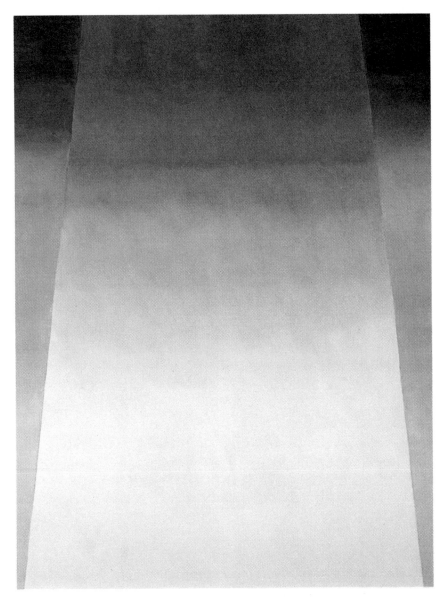

8.11 left
Georgia O'Keeffe. *From a Day with Juan, II.* 1977. Oil on canvas, 4 × 3′ (1.2 × .9 m). The Museum of Modern Art, New York.

two extremes are. The top has a very strong emotional impact, the bottom a very delicate one. The transitional area through the middle—especially where the grays are changing—has a mystical quality. This is a fantastic range of sensations, yet it is based merely on value changes in two hues.

Saturation

The third characteristic of color that theorists have isolated is **saturation** (also known as *chroma* or *intensity*). This is a measure of the purity and brightness, or grayness, of a color. Janet Fish's *Cut Peach and Blue Vase* uses all the colors of the spectrum at high saturation. [Figure 8.12] They appear almost as pure as transparent jewels with light passing through them. In comparison, the colors in the collage in Figure 8.13 are of low saturation, dulled as if by thin layers of grayed paint on top of purer hues.

In pigments, there are two major ways of graying a pure color of maximum saturation without changing its value: Mix it with gray of the same value, or mix it with its complementary of the same value (the color that lies opposite it on the color wheel). When mixed, complementaries will neutralize each other until—mixed in the right proportions—they form a gray that resembles neither, represented by the gray in the center of the color wheel (Figure 8.6).

There is another way of changing saturation that can be explained only by the one color principle that is true in all situations: *Colors are affected by the colors around them.* In Figure 8.13, the upper golden shape and the

8.12 below left
Janet Fish. *Cut Peach and Blue Vase.* 1993. Oil on canvas, 40 × 50″ (101.6 × 127 cm). Grace Borgenicht Gallery, New York.

8.13 below right
Paul Zelanski. Collage, 6¾ × 4¾″.

lower trapezoid of sea green appear duller and less saturated if you cover up the black surrounding them and view each in isolation. Their juxtaposition to black—which is of lowest saturation—makes them appear brighter by contrast. In any combination of colors, adjacent colors will affect our visual perception of their hue, value, and saturation. Even when working with very few hues artists can vary their effects by the ways they are combined.

Color Solids

To devise a single system for portraying the relationships among colors along the three variables discussed—hue, saturation, and value—color theorists have developed a variety of **color solids.** As indicated in Figure 8.14, these models typically show value as measurement up a vertical pole, from black at the bottom to white at the top (though a pure white is almost impossible to achieve, for even snow tends to reflect other colors). Saturation is represented as horizontal measurement away from this vertical pole, from neutral grays in the center to maximum saturation at the outer limit of this line. Varying hues are shown as positions on the circumference of the circle, just as they are in two-dimensional color wheels.

Three-dimensional models proposed for this color solid include perfect spheres, pyramids, double cones, and asymmetrical rounded trees. [Figure 8.15] The latter, patented by colorist Albert Munsell, has been adopted by the National Bureau of Standards in the United States to standardize color names. Instead of words like *chartreuse* and *vermillion,* which mean different things to different people, this system uses a rather limited list of hue names and combinations, broken down into 267 blocks precisely named and numbered by mathematical variations in saturation and value as well as hue.

The resulting solid is asymmetrical, because at their maximum visible saturation some hues are more steps away from the gray axis and higher or

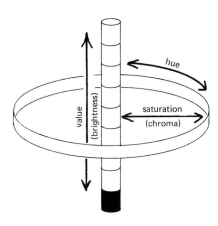

8.14 *above*
Model of a color solid with the three characteristics by which color can be measured: hue, value, and saturation.

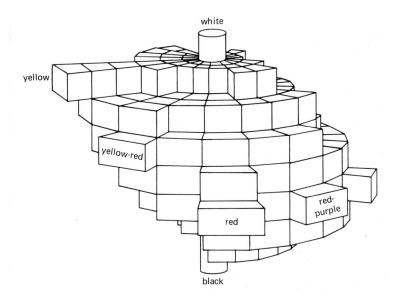

8.15 *left*
Munsell's three-dimensional model of a color solid.

8.16 right

In Munsell's color system, hues differ in their saturation potential and in the value step at which they reach maximum saturation (their location on the value axis).

lower on the value scale than others. Look at Figure 8.16. At its strongest, red is twice as many steps away from gray as blue-green (a). And if the value axis is numbered from 1 for black to 10 for white, yellow reaches its maximum saturation at 8, whereas purple-blue reaches maximum saturation at 3 —for pure yellow is a lighter color than pure purple-blue (b).

Although this and other color solids are useful means of standardizing color names and of demonstrating some color relationships, they should not necessarily be accepted as reality. Color wheels and color solids are a partial map of how we perceive colors. There is much that we do not yet know. Color theory is in a constant state of change, and different people perceive colors somewhat differently. Rather than being dogmatic about color theories, it is better to explore with an open mind what colors can do.

Computer Color Choices

Color exploration in computer graphics offers almost limitless possibilities. Sophisticated 24-bit computer graphics systems make available over 16 million possible colors from which to choose, far more than the human eye even can distinguish. These are all created from combinations of the three primaries—red, green, and blue-violet. In time, color generated by and mixed on the computer will have a tremendous effect on perception and use of color.

Existing images can be scanned into the computer's memory, and then the colors can be digitally manipulated by means of a **"color picker."** The

8.17 left
Photoshop screen with "color picker."

one shown in Figure 8.17 allows both numeric and visual methods for selecting and experimenting with different colors. Hue, saturation, and brightness also can be selectively altered, with independent choices for shadows, highlights, and midtones. Different areas can be handled differently.

To create the image shown in Figure 8.18, Douglas Kirkland began with a slide of Marilyn Monroe and then made a series of color choices that gave a less saturated outer band, very high values on the left side of the inner square, like washes of watercolor, and blues and purples replacing the original skin tones.

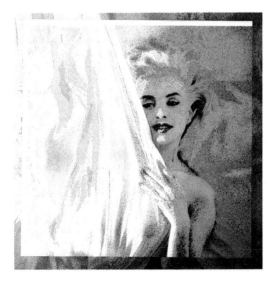

8.18 left
Douglas Kirkland. *Marilyn.* As manipulated in Photoshop.

Color Prejudices and Color Combinations

Prejudices toward a particular color theory can prevent us from making our own discoveries. Many of us are also victims of prejudices for or against particular colors and color combinations. In everyday speech we use color names in ways that implant or reinforce stereotypical ideas of their fixed emotional connotations.

Yellow, for instance, is often associated with negative connotations: A "yellowbelly" with a "yellow streak" is a disloyal coward, "yellow journalism" is distorted and sensationalist, a dishonorable discharge from the service comes on a "yellow paper." Red is typically associated with anger, passion, and warmth; blue and green with coolness and calm. Some of these associations probably come from typical experiences with our environment. We see fire and angry faces as red and therefore link the color with warmth and passion. We see skies as blue and therefore tend to link blue with the seeming coolness and distant serenity of the sky. But the sky at sunset may be red, an extremely hot object may glow white or blue, and to a person in an ice-bound land, red may bring a sense of peace. To limit ourselves to more familiar color associations, defining them as universals, is to overlook the exciting possibilities of presenting blue in a passionate, emotional design and red in a serene setting. We can do whatever we like with color, so long as we can make it work.

We may also be unwitting victims of prejudices toward certain color combinations. Color theorists have long tried to specify rigidly "the" combinations that work and how they work. Color combinations are said to produce a quiet, restful effect if they avoid strong contrasts and colors of high intensity. Two schemes thought to create this effect are *monochromatic* (using a single hue in a range of values)—as in Georgia O'Keeffe's *From a Day with Juan, II* (Figure 8.11)—and *analogous* (using three to five hues adjacent to or near each other on the color wheel, such as blue, blue-green, and green).

Color combinations with strong contrasts are thought to produce a bolder, more exciting effect. These include *complementary* schemes built on a pair of hues that lie opposite each other on the color wheel, such as the red and green of *Mastodo* by William Hawkins, a self-taught "outsider" artist. [Figure 8.19] **Double complementary schemes** are two adjacent hues plus the complements of each. **Split complementary schemes** use any hue plus the two hues to either side of its complement. *Triad schemes* combine any three hues that are of equal distance from each other on the color wheel. *Tetrad schemes* combine any four hues of equal distance from each other on the color wheel.

While there is nothing wrong with these color combinations, naming them does not begin to account for all the possibilities. How can the color combination in Franz Kline's painting be labeled? In Arthur Hoener's painting? Into what scheme do the purple, red-orange, and black of Tsutomu So's poster fit? Yet they all work. They all use color as a beautiful tool to titillate the eye. (See Figures 8.1, 8.10, and 8.20.)

8.19 left
William Hawkins. *Mastodon*. 1986. Enamel on Masonite, 3 × 4' (.91 × 1.22 m). Ricco/Maresca Gallery, New York.

8.20 left
Tsutomu So. Poster from *12th International Poster Biennale Warsaw 1988*. Courtesy the artist.

"Advancing" and "Receding" Colors

Another fallacy that commonly appears in writings about color is the notion that "warm" hues (such as reds) seem to advance, while "cool" hues (greens and blues) seem to recede. In actuality, any color can be brought forward or pushed back in space by the visual clues to spatial organization given with it.

Richard Lytle's painting *Early Sound Cantabria* overthrows the notions of advancing and receding colors by making the same colors advance and recede in the same painting. [Figure 8.21] Where reddish-brown areas are shown in the foreground (the bottom of the painting), associated with large objects, they seem to advance. The large reddish-brown area in the lower

8.21 below
Richard Lytle. *Early Sound Cantabria.* 1972. Oil on canvas, 7' × 7'6" (2.1 × 2.3 m). Collection of the artist.

a b

8.22 left
(a) Strong contrast in value and/or hue suggests spatial separation; (b) weak contrast in value and/or hue suggests spatial proximity.

center of the painting seems very close to the viewer. But in the next strip to the right, the reddish-browns shown in the upper part of the painting seem to recede as background.

Lytle contradicts the advancing-and-receding rule again and again by continually reversing the position of his colors, as though he were shifting colored films. The painting superbly holds our attention because we keep staring at it, trying to find some logic in the receding and advancing color forms. All is not confusion, however, for Lytle has used images that continue despite the color changes and has held the whole composition together by a chain of dark values.

Hues and values themselves may be used as clues to spatial organization. The greater the contrast in value and/or hue between two areas, the greater the distance between them will appear. [Figure 8.22] If heavy black type is placed on a white groundsheet (a), the type will seem closer than the ground-sheet, coming out toward us rather than occupying the same space as the page. This is because the black contrasts sharply with the white paper. The stronger the contrast between figure and ground, the farther apart they seem to be in space. As they approach each other in value and hue (b), they seem to exist more and more on the same plane.

Gugielmo Achille Cavellini's fictitious *Encyclopedia Article* about him-self seems to weave in and out as the colors fade toward the white of the page. [Figure 8.23] The juxtaposed lines of writing are in many places analogous in hue, supporting the visual logic of gradual value changes. Note that the three-dimensional spatial effect is more pronounced where the hues are shown side by side at the bottom, as colored crayons, than where they are used as writing surrounded by the contrasting white of the page.

The spatial effects of value contrast probably stem from our experiences with atmospheric perspective: We can see sharp edges on objects that are close to us. As things get farther away, their edges get out of focus; they seem to blend with the background.

Although type seems to come forward off a strongly contrasting ground because of our associations with the raised texture of typefaces, a figure that contrasts sharply with the ground may appear to be either very far behind it

8.23 right
Guglielmo Achille Cavellini. *Self Portrait Series* 1982. Collage and felt-tip pens on paper, 4'9⅜" × 3'5" (1.46 × 1.04 m). Courtesy GAC Archives, Brescia, Italy.

—like something seen through a hole in the groundsheet—or far in front of it, coming up off the groundsheet toward the viewer. In the absence of other visual clues, both interpretations are possible.

Roy Lichtenstein has used overlapping as a clue to three-dimensional relationships in his *Interior with Mirrored Closet*. [Figure 8.24] But the values are so flat and the shapes so simple that there is a fascinating interplay of ambiguities as to where these highly contrasting colors lie in space. There is a great deal of spacial tension between the dark and light diagonal lines.

8.24 left
Roy Lichtenstein. *Interior with Mirrored Closet.* 1991. Painted and printed paper on board (collage for painting), 30¼ × 36¾" (76.8 × 93.3 cm), board 40 × 47¼" (101.6 × 120 cm). Courtesy the artist.

"Subjective" Versus Local Color

Use of local color reports the actual colors of objects, as we would perceive them. *A Night in the Bike Store* is a tour de force of the ability of computer graphics to create the complexities of local color, including highlight and shadow effects. [Figure 8.25] By contrast, George Segal has used color subjectively in *Depression Breadline,* coloring flesh and hats a pale green to evoke the sickly, despairing, humiliated mood of the men waiting for the dole. [Figure 8.26] Douglas Kirkland has so manipulated the colors in his computerized *Marilyn* image (8.18) that they become utterly subjective, choices having little or nothing to do with local color.

The label **subjective color** is often misapplied to works in which the artist has observed and reported local colors very carefully. Monet's *Poplars* is an example of color use that is often mislabeled subjective. [Figure 8.27] Those who insist on seeing trees and grass as green are not looking carefully. Monet watched the colors of the same objects change as the light they reflected constantly changed. In *Poplars* he observes that the trees on a riverbank seen perhaps for a few fleeting moments during sunrise or sunset on a warm, hazy day actually appear to be blue and red rather than green

8.25 right
Eben Ostby. Still from *Red's Dream*. 1987.
Produced by Pixar, Richmond, CA.

8.26 right
George Segal. *Depression Bread Line*.
1991. Painted plaster, wood, and metal;
9′ × 12′4″ × 3′ (2.74 × 3.76 × .91 m).
Sidney Janis Gallery, New York.

8.27 *above*
Claude Monet. *Poplars.* 1891. Oil on canvas, 32¼ × 32⅛″ (82 × 81 cm). Metropolitan Museum of Art, New York (bequest of Mrs. H. O. Havemeyer, 1929, H. O. Havemeyer Collection).

and brown. A shadow is falling on them, darkening their values, while trees in the background are bathed in golden sunlight. Although these colors do not conform to stereotyped notions of what colors trees "are," the colors Monet used are truly local—the colors he saw—under specific, short-lived lighting conditions.

If you have trouble shaking the notion that objects always reflect the same color, a camera may help you "see" what your eye overlooks. Using

the same camera, with the same film, and standing at the same spot, take three color photographs of the same object outdoors at three different times during the day: one in the morning, one at noon, and one in the evening. When you look at the pictures, you may be amazed at the changes. At dusk, for instance, there is a surprising amount of red.

The same kind of tree will appear to be a different color not only at different times of day but also at different locations. In the mountains where the air is clear, a tree will reflect one color; in a smoggy area, with many particles in the air, the same kind of tree may be perceived as a different color. If you are interested in reporting true local colors, you must look with an open mind rather than being blinded by preconceived notions.

For decades, artists have been trying to expand our notions of what is real and true. And now scientists who probe what goes on at subatomic and cosmic levels are verifying that everything is in continual, interrelated flux—that our idea of matter as solid individual objects is just an illusion created by our inability to experience life at a submicroscopic or universal level. How then can we be dogmatic in defining the "true" colors of a landscape or even of a person's eyes?

Even when color reporting is photorealistically local, we may not see it as "color" unless it is associated with natural scenes—landscapes, still lifes. But Richard Estes finds color in city scenes of glass, chrome, and masonry. [Figure 8.28] To paint the local colors in highly reflective metals and glass is extremely difficult—and the result may seem strange and unfamiliar when brought to our attention in a painting, even though these color sensations are very much a part of urban existence.

8.28 right
Richard Estes. *Diner*. 1971. Oil on canvas, 3'4⅛" × 4'2" (1 × 1.3 m). Hirshhorn Museum and Sculpture Garden, Smithsonian Institution (gift of Joseph H. Hirshhorn, 1966).

Color Interactions

Not all artists report local color sensations of actual objects, of course. Some prefer to experiment with pure colors, freed from any association with the objects in the world of our experience. Their interest is in the exciting illusions that occur when certain colors are juxtaposed. Edges seem to disappear, shapes pop out or recede, afterimages appear where nothing has actually been laid down. These artists are dealing with a different kind of truth: what happens in the viewer between the eye and the brain. In a sense, this is the only real truth: what happens to *us*. We cannot know how someone living in the Sahara or in Siberia will respond to colors. We have no way of knowing if what we see as "blue" is perceived as the same color by other people, or whether their emotional responses to it are identical to ours. We can only know what we perceive, and—for us—this is reality.

Simultaneous Contrast

Some artists are fascinated with the effects color combinations produce on our visual perception apparatus. They are reporting what happens in their brains when they look at colors rather than what colors they think are reflected from objects they see. Certain optical illusions created with color combinations are based on a principle M. E. Chevreul called **simultaneous contrast.** In brief, complementary colors seem to intensify each other and vibrate along shared edges; if only one is presented, it seems to draw an afterimage of its complement from the background.

Our visual perception apparatus finds complementary hues so intensely contrasting that, when they are seen side by side, some kind of optical illusion almost inevitably occurs. Where they meet along an edge, our eye seems to be pulled back and forth between them so that the very edge seems to vibrate. This activity may even set up a new wavelength so that a third color can be "seen" along the edge. Along an edge between a highly saturated orange and a light blue, an optical illusion of a violet so pale that it is almost white might appear. In different lighting, the illusory color might look like a high yellow. At the same time the blue beyond the edge might appear darker and the orange so bright that it looks almost fluorescent, for complementaries intensify each other.

If we stare at a highly saturated color for a while and then look at a white area, an illusion of its complement will appear as a **negative afterimage.** If we stare at a green circle and then glance at a white area, we will "see" an afterimage of its complement red emerging as a red circle from the background.

Look at the white "explosion" in Figure 8.29, an ad for Bosch spark plugs, for fifteen seconds and then look at some white paper for a while. What colors appear? Try the same thing by staring at the "S" of the blue BOSCH and then looking at a sheet of white paper. As you stare at the letters, a glowing band may begin to appear against the adjacent red-orange.

8.29 below
Lucien Bernhard. Advertisement for Bosch spark plugs. 1914. Lithograph, 17⅞ × 25¼" (45.4 × 64.1 cm). The Museum of Modern Art, New York (gift of The Lauder Foundation).

8.30 right
Larry Poons. *Orange Crush*. 1963. Acrylic on canvas, 6'8" × 6'8" (2 × 2 m) square. Albright-Knox Art Gallery, Buffalo (gift of Seymour H. Knox, 1964).

And when you look at white, you may perceive the reverse: light orange letters glowing against a blue ground.

The physiological reason for the occurrence of these simultaneous contrast effects is not well understood. It may involve overstimulation and resulting fatigue of certain color-specific perceptual structures in the retina.

Some artists avoid complementary color combinations because they consider the effects too jarring. Others like to use these optical sensations to build active excitement in their works. Simultaneous contrast is the "subject" of Larry Poons's painting *Orange Crush*. [Figure 8.30] Because of simultaneous contrast between the blue of the circles and the orange of the background, several optical phenomena occur. Between the edges of the circles and the ground, a third "ghost" color may be perceived. It may appear as a thin band of pale but intense blue or yellow light. The blue also draws its complement out of the background, for afterimages of the blue circles begin to appear as circles of an intense orange against a ground that is nearly the same color. The color contrasts create so much vibration that viewers soon find it hard to focus on individual circles. If you let go and stop trying to focus,

you may begin to see a great multitude of both blue and orange circles. At some point you may be unsure of what Poons has actually put down and what is happening only in your head. The painting becomes a living thing, with myriad shapes appearing and disappearing.

Optical Color Mixtures

A second general form of color interaction used intentionally by certain artists is **optical mixing** of colors. Some of the Old Masters, such as Rubens and Titian, juxtaposed patches of paint of differing hues to coax the viewer's eye to mix them visually. Nineteenth-century French **pointillist** painters, such as Monet and Seurat, placed dots of unmixed colors on or near each other. When seen from a distance, the colors tended to blend to create new color sensations. [Figure 8.31] Instead of mixing their paints on a palette,

8.31 below
Georges Seurat. *Les Poseuses*. 1886-88.
Oil on canvas, 6'6¾" × 8'⅝" (2 × 2.5 m).
The Barnes Foundation, Philadelphia.

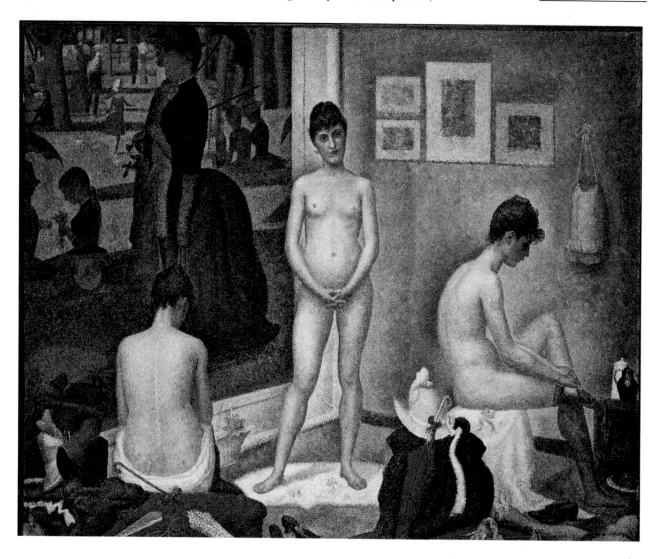

8.32 above left
Chuck Close. *Francesco I.* 1988. Oil on canvas, 8'4" × 7' (2.54 × 2.13 m). Courtesy PaceWildenstein, New York.

8.33 above right
Detail of 8.33.

the pointillists forced viewers to mix them optically. When it works, this technique evokes luminous color sensations that pulsate with life, for the colors are being continually created behind the viewer's very eyes.

Although this technique worked satisfactorily up to a point, the pointillists did not achieve optical color mixtures that approximated what could be done in mixing pigments. When the artists juxtaposed yellow and blue, viewers did not optically mix a green sensation from them. However, working from a different set of primaries and placing those colors in precise proportions against a light ground, Arthur Hoener created true optical mixtures. In his *Penuous* (Figure 8.10), orange and green truly mix to generate a third color sensation: yellow.

From a great distance—or in a small reproduction—Chuck Close's tenfoot-high painting of Francesco begins to resemble the local colors of the man's face, with saturation considerably heightened. [Figure 8.32] But at close range, as indicated in the detail view given in Figure 8.33, our eye cannot mix the dots of juxtaposed colors, so they take on an identity of their own. For the artist to work at this range with colored shapes that have their own identity and yet create an overall optical effect that can be perceived only at a distance is a striking achievement.

Another optical color mixture extensively explored by the color theorist Josef Albers involves **middle mixtures.** These are three analogous colors that relate to each other as parents and child: The third contains equal parts of the first two. A middle mixture of the hues blue and green would be blue-

8.34 left
Josef Albers. *Homage to the Square:
Intersecting Orange.* 1962. Oil on panel,
24 × 24" (61 × 61 cm). Collection of The
Josef and Anni Albers Foundation.

green. A middle mixture of dark and light values of the same hue would be a medium value. If the middle mixture is presented in the right proportions between the parents, their colors will seem to *interpenetrate* it. In *Intersecting Orange* from Josef Albers's *Homage to the Square* series, the middle mixture—the orange band—develops a red-orange glow near the yellow-orange and a yellow-orange glow near the red-orange, but is actually painted uniformly in a single color. [Figure 8.34] Albers's explanation for this optical mixture is that a color seems to subtract its own color from colors placed next to it. Albers's work clearly demonstrates the only absolute principle of color use: *Colors are affected by the colors around them.* We never see colors in isolation, but rather in juxtaposition to other colors which inevitably affect the way we perceive them.

Aware of the strong effects that colors have on each other when we look at them in juxtaposition, Barnett Newman created extraordinary visual sensations in his *Vir Heroicus Sublimis.* [Figure 8.35] As you look at the painting, many things begin to happen within your visual perception, if you give the optical sensations time to develop. The white stripe appears to develop a yellow cast because the bluish-red surrounding it subtracts blue and red from the white, leaving the only remaining primary: yellow. The other stripes change, too, as they interact with the red background. The center of

8.35 above
Barnett Newman. *Vir Heroicus Sublimis.* 1950-51. Oil on canvas, 7'11⅜" × 17'9¼" (2.42 × 5.14 m). The Museum of Modern Art, New York (gift of Mr. and Mrs. Ben Heller).

the painting may appear to be spotlit, reflecting a lighter value. Afterimages of the four stripes that Newman painted begin to appear all along the painting, turning it into a dynamic parade of ever-changing vertical stripes of many hard-to-describe colors. Some of these are strategically placed so that they may even overlap and mingle *their* color energies. Newman has thus evoked an extraordinary range of color sensations with an extremely limited palette.

This is the excitement of color. Even when you have only two or three colors to work with, you can coax from viewers a great range of responses. Depending on how you put them together, you can get much more from each color than a flat, unvarying reaction. To equate the possibilities once more with music, imagine the excitement of hearing a basso profundo sing in his lowest range and then hit a very high note. It can happen in music— and it can happen in color.

Color is so complex and rich in potential that the more you experiment with it, the more it will surprise you. The color theories of the past point to only some of the possibilities. It is up to you to explore further. The problems that follow merely scratch the surface. They are only appetizers, but we hope they will whet your taste for a full course on color alone.

STUDIO PROBLEMS

The color problems can be solved with computer, mixed paints, or silk-screened colored papers.

With computer, the results depend on the output device. The computer solutions shown here were printed on a Techtronic Phaser III, using Apple Macintoshes as hardware and Adobe Illustrator, Adobe Photoshop, and Aldus Freehand as software.

Color-Aid papers (available in many art stores or from the manufacturer: Geller Artist Materials, Inc., 116 East 27th Street, New York, NY 10016), come in a package of 202 6-by-9-inch sheets, including a range of values for twenty-four hues of the color wheel plus black, white, and grays. Such papers are ideal for classwork on color problems. If everyone is working with the same set of colors, solutions can easily be compared. The uniformity of the silk-screening insures that startling results can be attributed solely to color interactions rather than to discrepancies in the ways colors were painted. And having the colors already prepared allows experimentation with many color interactions. Since the silk-screened papers are rather expensive, you could share a package with someone else; half the quantity is more than adequate for the exercises here.

If you choose to paint your own papers for the cut-paper problems, you can paint an assortment of colors of varying hues, values, and saturations. It is best to paint large flat areas in uniform colors and then cut out the pieces you want to use. Otherwise you will not know whether the effects you see are a result of the color interactions or of inconsistencies in mixing and laying down the paints. Solutions to some problems can be painted directly. For practice in pigment mixing, we recommend acrylics, particularly Liquitex Modular Color Permanent Pigments, for they are formulated and labeled according to the precise steps of the Munsell system. A beginning set might consist of small tubes of six basic hues in value 5 (midway between black and white): red-purple, red, yellow, green, blue, and purple. You will also need a tube of white and a tube of black. And since yellow reaches its maximum saturation at value 8 and red at value 4, you might want to get a tube of value-8 yellow and a tube of value-4 red.

Colors can be used as they come from the tube or varied by mixing. The possible variations are infinite, but some changes are too subtle for the human eye to detect. To mix the secondary colors on the pigment color wheel (Figure 8.6), mix equal parts of adjoining primaries of maximum saturation and the same value. For tertiary colors, mix equal parts of a primary and an adjoining secondary (or two parts of one primary to one part of another primary). Innumerable additional hues can be created by combining varying amounts of two primaries. Varying combinations of yellow and red, for instance, will yield a great range of red-oranges and yellow-oranges.

Adding parts of the third primary—or mixing colors that lie at some distance from each other on the color wheel, such as orange and purple, which has the same effect—will subdue or kill the clarity of the colors

combined. Colors exactly opposite each other on the color wheel—complementaries—are particularly effective for subduing each other. A small amount of green will mute much of the "red" quality in a red. If equal amounts of complementaries are mixed (yellow and purple, for example) the saturation will theoretically be lowered to a neutral gray. In practice, it is difficult to create a neutral gray this way since it is not easy to isolate two colors that are exactly complementary to each other.

Tints, or lighter values of a hue, can be created by adding varying amounts of white to the hue; *shades*, or darker values of the hue, can be created by adding amounts of black. The exception to this rule is shades of yellow. When black is added to yellow the result is greenish. Yellow must be darkened by adding darker values of the tertiary hues on either side of yellow on the color wheel: yellow-orange and yellow-green.

Except in creating tints, pigment mixtures will be slightly darker than the pigments used, for mixing pigments is a *subtractive* method in which each color added subtracts its energy from the light reflected from the surface. To maintain the same value, it may be necessary to use slightly more of the lighter hue. Mixtures of light, by contrast, are *additive*: The more colors mixed together, the lighter the mixture will be.

Mixing the precise color desired is a somewhat inexact science. Because the range of possible hues, tints, shades, and saturations is very great, paint mixing is much like French cooking. Rather than following a standard recipe, many colorists add a pinch of this or that, adjusting the mixture by eye. Pigment mixing can be done on a homemade palette: a piece of glass with a sheet of white paper taped below, with the tape extending up to cover the sharp edges of the glass.

8.36 below
Covering a square with mixed colors. Student work.

8·1

COVERING A SMALL SQUARE WITH MIXED COLORS

Cover a 3-inch square with a series of similar shapes or similar strokes, each a different color that you have mixed. No two colors should be alike.

This problem introduces paint mixing—which can be quite complicated—in a way that allows you to enjoy experimenting with colors.

You could start by squeezing out a dab of each of the twelve Liquitex Modular Colors onto your palette. Using a small sable brush, apply a stroke —or shape—of each of these twelve colors somewhere within your square. Or you could work with just one of them at a time—the value-5 green, for instance—and try adding a little of this or that to it. You could mix in a bit of yellow, or blue, or white, or see what happens when you add a dab of each of those colors, or when you add a little more and then a little more of one of them. The more colors you combine, the duller the mixture becomes. The result of this experimentation will be a phenomenal range of color sensations. Figure 8.36 uses hundreds of different pigment mixtures.

The mechanics of this problem may predispose you toward working with gradations of hues rather than mixing an entirely new color for each stroke. If you have a little bit of paint on

your brush after doing a stroke, you are likely to mix it with something else rather than wash it all off. A logical pattern may evolve in the design, though this is not specifically required by the problem. In Figure 8.37, since many of the juxtaposed strokes are of nearly equal hue and light intensity, the edges between them tend to be lost. This ties the strokes together into a curling ribbon. In some places it seems to float above a greenish background, giving the design an ambiguous three-dimensional effect.

8·2
MAKING THREE COLORS LOOK LIKE FOUR

Choose two colors to use as groundsheets. Then find a third color that when placed on these groundsheets will develop different qualities on each. The result should appear to be a total of four different colors.

This classic color problem is one of the simplest ways of demonstrating that colors are affected by the colors around them. Silk-screened papers are the preferred medium, but hand-painted papers or acrylic paints can be used instead. The challenge is to create a hue change rather than a value change. To see what a *value* change looks like, select three sheets of the same hue: one a very dark value, one a very light value, and one a mid-tone in between. If you use the two extremes as groundsheets, placing the mid-tone across them horizontally, the mid-tone will look lighter at the end next to the dark color and darker at the end next to the light color. If you place a white sheet down the middle, covering all but the ends of this middle tone so that what you see of it is discontinuous, the illusion will work even better. [Figure 8.37]

This experiment will demonstrate what a value change looks like. It should not be confused with a *hue* change, which is what is called for in this problem. The third color you add should look like two actually different hues against the two groundsheets. To find three colors that will work together this way to create the illusion of four colors, try placing sheets from different hue families together—two vertically beneath and one horizontally on top, perhaps with an additional white sheet to separate the two ends visually. Keep experimenting with different combinations, replacing one sheet at a time, until you discover three that interact in this special way. Then cut pieces of them to make a simple design that appears to consist of four different hues.

Josef Albers held that to produce a hue change, the third color must be a middle mixture of the first two. Thus, if a blue and a green were used as groundsheets, a blue-green placed on them would appear bluish against the green groundsheet and greenish against the blue groundsheet. If complementary colors were used as groundsheets for their middle mixture, the gray would then appear to be different hues on each groundsheet.

Such changes work very well, but they are not the only possibilities. By trial and error, you may discover hue changes that are not based on Albers's rule. In the solution shown in Figure 8.38, the student has created a spectacular hue change in a third color that is not a mixture of the first two. If you

8:37 *above*
An optical value change.

8.38 right
Making three colors look like four. Student work.

are not convinced that the small pieces are all the same color, cover the design with a piece of paper with two peepholes cut so that you can see the third color and none of its surroundings.

This student came up with this solution because no one told her there was only one way to solve the problem. Theoretically it should not work, but it does. If you can treat traditional advice about design as helpful hints rather than as rules carved in stone, you too may discover exciting solutions that liberate design from a limited repertoire.

8.3
INTERPENETRATION OF COLORS

8.39 below
Interpenetration of colors. Student work.

Create a simple design with two colors, plus a third that, when placed between them, will give the illusion that the first two are reappearing on it.

This problem sounds difficult. But if you can find rather closely related colors for the ends and a middle mixture of sorts for the center, a surprising optical mixture may develop. Each of the end colors will seem to jump across the middle band to reappear (although perhaps in a somewhat muted form) on its far side.

In the solution shown in Figure 8.39, the student has used a red-violet, a red-violet-red, and a darker, highly saturated red. This combination works so well that it is almost impossible to see the middle band as a single flat color. It appears to be almost red on the left side, gradually changing to a pale red-violet on the right. The only way to see the true color of the middle band is to cover up the other colors. Even they become somewhat active in this solution: A muted version of what happens in the middle band seems to occur also on the red-violet band to the left and even (if you look at it long enough) on the red band to the right.

While this student has used three colors that are next to each other on

the color wheel, there are other possibilities. Instead of moving around the hue circle, you might try going toward the center of the color solid. For example, a neutral gray, a grayed green, and a green produce the interpenetration phenomenon. You might even try going through the middle and coming out the other side, working from one color through gray toward its complement. How far apart should the steps be? Can you go from a highly saturated color to gray to its highly saturated complement, or must you use grayed versions closer to the middle for each? If you use analogous hues on the color wheel, how close must they be? Should all three be of the same value? Different color combinations seem to

work in varied ways. The only way to find out what works is simply to experiment—to look and see what happens.

In addition to the colors you choose, the success of your solution will depend on the proportions you use of each color. Some color combinations seem to create an interpenetrating illusion only if the band between them is relatively wide. Others work better if they are separated by a narrow band. To find a combination that works well, keep overlapping different colors on each other, shifting their position and substituting sheets of different hues, values, or intensity until you find three that interact in this exciting way.

8·4
VIBRATING EDGES AND AFTERIMAGES

Create a design with two colors that, when placed together, form vibrating sensations along the edges where they meet or afterimages against a white background.

This problem is based on the simultaneous contrast of complementary colors. When juxtaposed, their color sensations create intense optical effects. Edges between them will often seem to vibrate. Depending on the image used and the amount and color of the background left exposed, a negative afterimage may also appear. Such effects may be used to increase the excitement of a design. Even if you find these effects visually disturbing it is important to know about them. If you

know how to create them, you will also know how to avoid them.

These optical phenomena occur fairly readily when highly saturated complementary colors are combined. But near-complementaries work, too. And even somewhat subdued colors may gradually produce vibrating edges or afterimages. The solution shown in Figure 8.40 does not use high-intensity colors. Both the orange and the blue are several steps lighter and/or grayer than their optimum saturations. Yet, because they are complementaries, combined in proportions that seem to work, an exciting set of sensations begins to occur if the design is viewed steadily.

Around each of the blue dots, vibrating bits of blue extend here and there into the orange background, while some of the orange seems to penetrate the outer edges of the blue circles themselves. If you look at the area covered with blue dots for a while and then glance at the "empty" orange area, you may see rows of glowing circles of a brighter orange as afterimages

8.40 below
Vibrating edges and afterimages. Student work.

of the blue circles. Some illusionary circles may also fill the open spaces within the dot-covered area. After staring at the solution for some time you may not be sure whether what you are seeing is illusion or images that the student has actually laid down.

The design itself adds to this illusion, for it almost seems as though some dots have jumped out of the pack to reappear in a different color beyond. Whereas the first two problems were color-discovery problems focusing on searches for combinations of colors that work together in certain ways, in this problem the design itself deserves some attention. Part of the reason this solution works despite the relative dullness of the complementaries is the choice of small circles, images the eye can easily repeat in the empty space provided.

8.5

OPTICAL TRANSPARENCIES

Using two or more opaque cut-paper, painted, or computer-printed shapes of different colors, create the illusion that they are transparent and overlapping each other at some point.

In order to give opaque paints or colored papers the illusion of being transparent, you must imagine what they would look like if they were optically mixed. What color would appear if both original colors were pieces of transparent film and laid on top of each other? The result will not be an exact middle mixture of the two, for this would indicate that they were both occupying the same space at once. For one to seem to be on top of or in front of the other in space, its characteristics must predominate in the mixture. In Figure 8.41, the upper orange triangle seems to overlap both the yellow ones below, for where they extend across each other's boundaries the mixture is more orange than yellow. These transparency effects work even when the color that appears to be on the bottom has actually been placed on top in preparing the design.

To create the solution shown in Figure 8.42, the student used the computer's ability to calculate layers of transparencies. With this relatively low-resolution output, you can study the overlapping areas with a magnifying glass to see the actual color mixtures of adjacent dots of CMYK (cyan, magenta, yellow, and black) colors. Does

8.41 below
Optical transparencies. Student work.

the spatial effect work as a flat blue-green rectangle overlapped by other colors, or do the mixtures bring it forward or push it back visually in different places? Do you find the arithmetically correct computer-rendered transparency effects more convincing or less convincing than the solution done by eye and executed in paints in Figure 8.42?

In addition to reflecting interesting and plausible color mixtures, transparency effects can create unusual spatial illusions. Overlapping, of course, suggests that one figure is in front of another. But differences in value and position on the page can contradict the overlapping clues to positioning. So long as they have some thread of consistent logic (in this case, the plausibility of the transparency effects), such ambiguities may hold viewers' attention as they try to make sense of the visual puzzle presented.

In solving this problem, be neat. If edges are not matched with preci-

8.42 left
Optical transparencies. Student work on computer.

sion, the viewer's eye will not follow through to "see" a single shape where two different colors have actually been pieced together to create the illusion of a transparency.

8·6
A CONSISTENT VALUE CHANGE

Create a design in which the values of all colors are raised in the same degree in a certain area. The effect should be that of light from a window or some other light source falling across the image.

Whether you are working with representational or nonrepresentational images, you often may want to indicate the effects of light falling across an area. The only way to make this work is to change all colors within the area by the same amount. If one color is lightened by four value steps, all other affected colors must be raised four steps as well. If you start with what appears to be a flat design and then raise some colors two steps and some five steps, the "lighted" area will not make spatial sense. Rather than appearing a flat plane, it will seem to advance here and recede there.

To be truly representational, "shadowed" areas should also be slightly less saturated than "lighted" areas, for colors appear pure only in the light. To lower the saturation of a hue by pigment mixing, add a slight amount of the hue's complement. If you are solving this problem with silk-screened papers, search for a color that is lower not only in value but also in saturation.

8.43 *above*
A consistent value change. Student work on computer.

Because of associations with the world of our experience, we tend to interpret darker colors as heavy and solid, lighter colors as airy, floating, almost disappearing. This range of effects is possible even when the number of hues is limited.

In the solution shown in Figure 8.43, the lighter section seems plausible because the values are uniformly raised relative to their counterparts on the outer border. If they were not, the line where the two sets of values meet would not appear to be a single straight edge. Some colors might seem to pop out rather than existing on the same plane.

8·7
DISTANCE BETWEEN EDGES

Choose a color for use as a groundsheet. Then, using the same hue, gradually change its value in strips of uniform width placed on the groundsheet at uniform intervals. Do a second design in which you change the hue of the strips you lay on a groundsheet. In both cases the effect should be an apparent change in the distance between the strips and the unchanging background.

Another possible application of what you learn in doing this problem: You can change the psychological effect of a work by changing its values.

Even in the absence of other clues to spatial organization, differences in value and hue between edges of areas will affect the viewer's sense of their spatial relationship. To illustrate this point, this problem requires that you eliminate all spatial cues except value and hue and then see what happens when these are varied.

The student whose work is shown in Figure 8.44 first used a rather dark purple and changed the values of strips on it from a purple almost as dark as the background to one several steps lighter. Although the strips resemble their neighbors in value, they become more and more unlike the groundsheet as they approach the center. As this contrast sharpens, the distance between figure and ground seems to increase. If you see the dark purple as background, the lightest purple strips in the middle will probably seem closer to you than the ends, which are nearly the same value as the dark purple background.

The second band shows a hue change from red-purple to a yellow against a dark blue-purple background. Here there is a contrast in values—culminating in the light yellow compared to the dark blue-purple—made even sharper by the strong contrast in hues. Yellow and blue-purple are so different that they are almost opposite each other on the color wheel. This strong contrast makes the edges in the center so sharp that this area seems closer to us than the ends, which di-

minish in contrast to the point that fig-
ure and ground are almost the same.
The center almost seems to bow out at
us. If you have trouble seeing this ef-
fect, try using your hands or dark sheets
to cover up the white page, thus can-
celing any effects it might have on your
perception of the work. What color of
mat might be used to increase the spa-
tial illusion?

In solving this problem, you may
show only one value change and one
hue change, or you may use a long
sheet to show many undulations in and
out in space. The background color
may be dark with strips on it gradually
getting lighter, light with strips becom-
ing darker, or a mid-tone from which
you work both ways. In the latter case,
some of the strips might seem to come
closer to you than the groundsheet;
others might seem to recede into it.
The point of the problem is to learn to
use value and hue relationships be-
tween colors to control their apparent
spatial relationship.

8·8
OPTICAL COLOR MIXTURES

Choose three or more colors to use
in wide bands as ground colors.
Then use strips of another color to
create optical color mixtures when
put on the original bands.

In this problem, exploration of the
effects colors have on each other is ex-
tended by making pairs of colors inter-
act optically, so that the one color that

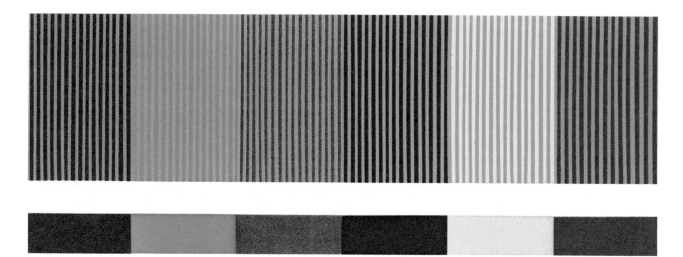

8.45 *above*
Optical color mixtures. Student work.

remains constant from one pair to the next actually seems to change. In some cases, you can make the ground colors seem to change also. And if you use the right colors together in the right proportions, you may even create the illusion of a third color mixture that is different from either the ground or the strips. Review the discussion of optical mixtures for clues to varying ways you can make viewers mix colors optically. Cut papers are preferable to paints for this problem, to verify that the effects are truly optical mixtures rather than variations in pigment mixtures.

The student whose work is shown in Figure 8.45 has used six ground colors and a seventh—a medium green—as strips. Shown below in isolation, they appear somewhat different than they do as they mix optically within the study. The green seems to change slightly from one band to the next—a little bluer here, a little yellower there, somewhat lighter here, somewhat darker there. The colors used behind the green also take on different qualities. And when seen from a distance, the green strips seem to merge with the colors behind, producing strange new mixtures. These optical mixtures are even more striking when you look at the design from a slight angle rather than straight on.

8·9
FOUR SEASONS

Choose four colors. Use them in different amounts to make four designs that look entirely different. In earlier problems, you were continually faced with one of the few color rules that are always true: *Color is affected by the colors around it.* Here you experiment with another truth: *You can make color do anything you want if you use it in the proper proportions.*

Mathematically, there are twenty-four possible ways four colors can be combined. In each combination, one is used in the greatest amount, one in the second greatest, one in the third greatest, and one in the least. When these proportions are changed, the results can be as different in feeling as

spring, summer, fall, and winter in a temperate climate. This understanding is particularly useful in contexts that require a limited color palette.

Changing the proportions in which colors are used will not automatically change the feeling of varying designs, however. In the solution shown in Figure 8.46, the fitting together of shapes and the unusual color juxtapositions are intriguing. Nevertheless, even though a large area in each design is covered by a different color, the four designs are not as different in feeling as they should be in a successful solution to this problem. Perhaps it is because the color combination is unusual that the same harmonies are seen in each of the four designs. The red and the yellow especially draw attention, for these colors are not often used together. Their relationship seems to dominate the design at the top and the third design down, and it can be picked out again in the mostly blue and the mostly brown designs.

To make the designs less similar, the student could have used less of the yellow, particularly in the mostly red design. If you cover up the wide lower bar of yellow in this design and perhaps a piece of the yellow in the "brown" design, you may begin to see the four variations as truly different in character.

It is possible to create four quite different designs by varying *only* the color proportions while holding other elements of the design constant. Even if the lines and shapes are identical from one design to the next, their colors can be varied in such a way that each seems quite different. This understanding may be useful in applications such as silk-screening or fabric printing: To create a totally different effect, you need only change the placement of particular colors.

8.46 below
Four seasons. Student work.

8·10
THE BEZOLD EFFECT

Make two five-color designs that are identical except for one color. By changing that one color, create an effect in the second design very different from that in the first.

This problem is based on a discovery by the nineteenth-century German meteorologist Wilhelm von Bezold, who made rugs as a hobby. He found that he could create what looked like a very different rug by changing a single color in his rug designs. This phenomenon is therefore sometimes referred to as the *Bezold effect.*

Now that you have had some experience with colors changing each other's effects and with the results of using colors in different proportions, you can combine these two principles to extend the possibilities of the Bezold effect. That is, you can choose colors with an eye to how they will change when juxtaposed with a different color and when color emphasis in a design changes as proportions are shifted.

In Figure 8.47 both designs are identical except for the shift from blue-purple to yellow. This change alters the appearance of the two versions dramatically, for whereas the dark blue-purple tends to merge with the red-purple, especially where values are similar, the yellow is such a contrast in hue and value that it springs forward from the background.

When many hues are used, with only one changing, you can see the

8.47 above left
The Bezold effect. Student work.

8.48 above right
The Bezold effect. Student work on computer.

great effect that colors have on each other. In Figure 8.48, solved on computer, the predominant color changes from yellow to blue-purple; the student has also flipped the design to increase the impression of change. The brown stripes and blue stripes undergo major visual alterations when presented against the blue-purple; the magenta stripes seem least affected.

The easiest approach to this problem is to change the color that covers the largest area in the design. Sometimes it is possible to change the total effect of a design by changing a color that covers less area. You might want to see if you can get a color change

going that works so well, it is stronger than the effects of colors used in larger portions. Anything learned in this color unit can be used to create different color sensations, such as using three colors to look like four, using interpenetrating colors, evoking vibrating edges and afterimages with complementaries, creating illusions of optical transparencies, changing values or spatial relationships, or making optical mixtures of colors. While you cannot use everything you have learned in a single design, you should by now have a rich repertoire of design tools from which to create any effect you desire.

8.49 opposite page
(a) Stuart Davis. *Midi.* 1954. Postcard. Original: Oil on canvas, 28 × 36⁹⁄₁₆″ (71 × 92 cm). Wadsworth Atheneum, Hartford (Schnakenberg Fund). (b) Converting a masterwork: exact copy. Student work. (c) Converting a masterwork: different colors. Student work.

8•11
CONVERT A MASTERWORK

Find a good reproduction of a painting you like. First copy the mas-

terwork exactly, color for color. Then create a second copy in which you duplicate the image but change the colors. You can use either mixed paints or cut papers.

In solving this problem, modern masters are easier to work with than older ones. Nevertheless, the first part

of the problem is very much like the old nineteenth-century way of learning to paint: You are to copy the masterwork exactly, color for color, brush stroke for brush stroke. You can learn much about what has gone into a good work of art by trying to duplicate what the artist did.

The second part of the problem diverges from the old copying method. This time you duplicate the design but change the colors, reinterpreting them to your own tastes. Values and spatial relationships should stay about the same but the hues used should differ from those in the original. Through your own color choices you should try to create something that is as good as—or even better than—the original.

The student whose work is shown in Figure 8.49 chose to duplicate Stuart Davis's *Midi*. Davis is a good choice for this problem because he works with the interlocking of flat colors. The student therefore avoided having to duplicate a lot of brush strokes.

Mixing precise imitations of colors (and most of these are mixed colors, not straight-from-the-tube colors) is surprisingly difficult. Since colors are affected by the colors around them, it is hard to isolate exactly what a color you see "is" and then search for a paint mixture that matches it precisely. Nevertheless, this student duplicated Stuart Davis's colors so well that it is very hard to distinguish the student's overpainted copy (b) from the postcard reproduction (a).

The second reinterpretation (c) is done with intricately cut silk-screened papers in colors of the student's own choosing. The student has used more intense colors, more active color combinations (such as red and green, which create vibrating edges where they meet), and a gray that seems to have more substance than Davis's white that it replaces. Some students

a

b

c

have felt that this rivals or even surpasses the original in creating the feeling of many shapes in an urban landscape vying for the same space. The high-contrast effect of midday lighting may come across a bit better in the original, though, for Davis has juxtaposed the greatest value extremes possible: black and white. But do intense contrasts between complementaries serve somewhat the same function in the student's version?

8·12
LANDSCAPE OR PORTRAIT IN COLORS

Do a landscape or a self-portrait from nature, using silk-screened papers, painted papers, found papers, or paints. The colors you use need not be local colors, but your color decisions should be made as you look at your actual subject.

Earlier, this chapter reproduced landscapes done by Matisse and Monet in surprising colors while working from nature. Monet used the actual local colors he saw under unusual lighting conditions; Matisse isolated single color notes and presented them in full intensity. You may choose to carry color choices even farther from the local colors of objects toward more symbolic uses. One student chose to represent her own face as a series of peach-and-yellow areas, with bright greens and blues for the shadowed areas. The hard edges where these strongly contrasting colors met helped give a chiseled modeling to her cropped, slightly abstracted contours. And the unexpected color combinations gave a dramatic sense of her flamboyant personality. It worked, even though some of these colors are not those we usually associate with the human body.

The self-portrait shown in Figure 8.50 is far more representational. It really looks like the student who created it, and the colors seem logical at first glance. Yet the colors he has chosen for his face—olive drab, grays, even

8.50 near right
Portrait in colored papers. Student work.

8.51 far right
Free study. Student work.

black—are not those typically associated with a "white"-skinned person. They seem to make sense nonetheless as a muted version of the range of "white" skin tones. These subdued colors are an appropriate choice, for the artist is a solemn person with a quiet sense of humor.

If you look closely, you will see that his hair is done in a great variety of hues—grays, ocher, browns, black, even a bit of purple. On the shadowed right side of the head, they are given in portions small enough to mix optically into a sort of brown with multicolored streaks. On the lightened left side of the head, the contrasting colors are presented as larger shapes so that the individual colors are seen. The bits of white along some edges are the result of tearing the silk-screened papers, exposing some of their white base, or of leaving some of the white groundsheet showing. These occasional flecks of white add paintlike highlights to the portrait and give hints of life to its otherwise somber darker values and muted hues.

8·13
FREE STUDY

Create a free study in color, using any materials.

Free studies can be done throughout this course as a complement to more structured problems. In contrast to the regular problems, they are subject to no stated restrictions and call for no specified end product. The only suggestion is that you draw on things you have already learned in the course to create highly personal works of art.

Free studies can be done in any colored medium or combination of media, including paints, papers, and found materials. The free study shown in Figure 8.51 is done with leaves presented against silk-screened papers. It is very difficult to use found materials in such a way that they do not stand out and call attention to themselves as isolated, foreign elements in a design. Leaves particularly have distinctive shapes that viewers immediately single out as *leaf*. To use found materials well you should usually blend them in so that viewers do not really notice what they are at first. Whether you apply leaves or magazine pictures or fabric or tin cans to your designs, viewers should see these materials only secondarily. Discovering them then enriches appreciation of the work. Based on this criterion, how well do you think the solution shown in Figure 8.51 works?

This free study is only a small sample of what you might do with what you have learned thus far. Through a series of problems you have begun to explore the possibilities of line, shape, form, space, texture, value, and color. You can now use them freely to discover and express what pleases or interests you personally. You have developed a basic vocabulary. Now you can start trying to make poetry in two dimensions. The final chapter will broaden your vocabulary into a third dimension.

9

THE THIRD DIMENSION

9
THE THIRD DIMENSION

The work we have examined thus far exists in only two dimensions: the length and width of a flat surface. Three-dimensional art has an added dimension: depth in space. These pieces are vastly different from two-dimensional works, for instead of suggesting spatial illusions from the walls of homes and galleries and pages of books and magazines, they are part of our three-dimensional lives. They range from sculptured works of art to constructed objects in our physical world.

Degrees of Depth

9.1 above
Frank Gallo. *The Face.* 1977. Cast paper, 40 × 32¾″ (102 × 83 cm). Courtesy the artist.

The distinction between two-dimensional and three-dimensional works is not very dramatic in the flattest of three-dimensional pieces: **low relief.** In Frank Gallo's very low-relief casting of a face the contours of the face and hair barely come off the flat surface. [Figure 9.1] Any work that truly occupies depth in space, no matter how shallow, should nevertheless be considered three-dimensional.

Another form of three-dimensional art is **frontal** art, which is designed to be seen from one side only, such as a piece of jewelry, a stage set, a dance work, or certain installation pieces. The same is true of two-dimensional art, but the staged arts are not at all flat. In Meredith Monk's production of *Vessel,* shown in Figure 9.2, the stage is rounded toward the audience, which is viewing a stage set occupying many different levels in space. Even a single dancer on a bare stage is a piece of three-dimensional art.

The most familiar form of three-dimensional art is work meant to be viewed in the **full round.** That is, we can walk all around these pieces or turn them in our hands to view them from every side. To see all of David von Schlegell's polished aluminum sculpture shown in Figure 9.3, viewers have to walk a great distance. The piece itself is 40 feet long and 5 feet wide. To get a full sense of it, one must stand very far from it at times and also walk in very close, bend down, and look up to see its understructure.

At the opposite extreme from low-relief work is three-dimensional art that actually surrounds the viewer. The soaring interior of a Gothic cathedral such as that at Rouen, France, is designed to surround worshipers with an uplifting sense of divine splendor. [Figure 9.4] A vast expanse of plains and sky is drawn into Walter De Maria's *Lightning Field.* [Figure 9.5] Its 400 stainless-steel poles, each about 21 feet high, are placed 220 feet apart, covering a large area of flat land in New Mexico. Viewers' emotional reactions to this earthwork are highly personal. It may evoke an eerie sense of

9.2 above
Meredith Monk. *Vessel.* 1981. Set design
realized by Tony Giovannetti and Georg
Herold. White muslin and lumber; approx.
65' (20 m) wide, 35' (11 m) deep,
20' (6 m) high. Schaubuhne am
Halleschen Ufer, Berlin.

9.3 below
David von Schlegell. Untitled. 1967.
Polished aluminum, 6'6" × 40' × 5'
(1.8 × 12.2 × 1.5 m). Collection of Nina
Freudenheim Gallery, Buffalo, New York.

9.4 above
Rouen Cathedral, France. Nave. c. 1250.

.5 above

Valter De Maria. *The Lightning Field*. Albuquerque, New Mexico, 1977. A permanent earth sculpture; 100 stainless steel poles with solid stainless steel pointed tips, arranged in a rectangular grid array, spaced 220' (67 m) apart; average pole height 20'7" (6.3 m); pole tips form an even plane.

loneliness, a heightened awareness, a feeling of insignificance, or extreme wonder or terror when the poles act as lightning rods for awesome electrical storms. To be so totally surrounded by a designed environment is quite a different experience than to gaze at a two-dimensional picture in a gallery or a book.

Looking at Photographs of Three-Dimensional Art

Something is always lost in looking at a photograph of a work of art instead of the original. This loss is particularly significant in two-dimensional photographs of three-dimensional works meant to be viewed in the round. Even

9.6 right
Constantin Brancusi. *Mlle. Pogany II*. 1920. Polished bronze, height 17¼″ (44 cm), width 7″ (18 cm), depth 10″ (25 cm). Albright-Knox Art Gallery, Buffalo (Charlotte A. Watson Fund, 1927).

9.7 below
Constantin Brancusi. *Mlle. Pogany II (de Profil)*. c. 1920-1921. Photograph by the artist. Private Collection.

if several photographs of a piece taken from different sides are available, one still cannot grasp what it is actually to move around the sculpture, watching the flowing change of its contours, or to walk through the building, or sit in the chair, except by guess and imagination.

The next best situation to seeing the original of a three-dimensional work of art often is to look at a photograph of the work taken by the artist. Such a photograph, though it does not allow us to examine the work in the round, at least reveals the artist's mental image of the piece. This image may be quite different from what we see in a standard photograph. For example, Figure 9.6 is the typical view presented by photographers of Brancusi's polished bronze sculpture, *Mlle. Pogany II*. Though well designed and executed, this full-face photograph gives an entirely different idea of the sculpture than one taken by Brancusi himself, shown in Figure 9.7, about the time the sculpture was made. It is difficult to recognize that the two photographs are taken of the same sculpture. The owlish grace of the standard photograph, taken from the front, gives no hint of what Brancusi saw from the side. His photograph shows the extreme forward bend of the young woman's head, suggesting an intensely alive human being as compared to the first photo, which is coldly elegant.

Photographs of three-dimensional work are therefore subject to severe limitations. They do not allow the work to be experienced in the round. They rarely manage to convey the weight and scale of a work. And, unless the photograph was taken by the artist, they may present a view altogether different than the one the artist would have chosen to convey in two dimensions the three-dimensional essence of the piece.

Working in the Round

Aware of the limitations of what can be shown in a two-dimensional photograph of a three-dimensional work, let us now look at some special considerations involved in working in the round. These include the need to involve the viewer, consider the effects of gravity, and strike a balance between form and function.

Involving the Viewer

To appreciate a three-dimensional piece fully, the viewer must take the time to examine it from all sides. The challenge to the artist is to make viewers want to investigate a work rather than merely to glance at one side and move on. Like a good book, a good three-dimensional work should capture our attention, make us want to read on.

One way of coaxing viewers to take the time to explore a three-dimensional work is to suggest changes that can be seen only in the round. In a sculpture, a contour that disappears from view, unfinished, may lead us around a piece to see what becomes of it. In Brancusi's side view of *Mlle. Pogany II,* the fluted arches of the back and "eyebrow" would lure us into walking around both sides to see the continuation of these contours.

Approaching Joanna Przybyla's *Preserve,* one would want to walk all around the splintered trees to see what they look like from all sides. [Figure 9.8] Not only are the forms odd and compelling, but they also draw us in by raising questions in our minds: What is going on here? Why splintered

9.8 Left
Joanna Przybyla. *Preserve.* 1988.
Splintered trees, iron. Zamoyski's Palace
Gardens, Warsaw.

9.9 *above*
Chie Matsui. Untitled. 1989. Lead, glass, mirror, brick and mixed mediums. Installed at the National Museum of Art, Osaka, Japan. Courtesy the artist.

trees? Przybyla walks daily through a forest of near-primeval trees to find such weather-beaten, storm-shattered, downed trees. Here she has assembled their stark forms with metal braces and installed them outside, among younger, robust trees. Puzzling over why she has done so keeps the viewer's attention on the work.

Another way of engaging people's attention is to have viewers function in, on, or with the object. In Chie Matsui's installation, shown in Figure 9.9, we can feel what it is to walk up its shallow, broad steps, and from that raised perspective, look out, look down, feel the enclosing walls, and run a hand over the uneven "railing."

Gravity

In addition to controlling viewers' physical movements, three-dimensional works also must contend with the principles of gravity. We accept the laws of gravity in our everyday lives and are accustomed to accommodating our actions to the weight of objects and the understanding that they will drop and perhaps break if released. What is less obvious (simply because gravity is so

familiar that we take it for granted) is that it may be very difficult to create three-dimensional artworks that withstand the pull of gravity. To make a sculpture stand firmly without toppling over, to design a building that will not cave in when walked in or snowed on or that will not collapse in high winds, to carve an outstretched wing that will not fall off from its own weight—these are truly difficult challenges.

In some cases, the necessity of taking the effects of gravity into account provides part of the excitement of a three-dimensional work. Pieces that seem to defy gravity—like helium-filled balloons or objects held up in space by opposing magnetic fields—are intriguingly novel, because familiar objects do not float. A cantilevered projection of a building provides a sense of dynamic tension, of one force just barely outweighing another in an exciting balancing act. Bruce Nauman's hanging *South America Triangle* gives us a very uneasy feeling. Will it fall? Will it tilt? Is it a threat to our safety if we walk beneath it? [Figure 9.10]

Rather than defying gravity, some three-dimensional pieces draw attention to the downward pull of gravity by exaggerating its force. Claes Oldenburg's soft sculpture of a pay telephone humorously pretends to illustrate what happens to a rigid object when it gives up its fight with gravity. [Figure 9.11]

9.10 below left
Bruce Nauman. *South America Triangle.* 1981. Steel, cast iron, wire; 14'⅛" × 3'3" × 14'⅛" (4.29 × .99 × 4.29 m), suspended 5'3⅞" (1.62 m) above the floor. Collection Hirshhorn Museum and Sculpture Garden, Smithsonian Institution, Washington (gift of Joseph H. Hirshhorn, 1966). Installed at the Museum Fridericianum, Kassel, June 18, 1982.

9.11 below right
Claes Oldenburg. *Soft Pay Telephone.* 1963. Vinyl filled with kapok, mounted on painted wood panel; 46½ × 19 × 12" (118 × 48 × 30 cm). Solomon R. Guggenheim Museum, New York (gift of Ruth and Philip Zierler).

Form Versus Function

Just as an artist may turn the apparent disadvantage of working with gravity to positive ends, the necessity of designing three-dimensional pieces with function in mind may be used creatively. Designers of the implements of everyday living—buildings, cars, furniture, cookware, clothes—must balance beauty of form with such utilitarian considerations as cost, comfort, and safety. Which is stressed more—form or function—and how—depends on the artist, the culture, and fashions of the time.

In furniture, the turn-of-the-century chair shown in Figure 9.12 is cherished by some collectors for its delicate beauty of form. Yet many Americans are afraid to sit on such pieces because they appear almost too fragile to be functional. Instead, we tend to furnish our houses with sturdy upholstered armchairs in which we can comfortably slouch or curl up. If these chairs happen to have a certain elegance or grace of form, so much the better, but function is typically the first consideration. This approach, institutionalized by twentieth-century schools of design such as the Bauhaus in Germany, is epitomized by the dictum "Form follows function."

Overemphasis on either form or function can be carried to extents that some people judge negatively. The most functional dinner plate might be square for efficient use of storage space. Yet we are so accustomed to seeing

9.12 above
Carlo Zen (attributed to). Side chair. c. 1900. Fruitwood, mother-of-pearl, brass, white metal; 37 × 14¼ × 14⅜" (94 × 36 × 37 cm). Cooper-Hewitt, National Design Museum, Smithsonian Institution (gift of Donald Vlack).

9.13 right
Gerrit Rietveld. "Red and Blue" chair. 1918. Painted wood; height 34½" (88 cm), width 26" (66 cm), depth 33" (84 cm). The Museum of Modern Art, New York (gift of Philip Johnson).

9.14 *above*
Charles William Moss. *Optimum 350.*
1978. Cotton and aluminum tent, 12 ×
24 × 24′ (3.7 × 7.3 × 7.3 m). Moss Tent
Works, Camden, Maine.

round plates as "normal" and aesthetically pleasing that many buyers would reject a square plate as ugly no matter how functional. On the other hand, certain styles in fine art have at times been extended to the functional arts in an effort to make architecture, furniture design, interior design, and even city planning mirror the philosophy of the art form. Such was the case with the *De Stijl* (The Style) movement. Like the paintings of its most famous member, Piet Mondrian, this art movement was based on the use of straight lines, right angles, and a restricted color palette as representations of human ability to discern and chart the logic of the universe. Gerrit Rietveld's red-and-blue chair, shown in Figure 9.13, is a prime example of how nonfunctional this form-stressing approach could be. Artistically, the chair would look just right next to a Mondrian painting, but some people find it extremely uncomfortable to sit on.

Function is not a consideration in most three-dimensional work designed only to be viewed; aesthetic form is often of secondary importance in the mass-produced artifacts of an industrial society. Yet when a designer manages to blend form and function, producing an object that is both beautiful and useful, there is reason for rejoicing.

Charles William Moss's *Optimum 350* tent, pictured in Figure 9.14, is such a piece. Its contours and lines have the clean grace of contemporary sculpture. At the same time, the geometry on which they are based—a hyperbolic paraboloid in a reverse curve—produces a spacious tension structure that spills wind and rain and strengthens the cotton fabric. Structural

supports are minimized to free interior space and to keep the tent light in weight. And since there are no flat walls or corners, air circulates freely to ventilate the interior. Originally designed for use in Saudi Arabia to withstand winds of up to 80 miles (128 kilometers) an hour and to lower desert temperatures of 120 degrees to 85 degrees (49°C to 29°C), the structure is an elegant marriage of form and function.

The Elements of Three-Dimensional Design

Artists who work in three dimensions use the same elements of design as those working in two dimensions. Although gravity makes ways of working with these elements quite different, they may still be dealing with line, shape, form, space, texture, value, and color, choosing from the same unifying principles available to two-dimensional artists—repetition, variety, rhythm, balance, emphasis, and economy—and the same principles involved in two-dimensional use of the elements. Yet three-dimensional art more closely resembles "real life," since to reduce life to two dimensions is an abstraction in itself. It is therefore often more difficult to isolate and recognize the elements of design in a three-dimensional piece, for these elements are themselves abstractions isolated from the unity of our perceptions of how things are. For instance, unless we are accustomed to looking as an artist does, we would not typically see a bare tree as a rhythmic repetition of lines. We would simply see it as "tree." Only in nonrepresentational three-dimensional works are we likely to be clearly aware that an artist is dealing with the abstract elements of design. And, despite the subtlety of their appearance, the unifying principles of design are, if anything, even more important in three dimensions than in two. If a piece is to hold our attention, it must change continually as we move around it, yet somehow maintain an overall sense of continuity.

Shape/Form

The most obvious design element in a three-dimensional work is *form.* This is sometimes paradoxically referred to as the shape of a piece, even though in two-dimensional art the word *shape* refers to flat-appearing areas. In three-dimensional work, the mass of a form is real rather than illusory. It is the area confined by the contours of the piece.

Major contours define the outer limits of the piece in space. In Gaston Lachaise's *Standing Woman,* the major contours constitute the overall outline of the woman's body. [Figure 9.15] Her **secondary contours** are inner modeled areas, such as the rounding of her abdomen and breasts, the creases in her pelvic area, the modeling of her face, and the hollow at the base of her throat. To work well, these secondary contours must usually be designed in harmony with the major contours. In Lachaise's sculpture they

help emphasize and pull together the unusual combination of muscular strength and voluptuousness. Some highly abstracted sculptures have no secondary contours at all. Both kinds of contour help to lead and guide the viewer around or through the work and can change dramatically as the viewer's perspective changes.

Another aspect of form is negation of form: a *void* within or created by a mass. In Henry Moore's *Locking Piece* the hole penetrating the center of the form is an integral part of the form itself, drawing us in and opening new vistas when the sculpture is seen in the round. [Figure 9.16] As in two-dimensional art, negative space may be just as important in a work as the positive or filled-in areas, sometimes more so.

Light

Two-dimensional art often deals with representations of light and dark areas as values; in three-dimensional work, light actually does fall on the piece, creating true areas of brightness and darkness. These effects can be taken into

9.15 above left
Gaston Lachaise. *Standing Woman.* 1932. Bronze, 7′4″ × 3′5⅛″ × 19⅛″ (2.24 × 1.04 × .48 m). The Museum of Modern Art, New York (Mrs. Simon Guggenheim Fund).

9.16 above right
Henry Moore. *Locking Piece.* 1963-1964. Bronze, edition of three; height 9′7½″ (2.9 m). The Henry Moore Foundation, Much Hadham, Hertfordshire, England; Banque Lambert, Brussels; Tate Gallery, London.

9.17 above
Le Corbusier (Charles Edouard Jeanneret-Gris). Notre Dame du Haut, Ronchamp, France. Interior, south wall. 1950-1955.

account and controlled to some extent by the artist, often with dramatic results. In Notre Dame du Haut, a view of which is shown in Figure 9.17, Le Corbusier opened a great variety of window slits in the thick concrete wall to create varying pools of light and shadow within the chapel. Similarly, within a Gothic cathedral, the colored light rays cast by stained-glass windows may have exciting spiritual effects on worshipers.

In sculpture, the effects of lighting can be used to complement form, accentuating or enhancing the visual interest of changes in contours and helping to draw the viewer into investigating gradual changes occurring as a work is viewed in the round. In a piece of uniform color, differences in value are created by variations in the ways contours catch the light. When part of a form blocks the light reaching a surface, it will be shadowed. Precisely where the shadow falls will change as the light source moves, and the color of the light will affect the color of the shadow. The value of the piece's surroundings will also affect how dark or light its surfaces appear and therefore how clearly it can be distinguished from its surroundings.

A sculptor may not be able to control values precisely, because the sun moves, artificial lighting placement may be unpredictable, light sources vary in intensity, and surroundings differ in value. Nevertheless, certain general observations give some predictability to relative gradations in value. Lower areas are usually darkened by shadow; higher areas bulging outward are

usually lighter. Smooth areas reflect more light than coarse-textured areas. Softly rounded contours, as in the central barrel of Raymond Duchamp-Villon's *The Horse,* tend to develop a gradually changing range of values. [Figure 9.18] Sharp distinct contours, as on the two ends of this ambiguous piece (Is it a horse's head or a rearing horse?), create dramatic juxtapositions of very dark and very light areas. In Lachaise's *Standing Woman* (Figure 9.15), the value changes playing across the sculpture accent the soft roundness of the female form and highlight the bulging musculature.

Gallery lighting is usually fairly even, but changes in placement of lights can change the visual impact of a three-dimensional work. Brancusi's photograph of his *Mlle. Pogany II* (Figure 9.7) differs considerably from the standard museum photograph (Figure 9.6) not only in point of view but also in the placement and intensity of lighting. In Brancusi's photograph, parts of the work are so darkly shadowed that they blend into the background, while the shoulder area catches the direct force of a spotlight. Outdoor pieces are subject to an even greater variety of lighting effects. Imagine the *Standing Woman* emerging from fog, glistening in rain, blazing with highlights under midday sun, presenting a dark contrast to the whiteness of snow. Awareness of these changes can add an exciting dimension to creation and appreciation of three-dimensional works.

9.18 left
Raymond Duchamp-Villon. *The Horse.* 1914. Bronze (cast c. 1930-1931), 40 × 39½ × 22⅜" (102 × 100 × 57 cm). The Museum of Modern Art, New York (Van Gogh Purchase Fund).

Space

Three-dimensional artworks give a sense of depth by their very nature, for they occupy three-dimensional space, physically jutting out toward, receding from, and perhaps surrounding the viewer.

Amalia Mesa-Bains's *An Ofrenda for Dolores del Rio* can be seen only from the front, like an altar, but it is set into an alcove and also spills forth into the room toward the viewer. [Figure 9.19] It also brings the adjoining walls into play as picture-hanging surfaces. While this space is filled almost

9.19 right
Amalia Mesa-Bains. *An Ofrenda for Dolores del Rio.* 1984 (reconstructed in 1990). Mixed mediums, 8 × 6 × 4′ (2.44 × 1.83 × 1.22 m). Wight Art Gallery, Los Angeles.

9.20 left
Claes Oldenburg. *Giant Blue Shirt with Brown Tie*. 1963. Canvas, cloth, kapok, dacron, metal, plexiglass; 4′6″ × 6′10″ × 1′ (1.4 × 2.1 × .3 m). Private collection.

to the point of clutter, some works *control* a fully three-dimensional area without actually *filling* it with solid forms. Bruce Nauman's *South America Triangle* (Figure 9.10) casts a clear shadow on the floor below, making it part of the work. And by looming so low and threatening, by its apparent weight, to fall to the ground, it affects one's response to the surrounding area as well. Some semi-conscious trepidation about our personal safety arises as we approach the piece.

The *scale*—relative size—of three-dimensional works also affects our feeling of our own size. We may feel dwarfed by a cathedral or by Claes Oldenburg's giant shirt, which is so large that it must be wheeled around with the huge tie sprawling across the floor. [Figure 9.20] By contrast, we ourselves feel gigantic—like Gulliver among the Lilliputians—when confronted with tiny objects that have been greatly scaled down from their normal size. Such scale distortions, or the use of familiar human scale, may be skillfully manipulated by the artist to control viewers' emotional reactions to a work. Certain everyday objects, when blown up to monumental proportions, may strike us as being amusingly preposterous. We may laugh at the disproportion between our own smallness and the largeness of the banal—or we may consider this an artistic statement of how things really are and find it depressing. Some objects, if greatly enlarged, are likely to frighten us. A giant bug would tend to make most viewers feel threatened, as if they had stepped into a horror movie.

9.21 right
Horse (tomb figure). T'ang Dynasty.
Earthenware with traces of orange paint;
height 14⅝" (37 cm), length 20" (51 cm).
Ashmolean Museum, University of Oxford.

Successful control of scale requires consideration of where a piece will be seen. When shown in a gallery, Von Schlegell's aluminum sculpture (Figure 9.3) overwhelms the room, stretching from floor to ceiling and wall to wall. When it is displayed outside, much of its monumental quality is lost. Even though the size of the work in relationship to the viewer remains unchanged, the impact of its size is diminished by its surroundings.

Line

Lines are very much part of our visual environment, though we usually do not isolate and see them as lines. A river seen from a distance, a crack in a boulder, a reed bending in the wind, a vapor trail etched in the sky by a high-flying plane, the telephone wires connecting pole to pole and town to town —all these can be seen as lines, for they are like marks whose lengths are much greater than their widths. Lines can also be seen in some three-dimensional art.

In some pieces, the emphasis is on form with lines used to guide the viewer around or through the work or as secondary elaboration. In the Chinese horse shown in Figure 9.21, the strong lines incised into the saddle and mane echo and emphasize the vigorous thrust of the legs. In other works, line may be the chief design element used. Alexander Calder's *The Hostess* uses great economy of line to suggest the contours of a high-society matron. Shown in a flat photograph, the work looks like a two-dimensional drawn caricature, but in the round it suggests the full form of the hostess. [Figure 9.22]

9.22 below
Alexander Calder. *The Hostess*. 1928. Wire construction, height 11⅛" (29 cm). The Museum of Modern Art, New York (gift of Edward M. M. Warburg).

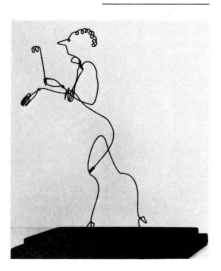

Texture

The texture of a three-dimensional surface may add seasoning to a piece, giving it a special character and emotional content. The texture of a face can reveal a great deal about the person. In Auguste Rodin's *Little Man with the Broken Nose*, the worn, lumpy quality of the surface emphasizes the subject's age and traumatic history. [Figure 9.23] Despite the determined set of the mouth, the surface texture suggests a fluid tendency to be molded by the vicissitudes of life.

Textural treatment may call our attention also to the material used. Polished metal, smooth marble, wood grain, and rough-cut stone have distinctly different textures and evoke quite different emotional responses in the viewer. Combinations of textures may also be used provocatively. In Donna Forma's *Soul's Replenishment,* the contrast between the coarse natural beauty of the rough-worked marble "rock" and the smoothness of the polished marble figure emerging from it accentuates the silky quality of the skin and gives us an opportunity to see the artist at work coaxing the desired form out of the raw material. [Figure 9.24] The shift in textures also helps to convey the theme of the piece: a person alone with nature, drawing strength from her surroundings, as if literally growing out of them.

Color

Though our attention may not be immediately drawn to the color of three-dimensional works, everything has color or reflects colors. The original color of the material being used is the first color the designer has to work with—the varying hues in stone, wood, or metals; the white of plaster; or even the

9.23 above left
Auguste Rodin. *Little Man with the Broken Nose* (Le Petit Homme au Nez Casse). c. 1882. Bronze with some gilt on marble base, 5 × 3 × 3⅞" (13 × 8 × 10 cm). Fine Arts Museums of San Francisco (gift of Alma de Brettsville Spreckels, 1942).

9.24 above right
Donna Forma. *Soul's Replenishment.* 1982. Carrara marble, 17 × 23 × 16" (43 × 58 × 41 cm). Courtesy the artist.

9.25 right
Virgin and Child. c. 1500 (Rhenish School). Painted wood, height 10¼" (26 cm). Metropolitan Museum of Art, New York (bequest of George Blumenthal, 1941).

way plastic reflects light or changes colors seen through it. Artists can also choose to add pigments to a surface to help create the desired response in a viewer. In the sixteenth-century *Virgin and Child* shown in Figure 9.25, paint has been applied to the wood to develop rather elegant gold borders and the blue symbolically associated with the madonna on the garments and rosy cheeks on the two figures, perhaps to increase their warm appeal. At one time, almost all sculpture was painted, in representational local color.

Time

As mentioned earlier, the time element is critical to three-dimensional art in the sense that viewers must want to take enough time to move around a piece, investigating it from all sides. Beyond this, some pieces themselves actually move; those that do so are called **kinetic art.** A classic example is Alexander Calder's mobiles, such as his *Lobster Trap and Fishtail.* [Figure 9.26] Although the photograph freezes this piece in a single pattern, in reality air currents cause the objects to revolve around one another and around

the central pivot point from which the mobile is hung. Relationships among its parts and their surroundings are ever-changing, a fascinating continual interplay of shapes. Because kinetic sculpture itself moves, viewers do not have to, though they may be drawn in as originators of the movement.

Arts involving the continuum of time—dance, theater, and film—are called **temporal arts.** Dancers change the patterns formed by their own bodies and by their relationships to other dancers and to the stage as they

9.26 below
Alexander Calder. *Lobster Trap and Fish Tail.* 1939. Hanging mobile: painted steel wire and sheet aluminum, 8'6" × 9'6" (2.6 × 2.9 m) (variable). The Museum of Modern Art, New York (Commissioned by the Advisory Committee for the Stairwell of the Museum).

9.27 right
Grotto. Nikolais Dance Theater production premiered in February, 1973, at the Brooklyn Academy of Music. Choreography, costumes, and lighting by Alwin Nikolais.

move through time and space. Occasionally these patterns become distinctly sculptural in intent: Groups of dancers sometimes arrange themselves to suggest a single moving form. In the Nikolais Dance Theater's *Grotto,* pairs of dancers within stretchable bags create moving sculptures whose forms, barely held from splitting apart by dramatic tensions, keep changing through time. [Figure 9.27]

The continuum of time may be used in varying ways. In a movie or a sculpture designed to revolve slowly on its stand, there is a set pattern of movement through time that will always repeat itself in the same way. Other works change through time in unpredictable patterns, restricted only by the physical limitations of the piece. In Jacqueline Monnier's *Skyworks* (Figure 3.7), the kites move randomly with the wind, though held within viewing distance by strings. Some aesthetic experiences happen only once: The release of a skyful of balloons can be seen only until they drift out of sight. We tend to view art as possessions whose value can be repeated in time by repeated viewings. However, the beauty we find in life itself is often ephemeral. The moment a certain light happens to fall on a flower that happens to be open can only be appreciated; it cannot be captured or repeated.

Three-Dimensional Construction Methods

The many ways of creating three-dimensional art can be conveniently grouped into five categories: ready-mades and found objects, addition, modeling, casting, and subtraction. All are subject to gravity, and some entail unique physical stresses, such as the tendency of clay to crack when it is fired. Artists who have developed a thorough understanding of the materials and techniques involved can most easily control these stresses and circumvent or use them to express their ideas through their work.

Ready-Mades and Found Objects

Perhaps the most direct method of creating three-dimensional art is finding a **ready-made:** an object that, divorced from its usual functional setting, can be presented and seen in a new way as a work of art. Marcel Duchamp, usually credited with inventing this "method," took a bottle dryer out of an institutional dishwashing setting and suggested that we look at it as an intriguing piece of metal sculpture. [Figure 9.28] A ready-made is anything found to be interesting or beautiful that is exhibited purely because it already expresses these qualities.

Similarly, **found objects** can be put together, perhaps after slight alteration, to suggest a form quite different from their original use. Picasso's *Head of a Bull* is a whimsical assemblage of a bicycle saddle and handlebars that really does resemble the head of a comically lean bull. [Figure 9.29] The chief skill required in ready-mades and found objects is a good eye, the imaginative ability to see an unexpected form in another totally unrelated object.

9.28 left
Man Ray. *Duchamp "Ready Made"* (photograph of Marcel Duchamp. *Bottle Rack.* 1914. Height 16⅛" [41 cm]. The Museum of Modern Art, New York [James Thrall Soby Fund].) Gelatin-silver print, 11⁷⁄₁₆ × 7⁷⁄₁₆" (29.1 × 18.9 cm). The Museum of Modern Art, New York.

9.29 below
Pablo Picasso. *Head of a Bull.* 1943. Assemblage, bicycle saddle and handlebars; 13¼ × 17⅛ × 7½" (34 × 44 × 19 cm). Musee Picasso, Paris.

Addition

A second method of constructing three-dimensional works covers an enormous range of possibilities and technical innovations. This is addition, or **additive sculpture**—the assembling of any of an unlimited variety of materials. This category includes the assembling of woods, metals, plastics, glass, and fibers with glue, nails, rope, chains, bolts, screws, rivets, and welding. Each piece added to the whole may itself be worked by a number of methods. John Matt's *Sandship I* was assembled from highly polished parts custommachined by the artist. [Figure 9.30] The materials are products of spaceage technology—aluminum alloys, chrome-plate, plexiglass. The sculpture itself, a fantasy machine, appears to have just touched down from outer space.

9.30 right
John Matt. *Sandship I.* 1972. Mixed media, 30 × 7 × 7′ (9.1 × 2.1 × 2.1 m). Courtesy the artist.

Presentation of such pieces is challenging, for it is often difficult to get them to hold together and stand up in precisely the way the artist intended. *Sandship I,* which is 30 feet long, is exquisitely crafted to be disassembled and reassembled for transportation and display. Because of its "high tech" appearance, the artist is able to integrate into the design the fastening devices used to hold it together. In other additive work, the nuts and bolts, rivets, or welding seams may detract from the desired impact and thus must be concealed.

Modeling

In **modeling** (sometimes called "manipulation"), a pliable material is coaxed by hand or tools into a desired form. The materials most often used are clay, wax, plaster, and sometimes cement. Since the materials are generally soft, worked pieces may need to undergo some hardening process before they can be considered permanent. Clay is first modeled and then fired for hardness. When worked directly by hand, these soft materials may retain the imprints of the artist's manipulation. In creating *Developpé en Avant,* for example, Edgar Degas took little dabs of wax and built them up into a dancer's form without fully smoothing them out. [Figure 9.31] The result

9.31 left
Edgar Degas. *Developpe en Avant.* 1920. Bronze, height 22⅞" (58 cm). Metropolitan Museum of Art, New York (bequest of Mrs. H. O. Havemeyer, 1929, the H. O. Havemeyer Collection).

9.32 left
Wire armature for a human figure.

clearly reveals the artist at work rather than the precision of a machine-made object.

The malleability of certain materials used in modeling—among them clay, plaster of Paris, wax, and papier-mâché—may require the construction of an **armature.** This is an understructure built of a relatively rigid material such as wood, metal, pipes, chicken wire, or polystyrene foam blocks. This framework (as in the wire armature for a small human figure in Figure 9.32) usually is not seen in the finished product but provides internal support for materials built up on the exterior.

Casting

9.33 above
In casting, all concave areas in the mold become convex in the cast, and vice versa.

A fourth three-dimensional method is **casting:** the substitution of one material for another by means of a mold. The simplest casting method is like sand casting: the reverse of the desired form is modeled in an area or box of sand, a liquified material such as plaster that will soon harden is poured into the mold, and the cast is lifted out once the material has hardened. Any area that was concave in the mold will be a convex area in the cast and vice versa, as shown in Figure 9.33. To translate an object that already has the desired contours into a duplicate of a different material, a mold is first made of the original. The second material is then poured in and allowed to harden. Once it does, the mold is broken away or pulled apart.

The usual point of these procedures is to allow the artist first to work a pliable material and then transfer the results to a material such as bronze that cannot be worked directly but can be melted for pouring into a cast and will later harden, or liquid plastic, to which a hardener is added when it is poured into a cast. Duane Hanson has extended the "uses" of this art form to include duplicating living people. His fiberglass and polychromed polyester

9.34 left
Duane Hanson. *Tourists*. 1970. Polyester resin/fiberglass, mixed media, 5'4" × 5'5" × 4' (1.6 × 1.6 × 1.2 m). Courtesy the artist.

9.35 below
Ancestral couple. Dogon, Mali. Wood, height 26⅛" (67 cm). Rietberg Museum, Zurich (Von der Heydt Collection).

casts made of real people, presented with appropriate clothes and accessories, amaze and delight viewers because they so accurately portray real life with all its absurdities. [Figure 9.34] Like many large metal castings, Hanson's people are cast in such a way that the sculptures are hollow and therefore much lighter in weight than if they were solid.

Subtraction

In contrast to the methods of building up a three-dimensional work, the final method is based on *subtraction;* **subtractive sculpture** comes about by carving material away. Some sculptors consider their work as liberating a form already existing in the material.

Any material that will withstand carving can be used, including stone, cement, wood, plaster, clay, and plastics. Tools used to remove bits of the original material range from knives, wire loops, and chisels to chain saws. The ancestor figures of the Dogon tribe were obviously carved from a single large piece of wood left intact to form a base for the statue. [Figure 9.35] As indicated in this piece, subtraction need not be limited to chipping

away at the surface but may instead carve voids which extend through the heart of the original material, creating negative areas that may be just as important as the areas left intact.

Planning Three-Dimensional Work

9.36 below
Kenneth Snelson. *Forest Devil's Moon Night.* 1989. Computer generated image. Hardware: Silicon Graphics computer. Software: Wavefront Technologies. 40 × 30″ (102 × 76 cm). Courtesy the artist.

To think through their ideas for two-dimensional projects, artists often experiment with trial sketches before they begin direct work on a piece. As a precursor to three-dimensional projects to be made of expensive or unwieldy materials, artists often make a small model out of inexpensive, impermanent, easy-to-work materials. Sculptors typically make a simple preliminary model—or **maquette**—of clay or wax for experimenting with contours and

9.37 left
A small Japanese garden in the traditional style.

relationships of forms before cutting into a block of costly marble. Models do not have the refinements of a finished piece, but they give artists a chance to see how well their general ideas will work.

Designers of three-dimensional pieces may also draw two-dimensional sketches of a planned work from several angles, imagining and shaping relationships among design elements. Sometimes these sketches are drawn from the side, with suggestions of three-dimensionality.

Computer-aided design programs now make it possible for the computer-literate artist to manipulate imagined forms in imaginary space, "viewing" them from all sides, with realistic shading effects, before selecting the specific form to be constructed. The computer can even calculate the dimensions of each part for fabrication. These "three-dimensional" fabrication plans may be works of art in themselves, as in Kenneth Snelson's *Forest Devils' Moon Night*. [Figure 9.36]

By contrast with this realistic preview, sometimes preliminary planning is done using drawings of what the project would look like if viewed from above. An interior designer may manipulate flat scale models of furniture on a floor plan rather than dragging the furniture around to see how it fits into a room. The difficulty in this approach is that it requires a great leap of the imagination, for the final product is a three-dimensional reality of varied forms, lines, textures, and colors, arranged in space that can be seen only in the mind's eye. The designer of the Tokyo garden shown in Figure 9.37 knew in sketching its layout from above that the stone water basin would be

9.38 right
Plan of garden of Takanaru Mitsui, Tokyo.

the focal point of the small garden, drawing attention into its center from both entrances. [Figure 9.38] Such knowledge comes with learning the specifics of one's chosen discipline; such imagination comes with practice and freeing of the intuitive approach to artistic creation.

STUDIO PROBLEMS

The problems in this section are designed to give you a quick sampling of what it is like to work in three dimensions using various construction methods. Many of the solutions shown are atypical, to illustrate the infinite range of possibilities. Most of these solutions were, however, done rapidly. If time allows, you could take longer on each piece and make it a work of art rather than a brief exercise. Some problems can be solved with a variety of construction methods, ranging from the simple to the more complex. Directions for use of the materials and methods suggested are given in the Appendix. In general, the smaller your solutions, the easier they will be to construct and present.

9·1
THE READY-MADE

Find an object that suggests a human or animal form, or will if slightly altered. Present it as a sculpture.

To solve this problem you do not need any mechanical skills; you simply need to learn to look for the possibilities in materials at hand. Once you are looking imaginatively, you will see that certain objects appear to be "mascu-line," some appear "feminine," and some look like animals or parts of animals, often humorously so. The problem then becomes one of presenting the object so that other people will immediately see in it what you saw.

The student whose solution is shown in Figure 9.39 discovered that a discarded head gasket from a car, bent and reshaped slightly, looks very much like a cow. Even the texture of the head gasket suggests a furry hide, and the bolt holes become spots on the cow's body and a woefully vacant eye on its head. Since this image of a cow is pared down to a very simple form—essentially a series of arches—the viewer must fill in the details from memory. But enough information is given for the piece to work very well.

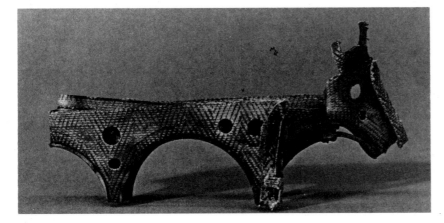

9.39 left
A ready-made object. Student work.

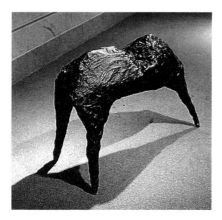

9.40 *above*
Modeling a simple form. Student work.

MODELING A SIMPLE FORM

Model a simple form in clay, plasticene, or plaster of Paris. Use your hands and/or any tools you choose. As you are working, be aware of changes viewers will see as they move around the piece.

Just as scribbling lines is usually the first way we start experimenting with art as children, building a mass with some soft material, such as clay or mud, is often our first experience with three-dimensional art. You can do this problem at that primitive level of just playing with the material to see what happens. But as you do, be aware of a more sophisticated concept: In order to coax viewers to look at your piece in the round, you will have to make them want to explore further. Remember that how you use forms, light values, lines, and texture can enhance the interest of the piece and lure viewers into wanting to discover what happens on the other sides by moving around the work.

The student who modeled the piece shown in Figure 9.40 arrived at a unique solution to this problem: a large sculpted form raised on three legs that plays against the negative form underneath it. There are deeply textured areas that contrast with the areas which are smoother textured. This animal-like form compels the viewer to walk around it to see if it has a head, which is implied. This effect happens no matter from which side the form is viewed. The student who modeled the piece used plaster of Paris, feeling that this is the most direct way of building a form.

CARVING A SIMPLE FORM

Carve a simple form from some easily cut material. One area should flow into another in a continuous series of changes.

This problem gives you an opportunity to explore subtractive sculpture. You can work with anything that is relatively easy to carve—soft wood, clay, sandstone, a block of plaster of Paris or cement cast in a milk carton, even soap. If time allows, you might try using several different materials to see how the resistance of the material affects the development of a form. Depending on the material, you can cut away extraneous areas with a saw, a knife, a file, a potter's wire loop, a rasp, hammer and wood or stone chisels, sandpaper, or an electric sander. Be aware not only of the mechanics of carving but also of the way changing contours lead the eye around the piece.

Figure 9.41 is an unusual student solution to this problem, for it is a low relief rather than a sculpture designed to be seen in the round. Nevertheless, its intertwined lines do lead the eye around and around, curiously exploring a branching path that seems to have no beginning and no end, only continuations. The lines are carved from a 4-inch-thick block of soft wood so heavily undercut in places that a

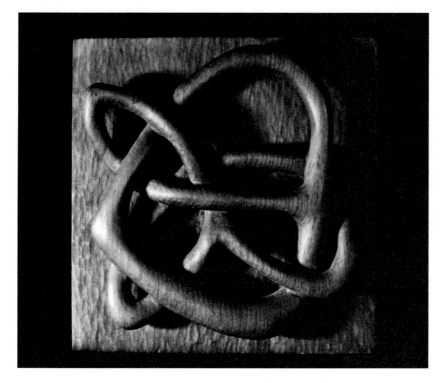

9.41 left
Carving a simple form. Student work.

finger can be slid between them and the base. This deep undercutting creates strong value contrasts, from the near-white of the highest area to the near-black of deeply shadowed areas.

The piece was stained to help bring out the grain in the wood and oiled to create glossy highlights. The considerable mechanical skill involved in the wood carving enhances the excitement of the piece, but you may prefer to experiment with simpler skills. Although the results would not be so intricate as this piece, you could work wood using nothing but sandpaper or an electric sander.

9·4
PAPER CASTING

Manipulate a piece of paper and then use it as a mold into which plaster of Paris is poured. After the plaster of Paris has hardened, cut away any undesired edges of the cast with a saw.

A simple introduction to the mechanics of casting is to fold, wrinkle, or score a piece of paper as a cast for plaster of Paris. No box is needed—the plaster can just be poured directly onto the paper. When the cast dries, the paper can be peeled or washed away, revealing its contours in reverse. Concave areas become convex in the cast, and vice versa. Chance lines and value contrasts made by the wrinkled

9.42 right
Paper casting. Student work.

paper may create interesting effects, as in Figure 9.42, or you may choose to manipulate the paper for a more structured, predictable effect. Areas that do not work well can be cut off with a saw. A number of paper casts may be presented together as variations on a theme.

9.43 below
Paper model. Student work.

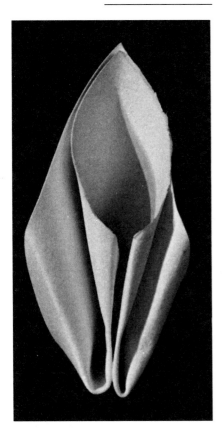

PAPER MODEL

Manipulate a piece of paper to make a low relief or free-standing object. Consider it a model for a larger piece.

As already noted, three-dimensional artworks may begin with the making of a model or maquette, just as a two-dimensional painting may begin with a series of drawn sketches. Paper is a good material with which to make a model of a work that will later be executed in a sheet material, such as a sheet of metal. Paper of any size, color, or weight can be scored, folded, crumpled, cut, or glued to make a pattern for a larger work. In making your paper model—or a series of models —picture what the piece would look like if blown up to much larger scale and executed in a more permanent material. How would you approach the technical problems involved in building and presenting the larger piece? How would people respond to the work if it were twice as large as the model? Fifty times as large? What effects would light have on its appearance?

The student work shown in Figure 9.43 is an exciting contradiction of the tendency of sheet materials to appear rigid, hard-edged, and sharply angled. Here a sheet of heavy watercolor paper has been rolled to soften its curves. Pale shadows created by these soft curves add mysterious interest to both concave and convex areas. The overall effect is one of organic plant-like grace and upward growth. The rounded bases of the curves allow the piece to stand by itself, resisting gravity, but are nonetheless drawn in closely enough to emphasize the outward flare of the piece as it grows upward. What would this solution look like if executed 3 feet tall in polished brass? If it were 20 feet tall and made of rolled steel?

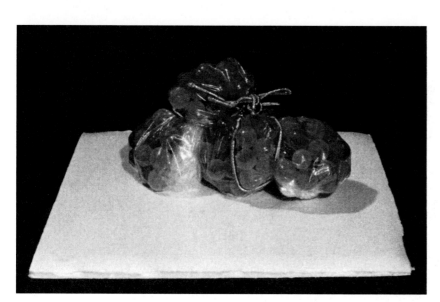

9.44 left
Fill-a-bag. Student work.

9·6
FILL-A-BAG

Fill a bag with some loose material. Present it in such a way that you control its form.

This is a seemingly frivolous problem that will nonetheless teach you something about working with physical laws. You can use any kind of bag —paper, plastic, burlap, rubber, cloth. Fill it with something—sand, stones, sugar, water, snow, air. The object is to control the presentation of this bag full of something by binding it somehow. It could be sewed, tied around itself, or bound with twine, rope, elastic, or whatever else you choose. You may find that what is in the bag does not want to go where you want it. And if you make a mistake, the bag may burst or your "sculpture" may topple over or ooze apart. If you are not aware of the need to control these tendencies in matter, your sculptures may eventually fall apart.

The student solution in Figure 9.44 is a transparent plastic bag full of semi-transparent blue marbles, tied with a gold elastic cord. Although it appears about to burst, it will not, for the student pushed the solution right to its limit and then stopped. The nearly bursting effect and the chance to see one marble through another make the piece fun to look at. Other solutions might play with natural forces by being floppy, or surprisingly tall, or changing in a controlled way through time. Like all works, the piece has to be movable and should not fall apart when it is being transported.

9·7
ADDITIVE WOOD CONSTRUCTION

Cut three or more blocks of wood. Put them together in an interesting and exciting way.

In this problem you will explore relationships among forms, working with a material—wood—that can be nailed or glued or screwed into additive sculptures. It can also be painted.

Whereas all the earlier problems involved manipulating a single form, here you must consider the effects of grouping. The same principles used for holding flat shapes together visually, discussed in Chapter 4, can also be applied to three-dimensional forms. To avoid appearing lost in space, they can be unified by overlapping, abutting, interlocking, stacking, suggestions of an interrupted whole, or mutual tension.

The solution shown in Figure 9.45 is a series of simple blocks of wood mounted on each other most precariously. The precarious angles create shadows which help tie the blocks together visually. Varying the size of the blocks and keeping one piece of wood with its bark unworked helps to avoid boring the viewer.

Remember that successful works often have both repetition and variety. In this problem, varying the scale, form, or texture of the pieces may increase the interest of the piece. How far can you push your variations without losing the unifying theme of the whole?

9.45 right
Additive wood construction. Student work.

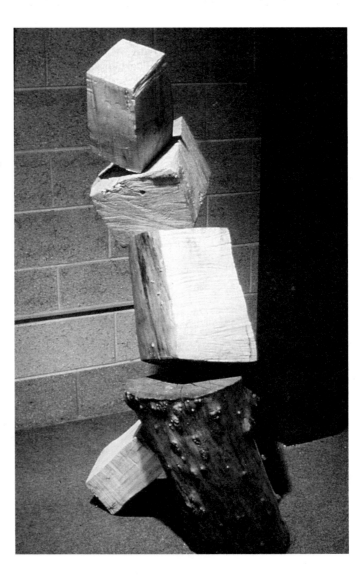

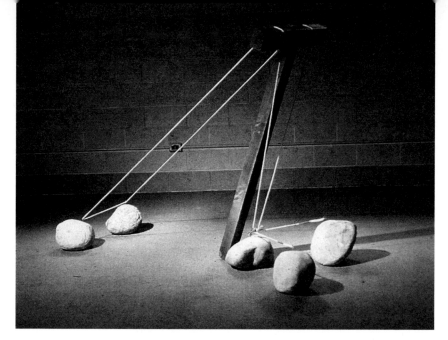

9·8
CONSTRUCTION WITH VARYING MATERIALS

Put together three or more objects of varying materials and varying forms. They should be seen as a coherent whole.

In assemblages of different materials, there is the possibility that objects will appear unrelated, stuck together but not as parts of a coordinated whole. To solve this problem you could work with any materials of any scale, remembering that smaller projects are usually easier to handle. You may also face problems in binding unlike materials together.

The solution shown in Figure 9.46 uses very familiar objects—rope, wood, and stones—but puts them together in such a way that the piece has visual tension. At the same time, it is very stable. The composition changes as the viewer walks around it, with different tensions being created as the relationships of objects change. They are all curiously bound together visibly by the rope. Variation in texture further adds to the interest of the piece. Such variations might be distracting and divisive if the piece were not so well held together, but this assemblage reads as a single object.

9·9
MODULAR CONSTRUCTION

Using a number of identical wooden forms, build an additive sculpture.

The difficulty in the preceding problem was to create a sense of unity in the midst of diversity. The challenge here is the opposite: to avoid boring viewers with too little variety when working with repetitions of the same module. The modular parts can be connected in any way—nailing, gluing, bolting—or even just placed near each other.

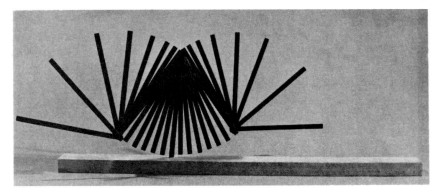

9.47 right
Modular construction. Student work.

The solution shown in Figure 9.47 was done with wooden coffee stirrers painted black and glued together at three pivot points. The varying intervals between the lines suggest movement through time and space. Do you think the piece would have worked better if the sticks had been painted in varying values or hues? To assemble it, the student had to glue the joints and hold them until they dried. In this case a larger-scale work bolted at the pivot points might have been easier to construct.

9·10
WOOD, BURLAP, AND PLASTER CONSTRUCTION

Build a direct sculpture (not a model), using wood, burlap, and plaster of Paris.

This problem gives you a chance to construct an armature of wood and then build up plaster forms on it. The burlap

9.48 right
Wood, burlap, and plaster construction. Student work.

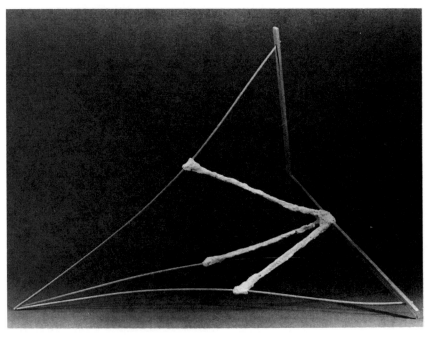

can be used both for binding wood joints and providing a base for the plaster of Paris. To increase the challenge of the problem, no other materials—not even nails or glue—can be used.

Contrary to the usual way of using an armature, the student who created the solution shown in Figure 9.48 chose to reveal the triangular wood framework as the emphasis. Struts of plaster-covered burlap hold it in dynamic tension and provide a visual counterpoint to the three slim wooden dowels thrusting out to a point on the left. Since the problem did not actually specify building up a form on an armature, this student used lines, quite successfully.

9·11
MODELING A HEAD

Using clay or papier-mâché or plasticene built up on an armature, model a bust of a person.

Even if you did not choose to use an armature in the traditional way—as an understructure—in the last problem, you should do so here for experience in building up a form on an armature. Since you are making a representational human form you must also pay attention to the understructure of the person whose face you are sculpting. Figurative sculptors need detailed knowledge of bone and muscle structures and relationships. This problem does not expect detailed knowledge of the finer points of anatomy, but you should at least be aware of the general forms lying beneath the skin.

The usual armature for a face is oval-shaped loops of wire with a wood or pipe stem attaching to a wooden base. However, Figure 9.49 was built up over the bone structure of a plastic human skull. Clay was added to flesh out all areas except the teeth, which shine forth provocatively in the white of the original plastic. Another startling feature of this solution is the student's choice to leave the eyes vacant, as they were in the eye sockets of the plastic skull.

In addition to being aware of the bones and muscles beneath your subject's skin, pay attention to how the clay is applied to represent the skin surface. In what direction should you stroke it in relationship to the facial contours? Should you leave it rough in places or smooth it evenly? These are creative decisions with no hard-and-fast rules, but they do deserve close attention.

9.49 below
Modeling a head. Student work.

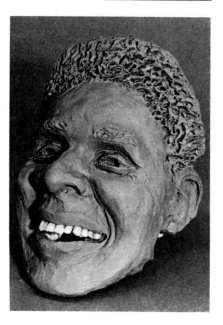

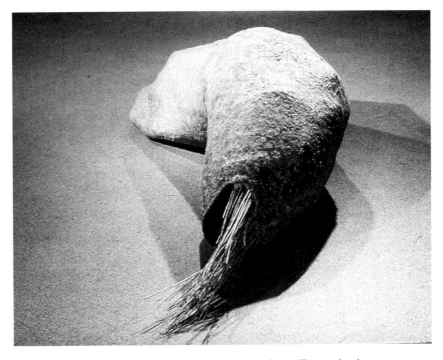

9.50 right
Confined space. Student work.

CONFINED SPACE

Using any material or combination of materials, make an object that occupies a confined space.

This problem can be done in any scale, with any material. You could incorporate found objects, castings, or toys into your piece or encase it in a glass dome, an old clock case, or a plastic box. The point is to create a contained space. Whatever objects you isolate within it will appear unusually special, as if sacrosanct.

In the solution shown in Figure 9.50, a cocoon-like form becomes a confining space for bits of straw. Their contrast in texture and scale add to the viewer's response to this piece. And the piece will surely evoke a conscious or subconscious response as a symbolic statement of some sort. Does it refer to growth? To death? One puzzles over its meaning. Straw by itself is nothing special, but thus confined by the cocoon, it seems to exist in a world of its own.

CONTROLLED TIME

Make a three-dimensional object that moves in a controlled space, in controlled time.

All three-dimensional art deals with time. Most pieces are passive in time; it is the viewer who must take time to walk around and investigate them. In this problem you are asked to hold the viewer's attention by creating a time sequence activity that changes in a controlled way through time.

Some students have solved this problem by building sculptures atop

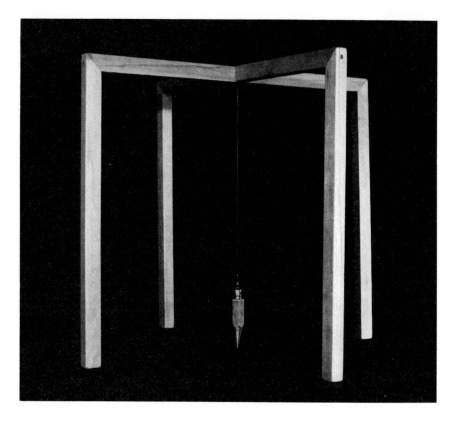

9.51 left
Controlled time. Student work.

wind-up toys or suspended above fans. The work shown in Figure 9.51 uses the activity of a surveyor's plumb bob, which when pushed in a side-to-side or circular motion will continue this pattern, gradually diminishing with time. Even air currents and the motion of the earth will cause it to swing subtly. The wood from which the plumb bob is suspended is elegantly simple, and by drawing our attention to the plumb bob itself the student forces us to recognize this found object as a thing of beauty. The student suggested that this lovely piece of kinetic sculpture could even be presented with the plumb bob tracing paths through a bed of sand or salt crystals. This combination of control, creativity, and aesthetic awareness is your goal in exploring the art of basic design.

MATERIALS AND METHODS

To design successful works you must pay attention not only to the principles and elements of design with which you are experimenting but also to the materials and mechanical skills involved. The many materials now sold as art supplies have distinctly different characteristics; you may also discover exciting possibilities in materials not traditionally seen as artists' tools. Whether traditional or nontraditional, media must be used with precision. For instance, if a drawn line is smudged or allowed to wander in unintended directions, the effect you are trying to create may be spoiled.

In general, the problems in this book specify use of simple, inexpensive materials and techniques. Their use will help you concentrate on the design problem at hand and help you avoid regarding your solutions as too precious to be changed. Nevertheless, there is also value in experimenting with unusual materials and techniques and developing greater control in use of more demanding and expensive media. Starting with inexpensive materials encourages you to experiment—to try many solutions to the same problem and then compare the results to see which one works best. On the other hand, to keep from becoming too casual and to learn what better materials offer that cannot be done with cheap materials, you should occasionally work with more expensive materials. The better equipment can be used for final projects and for works preceded by a series of experiments that have given you a good idea of what you want to do.

The possibility of solving the problems on computer is an option now widely available. Many of the problems can be approached through computer graphics. Initially, working on computer takes longer than other media, but once an image is created, it can be endlessly manipulated. Creativity is given free range for those who are computer literate. And computer graphics with scanning of existing images may make art possible for those who cannot use other media. To some artists, the computer is a tool, just like a T-square or a French curve for drawing. To others, especially younger people who have grown up with computers, the computer is a unique medium in itself with a distinctive look and its own special characteristics, which are just beginning to be explored.

Many of the problems in this book can even be solved with a camera. Instead of creating lines, shapes, textures, values, and colors on paper, you can search for these elements of design in your environment and then manipulate the camera angle, distance, lens opening, and shutter speed until you get the effect you want. If you use a Polaroid camera, you can see the results immediately.

You will probably feel more comfortable working with some materials than with others, and your instructor may or may not require you to use the materials and methods suggested in each problem. If you are allowed considerable flexibility and if you have the time, you can benefit from doing some of the problems more than once, using different media to see how these changes affect both the design and the process of designing. If carefully controlled, "disadvantages" of a certain medium may sometimes be used to advantage. This appendix offers a broad spectrum of materials and methods that could be used for this course, with emphasis on those specified

in the problems. There are many ways of using these materials; those given here are only suggestions.

Computer solutions

Computer hardware prices are dropping even as the technology is advancing. Most art departments and designers use Macintosh computer systems because of their ease in handling graphics. To handle standard graphics programs, at least 8 megabytes of RAM are needed. Saving the work also requires a lot of memory. With new compression programs, 10 color images can be stored on one floppy disk.

Software programs are still expensive, but they can do so many things. If you are going into graphic design as a profession, familiarity with major software programs is a must in competing for today's job opportunities. As this edition goes to press, the most widely used programs with which you should be familiar are Aldus Freehand or Illustrator for image-making, Quark Express or Pagemaker for page setup, and Adobe Photoshop for manipulation of scanned images. If you are interested in illustration, Fractal Painter (for color) or Sketcher (for black and white) are also useful. Most graphics programs are quite user-friendly and visual. If you know the basic method for working with a mouse—clicking and pulling down to move things on-screen—you can learn most of the programs just by experimenting with them.

When a computer is used as a design tool or medium, the weakest link is usually the printer. An image may look beautiful on the screen, but quite different when printed. Printers today range from only 300 dots per inch (DPI) dot-matrix printers at the low end, whose output looks like newspaper images, to laser production models giving over 1100 DPI. Some have a black screen; others make black just by overprinting the three primary colors. Thermal wax transfer and dye sublimation printers give results that look almost like continuous tone photographs.

If the only printer available is a cheap dot matrix, do not be discouraged. Students learn to use the characteristics of their printer, incorporating its quirks as part of the design. If the resolution is so low that edges are jagged, they use the "jaggies" intentionally.

Traditional Two-Dimensional Formats

In two-dimensional work, a consideration so basic that it may be overlooked is choice of *format:* not only the materials used but also the shape and presentation of the piece as a whole. We tend to use the simplest shape (a rectangle of some standard size) and to follow traditional prescriptions for relative dimensions of design and mat, if one is used. Of course, you may occasionally want to depart from these standard procedures to see what happens.

Shape of the surface The most familiar two-dimensional format is a rectangle with two sides slightly longer than the other two. This format has been used more often over the centuries than any other, for it is the easiest to work with. The Greeks even institutionalized it as the Golden Mean, or the *Golden Rectangle.* They developed a mathematical formula for the ideal relationship between the length of the sides of a rectangle: The short end is to the long side as the long side is to the short end plus itself. Mathemati-

cally, the ratio of the short to the long side is about 1 to 1.618. For instance, a rectangle approximately 10 by 16.18 inches is a Golden Rectangle. Classical artists considered these proportions the epitome of natural beauty. Not only paintings but also whole buildings, such as the Parthenon, were based on this ideal shape. Perhaps because of the economics of cutting as much paper as possible from large sheets, rectangular paper goods and photographs today are often somewhat shorter on the long side than a Golden Rectangle. We are now so familiar with the 3-by-5, the 5-by-7, the 8-by-10, and the 10-by-14 format that these proportions look right to us and are fairly easy to design within.

Rectangles that depart greatly from the Golden Rectangle are more difficult to work with. In a tall vertical format, the upper-left and lower-right corners are so far apart that it is hard to control the space between them. In a long horizontal format, the viewer's tendency is to look from left to right and off the page very quickly unless many barriers are set up to slow the eye. When elongated rectangular formats are used successfully, the result can be spectacular. For example, a newspaper ran a picture of basketball player Wilt (The Stilt) Chamberlain when he retired. It was trimmed to two columns wide but ran the entire depth of the page. This thin vertical format strikingly exaggerated his height. And contemporary artists such as Barnet Newman [see Figure 8.35] have done very large-scale horizontal paintings in which a strong vertical and its repeating afterimages break up the horizontal sweep of the eye.

A square is a surprisingly difficult format within which to develop a representational design. We are accustomed to rectangular windows, to horizons that stretch far to either side, and to taking in rectangle-shaped chunks of our environment with our two eyes. It is very hard to compose a pleasing design with a Polaroid camera, which takes square pictures. But a square format can work very well for nonrepresentational designs intended to be seen as figure-ground reversals or spontaneous interactions, for the equal-sided nature of the square format enhances the tendency of the design to keep turning back into itself.

Triangular formats are extremely difficult to work with; we are not accustomed to this shape. Designs that work within a triangle usually force us to give up any notions that what we see will look like any recognizable object and instead to respond on a totally nonobjective level.

Circular formats are also hard to work with. They tend to be seen as decorations—and this is how they were used classically, as ornaments high up in cathedral ceilings or windows. They were a logical choice for high places, because—unlike rectangles, squares, and triangles—they lacked the solidity of a straight base and could easily be seen as floating in space. In order to make a circular format work as a design to be looked at, you usually have to establish a strong horizontal or vertical line to give the viewer something solid to relate to. From this visual clue a sense of logical structure may evolve.

Although most of your work will probably be done in a format similar to the Golden Rectangle, it is exciting and instructive sometimes to break out of this mold to see what happens in a different format. One way to do this

is to shift "frames" about on top of your designs. For rectangular formats, this could be two large black Ls of cut paper. Try shifting them over your design to make the format taller or wider. When you hit on a format that seems to work well, you can mark the corners by indenting the paper with your fingernail. Then move the frames around some more. If you find yourself continually choosing the same format, it is probably the best one for you for that design. A different way to experiment with this would be to take a design you like and then try to figure out how to make it work in various overall shapes. You may also want to experiment with scale, testing how well a solution works if it is unexpectedly large or small.

Presentation

Many of the problems in this book are simply exercises to help you learn something rather than directions to produce a work of art. For the most part, the results will not be worth careful preservation. However, in some cases you may want to experiment with the effects of adding a border to two-dimensional exercises either by matting or dry-mounting.

A border can serve several functions. When the work is hand-held, the border provides an area that can be touched without damaging the design. If the design is placed on a figured or textured wall, the border helps set the design off from the visual distractions of the wall surface. In addition, the size and color of the border will affect the way the design works. Choice of a dark or light mat will affect which areas of a nonrepresentational design are seen as figure and which are seen as background. Value contrasts introduced by a mat may increase the dramatic impact of a design. Colored borders can interact with the colors of a design; if this effect is considered undesirable, a white mat can be used for color problems to eliminate this possibility. Finally, the proportions of border to design help control the viewer's response. An oversized mat tends to make the object it encloses seem more precious; it draws the viewer's attention in. An unusually thin border mat may make the work it surrounds seem larger in scale.

The traditional proportions for a mat border are 3 units on the two sides and top and 3¼ to 3½ units on the bottom. Like placement of lines and shapes within the design itself, this placement of the design slightly above the center of the mat "feels" right to the viewer and provides a base large enough to support the design visually. This rule of thumb is not inviolable, however, and other proportions are worth experimentation.

In *matting,* a window slightly smaller than the edges of the design is measured and cut with a sharp mat knife from an all-rag mounting board [Figure A-1]. If a cheaper board made from wood pulp is used, the acid it contains will damage the paper used for the design. The window is then hinged along the inside of the upper edge with gummed linen tape to another piece of mat board cut to the same outer dimensions [Figure A-2]. The design is likewise hinged along the top to the inside of the "window" piece [Figure A-3]. If further protection is needed, the matted work can be covered with acetate stretched across the front and taped to the back.

To save mat board, a single piece can be used as both border and backing. For temporary effects, the design can simply be attached to the board with loops of masking tape or with rubber cement. For a more permanent

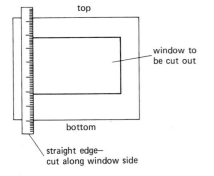

A-1

Cutting a mat board.

mounting, cover both the back of the design and the entire area where it is to be placed with rubber cement, wait until both are tacky or dry, and press them together. For *dry mounting,* cut a piece of dry-mount tissue to the size of the design and place it on the backing, cut either with or without a border. The design and backing can then be bonded with an electric dry-mount press or a warm iron, according to the instructions given with the tissue. Since heat is involved, this technique is inappropriate for greasy works such as crayon drawings, which might melt and run.

The Groundsheet

For the designed surface itself, you should probably buy a *drawing tablet* for the early two-dimensional problems. From it you can cut sheets to size for use as *groundsheets.* A groundsheet is simply the field that you start with, the sheet to which you apply an image. If you can't afford a drawing tablet, you or your art department might be able to get butt ends of newsprint from a local newspaper.

For drawing problems done with pencil or ink, you'll appreciate a good piece of paper. Cheap pulp paper will rip; it has no body. If you buy a good *rag paper,* you can draw on it without ripping or smudging, erase cleanly, and remove glue or tape easily. You can draw a very nice black and physically work "into" the paper by erasing some black areas to get grays or even the white of the paper itself. Because of its heavier weight and longer fibers, a good-quality paper is more likely to stand up to such treatment than a cheap paper. But either *watercolor paper* or a *charcoal paper* with tooth—a pebbled texture—can sometimes be substituted for a more expensive drawing paper.

For the more difficult value problems and color problems done with paint you will need to use *illustration board.* This is a cardboardlike stiff paper with a good surface, often with a high rag content. It usually comes in large sheets; most stores will sell you a half sheet.

Many people are now rediscovering the craft of making art papers by hand. If *handmade* papers are available in your area, you might like to try them and even ask to see how they are made. Their porous, coarse-textured surface is nice for pencil drawing or prints. But when ink is applied to handmade paper it tends to "feather" unless the surface has been coated with something to make it less porous.

Cut Papers

Just as you should do the early problems on an inexpensive groundsheet, you should also start with inexpensive materials to make the lines and shapes you apply to it. Cutting them out of paper will keep you from feeling that your solutions are too "finished" to redo as well as give you a chance to push things around and see how they work best before finalizing your design by gluing them down.

For cut paper lines and shapes, buy a package of *white construction paper* and a package of *black construction paper* in the standard 9-by-12-inch size. Notice that the two sides of construction paper are slightly different. In the black paper one side is somewhat blacker, the other somewhat grayer. It doesn't matter which side you use face-up, but you should

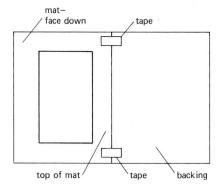

A-2 above
Hinging the mat.

A-3 below
Hinging the design at the top.

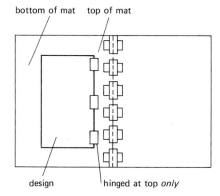

consistently use one side only in each design. For certain value problems, you may want to use more expensive *gray packs* of silk-screened papers, the values of which range from white to black with values in between. Many of the color problems suggest use of *silk-screened colored papers.*

You will also need something to cut with. *Scissors* are good for free lines that do not have to be straight, and some artists like to use scissors for all cutting jobs. You should have a good pair with blades at least 6 inches long. Many people prefer an *X-Acto knife* for cutting straight lines. A *mat knife* is more awkward; it has a large handle and requires that you bear down with your knuckles almost touching the paper. An X-Acto knife has a slimmer handle and can be held almost like a pencil. Any cutting tool must be sharp to make a clean edge. Scissors can be resharpened; X-Acto knives have replaceable blades.

For X-Acto knife work you will need a surface to cut on. A piece of glass at least 10 inches square or 10-by-12 inches works well as a *cutting surface.* It can also be used as a palette for paint mixing; the dried paint can be washed off with water or lifted off with a single-edge razor blade. If you put a piece of white cardboard under the glass with the white side up and tape it to the edges with masking or cloth tape, you will have a good white palette for paint mixing and you will not cut your fingers on the glass edges. If glass is not available, use a board or a piece of cardboard to cut on.

To cut strips with scissors you must turn the paper over, measure the desired width in two places (the top and bottom of the page, if you are using the whole sheet), place dots at the measured points to serve as guides, hold a metal ruler against the dots, draw the line with a pencil, and then cut. The pencil must be kept very sharp to avoid varying the width of the drawn lines. If you cannot see pencil on your black paper, use pen.

With an X-Acto knife you can eliminate the line-drawing step: Just hold the ruler against the dots and pull the blade cross the ruler. To save even more time when cutting a lot of thin strips, you may be able to cut them without even measuring, If you have a good eye, just keep moving the ruler over the same distance and cutting off strips with the X-Acto knife. If you are right-handed, keep the paper from which you are cutting to the left, with only the piece you are cutting off showing to the right of the ruler. This will help to steady the paper. (If you are left-handed, the piece you are cutting off is to the left of the ruler.)

Once you have cut your lines or shapes and decided where you want them to go, you will need to glue them down. *Rubber cement* is good for this purpose. Although it tends to come through the construction paper as a yellow stain after a long period of time, it is relatively cheap and easy to work with in solving problems. You might want to buy a large bottle of rubber cement with a brush dispenser since you will be using so much of it. If it thickens with time and evaporation, you can add rubber-cement thinner. More liquid glues such as Elmer's are not good for paper problems because they wrinkle the papers.

Used correctly, rubber cement makes a permanent bond. This requires applying the glue to *both* the figure and the groundsheet and waiting until the glue is dry or at least tacky before laying the figure on the groundsheet. Since they will bond instantly, you can slide a piece of waxed paper under the figure until positioned just as you want on the groundsheet. People typically put a lot of glue on the figure only and slide it around on the ground-

sheet while the glue is still wet. If you do this, when the glue dries it may peel off after a few weeks.

One of the nice things about working with rubber cement is that extra glue left on the design can be removed easily. You can roll off the excess glue with your fingers, but doing so may smudge the design. It's better to use a *rubber cement pick-up:* a small rectangle of rubbery material that lifts excess rubber cement off paper when pressed against it.

Drawing Tools

Another way to experiment with images is to draw many possible solutions to the same problem with a pencil or with pen and ink and then compare the results. (Certain two-dimensional problems in this book that involve value and modeling of forms specify use of drawing tools rather than cut papers.) Although this is not a drawing course, experimenting with various drawing supplies will broaden your awareness of design possibilities.

For pencil problems, you could buy only one *pencil*—perhaps a medium hard (HB) one—or you could buy several and experiment with their different effects. Pencils marked *H* have relatively hard lead. The hardest ones (6H and 5H) will make lines so hard and fine that they will cut paper. Softer leads are labeled *B*. Marks made with soft pencils smudge easily if you rub your hand across them. As a beginning assortment, try a 2H, an HB, a 2B, and a 4B. You could also get a flat *carpenter's pencil* to experiment with the calligraphic effects of wide lines. Pencils can be sharpened with an electric sharpener, a penknife, or a sanding block. Pencil marks can be erased from good paper with a pliable, self-cleaning *kneaded eraser,* a soft *gum eraser,* or a *pink pencil eraser,* though the latter may mar the paper.

Charcoal, made from charred wood or vine, is probably the most ancient of drawing tools. It can be easily used to indicate shading of forms and varying values as well as lines. However, charcoal marks will smudge unless sprayed with a fixative. A *workable fixative* allows you to continue working on a charcoal drawing that has been sprayed. *Vine charcoal* is extremely soft; its marks can easily be lifted from charcoal paper with a *chamois skin.* *Compressed charcoal* comes in sticks; both the broad side and the edge can be used to create a full range of values. In a *charcoal pencil,* wood surrounds the charcoal center, allowing the pencil to be sharpened to a point with a blade or pencil sharpener.

Like charcoal, *conté crayons* produce soft lines and shading of forms but cannot be intentionally blurred and smeared (or unintentionally smudged) quite so easily as charcoal. They are available in sticks or pencils, in soft, medium, or hard grades, and in four colors—sepia, sanguine (a red), black, and white. Conté crayons are hard chalk sticks. Conté pencils are encased in woodpulp that can be sharpened to a point with a sanding block for fine lines or left blunt for broader strokes.

A drawing tool rarely used well by adults is the *wax crayon,* or Crayola. Children use them very well. When adults try to draw with crayons, the results usually look like bad imitations of children's drawings. Perhaps adults try to force a crayon to work like a pen or a pencil. Instead it skips, slides, and scoots with a freedom all its own.

Inked marks can be applied with a great variety of pens. *Drawing pens* have nibs that flex open and closed; by varying the pressure you apply, you

can change the width of the line. Natural materials used for nibs include quills cut from the feathers of large birds (such as geese, swans, and crows) and reeds of bamboo or cane. Metal nibs come in a variety of shapes and widths for varying effects. *Ruling pens* have two blades that can be tightened or spread with a screw to vary line width; they can also be attached to a compass for making perfect circles. Technical pens such as *Rapidograph pens* have a reservoir for ink and a choice of tips for lines of varying width, including points that will make a very fine, precise line.

Drawing pens with a nib can be used with waterproof black *India ink* or *colored inks,* but for beginning exercises *water-soluble inks* are a better choice since they are cheaper and allow the pens to be cleaned easily. Water-soluble ink can also be applied as a wash with a brush. The paper itself can be wet, in which case the ink will "feather" as it is applied. Or the brush can be dipped into ink, used to make a dark area, and then dipped into water and smeared about to create a range of grays. Inks can be applied with any kind of *brush,* from fine artists' brushes of varying widths and shapes to old shaving brushes. Even a piece of wood can be dipped into ink and used experimentally as a drawing tool.

Some pens prefilled with ink make good and inexpensive drawing tools. *Razor-point pens* are a good substitute for Rapidograph pens and much cheaper. *Felt-tip* pens leave a dot wherever you pause in drawing a line, and their ink penetrates most papers. But the wetness that produces these sometimes undesirable effects also makes these pens glide easily across paper, producing a very free and fluid line. By contrast, a *ball-point pen* forces you to use a constricted hand movement, producing a less beautiful line. Its ink also has a tendency to smudge. Either ball-point or felt-tip pens can be moved in any direction, unlike a steel-nib pen.

If you are using any of these tools to draw a straight line, you will need a *metal ruler* at least 18 inches long (if you use a metal-edged ruler, the edge may dent). First you use the ruler to measure and place tiny dots. They must be small because they are marked on the right side of the paper and will become part of the drawn line. When you line up the ruler with the dots, how you hold your drawing tool against it is critical. If you hold the tool at an angle with the top leaning away from the ruler, the point will slip beneath the ruler, make a line in the wrong place, and perhaps smear if you are using ink. If you angle the top toward the ruler with the point pushed away from it, the line will again be in the wrong place and may waver. It is best to hold your tool directly perpendicular to the edge of the ruler, drawing it down toward you with a steady hand. To make sure that the ruler does not smear your work, you can tape three pennies to the back of the ruler—or buy one with a cork backing to hold it up off the groundsheet.

Most people find it easier to draw lines vertically rather than horizontally. If you need to make a horizontal line, you can turn the page sideways. If you are making a series of lines, work away from the ones you have already drawn to avoid smearing them.

Paints

We recommend use of *acrylic paints* for this course since they dry faster than oil-based paints and can be cleaned up with soap and water. Liquitex Modu-

lar Colors (Permanent Pigments, Inc., 2700 Highland Avenue, Northwood, OH 45212) are prepared and labeled in accordance with the Munsell system of controlled gradations in hue, value, and saturation, somewhat simplifying paint mixing. The twelve-tube set is adequate for this course. It consists of Value 5 Blue, Value 5 Red, Value 5 Green, Value 5 Purple, Value 5 Red Purple, Value 5 Yellow, Value 8 Yellow, Value 3 Red, Base Value Blue Green, Base Value 75 Blue Purple, Titanium White, and Mars Black. If you use other brands of paints not based on this modular labeling system, the generic names given below will provide approximately the same basic colors.

Value 5 Blue	Brilliant Blue
Value 5 Red	Scarlet Red, Cadmium Red Light
Value 5 Green	Permanent Green Light
Value 5 Purple	Brilliant Purple
Value 5 Red Purple	Medium Magenta
Value 5 Yellow	Bronze Yellow
Value 8 Yellow	Brilliant Yellow, Cadmium Yellow Medium
Value 3 Red	Deep Brilliant Red
Base Value Blue Green	Phthalocyanine Green
Base Value 75 Blue Purple	Ultramarine Blue

A white *palette* and unchanging lighting will help you see colors consistently when you are mixing them. As indicated earlier, the palette can be a piece of glass or Plexiglas with a sheet of white paper or white cardboard taped to the back. Dried paints can easily be washed or scraped off.

To apply paint in varying ways, you will need a few brushes of varying sizes. Brushes with plastic bristles designed especially for acrylic paints are available, but it is better to use *sable brushes.* Although the sable brushes are more expensive, they will last a long time if carefully cleaned after each use. Sable brushes lay the paint down better than "acrylic-paint" brushes because the latter are made of plastic bristles to which paint does not adhere well, particularly if it has been thinned with water. To work with acrylic paints you will also need two *containers for water*—one for cleaning your brushes and one for clear water for paint thinning—and a *rag* or *paper towels* for cleaning your brushes between colors.

Three-Dimensional Materials

The skills involved in creating three-dimensional masterworks are considerable. But to get an idea of what it is to work in three dimensions, you do not need to cut marble or cast bronze. Very simple and inexpensive materials and readily available tools are adequate for the problems given in this book.

Modeling A variety of modeling materials is available at art supply and novelty stores. *Children's modeling clays, plastilene,* and *Plasticene* are nonhardening, smooth, and pliable. They will not dry out and can be reused. *Moist terra-cotta* is a rich red-brown natural clay that resists cracking and can be fired in a kiln for hardness. Many parts of the country have *local clays,* which can be dug up and used for modeling. All these clays can be worked by hand and/or with knives and ceramic tools. *Foam rubber* can be cut or tied to desired forms, mounted on a board with nails or glue, and

painted with very wet plaster of Paris to harden the forms. Even *bread dough* can be modeled when soft and then baked.

Ready-made *armatures* for a head or human figure are available at art-supply stores. The figures are made of wire that can be flexed into any position even after clay has been applied, so long as the clay has not hardened. You can construct an armature out of any kind of wire, cut and bent to provide an understructure for a desired form. An armature can be used beneath *papier-mâché* to keep a piece from becoming too heavy and to allow it to dry from the inside. Papier-mâché can even be built up over a balloon.

Subtraction For carving, a soft wood such as *balsa* or *sugar pine* or stone such as *soapstone* will offer relatively little resistance. These can be worked with a knife, rasp, file, sandpaper, or electric sander. Other *woods* can be worked with carpenter's tools, a sculptor's wooden mallet and chisels, or a chain saw.

Plaster of Paris can be mixed with water and cast in a wax-coated milk carton. When the block is dry it can be carved with a knife, rasp, or file or shaped with sandpaper. *Cement* can be mixed and cast in the same way but is much harder and must be carved with stone hammer and chisels.

Blocks of *alabaster* are relatively inexpensive and somewhat soft for carving; this translucent stone allows light to filter through a piece. Art-supply stores also carry a variety of materials such as *carving bricks* that are made to look like stone but are much softer for simple sculpting projects. *Carving wax* can easily be worked with carving tools; scraps can be melted down into new blocks.

Casting *Plaster of Paris* is a simple material to use for casting. The white powder, available at hardware and art-supply stores, can be mixed with water in any container to a thick but still liquid consistency, following the directions on the bag. A 6- to 8-inch rubber ball, cut in half, will provide two mixing bowls for plaster of Paris that are very easy to clean. When the material starts to feel warm, the setting process has begun and the material should be poured into the cast before it sets. If you wait too long you will have a casting of half a ball (which then could be carved).

The casting problem given in this book uses crumpled paper as a cast; for other simple casting projects, plaster of Paris can be poured into a molded bed of moist *sand* or *plasticene* in a box (perhaps with small objects pressed in to be picked up as part of the cast). A *balloon* can be filled with wet plaster of Paris, twisted into desired forms, and then peeled away when the plaster inside has set. Casting can also become a very complex procedure; directions can be found in books about sculpture technique.

Additive construction Any material at all can be used in an additive sculpture, from found objects to wood to plastics. The technical problems incurred often involve questions of how to bind unlike materials to each other. For instance, how would you attach a stone to a piece of wood? Certain *super-glues* can be used to bond dissimilar materials, but you may prefer to use *rope, twine, chains,* or even *vines* to hold things together visibly. Traditional fasteners include *nails, screws, hinges, dowels, rivets, bolts,* and *welding.* For large works or sculptured environments you could use sheets of cardboard, held together with *duct tape, string, integral tabs, dowels,* or *laces.*

Within definitions, words that are defined elsewhere in this Glossary are *italicized.*

abstract Descriptive of representation of known physical objects with great *economy.*

abstract art An art form in which subjects are simplified, with emphasis on *design* rather than realism.

abutting shapes *Shapes* which touch one another.

actual texture The true features of a surface, apparent to the touch; also known as "local texture." See also *simulated texture; interpretive texture.*

additive (1) In *light mixtures,* descriptive of the progressive lightening of a mixture by the addition of other colors. (2) In *three-dimensional* work, descriptive of creation of a piece by assembling similar or dissimilar materials.

airbrush Mechanical spraying device used to apply paint to the surface of a work.

atmospheric perspective The use of softer *edges,* lessened *value contrast,* and less distinctive detail in areas intended to be interpreted as being farther away from the observer, as in hills seen from a distance.

afterimage The optical illusion of a *hue* that may be created after the viewer stares fixedly at its *complementary hue.*

analogous colors *Hues* that lie next to each other on a *color wheel.*

analogous color scheme Use of three or more *hues* that are close to each other on a *color wheel.*

applied arts Disciplines involving the use of the principles and elements of design to create functional pieces of art for commercial uses; also known as "applied design."

armature A relatively rigid internal support for modeling of more malleable materials.

assemblage A *three-dimensional* composition made from objects originally created for other purposes.

asymmetrical balance The use of *figures* of different *visual weights* to create an overall impression of balance; sometimes called "informal balance."

background In a *two-dimensional* work that creates an illusion of *three-dimensionality,* the area that appears farthest from the observer; also called *ground* or *field.*

balance Distribution of the *visual weight* of *design* elements.

biomorphic Reminiscent of forms from nature.

blind contour A *contour* drawing in which the artist's *eye* focuses on the object being represented rather than on the *image* being created on the drawing surface.

calligraphy Handwriting approached as an art form.

casting The substitution of one material for another by means of a mold.

chiaroscuro The effects of light and shadow in a *two-dimensional* work, especially when these are treated as strong *value contrasts.*

chroma See *saturation*

collage A composition formed from materials glued onto a stiff backing.

color How *hue, intensity,* and *value* are observed in *pigment* or light.

color picker Computer term for a series of color *palettes,* available in certain software

color scheme The choice of colors used in a work of art, such as monochromatic, analogous, complementary, or mixed.

color solid Any of several *three-dimensional* models for portraying color relationships according to variables of *hue, saturation,* and *value.*

color wheel Any various attempts to illustrate color relationships as positions on a circle.

complementary color scheme Use of a pair of *complementary hues* in a work.

complementary hues Colors that are opposite each other on a *color wheel.* Mixed, they "gray" or neutralize each other; juxtaposed, they may produce strong optical effects.

compositional position Means of organizing *shapes* within a work to help define *space.*

computer aided design Allows an artist to view and manipulate a *design* in three dimensions prior to fabrication.

concept An idea or general notion, as in the underlying meaning of a work of art.

content The idea being conveyed in a work of art.

continuous tone Referring to art with solid and infinite gradations of values, as in a photograph, rather than the illusion of values created by broken screen patterns or drawing devices.

contour The outline of a *three-dimensional form.*

control To organize areas of a work—including unfilled areas—so that they have the intended effect on the viewer.

crafts Disciplines involving the creation of functional pieces by hand, usually on a small scale.

cropping Showing only part of an *image,* giving enough information that viewers can mentally complete it.

cross-hatching Use of intersecting, closely spaced parallel lines to create tones in a black and white work.

design To choose and arrange elements in such a way that they satisfy an artistic and/or functional intention.

digitize To convert any *image* into a *form* that can be electronically processed, stored, and reconstructed.

double complementary schemes Schemes made up of any two sets of complementary colors.

earthwork A large-scale, *three-dimensional* project involving physical alterations of the earth's surface for aesthetic purposes.

economy Using only what is needed to create an intended effect, eliminating any elements that might distract attention from the essence of an idea.

edge A boundary along which two different colored areas or surfaces meet.

emphasis Drawing attention to a portion of a composition.

erasure A subtractive method used in working a surface.

expressive line Quality or variation of a line made with any media.

eye-level line The imaginary line we "see" when we look straight ahead and from left to right.

field See *ground*

figure In *two-dimensional* work, an *image* that appears to be somewhat closer to the viewer than the *background* against which it is presented; also referred to as a *positive shape.* The relationship between figure and background is variously referred to as "figure/ground," "figure field," and "positive shape/negative space."

figure-ground relationship Relationship of a *shape* to the material it is imposed upon.

figure-ground reversal A composition in which it is difficult to tell what is *figure* and what is *background,* for the *design* can be seen either way; sometimes called "figure-ground ambiguity." See also *physical figure-ground reversal*

fine arts Disciplines involving the creation of artwork principally for aesthetic appreciation; also called the "visual arts."

flat compositions *Two-dimensional designs* that eliminate all clues to depth.

flat space See *two-dimensional space* or *flat compositions*

focal point The area toward which the viewer's eye is most compellingly drawn in a composition.

foreground In a *two-dimensional* work that creates an illusion of *three-dimensionality,* the area that seems closest to the observer.

form (1) In *two-dimensional* work, a *figure* that appears to be *three-dimensional;* sometimes called "mass" or "volume." (2) In *three-dimensional* art, the area confined by the contours of a piece; sometimes called "*shape.* " (3) The overall organization of a work.

format The dimensions and shape of a work.

found object Something extracted from its original context and used in creating a work of art.

frontal A *three-dimensional* work designed to be seen from one side only.

frottage French for rubbing; a method in which a positive *image* is created by placing paper over an object and rubbing to reproduce its surface.

full round Work meant to be viewed from all sides.

geometric shape A *shape* created according to mathematical laws, such as a square or a circle.

gestalt The dynamic unity of a successful work of art—a configuration so integrated that its properties cannot be determined by analyzing the parts in isolation; derived from Gestalt psychology, the doctrine holding that psychological phenomena are configurational wholes.

gesture The attitude or expression of movement in a work, as in gestural drawing; usually drawn rather quickly to capture the feeling of movement.

gradation Compositional term referring to the transition from one form to another by changes in *value.*

gray scale A graded range of equal steps of gray between white and black.

ground (1) The initial surface of a *two-dimensional design.* (2) The area of a *two-dimensional* work that appears to be farthest from the viewer; also called "background" or "field."

groundsheet In *two-dimensional* pieces, the paper on which an *image* is developed.

hard edge A precise boundary between areas, sometimes emphasized by strong *value contrast.*

harmony Pleasing arrangement of elements of design in a work of art.

hatching Use of closely placed parallel lines to create tones in a black and white work.

high contrast Use of extremely light and extremely dark *values* exclusively in the same work.

horizon line The distant point at which sky and ground appear to meet.

horizontal balance Balancing of the right and left sides of a composition in terms of *visual weight.*

hue The name of a color (as in "red," or "red-yellow").

illusionary space In a *two-dimensional* work, creating the illusion of three dimensions.

image (1) A representation of an object, individual, or event. (2) In *non-objective art,* a *positive shape.*

impasto Use of thick paint with brush or knife strokes that show as textural effects.

implied lines *Lines* that do not exist on a surface but are created or completed in the viewer's imagination.

implied shape An illusion of a *shape* suggested by the artist but actually created in the viewer's imagination.

intensity See *saturation*

interlock To fit together like pieces in a jigsaw puzzle.

interpenetration A phenomenon in which a color takes on the color characteristics of adjoining colors.

interpretive texture Use of a *texture* that conveys an idea about an object rather than representing its visible surface features.

interpretive values Use of *values* to convey an idea rather than to represent accurately the degrees of light and dark actually seen in an *image* from the *three-dimensional* world.

invented shape A *shape* created by the artist's imagination.

juxtaposition Placement side by side.

kinetic art *Three-dimensional* art that moves.

leading edge The *edge* that seems closest to the viewer.

light mixtures *Hues* that can be obtained by mixing light rays of different *wavelengths.*

line A mark whose length is considerably greater than its width.

linear Relating to or resembling a *line* or lines.

linear perspective In *two-dimensional* art, a system of representing *three-dimensional spatial* relationships derived from the optical illusion that parallel lines, if extended to the horizon, appear to converge; also called "vanishing-point perspective."

local color The color that an object from the world of our experience appears to be.

local texture See *actual texture*

local values The actual colors of an area of the *three-dimensional* world, translated directly into grays that represent relative degrees of lightness and darkness.

low contrast Predominant use of medium *values* in a work.

low relief A *three-dimensional* work in which *contours* barely rise off a flat surface.

major contours The outer *spatial* limits of a *three-dimensional* piece.

manipulation See *modeling* (2)

maquette A preliminary model of clay or wax used in planning the form of a sculpture.

mass See *form*

medium Material used to create art, such as pen, pencil, paint, etc.

metamorphosis Transformation from one *shape* or *form* to another.

middle ground In a *two-dimensional* work that creates an illusion of *three-dimensionality,* the area that appears to lie in a middle distance between the *foreground* and *background.*

mid-tone A color or a gray of medium *value.*

middle mixtures Three *analogous colors* in which one is an approximate mixture of the other two, used in creating certain color illusions.

mobile A sculpture consisting of parts that move in air currents.

modeling (1) In *two-dimensional* work, use of *shading* on *contours* to give the illusion of *three-dimensional form.* (2) In *three-dimensional* work, using hands or tools to manipulate a pliable material into a desired *form;* also called "manipulation."

module A uniform structural component used repeatedly.

monochromatic color scheme Use of a single *hue,* in varying *values.*

monotype One of a kind print made from painted or inked surface.

morphing Computer term for the process of transforming one *shape* into another in real time.

multiple point perspective Using three or more vanishing points within a work to create the illusion of *space* on a *two-dimensional* surface.

negative Descriptive of areas in a work that appear to be unoccupied or empty.

negative afterimage After staring at a highly saturated color, then look at a white area, an *image* of its complement will appear.

nonfigurative art Without figures. See *nonrepresentational art.*

nonobjective art Art that is not a representation of any particular object from the world of our experience.

nonrepresentational art Art that does not depict real or natural things in any manner.

one-point perspective *Spatial* rendering of a *figure* whose sides recede toward a single *vanishing point;* sometimes called "one-vanishing-point perspective."

optical color mixture A color-mixing sensation created in the viewer's perception by use of *juxtaposition* of small areas of different *hues.*

optical figure-ground reversal Use of unequal amounts of two or more colors in such a way that it is difficult for the viewer to distinguish which is *positive figure* and which is *negative background.*

optical mixtures Illusions of *mid-tones* created through the *juxtaposition* of light and dark areas.

overlapping Obscuring of part of an *image* by another one that seems to lie between it and the viewer.

palette (1) The surface on which paints are mixed. (2) The range of colors used in a particular work or by a particular artist.

patina A smooth texture and sheen created on a surface by aging and use or by chemicals.

pattern A coherent visual structure, usually created by *repetition* or similar *design* elements.

photogram Use of a light source to record *images* directly on a special paper without a camera.

photorealism A style of art that mimics life as the camera sees it.

physical figure-ground reversal Use of equal amounts of two or more colors to create ambiguity as to which is the *positive figure* and which is the *negative background.* See also *figure-ground reversal*

pictorial See *pictorial compositions*

pictorial compositions Compositions that develop an illusion of the *three-dimensional* world on a *two-dimensional* surface.

picture plane In a *two-dimensional* work, the flat surface having only height and width.

pigment A substance that reflects approximately the same color as the band of the same name in a spectrum of *refracted light.*

pigment mixture A color, obtained by mixing paints, whose apparent hue results from *reflected light.*

pixel An individual dot of light on a computer monitor that contributes to a total image.

plane A *two-dimensional* surface or area.

plane structure Analysis of a *three-dimensional form* as a series of flat surfaces.

point of view (1) The place where the viewer appears to be in relationship to *images* depicted in a composition. (2) In *linear-perspective* drawing, the point from which the artist is looking.

pointillism (1) Use of small dots of varying colors in painting to create *optical color mixtures.* (2) A nineteenth-century French school of painting that used this technique.

position Placement of an *image* relative to the *picture plane,* a consideration that may affect where the *image* appears to lie in space.

positive Descriptive of an area that appears to be filled or occupied in a *design.*

primary colors The irreducible *hues* in a color system from which all other hues can be mixed.

principal colors In the Munsell *pigment mixing* system, the five initial *hues* from which all other hues can be mixed.

print (1) To reproduce the raised surface features of an object by inking them and applying the object to another surface. (2) The image created by this process.

read With reference to the visual arts, to look at and assign meaning to a visual image.

ready-made An object divorced from its usual function and presented as a work of art.

reflected color The color that the eye perceives as reflected from a surface that absorbs all other *wavelengths.*

refracted light The light rays produced when sunlight is deflected through a prism.

repetition Use of similar *lines, shapes, forms, textures, values,* or colors to unify a *design.*

representational Descriptive of art that depicts objects from the world of our experience.

reverse atmospheric perspective The out-of-focus blurring of objects very close to the observer, with more distinct *edges* and *values* contrasts in objects farther away.

rhythm A particular visual "beat" marking the movement of the viewer's eye through a work, often established by *repetition* of similar or varying *design* elements.

round An allusion to *three-dimensionality,* usually in the phrase "in the round."

rubbing A reproduction of the *texture* of a surface made by placing paper over it and rubbing the paper with a drawing tool.

saturation A measure of the relative brightness and purity or grayness of a color.

scale The relationship between the size of an *image* and the size of its surroundings.

scanning The path the viewer's eye takes in looking at a work of art.

secondary colors *Hues* obtained by mixing two *primary* colors.

secondary contours Interior *modeling* of a *three-dimensional* work, as opposed to the outer *major contours*.

semi-abstract Type of art in which objects in a work may be partially identifiable as elements of the natural world.

shade (1) A dark *value* of a *hue*, created by adding black. (2) In some *pigment mixing* systems, a *hue* neutralized by its *complementary hue*.

shading In *two-dimensional* work, the depiction of relative darkness in areas where light has been partially blocked.

shape (1) In *two-dimensional work*, a *figure* that appears to be flat. (2) In *three-dimensional* work, a term sometimes used to refer to the entire area within the *contours* of a piece. See also *form* (2)

simulated texture The optical impression created by artistic means that a surface could feel a certain way if touched; also called visual texture. See also *actual texture; interpretive texture*

simultaneous contrast *Juxtaposition of complementary hues,* creating such optical illusions as intensification of each *hue* and vibrations along the *edge* where they touch.

soft edge A blurred boundary between areas, sometimes rendered even less distinct by similarities in color and *values.*

space The unoccupied area in a work of art, the distance between *shapes* and *forms.*

spatial Pertaining to or creating the illusion of *space.*

split complementary schemes A color combination in which a *hue* is used with hues lying on either side of its direct complement.

spontaneous interaction A composition in which *design* elements interact to make the viewer perceive optical illusions.

stippling The use of dots to create *tones* in a black and white work.

subjective color Use of color to create a certain effect rather than to portray the apparent *local color* of a scene from the world of our experience.

subtractive (1) In *pigment mixing,* descriptive of the progressive darkening of a mixture by the addition of other colors, which removes their energy from the light reflected from a surface. (2) In *three-dimensional* work, descriptive of creation of a piece by carving away the material.

surreal Like pictures from a dream or the unconscious mind.

symmetrical balance Formal placement of identical *figures* on either side of an imaginary central line; also called *formal balance.*

synergy A process in which two or more elements interact to create effects of which they are individually incapable.

tactile Pertaining to the sense of touch.

temporal arts Art involving the continuum of time, as in dance, theater, and film.

tension Term of composition used to denote strain or pull in the relationship between design elements within a work.

tertiary colors *Hues* obtained by mixing a *primary color* with a *secondary color.*

texture Surface features that can be felt with the hand or interpreted by the eye. See also *actual texture; simulated texture, interpretive texture.*

three-dimensional Having length, width, and depth in space

tint A light *value* of a hue.

tone (1) See *value.* (2) To give a surface an all-over mid-value before working darker and lighter areas onto it. (3) In some *pigment mixing* systems, a *hue* with black added.

toning Changing the color of a surface to create a base on which to work.

transfer To convey a *design* from one surface to another.

transparency A composition in which a distant *plane* can be seen through a closer one.

two-dimensional Having length and width.

two-dimensional art A shape that has height and width but no true depth.

two-point perspective *Spatial* rendering of a *figure* whose visible sides recede toward two *vanishing points;* sometimes called "two-vanishing-point perspective."

unity Sense of coherence or wholeness in a work of art.

value The degree of lightness or darkness of a surface, sometimes called "tone."

value contrast The degree of difference between light and dark areas (as in *high contrast* or *low contrast*).

value gradations Gradual stages between light and dark.

vanishing point The point on the horizon at which visually converging parallel lines appear to meet.

vanishing-point perspective See *linear perspective.*

variety Variations on a theme or strong contrasts in a *design.*

vertical balance *Balancing* of the *visual weight* of upper and lower areas of a composition.

viewing angle The controlling position the artist gives a work.

viewing distance The distance from which an observer looks at a work of art.

visible spectrum The range of light rays that can be discerned by the human eye.

visual arts See *fine arts*

visual texture See *simulated texture*

visual weight The illusion of relative weight in a portion of a work of art.

void A hole, or *negative form,* in a *three-dimensional* piece.

volume See *form*

wavelengths Frequencies of electromagnetic radiation, some of which we can see as colors.

Weber-Fechner theory Geometric formula for creating arithmetic steps of color.

woodcut A carving into wood that leaves the *image* raised so it may be inked and printed.

References are to page numbers. **Boldface** page numbers indicate illustrations. Works of art are listed under the names of their creators. Student works are listed under Studio Problems titles. Many technical terms are included in the Index, with references to their text definitions, as well as the definitions in the Glossary.

CREDITS

Chapter 1 **3:** John Wilson White. **4:** Photo courtesy of Exxon Company, U.S.A., © Exxon Corp. 1995. **5:** © 1995 Artists Rights Society (ARS), New York/ADAGP, Paris. **8:** © 1995 Artists Rights Society (ARS), New York/SPADEM, Paris. **10:** Photograph by Edward Weston, Copyright © 1981 Arizona Board of Regents, Center for Creative Photography. **13:** Photograph © 1995 The Museum of Modern Art, New York. © 1995 Artists Rights Society (ARS), New York/ADAGP, Paris. **15:** Photograph © 1995 The Museum of Modern Art, New York. **17:** Photograph © 1995 The Museum of Modern Art, New York. **19:** Julius Shulman, Los Angeles. **21:** Wolfgang Volz, © copyright Christo 1976. **22:** © 1992 U.S.P.S. **24:** Photograph © 1995 The Museum of Modern Art, New York. **31:** Photograph © 1995 The Museum of Modern Art, New York. **32:** © 1995 Artists Rights Society (ARS), New York/SPADEM, Paris. **33:** © 1995 ABC/Mondrian Estate/Holtzman Trust. Licensed by ILP. **34:** © 1995 ABC/Mondrian Estate/Holtzman Trust. Licensed by ILP. **35a-g:** By permission of the Hartford Whalers Hockey Club.

Chapter 2 **2:** © The Board of Trustees of the Victoria & Albert Museum. **3:** Tom Haartsen/Frans Hals Museum. **7:** MMA accession no. 61.101.17. **8:** Photograph © 1995 The Museum of Modern Art, New York. **11:** Reprinted courtesy Eastman Kodak Company. **13:** Life Magazine © 1954 Time Inc. **15:** Yasuhiro Ishimoto, Tokyo. **16:** © 1996 Al Held/Licensed by VAGA, New York, NY. **17:** Photograph © 1995 The Museum of Modern Art, New York. © 1995 Artists Rights Society (ARS), New York/VG Bild Kunst, Bonn. **19:** Copyright IRPA-KIK, Brussels / Copyright A.C.L. Brussels. **23:** Photograph © 1995 The Museum of Modern Art, New York. **24:** © The Cleveland Museum of Art, 1995. **27:** Gabinetto Fotografico Nazionale, Florence. **28:** Bloch 1968 389.undesc. and 389.xi/xi. © 1994 Board of Trustees, National Gallery of Art, Washington. © 1995 Artists Rights Society (ARS), New York/SPADEM, Paris **29:** Used by permission of Volkswagen United States, Inc.

Chapter 3 **3:** © Gianfranco Gorgoni/Contact Press Images, New York.

6: © 1995 Artists Rights Society (ARS), New York/VG Bild Kunst, Bonn. **7:** Jean-Louis Bloch Laine. **8:** James Cox/Salk Institute. **9:** Photograph © 1995 The Museum of Modern Art, New York. **10:** © David Howells. **11:** © 1995 Artists Rights Society (ARS), New York/BONO, Oslo. **12:** © 1995 Artists Rights Society (ARS), New York/ADAGP, Paris. **13:** Photo © Hans Namuth, New York. © 1995 Pollock-Krasner Foundation/Artists Rights Society (ARS), New York. **15:** Photograph © 1995 The Museum of Modern Art, New York. **17:** Photograph © 1995 The Museum of Modern Art, New York. © 1995 Artists Rights Society (ARS), New York/SPADEM/ADAGP, Paris. **18:** Foto Marburg/Art Resource, New York. **20:** © 1995 Succession H. Matisse, Paris/Artists Rights Society (ARS), New York. **23:** Copyright British Museum. **27:** © 1995 Artists Rights Society (ARS), New York/VG Bild Kunst, Bonn. **28 - 34:** Joseph Szaszfai, Branford, CT.

Chapter 4 **1:** © 1986 Mark Wilson. **2:** © 1995 The Georgia O'Keeffe Foundation/Artists Rights Society (ARS), New York. **5:** Photograph by Lee Stalsworth. © 1995 Estate of Arshile Gorky/Artists Rights Society (ARS), New York. **6:** © Robert Motherwell, 1984. Photo © 1994 Board of Trustees, National Gallery of Art, Washington. © 1996 Daedalus Foundation/Licensed by VAGA, New York, NY. **8:** Photograph © 1995 The Museum of Modern Art, New York. **9:** Photograph © 1995 The Museum of Modern Art, New York. © 1995 Artists Rights Society (ARS), New York/VG Bild Kunst, Bonn. **10:** © 1994 Board of Trustees, National Gallery of Art, Washington. © 1995 Succession H. Matisse, Paris/Artists Rights Society (ARS), New York. **11:** © 1995 M. C. Escher/ Cordon Art, Baarn, Holland. All rights reserved. **15:** Joseph Szaszfai, Branford, CT. **19:** Photograph © 1995 The Museum of Modern Art, New York. **24:** Arthur Tooth & Sons, London. **25:** Art Resource, NY. **26:** Ezra Stoller © ESTO. **27:** Frank Thomas, Los Angeles. **28:** © 1995 Artists Rights Society (ARS), New York/ADAGP, Paris. **29:** Hirmer Foto Archiv, Munich. **31:** Met acc. 20.46.12. **33:** Joseph Szaszfai, Branford, CT. **34:** Photo by Lee Stalsworth. © 1996 James Rosenquist/Licensed by VAGA, New York, NY. **35:** Photo by Lee

Stalsworth. © 1995 The Georgia O'Keeffe Foundation/Artists Rights Society (ARS), New York. **36 - 39:** Joseph Szaszfai, Branford, CT. **42 - 46, 49 - 52:** Joseph Szaszfai, Branford, CT.

Chapter 5 **6a & b:** Giraudon/Art Resource, New York. **7:** John A. Hands. **8:** © The Walt Disney Company. **9:** neg #L-9 **11:** Photograph courtesy Frumkin/Adams Gallery, New York. **13:** © 1995 The Georgia O'Keeffe Foundation/Artists Rights Society (ARS), New York. **16:** Photograph © 1995 The Museum of Modern Art, New York. © 1995 Artists Rights Society (ARS), New York/ADAGP, Paris. **18:** Photo Lennon Weinberg, Inc., New York. **19:** Photo Chris Watson. **21:** Copyright © by the Trustees of the Ansel Adams Publishing Rights Trust. All rights reserved. **24:** Photographs Hiroji Kubota/Magnum and John Bryson/The Image Bank **25:** © 1995 M. C. Escher/ Cordon Art, Baarn, Holland. All rights reserved. **26:** © 1995 C. Herscovici, Brussels/Artists Rights Society (ARS), New York. **27:** © 1995 ABC/Mondrian Estate/Holtzman Trust. Licensed by International Licensing Partners, Amsterdam. **28 - 30:** Joseph Szaszfai, Branford, CT. **33, 35 - 38:** Joseph Szaszfai, Branford, CT.

Chapter 6 **3:** Lee Stalsworth. **5:** Photograph © 1995 The Museum of Modern Art, New York. © 1995 Artists Rights Society (ARS), New York/VG Bild Kunst, Bonn. **8:** Jerry L. Thompson. **10:** Anne Gold, Aachen. **11:** Photograph © 1995 The Museum of Modern Art, New York. © 1995 Artists Rights Society (ARS), New York/ADAGP, Paris **12:** © 1995 Pollock-Krasner Foundation/Artists Rights Society (ARS), New York. **16:** Eliot Elisofon. **20:** © The Word/Form Corporation, 1978. **22:** © Marshall Cavendish, Ltd., 1970.

24: Joseph Szaszfai, Branford, CT.
26: © 1995 Artists Rights Society (ARS),
New York/SPADEM/ADAGP, Paris. **27:**
© 1996 Robert Rauschenberg/Licensed by
VAGA, New York, NY **29 - 32:** Copyright
© 1994 by Bill Niffenegger. Reprinted by
permission of Bill Niffenegger and Random
House Electronic Publishing from *Photoshop
Filter Finesse* by Bill Niffenegger, pp. 214,
215, 223. SyQuest cartridge from
VersaTech Associates. Images provided by ©
1995 PhotoDisc, Inc. **33 - 42, 43 - 49:**
Joseph Szaszfai, Branford, CT.

Chapter 7 1: © Wynn Bullock.
Reprinted by permission of Aperture, New
York, from *The Aperture History of
Photography Series.* **3:** © RMN/SPADEM.
4: acc. no. 1975.1.862. **5 - 6:** Copyright
of the Trustees of the British Museum. **7:** ©
Thomas Porett. **8:** acc. no. 38.123. Photo
by Patricia Layman Bazelon. **11:** Photo by
John D. Schiff/Barbara Krakow Gallery,
Boston. **12:** Giraudon, Paris. **13:** Steichen
Carousel, Carousel Research, Inc. **14:** ©
1970 The Imogen Cunningham Trust, New
York. **15:** acc. no. 47-71. **16:** Photograph
© 1995 The Museum of Modern Art, New
York. © 1995 Artists Rights Society (ARS),
New York/ADAGP, Paris. **21:** Joseph
Szaszfai, Branford, CT. **22:** © The Board of
Trustees of the Victoria and Albert Museum.
27: Joseph Szaszfai, Branford, CT. **28:**
Popperfoto, London. **29:** © The Board of
Trustees of the Victoria and Albert Museum.
30: Copyright the Dorothea Lange
Collection, The Oakland Museum, The City
of Oakland. **31:** © 1995 Kate Rothko-Prizel
& Christopher Rothko/Artists Rights
Society, New York. **32:** © Robert
Motherwell, 1984. © 1996 Daedalus
Foundation/Licensed by VAGA, New York,

NY. **35 - 36:** Joseph Szaszfai, Branford,
CT. **38 - 41, 43:** Joseph Szaszfai,
Branford, CT. **44:** acc. no. 55.5. © 1995
Demart Pro Arte, Geneva/Artists Rights
Society (ARS), New York. **45 - 46:** Joseph
Szaszfai, Branford, CT. **48 - 50:** Joseph
Szaszfai, Branford, CT.

Chapter 8 1: VAGA. **11:** Photo by
Malcolm Varon, New York. © 1995 The
Georgia O'Keeffe Foundation/Artists Rights
Society (ARS), New York. **12:** © Beth
Phillips. **17:** Photo by Frank Noelker,
UConn. By permission of Adobe Systems.
18: Photograph and Photoshop work by
Douglas Kirkland. From his book *Icons.*
24: © Roy Lichtenstein. Photo by Robert
McKeever. By permission of Roy
Lichtenstein c/o Shelly Lee, New York.
25: © 1987 Pixar. **26:** © 1996 George
Segal/Licensed by VAGA, New York, NY.
28: Photo by Lee Stalsworth. © 1996
Richard Estes/Licensed by VAGA, New
York, NY. **29:** Photograph © 1995 The
Museum of Modern Art, New York. **30:** ©
1996 Larry Poons/Licensed by VAGA, New
York, NY. **31:** Photograph © 1995 by The
Barnes Foundation. All rights reserved. **34:**
© 1995 Artists Rights Society (ARS), New
York/VG Bild Kunst, Bonn. **35:**
Photograph © 1995 The Museum of
Modern Art, New York. **49:** © 1996 Estate
of Stuart Davis/Licensed by VAGA, New
York, NY.

Chapter 9 1: By permission of Frank
Gallo. **2:** Ruth Walz, Berlin. **4:** Roger-
Viollet, Paris. **5:** Photo by John Cliett. All
reproduction rights reserved. © Dia Center
for the Arts 1980. **6:** © 1995 Artists Rights
Society (ARS), New York/ADAGP, Paris.

7: Grob Galleries, London. © 1995 Artists
Rights Society (ARS), New York/ADAGP,
Paris. **8:** Photo courtesy the artist, Poznan,
Poland. **10:** Photograph © Giorgio
Colombo, Milan. © 1995 Bruce
Nauman/Artists Rights Society (ARS), New
York. **11:** David Heald © The Solomon R.
Guggenheim Foundation, New York.
12: Photo Art Resource, NY. Acc. no.
DA1971-49-1. **13:** Photograph © 1995
The Museum of Modern Art, New York. ©
1996 Estate of Gerrit Rietveld/Licensed by
VAGA, New York, NY. **14:** J. Rico
Eastman, Santa Fe, New Mexico.
15: MoMA. **17:** Photo by G. E. Kidder
Smith, FAIA, from his book *The New
Churches of Europe.* © 1995 Artists Rights
Society (ARS), New York/SPADEM, Paris.
18: MoMA. **20:** Art Resource, NY.
22: Photograph © 1995 The Museum of
Modern Art, New York. © 1995 Artists
Rights Society (ARS), New York/ADAGP,
Paris. **23:** acc. no. 1942.43. **24:** Photo by
Tom Forma, Storrs, CT. **25:** acc. no.
41.190.104. **26:** Photograph © 1995 The
Museum of Modern Art, New York. © 1995
Artists Rights Society (ARS), New
York/SPADEM, Paris. **27:** Photo by Tom
Caravaglia, New York. **28:** © 1995 Man
Ray Trust, Paris. Photograph © 1995 The
Museum of Modern Art, New York. © 1995
Artists Rights Society (ARS), New
York/ADAGP, Paris. **29:** © RMN. © 1995
Artists Rights Society (ARS), New
York/SPADEM, Paris. **31:** acc. no.
29.100.394. **34:** By permission of the
artist. **37:** © Michael S. Yamashita.
38: From *The Art of the Japanese Garden*
by Tatsuo Ishimoto, copyright © 1958 by
Crown Publishers, Inc. Reprinted by
permission of the publisher. **39, 41 - 44,
47 - 49, 51:** Susan Hansen, Apple Creek,
OH.